"YORKSHIRE MONASTICISM„

Archaeology, Art and Architecture, from the 7th to 16th Centuries

Edited by
Lawrence R. Hoey

THE BRITISH ARCHAEOLOGICAL ASSOCIATION
CONFERENCE TRANSACTIONS XVI

Copies of these may be obtained from W. S. Maney and Son Limited, Hudson Road, Leeds LS9 7DL

ISBN Hardback 0 901286 53 2
Paperback 0 901286 54 0

British Library Cataloguing-in-Publication Data
A catalogue record for this book is available from the British Library

PRINTED IN GREAT BRITAIN BY W. S. MANEY AND SON LIMITED
HUDSON ROAD, LEEDS LS9 7DL

CONTENTS

ABBREVIATIONS AND SHORTENED TITLES

Antiq. J.	*Antiquaries Journal*
Archaeol. J.	*Archaeological Journal*
BAA CT	*British Archaeological Society Conference Transactions*
B/E	N. Pevsner *et al.*, eds, *The Buildings of England* (Harmondsworth various dates)
Brit. Nus. J.	*British Numismatics Journal*
HMBCE	*Historic Monuments and Buildings Commission England*
JBAA	*Journal of the British Archaeological Society*
Med. Archaeol.	*Medieval Archaeology*
Proc. Soc. Antiq. London	*Proceedings of the Society of Antiquaries of London*
RCHM	Royal Commission on Historical Monuments
RIBA	Royal Institute of British Architects
VCH	Victoria County History
Yorks. Archaeol. J.	*Yorkshire Archaeological Journal*

Anglo-Saxon and Later Whitby

By Philip Rahtz

INTRODUCTION

This paper reviews the research that has been generated by the Abbey complex on the eastern cliff-top, and relates it to the present 'heritage' context, the subject of a major new initiative by English Heritage and Scarborough Borough Council.

While the historical sources for Whitby are relatively well-known, the archaeological evidence has not been so widely appreciated. Excavation in the 1920s, in 1958 and in 1989, have yielded a mass of data, and very much more is still buried; its conservation in the face of development and tourism has been a cause of concern, but hopefully threats can now be averted.

It is, however, not only the academic research potential which must be considered. The complex offers major opportunities in public education; presentation of the Abbey ruins and site is still undeveloped by comparison with the magnificent exposition of other monastic sites in the north-east, such as Mount Grace, Rievaulx, Fountains, Jarrow and Lindisfarne.

Whitby or Strensall?

The monastery of *Streoneshalh* (as it was known to Bede and his contemporaries) was founded in A.D. 657 on an estate of ten hides donated by King Oswiu, as part of a gift to the church in thanksgiving for a victory at *Winwaed* in 655. It is not clear whether there was already a settlement at the place. The first abbess was Hild; she appears to have established a regular training school for ecclesiastics: five of her pupils became bishops. The monastery was also important as a burial place for the Northumbrian royal house, and the famous synod was held there in 664; both of these functions stress the political importance of the monastery.

By the 12th century, it was believed that *Streoneshalh* (which had been destroyed in the 9th century) was at Whitby; William of Malmesbury says that King Edmund pillaged Hild's bones from Whitby and removed them to Glastonbury *c.* 944.[1] To the monks who came from Evesham and Winchcombe to reoccupy the site in the late 11th century, the cliff-top site at Whitby was promoted as Hild's monastery. Rosemary Cramp suggests that *Witebi* was originally the harbour settlement, and absorbed the hill-top settlement of *Prestebi*.[2]

William of Malmesbury[3] clearly also believed that *Prestebi* was the 'most ancient monastery of St Peter', and adds a little local colour: 'there were at that time, in the same place, as aged countrymen have informed us, *monasteria* or oratories to nearly the number of forty, whereby the walls and altars, empty and useless, had survived the destruction of the pirate host' — suggesting to Rosemary Cramp[3] that the buildings then visible were of stone.

The name *Streoneshalh* was 'explained' by Bede as being derived from *sinus fari*. Professor Cramp favours the translation of this as 'haven of the watch-tower': eleven late-Roman coins and pottery have been found on the site.[4] Other interpretations of Bede's Latin are however possible, including 'corner of generation'.[5]

Dr Lawrence Butler revived an older idea that cast doubt on the equation of *Witebi* or *Prestebi* with *Streoneshalh*; he suggests that the identification may have been the result of a local tradition being 'assiduously promoted by the newly-founded Benedictine house in the

late 11th-12th century'.[6] The alternative location for the monastery would be at Strensall, just outside York on its north side, in the area of the later Forest of Galtres, approached by a road out of the city at Bootham Bar. Butler is impressed not only by its name, but also by the royal associations of *Streoneshalh*.[7] The monastery would, at Strensall, be close to the royal city of York, whose (still unlocated) Saxon cathedral was founded by Edwin, and dedicated to St Peter.

Archaeologically, nothing visually survives at Strensall of any antiquity. St Mary's Church there is 19th century. There is, however, a Roman site close to the church on the other side of the River Foss.[8]

The only material evidence for the abbey at Whitby being *Streoneshalh* is the stone plaque inscribed with an epitaph to Alflaed, daughter of King Oswiu, who was Hild's successor as abbess in 680–713/14. Part of this was found in the excavation in the 1920s.[9] If this interpretation is indeed susceptible of no other interpretation (and no one at the York 1988 conference was aware that doubt had ever been cast) this would seem to be the one piece of evidence that would discount the possibility that Strensall was the *sole* element of Hild's monastery.[10]

If Butler and his predecessors were right however, in discounting Whitby as *Streoneshalh*, then the medieval equation was misguided or misleading; but we would still be left with a major Anglo-Saxon archaeological site beneath the Benedictine Abbey of Whitby.

ARCHAEOLOGY (Fig. 1)

The excavations of 1920–8 were in the Guardianship area, and like many of their day, were initiated and conducted with the primary aim of explicating the monument. The principal objectives were to uncover foundations and other substantial features so that the Abbey ruins could be interpreted more completely, and presented to the public in a more intelligible manner. In this way, part of the plan of the Norman church which preceded the present one was recovered. During the course of this work, Anglo-Saxon features were discovered, and this led to the major excavation for which the site is best known. The work was not carried out by archaeologists, but by unskilled labour, with periodic visits from the Inspectorate to instruct the foreman. Stratigraphy was thus minimal in the work; the stratification was largely removed without record, apart from noting the approximate location of finds (see below).

The 1958 excavations were initiated in a rescue context. In those north of the Abbey (Site One, Fig. 2), the work was done because it was planned to level some earthworks; and that to the south (Site Two) was in advance of the building of a new structure for the Royal Observer Corps. Both were done by unskilled labour and volunteers, but with the continual presence of an archaeologist (Tony Pacitto or the writer).

The only other excavation was done recently by Mark Johnson in 1989, because a new visitor shop was being built at the entrance to the Abbey grounds; this was a single-handed operation.

These excavations will now be considered in more detail.

1920–8
The clearance work inside and immediately around the Abbey ruin has not been fully published, though further detail may reside in English Heritage archives.

It was the discovery of burnt daub in the clearance of the western range that led to a large area excavation (Figs 1, 2) south of the ruins. Most of the ground between the north side of the church and Abbey Lane was excavated to various depths (see below). Some 1,200 sq m

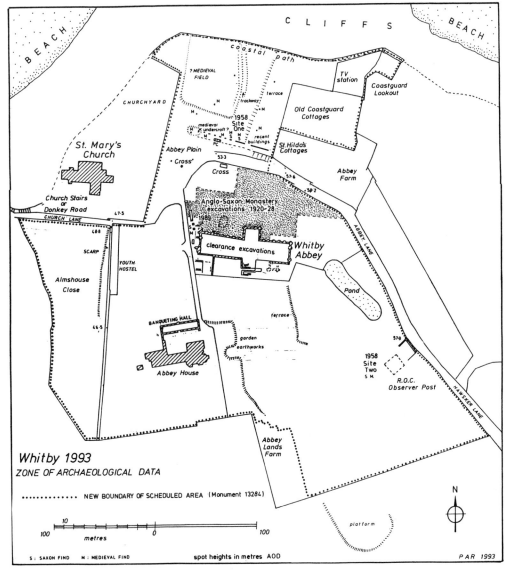

FIG. 1.

survived however to the north-west, and a further *c.* 800 sq m to the north-east; beyond the southern boundary fence, however, there is still a large area of open ground, unexplored except for the small dig done in 1958.

The Anglo-Saxon remains, being perhaps more strictly archaeological, were published in full, but only after the lapse of fifteen years.[11] The report dealt with the structural remains discovered, but was especially concerned with the numerous finds, the international importance of which was and is universally recognised. The interpretation was of course coloured by the belief that the cliff-top site was to be equated with the historical

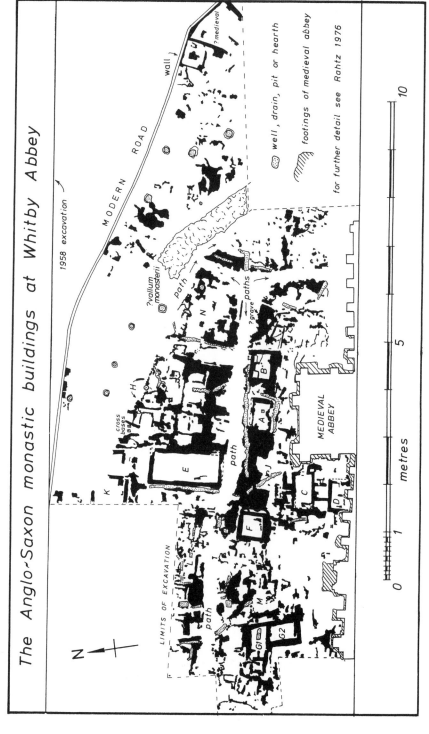

The Anglo-Saxon monastic buildings at Whitby Abbey

FIG. 2.

Streoneshalh, as most people believe. A further thirty years passed before this report was again considered in detail (see below).

1958 — Site One

The main excavation in the 1950s was in the area north of Abbey Lane; it consisted of fifteen small trenches or test-holes, to examine the stratification in this open grassed area; *c.* 6,000 sq m were tested in this way in two weeks.[12] The area included a possible medieval field, in which ridge and furrow could be discerned aerially.

It should be noted that this field, and the churchyard of St Mary's to the west, have both been truncated by coastal erosion. This was formerly estimated to be causing the cliff to retreat at the rate of *c.* 20 m per century. Thus, in the 8th century, the Anglo-Saxon monastery may have been several hundred metres further from the cliff than it is today.

Anglo-Saxon pottery, post-holes, burnt and unburnt clay, and dark soil, were found in the cuttings *c.* 15 m north of Abbey Lane (Fig. 2) at depths of up to a metre. This made it clear that occupation of this date extended over 20 m beyond the limits of the 1920's excavation and even more beyond the *vallum* (see below).

Medieval pottery or minor features were located in most cuttings (the incidence of pottery is shown in Fig. 2). There was also, in a hollow *c.* 33 m north of the Abbey Plain cross (Fig. 1) what may be the undercroft of a medieval building, with subsidence columns. In this area, too, were drains and evidence of industrial activity.

1958 — Site Two

The excavation here located what is probably a mixed lay cemetery, with intercutting graves.[13] The skeletal remains represented twenty-one individuals, with a predominance of females and children. Most, if not all, were of medieval or later date (from the evidence of pottery). The graves and bones were in an area dug of only 18 sq m (20 × 10 ft) so this cemetery is likely to be dense and of long duration.

The graves penetrated to the water table (at a depth of *c.* 1.50 m), so any earlier levels will have been destroyed. A 9th-century *styca* was, however, found and suggests that Anglo-Saxon occupation may have extended this far.

1989

This excavation was carried out by Mark Johnson for English Heritage in 1989.[14] He made two small cuttings, each two metres square. It was shown that in this area at least, there were intact stratified Anglo-Saxon and medieval deposits which had survived the campaign of the 1920s. There was some evidence of terracing here, possibly of medieval date; this may have truncated earlier stratification, and have led to secondary deposition of Anglo-Saxon material. Much daub was found, some with wattle impressions and prepared surfaces with a buff coating.

The area Johnson examined is immediately adjacent to the 1920–8 area; the interpretation of his evidence in relation to the earlier work is discussed below.

The re-evaluation of the 1943 report on the excavation in the 1920s

In the early 1970s Professor Rosemary Cramp and the writer quite independently cast a critical look at the 1943 published report of the guardianship area excavations; she was concerned with the location of the finds and the light that this might shed on the date and functions of the buildings whose foundations were uncovered in the 1920s, while I was interested in the published plan, which had been subject to gross misinterpretation. We were helped to locate the original drawings and notes in the then DOE archives in London[15] and (for the finds) in the British Museum. No proper report survived of the earlier work nor any

detailed plans or sections; there were photographs, but Radford wrote his published report only from these and the foreman's diary, as he later told Professor Cramp.

The results of our enquiries were published by us in 1976;[16] but, since this was in a book of essays that was principally archaeological, it was not much read by historians and art historians; and that was the principal justification for giving this paper to the 1988 York conference, whose members were indeed largely unaware that there were problems about the archaeology of the site.

The plan published in 1943 has the title 'Whitby Abbey: foundations of early monastery shown in red'. The reasons for colouring some of the foundations red are clear: although wall foundations of many buildings were discovered, the only units that were clearly recognisable in the earlier decades of the century were those that had at least three walls, and preferably (to Peers and Radford) four: only these were deemed to enclose a space which could be called a building. One may ask how it was that, in such an early excavation, a plan was drawn of the uncovered foundations in detail: not just the red elements identified as buildings, but every stone in a manner of which even Philip Barker would be proud — a good example indeed of the tedious procedures which archaeologists use nowadays. The answer is one from which it is possible to draw a moral: a professional surveyor who knew absolutely nothing about archaeology was told to get out there and make a plan of the stones — which he did. Sir Charles Peers must have been rather embarrassed, hence the red elements.

The plan was, however, published as the surveyor had drawn it; and the shading in red was a legitimate if limited piece of contemporary interpretation. Unfortunately, others, including the then DOE themselves, only reproduced the red elements, as 'the plan of the pre-Conquest monastery'. Such a plan will be found in the earlier official handbook,[17] and in other general works. It is still (1993) displayed in the abbey.[18]

From such selective versions of the plan, an inference was drawn that was as far from the truth as it could be: that the buildings shown were isolated cells, comparable historically with Bede's account of individual cells at Coldingham, and archaeologically with the western British ('Celtic') monastic sites such as Skellig Michael, off the coast of Kerry; or with what was believed to be a monastery at Tintagel; the latter is now shown to be a semi-urban concentration of buildings which appears to be a secular site of very high status in the 6th century.[19]

In the early 1970s, the plan was redrawn from the original drawings at the DOE.[20] The 'red' buildings were included and named with letters; and others were named that could be discerned among the foundations.

All graves were omitted, because they tend to obscure the detail of the wall foundations in the 1943 published plan. There were about 250 of these; one possible grave-pit is suggested in the report to be Anglo-Saxon, and that was left in. The rest are 12th century or later, 'dug at random through the old foundations'; 'the site of the Anglian cemetery is unknown'.[21] There is thus no doubt that virtually all the graves belonged to the medieval Benedictine abbey. In the light of the quotation above, it is odd that the report includes a specialist report on the textile remains 'in the Saxon cemetery at Whitby';[22] the report does not specify which of the graves on the plan the textiles came from — they were presumably actually medieval.

Professor Cramp is of the opinion, however, that my plan is misleading in leaving off the graves, because she believes that some at least were in fact Anglo-Saxon (see below).[23] Clearly what is needed is a detailed larger scale plan of each area with and without graves, or omitting only those which are shown in the plan to have had medieval stone grave covers.[24]

To return to the plan: firstly, it will be clear that the half-hectare that was uncovered is only part of the Anglo-Saxon layout. The small excavation north of this area, on the other

side of the modern road, encountered Anglo-Saxon features and pottery;[25] and similar remains have been found to the south of the Benedictine church and in front of the west door.[26] No plan is known of the latter areas.

In the area excavated in the 1920s a construction of stones and soil extending north-west — south-east in the north-east part of the site was interpreted as a roadway; or, as Clapham later thought,[27] the foundation for a broad wall or bank — the *vallum monasterii*. If this construction did, either as a road or a *vallum*, mark a boundary to the complex on this side, it must have been a secondary retrenchment, as some of the wells on the plan lie beyond it to the north-east, as well as the discoveries further north again. There is moreover, as Professor Cramp points out,[28] as great a density of Anglo-Saxon finds, and of a similar range beyond the *vallum*, as those in the area to the south.

The stones on the plan are what was left after the removal of workmen of all overburden (what we would nowadays call the archaeological stratification) and apparently some of the natural underlying clay as well. The stones are seen in photographs to be on pillars of natural clay, divorced from their archaeological deposits, and nakedly exposed, even when they were originally below the contemporary ground level. Most of the stones shown were foundations; what had been above-ground walling, according to the report, only survived in a few places.[29] The foundations were set in clay, not mortar, and averaged *c.* 0.6 m (2 ft) in width. A stone superstructure therefore seems unlikely, though it seemed to Professor Cramp to be implied by the account mentioned above;[30] Peers, too seemed to believe this, presumably because there were some architectural fragments among the finds. Quantities of burnt daub were found, probably from the main walls of wattle and daub, or from partitions; but nothing is known of contexts, and the daub might belong to an earlier timber phase. No roofing material was found; this might have been of thatch or shingles or other organic material.

The stones which were drawn are not, however, all of building foundations; some are floor slabs, and others are of drains, many of these slab-covered. There are also several linear blank areas, which I interpreted as paths or access lanes; they were never specified as such in the report, but Clapham also believed that this is what they were.[31] One appears to run inside the road or *vallum*, similar to a medieval intra-mural urban roadway behind the defences.

The plan is thus of an organised and dense conglomeration of structures, many of which are rooms or elements of large and complex ranges of buildings, set on both sides of a network of paths.

The finds make it clear that this complex is pre-Conquest and that its use extended over at least the 7th and 8th centuries, and probably later.[32] The burnt daub suggests destruction by fire at one stage; but it would be unsafe to assume that all the finds from the excavation are earlier than the fire.

Presumably, these were some of the builidings which were assumed to be those of the earlier monastery by Simeon of Durham's 'aged countrymen' and also by the monks of Evesham and Winchcombe, by which date the buildings were ruinous.

Professor Cramp did some excellent detective work in the DOE and British Museum to try to pinpoint the finds published in relation to these buildings. She discounts the suggestion that one of the buildings was a smithy,[33] as the original report suggested;[34] there is no hint of metalworking here in the finds register, and (surprisingly, and perhaps unjustifiably!) she thought it unlikely that smithing would be done by females.[35]

The large area west of the transept of the later church was, she believed, the focus of important Anglo-Saxon burials. The finding here of wall slabs and a baluster shaft suggested to her that the Anglo-Saxon church was somewhere near, perhaps under the present nave. There were also in this area parts of Anglo-Saxon crosses, inscriptions, and

Anglo-Saxon coins. But below all these was 'Saxon paving' with pottery. The pieces of crosses and inscriptions are thus most likely to be secondary dumped material here. Other finds, such as sceattas, pottery, bone pins and styli *could* be from graves, but all are matched from other areas of the excavation; there was also a loom-weight and a millstone in this area, unlikely to have been in graves.

On balance, it still seems unlikely that *any* of the graves found in the earlier excavations were of pre-Conquest date,[36] and certainly not any 'important Anglo-Saxon burials' west of the North Transept.[37] It is unfortunate that this misapprehension was repeated recently by Dr Glyn Coppack;[38] who also uses the earlier plan, with all the graves shown.

Finds in general were astonishingly numerous; the recovery of so many coins and metal objects was expedited by a reward system to workmen: very special metal objects and exceptional coins earned 2s. 6d. (12.5p) and other Anglo-Saxon coins 1s. (5p).[39] In spite of this, it seems that more finds were recovered during backfilling than in excavation.[40]

The range of finds is also wide; normal domestic activities are represented by millstones, querns, bronze and glass vessels, loom weights, a whale vertebra, and pottery (including imported ware). Personal items include tweezers, needles, shears, dress-fastenings, combs, spindle-whorls, pins, rings, and jet. Book production is suggested by styli and book clasps. The only religious object, apart from the cross fragments and other sculpture, is a bronze pectoral cross.

Professor Cramp comments on the richness of the assembly by comparison with that from Monkwearmouth or Jarrow.[41] The site is certainly one of high status in archaeological terms. Even if there are no Anglo-Saxon graves in the area dug in the 1920s, there must be a cemetery nearby, and also the substantial building believed by Professor Cramp to be a church.

In isolation, in purely archaeological terms, the site could be that of a high status secular community. Material culture assemblages from such places and monasteries may be very similar,[42] and there are similar problems in the interpretation of Brandon, Suffolk,[43] and in recent work at Flixborough, Humberside.

Professor Cramp has recently provided a valuable reconsideration of the material culture of Whitby in relation both other sites excavated in the north (Hoddom, Whithorn, Hartlepool, Monkwearmouth, and Jarrow). She also puts Whitby into a wider continental perspective, notably in relation to the exotic finds of pottery and glass, and its remarkable range of sculpture.[44]

In the historical context, and in view of what followed in the medieval period, it would be myopic not to believe the Anglo-Saxon remains were those of a monastery, though certainly with high-status secular associations. Professor Cramp is probably right in identifying the excavated part of the complex as the equivalent of the *domunculae* of Coldingham, used by the female members of the community, the communal buildings being on the other (south) side of the monastic church.

There is similarly no serious reason to doubt that this was *Streoneshalh*. Even if Butler was right in his suggestion that Strensall derives also from this name, one must believe that, as the York 1988 conference members unanimously agreed, this was a 'monastery in two places', one near the royal centre at York, the other (and major?) element on the cliffs at Whitby.

The excavated remains of which we have the plan are not however, it must be emphasised, isolated cell-like buildings, but are part of an urban-type layout more familiar in the complex claustral plans such as St Gall, Monkwearmouth/Jarrow, or the later foundations discussed elsewhere in this volume.

Johnson emphasised the uncertainty in separating Anglo-Saxon from medieval structures in the earlier plan, let alone determining which of the stones were drains, paving or

foundations.[45] He points out that the 1943 plan does show spot heights, which should enable future excavators to remove the back-filling of the 1920s excavation with some precision. He has also provided a new version of the plan which emphasises the degree of disturbance by medieval graves and other features; and raises the interesting point that there is no record in the 1943 report of any human bones having been lifted or examined, or even seen![46] If they are still *in situ*, they would be a valuable addition to the social and demographic data for at least the later abbey. Bones should be preserved fairly well, to judge by those which periodically appear when the cliff on the edge of St Mary's graveyard suffers erosion from the sea!

A great opportunity was lost in the 1920s. In no other early monastery has such a dense agglomeration of structures, with such an important array of finds, been located or excavated. Even without further excavation, more could be done on the data available. Neither Professor Cramp nor the writer went to the limits of analysis, either in terms of the plan or the finds.

THE NEW INITIATIVE: RESEARCH, CONSERVATION AND PRESENTATION

The urgent need is, however, to secure the future preservation of what remains in the ground. While the guardianship area is safe, it is now widely recognised that the abbey site (including parts of the pre-Conquest monastic complex) extends well beyond this, into areas which are by no means secure, from development or from visitor erosion.[47]

The latter has been serious in recent years in the area north of Abbey Plain. Here the intensive vehicle movement has eroded the soil, exposing foundations of unknown date; temporary measures have now been taken (with 'Terram' membrane) to protect the structures and stratification being exposed.[48]

It was this problem, of where to park cars for visitors to the Abbey, to St Mary's Church, and to the town below, that led to a new initiative in 1990 under the joint auspices of English Heritage and Scarborough Borough Council. On the one hand, it was realised, in trying to decide what should be conserved, that the limits of Anglo-Saxon and medieval settlement were neither known nor clearly defined. On the other hand, English Heritage were anxious to improve their own academic understanding of such an important place in order to assist their presentation of the monument, although there is now a small visitor centre.

Neither residents, nor visitors, have much awareness of the site or its remarkable collection of finds, which are mostly in the British Museum. Whitby Museum, though a venerable and valuable example of an 'unrestored' museum, does little to attract visitors to the Abbey.

Not surprisingly, it was recently estimated that only some of the innumerable visitors who park their cars on the Abbey Plain visit the Abbey itself (100–136,000 per annum); they are more attracted by St Mary's Church (c. 160,000 visitors per annum), the cliffs, or the route down the donkey road to the remarkably well-preserved old town below.

In the new initiative, a multi-disciplinary approach was set in train, involving the Universities of Durham, York and Lampeter, with the York Archaeological Trust.
The work executed or planned includes:

1. detailed survey of the area, by electronically aided instruments, leading to detailed contour and other plans (under way);
2. recording of the fabric of the Abbey ruin as it is now, stone-by-stone, using photogrammetry, manually edited (the stones are steadily being eroded by natural causes, accelerated by air pollution) (under way);

3. environmental survey of beetles, pollen, fauna etc., both present and buried. The sediments in the pond (Fig. 2) have been examined by means of augered cores;
4. geophysical survey, by radar, electrical resistance, magnetic variation, and sonic resonance etc., to map the ground below the turf, and predict the location of buried features such as walls, pits, graves and ditches. What may be the infirmary was located near the pond in Fig. 2 (under way).

These methods are all new to Whitby; but additionally, the new initiative offers an opportunity for a new look at the Anglo-Saxon finds, notably the sculpture: a review of the documentary evidence; and further research into the wider topic of early monasticism in the north-east of England. The latter will enable the archaeology of Whitby to be formally compared with the results of excavations at Hartlepool, Tynemouth, Monkwearmouth and Jarrow and associated research at other ecclesiastical sites such as Hexham, Lindisfarne and Durham.

Excavation has been taking place in the areas destined to be the new parking area and enlarged visitor centre; and further large-scale work is planned for 1995 and subsequent years. There have also been watching briefs on disturbances for ancillary access routes, including the Donkey Road and the steep slope below Almshouse Close (Fig. 2).

The new appraisal of the area around Whitby Abbey has led to a heightened awareness of its importance, both to academic research and as an attractive magnet for tourism. English Heritage are concerned not only with the conservation of monastic remains, but with other structures such as the 17th-century Cholmley Manor House, with its ruined Banqueting Hall,[49] the 14th-century cross on the Abbey Plain, the paved and stepped Church Stairs or Donkey Road and of course the magnificent cliff-top environment. To this end, they have formulated a scheme, in collaboration with Scarborough Borough Council, to repair and conserve structures, and to make new provision for vehicle parking in an area where no damage can be done to buried strata. To this end they have increased the scheduled area by 250 per cent from 4 ha to 10 ha.[50]

CONCLUSION

One of the truisms dreamt up in modern theoretical archaeology is that the residues of the past — above ground or below — are not the *past* waiting to be revealed to scholars or tourists: they are a feature of the *present*, data which can be interrogated by each generation according to its predilections. The important thing is that the data should not be destroyed or eroded before they can be put into the witness-box. The Anglo-Saxon monastery, the Benedictine Abbey, the medieval cross, St Mary's Church and graveyard, the post-medieval manor, and the donkey road comprise a dramatic complex in an incomparable cliff-top environment 'bounded' by the 'heritage coast', and above a remarkable harbourside urban nucleus. The new initiative by English Heritage and the Scarborough Borough Council has provided a secure foundation for their survival, and for their exploitation in the pursuit of truth and the education of the public.

REFERENCES

1. R. Cramp, 'Monastic Sites', *The Archaeology of Anglo-Saxon England*, ed. D. M. Wilson (London 1976), 223.
2. Ibid., 223.
3. Ibid., 223.
4. Ibid., footnote 68, p. 251.
5. Ibid., 223.

6. L. A. S. Butler, 'Church dedications and the cult of saints', *The Anglo-Saxon Church*, eds L. A. S. Butler and R. K. Morris (London 1986), 44–50, especially footnote 11, p. 49.
7. *In lit.* to the author.
8. Inf. John Bateman, University of York.
9. C. Peers and C. A. Ralegh Radford, 'The Saxon Monastery of Whitby', *Archaeologia* 89 (1943), 41–2, Fig. 4.
10. Cf. R. Cramp, 'A Reconsideration of the Monastic Site of Whitby', *The Age of Migrating Ideas*, eds R. M. Spearman and John Higgitt (Edinburgh 1993), 64.
11. Peers and Radford, 'Whitby'.
12. P. A. Rahtz, 'Whitby 1958', *Yorkshire Archaeological Journal* 40 (1959–62), 604–18.
13. P. A. Rahtz, 'Whitby Site Two', *Yorkshire Archaeological Journal* 42 (1967–70), 72–3.
14. M. Johnson, 'The Saxon Monastery at Whitby: past, present, future', *In Search of Cult*, ed. M. O. H. Carver (Woodbridge 1993), Ch. 11.
15. Department of the Environment, now HBMC/English Heritage.
16. R. Cramp, 'Monastic Sites' and 'Analysis of the Finds Register ...'; P. A. Rahtz, 'The Building Plan of the Anglo-Saxon Monastery of Whitby Abbey', both in *The Archaeology of Anglo-Saxon England*, ed. D. M. Wilson (London 1976), 223–9, 453–7 and 459–62 with Fig. 5.7.
17. A. Clapham, *Whitby Abbey, Yorkshire* (London 1952).
18. A full plan is, however, shown in the recently designed presentation in the visitor centre.
19. C. Thomas, *English Heritage Book of Tintagel* (London 1993).
20. P. A. Rahtz, 'Building Plan' with Fig. 5.7, pp. 224–5; simplified now as Fig. 1 in this volume.
21. Peers and Radford, 'Whitby', 29 and 33.
22. Ibid., 86.
23. Cramp, 'Monastic Sites', 228; and 'Reconsideration', 65.
24. Johnson, 'The Saxon Monastery'.
25. Rahtz, 'Whitby 1958'.
26. Peers and Radford, 'Whitby', 29.
27. Clapham, *Whitby Abbey*, 10.
28. Cramp, 'Finds Register', 457.
29. Peers and Radford, 'Whitby', 31.
30. Cramp, 'Monastic Sites', 223.
31. Clapham, *Whitby Abbey*, 11.
32. See now Cramp, 'Reconsideration', for new datings and finds.
33. G on the published plans.
34. Peers and Radford, 'Whitby', 31.
35. Cramp, 'Finds Register', 456.
36. Cf. Johnson, 89.
37. Cramp, 'Monastic Sites', 22.
38. G. Coppack, *English Heritage Book of the Abbeys and Priories* (London 1990), 61–2.
39. Cramp, 'Finds Register', 454.
40. Ibid., 455.
41. Cramp, 'Monastic Sites', 229; she comments, however, in 'Reconsideration', 71, that the assemblage may not now appear to be so rich in the light of the material found at Whithorn and Flixborough.
42. Cf. P. A. Rahtz, 'Monasteries as settlements', *Scottish Archaeological Forum* 5 (1973), 125–35; R. Gilchrist and R. Morris, 'Monasteries and settlements; religion, society and economy, AD 600–1050', in *In Search of Cult*, ed. M. O. H. Carver (Woodbridge 1993).
43. R. D. Carr, A. Tester and P. Murphy, 'The Middle Saxon Settlement at Staunch Meadow, Brandon', *Antiquity* 62, No. 235 (June 1988), 371–7.
44. Cramp, 'Reconsideration'.
45. Johnson, 'The Saxon Monastery', 90.
46. Ibid., Fig. 11.1.
47. Including parts of the pre-Conquest monastic complex.
48. Nearly 50,000 cars were parked here in 1990–1.
49. 'Abbey House' in Fig. 2.
50. National Monument number 13284. This includes Almshouse Close (Fig. 2). Important Anglo-Saxon finds were made on the steep slopes west of this in the last century; it seems likely, therefore, that the Anglo-Saxon monastic area extends right to the cliff edge here. See A. White, 'Finds from the Anglian Monastic at Whitby', *Yorkshire Archaeology Journal* 56 (1984), 33–9; also R. Annis, *Well Court, Whitby*, MS, report on watching brief in this area by Cleveland County Archaeological Section for Scarborough Borough Council, 1994.

Antiquaries and Archaeology in and around Ripon Minster

By R. A. Hall

Ripon lies on the west flank of the Vale of York, 21 miles/33 kms north-west of York. Thomas Gent surmised that the site 'wanted nothing of the advantages of nature to adorn it. The pleasant streams of a beautiful river, now call'd Ure, on the North, and those proceeding from the Rivulet Skell on the south, were unspeakably attractive and inviting'.[1] 'The troublous Skell', as it was described by Spenser in his *Faerie Queen*, joins the main river some three quarters of a mile (1.2 km) downstream from the Minster.

The description of the town by Edward Haynes, written after a visit in 1803, still seems apposite. Ripon, he said, is 'a large and respectable borough-town, and the inhabitants are gay and sociable ... No great degree of trade is carried on. ... the people living chiefly within themselves'.[2] This feeling was echoed, perhaps in the early 1950s, by the Ripon Publicity Committee who noted that 'salubrity is the keynote of residence at Ripon'.[3] Previously, in the 17th and earlier 18th centuries, the town was noted for the production of spurs, and the phrase 'As true as Ripon rowels' became proverbial; from the later medieval period, Ripon had also been a centre for the wool trade. The medieval and post-medieval town has been investigated in archaeological excavations directed by P. Mayes in St Marygate in 1973–4[4] and by D. Perring at Bedern Bank in 1985.[5] However, it has been two other aspects of Ripon's historical topography which have dominated antiquarian and archaeological research.

The first of these is Ailey Hill, alias Ailcy Hill, a tree-covered knoll which lies some 220 yards (200 m) due east of Ripon Minster. It first became a topic of antiquarian curiosity in 1695, when a hoard of Anglo-Saxon *stycas* was found there, and further speculations were fuelled by the discovery of human skeletons on various occasions. These were placed in their true context, as part of an Anglo-Saxon cemetery on a natural glacial feature, during excavations in 1986 and 1987. The development of antiquarian and archaeological thought concerning Ailey Hill, and the detailed results of these excavations, will be dealt with in a future report.[6]

The second and better-known theme is introduced by Bede, in both the *Ecclesiastical History* and his prose *Life of St. Cuthbert*, and by Eddius's *Life of Wilfrid*. Between them these sources relate how Alhfrith, sub-king of Deira, granted to Wilfrid *c.* 660 the monastery of *Inhrypum*, a site which only a short time previously he had given to Eata of Melrose. Eata had founded a 'Celtic' community in which Cuthbert was guest-master; Alhfrith's transfer of allegiance to Wilfrid's 'Roman' form of Christianity may have taken place as a political move against his father King Oswiu of Northumbria, whose links were with the Celtic church. These circumstances, incidentally, stimulated one partisan mid-19th-century commentator to suggest that 'Ripon owes its foundation to the existence of one of England's first Protestant Churches'.[7]

The name *Inhrypum* is, according to Smith, the dative plural of an old folk name, and means 'among the Hrype'; Smith suggests that they were an important Anglian folk who gave their name, *inter alia*, to Ripley (Yorkshire) and to Repton (Derbyshire).[8] While there is no reliable archaeological evidence to characterise this early-7th-century royal holding, discoveries made in 1866 at North Terrace, Ripon, some three quarters of a mile (1.2 km) north-north-east of the Minster, may perhaps relate to this era. Workmen lowering the

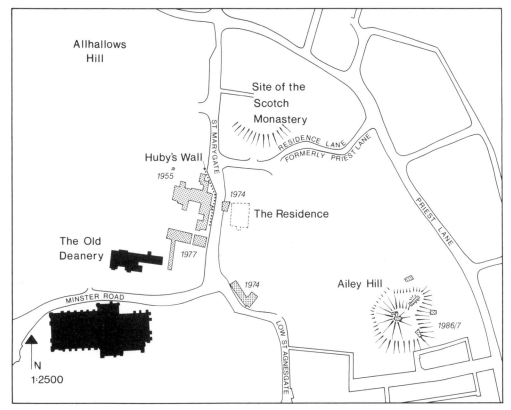

FIG. I. The area north and east of Ripon Cathedral, showing principal streets, structures and excavation sites mentioned in the text

ground level in the back garden of Mr H. Sharpin came upon fragments of pottery which were initially thought to be of Roman date. Investigations by local antiquarians including J. R. Walbran resulted in the discovery of 'a large quantity of urn pottery embedded in clay, partly baked, and a quantity of charcoal ashes, mostly below the clay'.[9] The passage subsequently makes it clear that it was the clay, not the urn pottery, that was partly baked.

At the first the discovery was interpreted as a barrow or burial mound of the Roman period which had subsequently been disturbed and the urns smashed. A short time later, however, the place was further examined (it is not clear by whom), and the likely date of the remains was revised to the Anglo-Saxon period. The present whereabouts of the fragmentary urns is not known (could they be the 'medieval urns found at Ripon' which were acquired by the Yorkshire Archaeological Society from Rev. Canon Raine on 1 October 1872?); it is thus impossible to establish the accuracy of the mid-19th-century interpretation. If this was an Anglo-Saxon cremation cemetery, it is the only such pagan Anglo-Saxon find spot in the vicinity, apart perhaps from Ailey Hill.

If, on the other hand, the urns were of Roman date, as first surmised, this would be one of a number of discoveries of Romano-British date in and around Ripon. These include sporadic finds of coins,[10] including *denarii* recovered in the Minster Yard 'at such depths as to show they were not originally lost or deposited very near the surface',[11] and the coin of

Vespasian found in 1827 at a depth of 3 ft (0.9 m) on Skellbank;[12] part of a glass bangle recovered in 1987 at Ailey Hill; pottery, such as the 'Roman vase' found at a depth of 7 ft (2.1 m) in the Horsemarket (North Street);[13] and various pieces of architectural stonework, notably those reused in the Minster crypt (below p. 25). While all of these could have been brought to Ripon from a site relatively close at hand, such as the *civitas* capital at Aldborough (*Isurium Brigantum*), they could alternatively represent contemporary occupation in or immediately around the area of medieval settlement. Walbran has a tantalising reference to a sketch of a Roman tesselated pavement, supposedly discovered in Ripon, 'among the papers of the learned Gale', but it has not yet proved possible to locate his source.[14] Any hypothesis concerning a continuity of occupation at Ripon from a Romano-British settlement *via* a pagan Anglo-Saxon phase to the introduction of Christianity is, however, purely speculative at present.

Nothing survives of Eata's monastery, which apparently received its first antiquarian mention — just a passing reference — in Gibson's 1695 edition of Camden's *Britannia*.[15] Jefferys's (1771) plan of Ripon marked the site of the *Scotch Monastry* on a neck of land between Priest Lane and St Marygate (Fig. 1). Farrer could only record a belief that there had been two monasteries at Ripon, of which one, adjoining Priest Lane, had been founded by one of the kings of Scotland.[16] Linney, referring to Eata's monastery, noted that

FIG. 2. Tuting's illustration of a 'brass or bronze Saxon needle found AD 1861'. University of Leeds, Brotherton Library, Ripon Dean and Chapter MS 58, p. 110

'inequality of the ground in a field between Stammergate and Priest Lane, marks the site of this monastery; and the place to this day is vulgarly called Scott's (*sic*) Monument Yard'.[17] Walbran, referring to that same location, hypothesised that Eata's church stood in the field called *Scots Monument Yard*, on the east side of the House of Correction, where 'the remains of Early English shafts found in the mound of gravel show a building as late as the 13th century'.[18]

This 'mound of gravel' is presumably the feature shown on Jefferys's 1771 plan by a convention similar to that used for Ailey Hill, and it may have been a similar natural feature of glacial origin. Dean Waddilove, the author of a historical and descriptive account of the Minster,[19] who died in 1828, planted two poplar trees on the mound to mark the presumed site of the monastery; the mound may have been removed when the National School was built in 1853. Walbran noted that several *stycas* of Ethelred (of Northumbria) and a part of a grit-stone column with a diameter of 4 ft 5 in (1.35 m) had been dug up in the field, and although none of these discoveries can have been connected with Eata's monastery, they do indicate the interest of this site, which is now occupied in part by Ripon House, an Old Peoples Residential Home.[20]

If, however, Eata's monastery did not stand on this site (which has never been associated with Wilfrid's monastery), then it is most likely to have occupied the area where Wilfrid's community established itself. The location of Wilfrid's monastery has been the subject of much debate since Leland, who visited Ripon in the mid-16th-century, recorded that

'The old abbay of Ripon stoode wher now is a chappelle of our Lady in a botom one close distant by from a new minstre.

One Marmaduke abbate of Fountaines, a man familiar with Salvage Archebisshop of York, obteinid this chapelle of hym and prebendaries of Ripon: and having it gyven onto hym and to his

abbay pullid down the est end of it, a pece of exceding auncient wark, and buildid a fair pece of new werk with squarid stones for it, leving the west ende of the very old werk stonding.

He began also and finishid a very high waul of squadrid ston at the est end of the garth, that this chapel stondith yn: and had thought to have enclosid the hole [garth with a like] waulle, and [to have made the]ere a celle of [white monks. There lyethe one of the Engelbys] in the est end of this chapel, and there lyith another of them yn the chapelle garthe, and the chapel singith a cantuarie prest.

One thing I much notid, that was 3. crossis standing in row at the est end of the chapelle garth. They were thinges *antiquissimi operis*, and monumentes of sum notable men buried there: so that of al the old monasterie of Ripon and the toun I saw no likely tokens left after the depopulation of the Danes in that place, but only the waulles of owr Lady chapelle and the crosses'.[21]

By the 'old abbay' Leland presumably meant the Wilfridian monastery rather than its short-lived Columban predecessor; but he did not refer to Wilfrid by name in connection with Ripon or its Minster. Neither did he single out the Minster's crypt for attention, remarking 'Howbeit the hole chirch that now standith indubitately was made sins the Conquest'. He did, however, allude to its pre-Norman site when he recorded the common opinion that Archbishop Oda of Canterbury (942–68) 'had pitie of the desolation of Ripon chirch, and began or caussid a new work to be edified wher the minstre now is'.[22]

The enclosing wall built by Marmaduke Huby, Abbot of Fountains Abbey 1495–1526, to which Leland referred, still stands in part to the north of the Minster (Fig. 1). The area within it was the subject of a sketch plan drawn in 1842 by the Ripon painter and antiquarian John Tuting (1785–1865), annotated (or perhaps re-annotated) in 1861, and now in the Brotherton Library at Leeds University.[23]

From internal evidence, the drawing (Figs 3–4) was apparently occasioned by the unearthing of various features during alterations to the area carried out at the behest of Dean Webber in 1840–1. The principal structure encountered and removed in this operation was a 'foundation wall' measuring about 27 ft (8.2 m) in length and 3 ft (0.9 m) in thickness, which stood about 2 ft (0.6 m) high. Tuting identified this as the site of the Lady Chapel; Walbran states that the Chapel had been demolished when a garden for a projected ecclesiastical college was prepared in 1596.[24] The sketch also records that it was in this vicinity that Dean Webber found 'cubes of pavement' in 1841 (it was in 1837 according to Walbran in 1846), which Walbran later interpreted as being of Saxon or Early Norman date.[25] The level in this area was raised by a covering of soil in 1861, but although Webber's activities had destroyed some structural evidence here, traces of buildings may have been left *in situ*, for some four decades later Lukis reported '...in what is now the Deanery garden ... remains of buildings may yet be traced'. Precisely where around the Deanery he was referring to is not, however, clear.[26]

There have been two modern archaeological investigations within Huby's wall. The first, undertaken by T. Baggs in 1955 in advance of building the cottages that now occupy part of the area, recovered foundations which correspond in their position to the wall noted by Tuting. They formed the west wall of a two-cell structure, the date of which has not yet been determined. Some pre-Conquest material was also found, including small fragments of decorated stone crosses; thoughts of Leland's '3 crossis ... *antiquissimi operis*' almost inevitably arise. Among other features uncovered was part of a cemetery where four of the skeletons were accompanied by Anglo-Scandinavian style antler combs, two with comb-cases. If there were indeed no other objects in the graves, this pattern of comb deposition is unusual. May they have been for ecclesiastical use?

In addition to the cross fragments found in the 1955 excavation, there is another, hitherto neglected, piece of sculptural evidence for a late-7th–mid-9th-century graveyard here. In an unprovenanced and undated but, from internal evidence, post-1843 press-cutting pasted

36 Alfonsus Fute Blacketts xo Fute To Agnogate

From ye Bridge

Void

Deanery Garden

No 1. line of Trees — 2 Gate way — 3 waste inclosed by Dean
Waddilove — 4 Cowhouse — 5 line of Trees inside original
wall — 6 visible return of Ashlar wall across the Croft to
No 10, where the garden wall assumes a more ancient appear-
ance 8, antique way into Croft covered over, 7. Scite of St
Marys Church, late level platform about 83$\frac{7\text{th}}{y}$ & 38
much curtailed by adding to the Garden, in 1840 & 41
several bodies found one an infant west end outside of
a wall, the foundations were then taken up the lower course
the usual large cobbles next course regular wrought
Stones the whole about 2 feet high under the grass 3 ft wide
the bodies they are laid on the gravel it is a curious fact which I
witnessed, the person digging knew when he was very near
a corpse, by the fine light crumbling of the Earth near
it, a Skull was thus exposed, though not removed
No 6 Nic Torreys pond; this Torrey had a garden in the field
X a covered well, This Pond was cleaned out in ye memory
of man at a very dry season a cess pool was dug to receive the
water, ▉ antiquities found; "

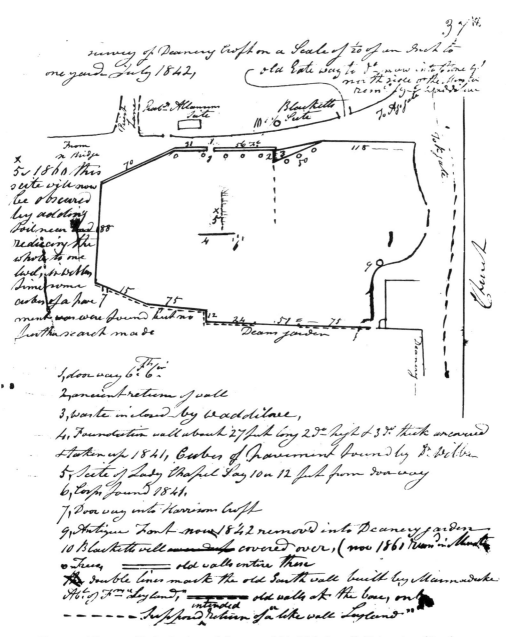

FIG. 3 and FIG. 4. Tuting's plans of the area within Huby's wall. University of Leeds,
Brotherton Library, Ripon Dean and Chapter MS 58, pp. 36 and 37

into Tuting's manuscript book, there is a record of the construction of a large drain at the south end of St Marygate. While digging 'just east' of Huby's wall and 'opposite' The Residence, the workmen exposed several human skeletons, oriented with feet to the east, within 1 ft (0.3 m) of the surface. Furthermore, some 15 in (0.38 m) from the surface, the workmen found

'nothing more nor less than a genuine Saxon Christian gravestone, of the same type as those found, in a long forgotten cemetery at Hartlepool in 1833, 1838 and 1843; but the letters are exactly similar to those engraved on the coffin of St Cuthbert. The inscription (simply the name of the deceased, and another word) is partly broken; but hoping that the missing fragment may yet turn up, we postpone giving it until our next impression'.[27]

If the inscription was ever published, the promised second report did not reach Tuting's notebook. None the less, the statement that the inscription consisted of a name and another word prompts the hypothesis that the stone found in these works was that with the inscription +ADH[Y]SE [PR]B, bought for their museum, now the Yorkshire Museum, by the Yorkshire Philosophical Society, from Mr H. Sharpin of Ripon, on 1 October 1872.

This stone, the upper part of a cross shaft, is dated epigraphically by Okasha as 'possibly eighth to ninth century'.[28] Although its letter forms, given the different media on which they were cut, are broadly similar to those on Cuthbert's coffin, it is completely different in shape from the Hartlepool series of slabs. None the less, it is quite possible that this is the stone referred to in the press-cutting; if it is, this may be another indication of pre-Norman priestly burials in the vicinity of the Lady Chapel, Leland's 'Old Abbay'.

The second modern investigation within Abbot Huby's wall, further to the south than that summarised above, took place over six weeks in 1977–8 under the direction of D. Greenhaugh. A few graves were encountered, although none had associated grave goods. Among the earliest features was a layer of soil, mortar and stone fragments, perhaps representing the demolition of a stone building. No pottery was associated, but the context did produce a 7th-century gold and garnet setting or mount.

Human skeletons have been discovered in both these modern investigations, and Tuting's sketch plan had also noted one, found close to the foundation in 1841. This is the earliest in a series of records of human skeletal remains in this vicinity. Parker, for example, stated that 'in all directions around [the Deanery] lie mouldered remains of many ancestral generations. In a gale in 1883 the fall of a tree near the entrance exposed interleaved with its roots several of the city's sleeping forefathers'.[29] A cemetery or cemeteries hereabouts clearly extended over a quite considerable area. Writing of the street which runs outside Huby's wall, Allcroft recorded that... 'the subsoil is literally made of bones', and he went on to suggest that the street follows the line of a ditch around Ailey Hill which had been filled up with bones from charnel houses.[30] As noted above, Ailey Hill itself is a natural feature, and the site of an Anglo-Saxon cemetery; there is no reason to associate it with a ditch. The excavations by Mayes at the north end of Low St Agnesgate did reveal part of a ditch, but it was of approximately 13th-century date, and had no associated human bone. Mayes's other site, directly across St Marygate from the excavations of 1955, revealed undated human skeletons, sealed beneath a cobbled yard associated with the 19th-century building 'The Residence'.[31] From these various sightings it is clear that human burials have taken place in an extended area to the north and east of the Minster; the chronology of these interments is for the most part uncertain.

Camden, the 16th-century antiquary, attributed Ripon's greatness to Wilfrid's monastic building which, he claimed, had been entirely destroyed by the Danes and then rebuilt by Oda. He was also the first antiquarian to comment on Wilfrid's Needle, the aperture created

by breaking through the back of a lamp niche in the north wall of the crypt's main chamber to link it with the north passage. The Needle, he reported, 'was famous in the last age. The business was this; there was a straight passage into a room close and vaulted, under ground, whereby trial was made of any woman's chastity; if she was chaste, she passed with ease, but if otherwise, she was, I know not by what miracle, stopped and detained'.[32]

It had been as recently as 1567–8 that Her Majesty's High Court of Commission at York had decreed that Thomas Blackburne, one of the Curates of the church of Ripon, 'shall cause the place within the churche of Rippon called St Wilfride's nedle to be stopped up, and an alter standinge in a lyttle chappell in the vawte where the same nedell is, to be tayken downe and defaced..'. He was also ordered to acknowledge publicly his fault in leaving undefaced and undestroyed 'that olde, abhominable, and supersticious vawte called the Wilfrede's nedle and the alter therein'.[33] This is the earliest certain reference to St Wilfrid's Needle and the crypt. A reference in Archbishop Young's Visitation Book for 1399–1400 reads '*Et in j sera emp. praedicto Joh pro ostio in le Cruddes, 6d*' (And for one key bought by the aforementioned John for the door in the crypt, 6d.).[34] This may refer to the crypt containing St Wilfrid's Needle, as Fowler appears to have believed, although it may alternatively have related to the Norman undercroft below the Chapter House.[35]

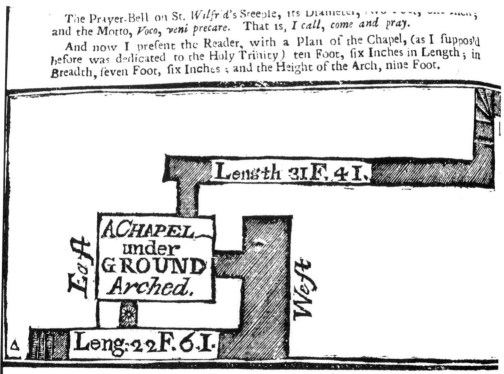

The Prayer-Bell on St. *Wilfr'd's* Steeple, its Diameter, ~~two Feet, ten Inch~~; and the Motto, *Voco, veni precare.* That is, *I call, come and pray.*

And now I present the Reader, with a Plan of the Chapel, (as I suppos'd before was dedicated to the Holy Trinity) ten Foot, six Inches in Length; in Breadth, seven Foot, six Inches; and the Height of the Arch, nine Foot.

Length 31.F. 4 I.

East

A CHAPEL under GROUND Arched.

West

Leng. 22 F. 6 I.

‖ Nine Steps down to the Passage. ✳ The *Little Hole*, call'd St. *Wilfrid's* Needle, where People are drawn through into the Chapel. △ The Steps which are suppofed to have led up to the Choir, but now wall'd up.

FIG. 5. Thomas Gent's plan of the crypt (1733)

Returning to the antiquarian tradition, Sir Thomas Herbert's (d. 1681) *History of Ripon Collegiate Church* referred in passing to Wilfrid as the church's founder, but claimed implicitly that his church 'being, by enraged Dane in a sort thrown down and made even with the ground', did not survive; no mention was made of the crypt.[36]

Thomas Gent, in his *Ancient and Modern History of the Loyal Town of Rippon* was apparently the first to publish a plan of the crypt (Fig. 5).[37] He captioned the main chamber 'A Chapel Underground' and suggested it was the location of a known medieval chantry beneath the choir. This, he surmised, was in 'the larger place, next that hole, now called St Wilfrid's Needle, some small part being underneath it [the choir]; and where formerly, if I am not much mistaken by the appearance, had been some steps to ascend up thereto'.[38] The plan shows the essential elements of the crypt — an east–west passage on its south side, of which approximately the western one third is not original, opening directly into the main chamber, which has a recess in the east wall and various lamp niches; a doorway in the west wall of the main chamber gives access to a small antechamber and a passage leading at a slightly higher level outside the north wall of the main chamber to a blocked stairway up towards the present choir.

Later 18th- and early-19th-century reporters had little of substance to add on the subject of the crypt. Carter, who visited in 1790, described it as 'so dreary a cell', noted that it was called St Wilfrid's chapel or Needle, and suggested that the needle itself was a squint.[39] As for date, he made no explicit claim for the crypt, but noted that the whole building was said to have been founded around the time of William I. Linney in 1838 placed it even later, suggesting tentatively that it was part of Thurstan's (1114–40) building.[40] In the following year an anonymous guidebook published by Procter and Vickers recorded that it was dedicated to the Holy Trinity,[41] while at about the same time Bruce was drawing a parallel with the so-called 'Virgil's Tomb', near Naples.[42] He suggested that if not a Roman relic, the crypt showed that the Saxons had succeeded admirably in imitating the Roman style of architecture; and that it was a tomb, possibly a Roman one.

It was at the British Archaeological Association's Second Annual Conference, held in Winchester in 1845, that the Ripon antiquary John Richard Walbran presented the first of a series of papers which progressed a long way towards identifying the crypt of Ripon Minster as the Wilfridian legacy which it is. In this initial discussion of what he described as 'a damp and gloomy cell, dark and cheerless as the grave', he weighed the possibilities of its being Roman or 'Romano-British/Northumbrian', and eventually inferred by comparison with the crypt at Hexham that it was a Wilfridian work.[43] As, however, he accepted Leland's remarks concerning the position of the 'old abbay', i.e. Wilfrid's church, he was forced to conjecture that the crypt was part of a Wilfridian parish church, possibly used as a confessional, and perhaps also a 'sepulchre for the host or image of Christ'.

By the subsequent year he had upgraded his opinion of the monument, which he described to the Annual Meeting of the Archaeological Institute of Great Britain and Ireland as 'one of the most Ancient and interesting Christian monuments in the Kingdom'.[44] He had also refined his interpretation, for although he still believed that it could not have been Wilfrid's monastic church, he agreed that it might have lain within the monastic precinct. As for its use, he suggested it was a place of retirement, meditation, penance, prayer, or for some unknown Saxon ritual, and this remained his view until his death in 1869. He also undertook structural investigation which will be discussed later; here it is sufficient to note his comment on the tradition regarding St Wilfrid's Needle — 'as far as contraction of space was concerned, the frailest of the frail might have rioted in intrigue, unconvicted'.[45]

While at the Royal Archaeological Institute's 1874 meeting at Ripon, Professor Stubbs (an old boy of Ripon Grammar School) was reported to have doubted Walbran's view of the

structural associations of the crypt,[46] but it was J. T. Micklethwaite in 1882 who unequivocally stated a belief that the crypt was an integral part of Wilfrid's monastic church.[47] Calling upon Walbran's work, he drew a series of comparisons with Hexham, suggested that Wilfrid's model for the construction was an Italian *confessio*, and by some tortuous argument deduced that at both Hexham and Ripon the crypt had stood beneath a high altar at the western end of the church. The latter suggestion has not received further support; Brown raised the possibility only to discard it as improbable, and it has been described by Taylor as somewhat fanciful.[48] Investigations at Hexham have demonstrated that there, at least, this was not the case.[49]

Notable 20th-century discussions of the crypt include those by Brown who, among other points, traced its origin in Roman tombs and recognised its role in housing relics; by Clapham, who also judged that it was almost certainly built to house relics; and by Taylor, who concurred on this point.[50] Fernie has drawn attention to possible Gaulish prototypes, and, most recently, Bailey has published an important comparative study of the Hexham and Ripon crypts which includes particular reference to their inspiration and metrology.[51]

Carter, in his 1806 paper, had been the first to record details of the crypt's contemporary appearance which went beyond its main architectural features.[52] He described the east end of the main chamber as having the remains of an altar, with a holy water niche on the west (sic) side, with a 'stopped-up window' above. He also remarked upon two similar features, each a 'small opening looking into a receptacle for bones'. One of them was in the eastern (end) wall of the south passage, and the other in the south wall of the main chamber. These features were sealed up at an unknown date between Carter's visit in 1790 and 1846, when Walbran commented that there was no recollection of them; he ventured that this blocking might have been effected when the church was repaved 'some years ago after Carter was here'.[53] This may perhaps be an allusion to the restoration work carried out at the Minster under the direction of Blore *c.* 1830. There was, however, no mention of the crypt in the architectural reports by Blore (1829), Railton (1841) or Scott (1859–68), for there were other, far more pressing conservation requirements during that time.[54]

Walbran himself investigated the main chamber's southern niche in the months between his reading a paper '*On St Wilfrid, and the Saxon Church of Ripon*' at Ripon on 14 September 1858 and its publication in the following year, when his new discoveries were made available in a footnote:

[on] 'the removal of some mortar with which a fracture at the back of it had been closed ... the "receptacle" has been discovered to be a large cavity wrought in the substance of the wall, probably by treasure hunters, after the Reformation. It still contains a number of human bones mixed with those of animals, thrown there most likely in modern times; though a flat bronze needle or bodkin with three eyes, apparently of Saxon date, was found among the rubbish, and a small hoop and several pieces of wrought iron half decomposed, of uncertain age'.[55]

A second examination of the same spot took place on 30 November and 1 December 1891. It was occasioned by Micklethwaite's speculation that there had originally been an eastern stairway into the south passage, and that these stairs had been blocked to allow the burial of Wilfrid at this spot.[56] This, thought Micklethwaite, would correspond with Bede's reference to the grave being '*iuxta altare ad Austrum*'.[57] Rather than tunnelling in, permission was given to dig down from above, and a distinguished team from the Society of Antiquaries of London was assembled to observe and supervise the work. It consisted of Micklethwaite, C. H. Read (the Society's secretary), W. H. St. J. Hope (its Assistant Secretary, whose notes on the discoveries are in the Society's library,[58] T. M. Fallow and J. W. Walker (local secretaries for Yorkshire) and J. T. Fowler, editor of the Surtees Society's *Memorials of*

Ripon and subsequently author of a report on the second modern opening of St Cuthbert's grave.[59] The excavation was begun in the early afternoon and continued until the late evening service: it was resumed at six o'clock next morning with only two of the participants present (to Micklethwaite's obvious disgust), and the hole was being backfilled when he left that afternoon.[60]

A stratified sequence below the Minster floor was revealed. This consisted of 1 ft 7½ in. (0.5 m) of earth and bones above a 3 in. (76 mm) thick layer of mortar (lime and sand plaster), interpreted by (anachronistic) analogy with Peterborough[61] as forming a well-made floor for Wilfrid's church. Below this was 4 ft (1.2 m) of made ground, consisting of clean sand and gravel with no bones or inclusions except a few scraps of mortar, then 1 ft (0.3 m) of undisturbed gravel, and then sand. The original cut made for the insertion of the crypt was also recognised.

Behind the lamp niche at the eastern end of the south passage, some 7 ft (2.15 m) below the floor surface of the crossing, a deposit of bones was found, together with a leather fragment, identified by Micklethwaite as part of shoe sole. This cache reminded an onlooker of Walbran's earlier discovery of bones behind the niche in the south wall; that niche was duly reopened, and the bones re-examined. Both groups were catalogued by Fowler; both contained human bones, representing several individuals, and both also contained bird and/or animal bones. Each group was reinterred in its findspot, the newly discovered one in a four-gallon jar, and both were accompanied by a lead plate engraved with a record of the event.[62] (The group behind the east end of the southern passage was seen again in the 1950s or 1960s by the Minster's recently retired Clerk of Works, Mr Jack Yarker, when a hole was dug near the south end of the choir screen in the hope of locating St Wilfrid's tomb; he recalls a few bones with a note and a glazed pot, which were left *in situ*.

Meanwhile, the bronze needle which Walbran had found with his bone group, and which had been preserved in the vestry, was re-examined by Read. He identified it as a brass bodkin, 3⅞ in. long (98 mm), and 'without hesitation' assigned it to the mid-16th century. It was interpreted as the fastening for an original wrapping around the bones, although as an afterthought Micklethwaite added a footnote to the effect that it was not certainly associated with the bones, 'since it may have been slipped into a crevice in the wall at any time'.[63] None the less, this dating contributed to a feeling that the bones were relics, hidden for safety at the Reformation; comparisons could be drawn, for example, with the supposed relics of St David at St David's, discovered in 1864, or those of St Rognvald and St Magnus at Kirkwall Cathedral, discovered in 1849 and 1919 respectively.

The 'bodkin' cannot now be located at Ripon. It had, however, been illustrated by Tuting in his manuscript book, where he assigns its discovery to 1861 (Fig. 2).[64] Comparable objects made of bone are known from Roman and Anglo-Scandinavian contexts in Britain.[65] The only copper-alloy parallels, however, seem to be Dutch hair-pins of 16th-17th-century date, which occasionally are found on British sites.[66] While certainty is impossible, Read's dating may thus have been broadly correct, although the identification of the bones as relics remains speculative.

As a result of these investigations, Micklethwaite abandoned his theory of a stairway blocked to allow Wilfrid's burial, and in place of this he substituted another, that the crypt had originally had only one entrance stair, and that the eastern, original part of the southern corridor was Wilfrid's burial chamber.[67]

Between these investigations of the lamp niches, plans for two improvements to the Minster had threatened the crypt. On 18 May 1861, a letter from G. Haden and Sons, Heating Engineers, of Trowbridge, Wiltshire, reported 'We find that the crypt under the tower cannot be disturbed or used as the vault for Apparatus; otherwise its central position

would reccommend (sic) it for that purpose'.[68] When, however, it came to the restoration of the organ in 1878, the crypt did not escape unscathed; 'those engaged . . . began to alter the old vault to fit it for the reception of some of their machinery. This was very properly stopped . . .'.[69]

The only recorded observation of these works east of the crypt, during which a passage was driven behind the large niche in the east wall of the main chamber, was that by Rev. W. C. Lukis FSA. Micklethwaite recorded that Lukis had been able to examine the outside of the crypt's east wall, which was so irregular that he thought it was never intended to be seen; Micklethwaite himself interpreted this as an indication that facing stones had been removed for re-use at some unspecified alteration to the Minster's fabric.[70] In 1891 (below p. 25) he was to see for himself that the external stonework was 'very rough'.[71]

The 1878 works were but the first in a series involving the digging out of chambers and ducts for organ blowers, bellows and trunks, undertaken in a variety of operations between 1878 and 1957. In them, trenches have been cut across crucial areas to the east of the crypt where traces of Wilfrid's buildings should lie, and further works for the installation of other mains services have also severed the transepts and crossing, equally sensitive positions. Sadly, the deaths of Tuting (1865) and Walbran (1869) deprived Ripon of anyone with sufficient interest and understanding to seize the opportunities provided by such works and to undertake the necessary investigations; there was no one in Ripon in the late 19th or early 20th century with the interests and skill showed at this time at Hexham by Hodges.[72]

It is now ironic, but not surprising, that although such subterranean depredations apparently caused no concern, anything that might affect the visible fabric was more carefully considered, as noted above. Another instance of this concern is attested in a letter from Bishop Lucius Smith of Knaresborough, a Canon Residentiary of Ripon, written in May 1912 to the Durham organ builder Mr Harrison. A new engine and blowing house were under discussion, and the plan then envisaged would have involved destroying some of the groining in the Chapter House crypt. The Bishop, however, put forward an alternative suggestion to mitigate the destruction, commenting that 'Canon Waugh, I think, has the fear of the antiquarians before his eyes'.[73]

Other aspects of the crypt apart from its walls and niches also excited 19th-century antiquarian interest. Walbran had originally described it as paved, but subsequently stated that there was 8 in. (0.2 m) of earth on the floor.[74] While the Dean, he reported, had promised to remove the modern plaster and limework from the walls, no alteration to the floor was apparently contemplated, and none seems to have taken place until the very end of the century. Although there is a record that the refurbishments of 1861–71 included putting the crypt 'into decent order', its context suggests strongly that the crypt in question was that below the Chapter House.[75] The Wilfridian crypt was, however, affected by unspecified works which improved its ventilation in 1898.[76]

In 1900 the crypt's earth floor was lowered. Parker's account of this work, which has passed unnoticed, is as follows:

'In 1900 by permission of the Dean and Chapter, excavations were made within the chamber [of the Saxon crypt] under the superintendance of Mr H. Williams, the Canons' Verger and Parish Clerk, who has had considerable experience in building and takes the greatest interest in the construction of the whole fabric of the Cathedral. The soil which had been taken down seemingly to remedy the unevenness of the floor and to raise it to a level with the entrance steps, was removed from the original floor which was found to be of a hard description of concrete and much broken; the footings of the walls and the bottom of the step rising into the porch were bared. A quantity of human and other bones were discovered beneath the floor in a square compartment with an edging of loose stones at the position where the altar would formerly have stood'.[77]

Hallett also referred to this work which, he wrote, revealed an offset running around the chamber.[78]

The 'concrete' floor mentioned by Parker may indeed have been an original, or at least a pre-Conquest, feature; it might be compared with those discovered at Monkwearmouth and Jarrow, or further afield at St Augustine's Abbey and St Martin's church, Canterbury, and at Glastonbury.[79] If Parker's 'concrete' was a Wilfridian survival, then the offset presumably served as a foundation course rather than as a support for a timber floor. Among a collection of mortar, plaster and stone fragments kept prior to 1989 in the north-west tower, together with a label associating them with the crypt (below p. 24), there survives a single piece of resilient mortar containing chips of tile or brick. Unfortunately, it is impossible to confirm the precise provenance of this intriguing fragment, and to link it with Parker's concrete. The insertion of a new concrete floor, variously remembered as having taken place in c. 1956 or in 1974, in preparation for the crypt's temporary role as a 'treasury' (below, p. 24) has, for the moment, sealed any traces of this earlier 'concrete' that may have survived in situ.

Hallet also provides additional information about the stones uncovered near the east of the crypt, and they are drawn on the accompanying plan.[80] They included a long stone parallel to the east wall, and immediately east of it a parallel row of smaller stones with eastward returns at their ends. Together, these formed three sides of a rectangle against the east wall; part of this is still visible, protruding above the concrete floor. These remains may perhaps be traces of the altar which Thomas Blackburne was ordered to destroy in 1567–8 (above, p. 19).

This rectangular stone setting was described as a pit, and within it were found the bones of a man, an ox and a bird — a similarly mixed collection to those recovered from the wall niches. These bones were retained until at least 1947 in the Cathedral Library; they may well be the hitherto unlabelled collection of bones, broadly corresponding to this description, stored for some time prior to 1989 in the Minster's north-west tower, and catalogued in Appendix 1 below by Dr T. P. O'Connor.

This examination of the crypt's fabric in 1900 also included the 'cleaning' of the second of four steps up into the northern passage, and the recognition that it bore carved decoration. This was noted afresh by Pritchard in 1962, and subsequently the stone was removed from the steps at the behest of Canon Bartlett.[81] It formed the outer half of the tread of a wide, shallow step, and it was not replaced; its profile remains visible in the north wall of the passage. On the basis of the stone's decorative elements, Pritchard suggested that either a Romano-British or pre-Norman date for it was possible. If, however, it was re-used during the initial building of the crypt, and there is no reason to doubt this, then it must be of Romano-British origin, like some of the slabs which form the roofs of the crypt's passages (see below).

There have been three 20th-century investigations of the crypt, all reactive rather than research-oriented. In the earliest of these, the installation of a central heating system in 1930 involved the exposure of features beneath the Minster's central crossing.[82] The roofs of both the main and the subsidiary chamber, as well as of the north and south passages, were uncovered (Pl. Ia). The main chamber roof was formed of arched ribs at 2 ft 3 in. (0.68 m) centres (Pl. Ib). Each was about 4 in. (0.1 m) or 15 in. (0.38 m) deep, and wedge-shaped in section with an 8 in. (0.2 m) intrados and a 5 in. (0.13 m) extrados. Between the ribs the roof of the vault was made of small stone slabs, a few inches (50 mm) thick, with a lime mortar bonding their upper surface. The half vault of the western antechamber was similarly constructed (Pl. Ic).

Several lumps of mortar, preserved for some time prior to 1989 in the north-west tower of the Minster, had with them a note reading 'lime concrete from upper surface of St Wilfrid's

crypt'. They exhibit a variety of different mortars, some pink and some off-white in colour; one has a pebble layer at its base. It is not certain that these samples were taken in the 1930 investigation, but this seems the most likely origin for them.

The side passages were roofed with heavy slabs, some retaining Roman mouldings; the south passage roof consisted of roughly squared stones, some of limestone and others of sandstone or gritstone, including one moulded at its edges.

The crypt structure lay between two lengths of foundation, some 9–10 ft (2.75–3 m) wide, running east–west on the line of choir (Pl. IA). The southern one consisted of two courses of dressed stone, the upper course slightly recessed, with remains of what may have been part of a shallow rectangular pier or buttress at one point. The facing stones of the northern foundation had all been removed. These foundations rested on a sandy subsoil and were about 6 in. (0.15 m) below the level of the capstones of the crypt's south passage. A substantial stone drum was apparently incorporated into each length, at the present south-west and north-west crossing piers. That on the south side, a limestone drum variously reported as 3 ft 6 in. (1.06 m) or 3 ft 10 in. (1.16 m) in diameter and 8½ in. (0.22 m) deep, was embedded too far into the superimposed pier foundation to be removed. That on the north, of gritstone, lay with its wider face uppermost, and was apparently re-used in this position.

It was possible to remove this northern stone, and for many years it stood in the Consistory Court at the west end of the north aisle, until in 1984 it was re-used as the central element of a composite altar in the Chapel of the Resurrection. It is 3 ft 6 in. (1.06 m) in greatest diameter, receding in three approximately equal steps to a diameter of 3 ft 4 in. (1.01 m); its total depth is 17½ in. (0.45 m) (Pl. IIA). The larger side has a very slightly concave surface with rough, irregular tooling; the smaller side has a centrally positioned circular seating 2 ft 6 in. (0.76 m) in diameter, only a few millimetres deep and irregularly tooled, although the surround is smooth, like the stepped sides of the drum (Pl. IIB). There are no sockets or holes in either face.

Comparable stones are rare, although a group of broadly similar pieces was found, re-used in an 11th-century or earlier context, at St Mary Castlegate, York.[83] Partly for the lack of any clearly dated late-Saxon parallel, and partly because it was apparently re-used in the length of foundation, the Ripon stone and its near twin have tentatively been attributed to Wilfrid's church of the late 7th century.[84] This was described by Eddius as *variis columnis et porticibus suffultam*.[85] Conversely, because what may be Wilfridian architectural fragments were apparently re-used in them, the twin parallel lengths of foundation are usually thought to relate to a late-Saxon rebuilding.

The second investigation of the crypt this century was occasioned by its conversion to a 'treasury' in 1974, with the attendant demolition of the blocked steps at the eastern end of the north passage. Archaeological recording, which began midway through this operation, revealed that the steps were composite; they had been set into a cut through the natural sands, apparently similar to that described by Micklethwaite in 1892. Layers of mortar and rubble had then been placed behind the steps to backfill the cut where necessary. These discoveries have been published already; the same report contains a note by L. A. S. Butler on his observations made during construction work below the eastern end of the north transept in September 1974.[86] This did not reveal any traces of pre-Conquest work, and indeed none had been noted by Peers when the paving in the transepts was removed in 1930, although the extent of that removal is not recorded.[87]

The third investigation took place in 1989, when the glass screens, lighting and security devices installed for the 'treasury' in 1974 were removed and some new wiring was installed. Examination of the chases cut into the plasterwork and stonework in 1974

allowed sequences of mortar and plaster to be identified and sampled, permitted the collection of a number of stone samples, and prompted a detailed examination of the lamp niches and 'great east niche'.[88]

Following Wilfrid's burial at Ripon in 709, relatively little information about the monastery is recorded in historical sources for the 8th–mid-10th centuries. Ripon's status in the mid-8th–mid-9th centuries is emphasised by the relative density of contemporary coin finds, which have been discussed most recently by Pirie, and which are still coming to light in manuscript records.[89] None the less, Metcalf's assertion that Ripon 'was a centre of monetary affairs in the Northumbrian kingdom' must be seen in the broader context of coin finds from other contemporary monastic or episcopal sites in Northumbria including Whitby, Beverley, Jarrow, Lindisfarne, Hexham, Monkwearmouth, Norham, Coldingham and Dacre.[90]

Other archaeological evidence for the pre-Viking period is limited. In addition to the cross fragments from the area of the Lady Chapel (above, p. 24), it includes a small fragment of cross-head which was found when digging at a depth of 7 ft (2.15 m) in the churchyard off the north-east corner of the Minster in 1883.[91] This is from a small monument — Collingwood estimated that the head was some 18 in. (0.45 m) across. The only other pre-Viking carved stonework at Ripon is the pieces of Anglian architectural embellishment built into the north-western corner of a buttress to the north transept.[92] Three tracings of rubbings from two of these stones, which G. F. Browne (Disney Professor of Archaeology at Cambridge University 1877–81) had taken in what he described as difficult conditions, up a ladder in a snowstorm, survive in the Brotherton Library, University of Leeds.[93]

The direct impact upon Ripon and its minster of the Scandinavian settlement of Yorkshire in 876 is all but unknown. There is, however, evidence for the introduction of new ideas, presumably at the demand of new patrons, to the school of sculptors who supplied the memorials erected around the Minster. The 1974 work in the north transept brought to light part of a gritstone cross-head, bearing on one side a representation of the Germanic hero Sigurd. This places it squarely in the Anglo-Scandinavian period, and makes it one of the few indisputable strands of evidence for the Viking-age church at Ripon.[94]

The knotwork on the other face of the Sigurd cross-head matches that on another Ripon Anglo-Scandinavian cross-head which is now in St Wilfrid's Church, Mereside, Blackpool. The other side of that head bears a design of two poorly executed birds confronting each other over a central boss. This may well be the 'head of a cross which may very well be Saxon' which c. 1869 was 'over the door of the bone house', now the Chapel of the Resurrection, and which had been found in 1832 on dismantling a supposedly mid-16th-century wall between the two buttresses that frame the eastern window.[95] The way in which the head has been dressed supports the view that it could have served as building rubble. This may also be 'the head of an Anglian cross, certainly early, but of such poorly designed and executed sculpture that I feel sure it is not of anything like Wilfrith's (sic) date' which Browne reported as being 'in the vault which was once the famous "Ripon bone-house"'.[96] More certainly, it was for a time in the Wilfridian crypt.[97] A third Anglo-Scandinavian scultured stone is part of a recumbent grave slab decorated with a cross in relief, re-used in the roof of the crypt's south passage.[98]

The form and site of the church itself during the generations after the Scandinavian settlement are completely enigmatic. The Ripon community after the Norman conquest asserted that King Athelstan had granted their church various privileges, but the writ adduced in support of this has been identified as a compilation of post-Conquest date.[99] Athelstan's half-brother, King Eadred, treated the Minster rather differently in the face of a

renewed bid for Anglo-Scandinavian independence in Northumbria in 948 — his army burned what the *Anglo-Saxon Chronicle* called the 'glorious minster'.

It is ironic, therefore, that a silver penny of Eadred (946–55) is one of the few pieces of archaeological evidence for late Saxon/Anglo-Scandinavian activity in the vicinity. According to manuscript notes in the archive of Baggs's 1955 excavations, it was found during trenching in Minster Road 'a few years ago'. Part of what was described in the same source as 'a hog back comb' was apparently found at the same time, but it is not clear whether it was associated with the coin. The manuscript indicates that the comb was like those found in the 1955 excavations, and thus it is broadly contemporary with the coin. At present, neither comb nor coin can be located.

A reconstruction of the fire-damaged church by Oswald, Archbishop of York (972–92), is recorded in his *Anonymous Life*.[100] What precisely was standing in 995, a time when St Cuthbert's community is reported to have returned briefly to Ripon, remains unknown. To elucidate this, to shed light on the Wilfridian monastery, and to answer the many questions posed by the records and evidence summarised above, there is at the very least a clear and continuing need to take each and every opportunity to monitor operations which disturb the ground and the fabric in and around the Minster.

APPENDIX

Bones from Ripon Cathedral, north-west tower, 1989. By T. P. O'Connor, Department of Archaeological Science, University of Bradford.

1. Cattle phalanx prima; adult.
2. Cattle right femur, distal two-thirds of shaft. Distal end heavily gnawed, probably by a dog.
3. Cattle right astragulus.
4. Cattle right calcaneus; adult. Not a pair with 3.
5. Pig thoracic vertebra; subadult.
6. Cattle right humerus, distal end; adult. Shaft chopped through e.g. by a heavy cleaver.
7. Cattle phalanx secunda; adult.
8. Domestic fowl left tarsometatarsus; adult. Spurred, so probably male.
9. Sheep left os innominatum; adult male. Gnawed around pubis and ischial tuberosity.
10. Dog right scapula, articular end; adult.
11. Goose (probably domestic) left tarsometatarsus; adult.
12. Domestic fowl right tibiotarsus; adult.
13. Not a bone. Tip of a cattle right horn.
14. Human right fibula, distal end; adult.

Preservation of 1, 2 and 14 was rather poor, but the other specimens were in very good condition. The horn 13 seems to have been preserved by desiccation, i.e. by burial in a dry medium. This is rather unusual.

ACKNOWLEDGMENTS

Assistance in the preparation of this paper has been diverse and generous. At Ripon Cathedral I am grateful to the Dean and Chapter and to the Minster's staff for their help and attention. The Cathedral's Architect, Mr Neil Macfadyen, kindly assisted with the provision of plans. Professor Richard Bailey, the Cathedral's Archaeological Consultant, has given considerable support and advice, and has drawn my attention to the reference in Archbishop Young's Visitation Book. Mr Jack Yarker, who retired as Clerk of Works in 1990, provided practical assistance and was a source of much otherwise unrecorded information about structural works in the last fifty years. Many parishioners and townsfolk also provided assistance and encouragement, among them Mr Ted

Pearson, who brought to my attention the Court of Commission reference to St Wilfrid's Needle, Mr Mike Younge, and Mrs C. Young of Ripon Library.

Mr P. S. Morrish, Sub-Librarian responsible for manuscripts and special collections at The Brotherton Library, University of Leeds, Bernard Barr and Susan Beckley of York Minster Library, Bernard Nurse, Librarian to the Society of Antiquaries of London, Dr Timothy Hobbs, formerly sub-librarian at Trinity College, Cambridge, Stephanie Harding and Mhairi Handley at the National Monuments Record, Mary Kershaw of Harrogate Museums and Elizabeth Hartley at the Yorkshire Museum were all most assiduous in their help with material in their charge. Through Mr J. Bowman, Mr C. G. F. Ward kindly made available drawings of the discoveries of 1931; Mr Mark Venning, Managing Director of Harrison and Harrison, of Durham, generously gave me access to the firm's archives of work at Ripon, and Mr Alan Howarth, Works Manager, greatly assisted my understanding of them. Jim Lang discussed aspects of sculpture, and the Reverend Eric Sillis of St Wilfrid's, Mereside, confirmed the presence there of a Ripon stone. Penny Walton Rogers, Nicky Rogers, John Cherry, Brian Ayers and Dave Hooley helped with possible parallels for the bodkin, Chris Daniell advised on the translation of medieval Latin, and Dr Terry O'Connor identified the group of bones. To all these, and to others who have helped, I am most grateful. Photographic assistance has been provided by Simon I. Hill, Tessa Bunney and Jan Dennis; drawings for this article have been prepared by Charlotte Bentley. I am indebted to Ripon Historical Society, Ripon Museum Trust, Ripon Civic Society and to the Dean and Chapter of Ripon Cathedral for contributing the costs of their preparation.

REFERENCES

1. T. Gent, *The Ancient and Modern History of the Loyal Town of Rippon* (York 1733), 62.
2. E. Haynes, *A Picturesque Tour through Yorkshire and Derbyshire*, 2nd edn (London 1825), 126–9.
3. Ripon Publicity Committee, *Ripon and Fountains Abbey* (n.d.), 5.
4. L. E. Webster and J. Cherry, 'Medieval Britain and Ireland in 1985', *Med. Archaeol.* 19 (1974), 248; F. Thorp, 'The Yorkshire Archaeological Register 1974', *Yorks. Archaeol. J.* 47 (1975), 8.
5. S. M. Youngs, J. Clark and T. Barry, 'Medieval Britain and Ireland in 1985', *Med. Archaeol.* 30 (1986), 173.
6. R. A. Hall and M. Whyman in prep., 'Excavations at Ailey Hill, Ripon, 1986–7'.
7. J. R. Walbran, 'On St Wilfrid , and the Saxon Church of Ripon', *Associated Architectural Societies Reports and Papers* 5/1 (1859), 10.
8. A. H. Smith, *The place-names of the West Riding of Yorkshire V. Upper and Lower Claro Wapentakes* (Cambridge 1961), 165.
9. W. Harrison (ed.), *Ripon Millenary Record* (Ripon 1892), 195.
10. J. R. Walbran, *The Shilling Guide to Ripon*, 8th edn (Ripon 1862), 4.
11. J. R. Walbran, 'On a crypt in Ripon Cathedral, commonly called St Wilfrid's Needle; with observations on the early history of the church of Ripon', *Trans. Brit. Archaeol. Assoc., 2nd Annual Congress, Winchester, 1845* (1846a), 349.
12. J. L. Linney, *The Tourist's Guide: being a concise history and description of Ripon*, 2nd edn (Ripon 1838).
13. Walbran, 1862, 4.
14. Walbran, 1862, 4.
15. E. Gibson, *Camden's Britannia newly translated into English with large additions and improvements* (London 1695), 715.
16. W. Farrar, *The History of Ripon*, 2nd edn (Ripon 1806), 76.
17. Linney 1838, 36.
18. Walbran 1859, 9–10.
19. R. D. Waddilove, 'An historical and descriptive account of Ripon Minster ...', *Archaeologia* 17 (1814), 128–37.
20. Walbran 1862, 19–20.
21. L. T. Smith, *The Itinerary of John Leland Pt 1* (London 1907), 80–1.
22. Smith 1907, 80–1.
23. Ripon Dean and Chapter MS 58.
24. Walbran 1862, 23.
25. J. R. Walbran, *The Pictorial Pocket Guide to Ripon and Harrogate* (Ripon 1846b), 23; J. R. Walbran 1862, 23.

26. W. C. Lukis, *Ancient Ripon. An Historical Sketch* (Ripon 1886), 5–6.
27. Brotherton Library, University of Leeds: Ripon Dean and Chapter MS 58.
28. E. Okasha, *Hand-list of Anglo-Saxon non-runic inscriptions* (Cardiff 1971), 107.
29. G. Parker, *Ripon Cathedral. Past and Present* (Ripon 1902), 181.
30. A. H. Allcroft, *Earthwork of England* (London 1908), 423 note 3.
31. Webster and Cherry 1974, 248; F. Thorp 1975, 8.
32. W. Camden, *Britannia* (London 1586); translation from the revised edition, translated by P. Holland (London 1637), 700.
33. J. T. Fowler, *Memorials of Ripon III*, Surtees Society, ed. J. T. Fowler (1888), 346–7.
34. Fowler 1888, 129.
35. Fowler 1888, 129 note 1.
36. Sir Thomas Herbert, *History of Ripon Collegiate Church*, published by Maynard in W. Dugdale, *The History of St Paul's Cathedral ... whereunto is added ... an historical account of the Northern Cathedrals and Chief Collegiate Churches in the Province of York* (2nd edition, London 1716), and re-published in an edition by W. D. Bruce, *The History of Ripon Collegiate Church by Sir Thomas Herbert, Baronet* (York 1841) included as an appendix to F. Drake *Eboracum, or the history and antiquities of the City of York* (London 1736); reprinted East Ardsley, Wakefield 1978), xci–xcv.
37. Gent 1733, 120.
38. Gent 1733, 111.
39. J. Carter, 'Pursuits of Architectural Innovation No. XCIX', *Gents Mag*, July 1806.
40. Linney 1838.
41. *The History of Ripon* (Procter and Vickers 1839), 64.
42. W. D. Bruce, *Sepulchri a Romanis Constructi infra Ecclesiam S Wilfridi in Civitati Riponensi Descriptio*, 3rd edn (London/York/Ripon 1841), 6, 12.
43. Walbran 1846a, 344.
44. J. R. Walbran, 'Observations on the Saxon crypt under the Cathedral Church of Ripon, commonly called St Wilfrid's Needle', *Memoirs illustrative of the history and Antiquities of the County and City of York communicated to the Annual Meeting of the Archaeological Institute of Great Britain and Ireland held at York, July, 1846* (London 1848), 4 (each contribution separately paginated).
45. Walbran 1859, 20.
46. G. G. Scott, 'Ripon Minster', *Archaeol. J.* 31 (1874), 309.
47. J. T. Micklethwaite, 'On the crypts at Hexham and Ripon', *Archaeol. J.* 39 (1882), 347–54.
48. G. B. Brown, *The Arts in Early England II. Anglo-Saxon Architecture*, 2nd edn (London 1925), 164; H. M. and J. Taylor, *Anglo-Saxon Architecture I–II* (Cambridge 1965), 518.
49. E. S. Savage and C. C. Hodges, *A Record of all works connected with Hexham Abbey since January 1899 and now in progress* (Hexham 1907), 39; R. N. Bailey and D. O'Sullivan, 'Excavations over St Wilfrid's crypt at Hexham, 1978', *Archaeologia Aeliana*, 5th ser., 7 (1979); E. Cambridge, 'C. C. Hodges and the nave of Hexham Abbey', *Archaeologia Aeliana*, 5th ser., 7 (1979) 158–68. NB: There is an important correction to the plans accompanying this latter article in *Archaeologia Aeliana*, 5th ser., 8 (1980), 172–3.
50. Brown 1925, 162f.; A. W. Clapham, *English Romanesque Architecture Before the Conquest* (Oxford 1930), 158; H. M. Taylor, *Anglo-Saxon Architecture III* (Cambridge 1978), 1016.
51. E. Fernie, *The Architecture of the Anglo-Saxons* (London 1983), 62; R. N. Bailey, 'St Wilfrid, Ripon and Hexham', *Studies in Insular Art and Archaeology. American Early Medieval Studies 1* (1991), 3–25.
52. J. Carter 1806.
53. Walbran 1846a, 346.
54. References to the reports by Blore, Railton and Scott are in the Ripon Dean and Chapter collection at the Brotherton Library, Leeds University, at 92.4, 96, and 98.3–4.
55. Walbran 1859, 20.
56. Micklethwaite 1882, 354.
57. Bede, *Hist. Eccles. v. 19*; for a reconsideration of the implications of this reference see M. Biddle, 'Archaeology, Architecture, and the Cult of Saints in Anglo-Saxon England', eds L. A. S. Butler and R. K. Morris, *The Anglo-Saxon Church*, CBA Research Report 60 (London 1986), 9, 11; and cf. R. Cramp, 'The furnishing and sculptural decoration of Anglo-Saxon Churches', ibid., 103.
58. Pressmark 443f. 785.4.
59. J. T. Fowler, 'On the examination of the grave of St Cuthbert in Durham Cathedral Church', *Archaeologia* 51 (1901), 11–28.
60. J. T. Micklethwaite, 'Notes on the Saxon Crypt at Ripon Minster', *Proc. Soc. Antiq. London*, 2nd series, 14 (1891–3) (1892), 192.
61. J. T. Irving, 'Pre-Norman remains at Peterborough Cathedral', *Associated Architectural Societies' Reports and Papers* 17, ii (1884), 277–83.

62. W. Harrison (ed.), *Ripon Millenary Record* (Ripon 1892), 301; both groups were re-interred in jars, according to Fowler in J. R. Walbran, *A Guide to Ripon...*, 18th edn (1891), 40.

63. Micklethwaite 1892, 195.

64. Brotherton Library, University of Leeds, Ripon Dean and Chapter MS 58, 12 and 113.

65. J. D. Zienkiewicz, *The Legionary Fortress Baths at Caerleon II. The Finds* (Cardiff 1986), 202, Fig. 70, no. 62; A. MacGregor, *Objects of bone and antler from 16–22 Coppergate, York. The Archaeology of York*, ed. P. V. Addyman (forthcoming).

66. J. Baart *et al.*, *Opgravingen in Amsterdam* (Amsterdam 1977), 217–9.

67. Micklethwaite 1892, 194.

68. Brotherton Library, University of Leeds, Ripon Dean and Chapter MS 92.3.

69. Micklethwaite 1882, 353.

70. Micklethwaite 1882, 354.

71. Micklethwaite 1892, 192.

72. C. C. Hodges, *The Abbey of St Andrew, Hexham* (Hexham 1888); C. C. Hodges, *Guide to the Priory Church of St Andrew, Hexham* (Hexham 1913); Savage and Hodges 1907.

73. Harrison and Harrison Archive.

74. Walbran 1846a, 344; Walbran 1848, 8.

75. J. R. Walbran, *A Guide to Ripon...*, 12th edn (1875/6), 48.

76. Parker 1902, 75.

77. Parker 1902, 132.

78. C. Hallett, *The Cathedral Church of Ripon* (London 1901), 73–4.

79. R. Cramp, 'Excavations at the Saxon Monastic Site of Wearmouth and Jarrow, Co. Durham: an Interim Report', *Med. Archaeol.* 13 (1969), 21–66; Taylor 1978, 1061.

80. Hallett 1901, 72.

81. V. Pritchard, 'A carved stone in Ripon Cathedral', *Antiq. J.* 53 (1973), 265 and Pl. LA.

82. C. R. Peers, 'Recent discoveries in the Minsters of Ripon and York', *Antiq. J.* 11 (1931), 113–22; W. T. Jones, 'Recent discoveries at Ripon Cathedral', *Yorks. Archaeol. J.* 31 (1932), 74–6. A photographic record of these discoveries exists in the Library of the Society of Antiquaries of London; copy negatives are held in the National Monuments Record.

83. R. A. Hall, 'St Mary's Church, Castlegate: observations and discoveries' in L. P. Wenham *et al.*, *St Mary Bishophill Junior and St Mary Castlegate. The Archaeology of York*, ed. P. V. Addyman, 8/2 (1987), 147–65.

84. Peers 1931, 114; H. M. and J. Taylor 1965, 517.

85. B. Colgrave (ed.), *The Life of Bishop Wilfrid by Eddius Stephanus* (Cambridge 1927), 36.

86. R. A. Hall, 'Rescue excavation in the crypt of Ripon Cathedral', *Yorks. Archaeol. J.* 49 (1977), 59–63. NB: Incorrect scales give the impression that dimensions on Figs 1 and 3 are twice as large as they really are.

87. Peers 1931, 114.

88. R. A. Hall, 'Observations in Ripon Cathedral Crypt, 1989', *Yorks. Archaeol. J.* 65 (1993), 39–53.

89. E. J. E. Pirie, 'The Ripon Hoard, 1695: Contemporary and current interest', *Brit. Numis. J.* 52 (1982), 84–103.

90. D. M. Metcalf, 'Some Finds of Medieval Coins from Scotland and the North of England', *Brit. Numis. J.* 30 (1960), 99; E. J. E. Pirie, 'Finds of sceattas and stycas of Northumbria', in M. A. S. Blackburn (ed.), *Anglo-Saxon Monetary History* (Leicester 1986), 67–90.

91. G. F. Browne, *Theodore and Wilfrith* (London 1897), 284; W. G. Collingwood, 'Anglian and Anglo-Danish sculpture in the West Riding', *Yorks. Archaeol. J.* 23 (1914), 233.

92. Collingwood 1914, 233.

93. Ripon Dean and Chapter 104; Browne, letter to Dean of Ripon, 21 June 1883.

94. J. T. Lang, 'An Anglo-Scandinavian cross-head from Ripon Cathedral', in Hall 1977, 63.

95. R. J. King, *Handbook to the Cathedrals of England. Northern Division Part 1 York–Ripon–Carlisle* (London 1869), 176.

96. Browne 1897, 83.

97. Collingwood 1914, 235; W. E. Wilkinson n.d.: *The Pictorial History of Ripon Cathedral*, 6.

98. R. N. Bailey, pers. comm.

99. F. E. Harmer, *Anglo-Saxon Writs* (Manchester 1952), 14 note 1.

100. J. Raine (ed.), *The Historians of the Church of York and its Archbishops* 1 (1879), 462.

The Early Monastic Church of Lastingham

By Richard Gem and Malcolm Thurlby

HISTORICAL CONTEXT

The church of Lastingham is the best surviving architectural witness to the earliest stages of that revival of monasticism in Northern England which began in 1074 when a small party of monks set out from Winchcombe in Gloucestershire and Evesham in Worcestershire to refound some of the historic monastic sites of the Anglo-Saxon period in Northern England.[1] The primary efforts of this group were directed towards Jarrow, Melrose, Wearmouth and Whitby, but a secondary interest grew in other ancient sites such as Tynemouth and Hackness shortly afterwards, and it is surely no coincidence that Lastingham likewise had a distinguished Anglo-Saxon past.

The early history of Lastingham is to be gathered almost entirely from Bede's *Historia Ecclesiastica*.[2] The founders were accounted the brothers Cedd and Ceadda, both monks and at one time bishops, while the patron was the sub-king Aethilwald of Dere (*c.* 651–54) who intended the monastery to be a place both where he could come and pray and where he could be buried. Bishop Cedd died at the monastery in 664 and

'at first was buried out of doors; but as time went on, there was in the same monastery a church in honour of the blessed Mother of God built of stone, and therein his body was reburied to the right of the altar'
(*Qui primo quidem foris sepultus est; tempore autem procedente, in eodem monasterio ecclesia est in honorem beatae Dei genitricis de lapide facta, et in illa corpus ipsius ad dexteram altaris reconditum*).[3]

There is an ambiguity here, which leaves open the question of whether the stone church itself was built sometime after 664, as distinct from Cedd's reburial being after this date. Perhaps it is to be expected that in the early 650s in Northumbria the church may have been of timber, especially as Lastingham followed the monastic customs of Lindisfarne. But on the other hand there is to be balanced the possibility that the surviving masonry church of Cedd's monastery at Bradwell in Essex dates to his lifetime and provides a parallel for a masonry church at Lastingham.

The monastery clearly flourished into the first third of the 8th century, since Bede cites the monks as his major source of information relating to Cedd and Ceadda.[4] Thereafter the historical sources fall silent, but the evidence of the sculptured stonework from the site indicates that it continued into the later 8th and 9th centuries. This sculpture includes not only parts of three crosses and what may be a fragment of a liturgical chair, but also sections of two door jambs, decorated the one with a plant scroll and the other with interlace.[5] We do not know from what building these doorways may have come. The presence of even later sculpture of the Scandinavian period indicates a Christian continuity on the site into the 10th and 11th centuries, but by this date the monastic community must have lapsed.

The precise chronology of the monastic refoundation of Lastingham in the late 11th century is intimately bound up with the events relating to the foundation of Whitby Abbey and St Mary's Abbey, York. However, the recorded traditions of the latter two houses are divergent and not easily reconcilable in detail.[6] The Whitby community had been established, sometime following 1074, by the monk Reinfrid of Evesham and had attracted an endowment from William de Percy. Subsequently a dispute arose between William and a

part of the Whitby community headed by the monk Stephen. According to the tradition incorporated in the tract *De Fundatione Abbatiae Sanctae Mariae Virginis Eboraci*,[7] the discord between Stephen and William, compounded by attacks from pirates which made Whitby insecure, led to Stephen petitioning the King and, sometime in or after 1078, being given the site of Lastingham. Stephen's monks then 'began to restore (Lastingham) gradually, and to build what things were necessary for monastic habitation' (*paulatim restaurare, et quae habitationi monachicae erant necessaria coepimus aedificare*);[8] and then, faced with renewed hostility from William de Percy, they transferred their community to the new site.

The settlement at Lastingham was only temporary, however, for Earl Alan Rufus soon offered to the monks the church of St Olave and the land adjoining in the City of York, and persuaded the community to move there.[9] This must have been in or before 1086 when Stephen is described by Domesday Book as Abbot of York rather than Lastingham. In other respects the Domesday survey is not as helpful as it might have been since, although it lists the Abbot [of York] among the tenants in chief, the survey of his actual holding has slipped from the main text (for whatever reason). None the less, it seems that of the Abbot of York's three carucate holding in Lastingham, one carucate was held by him from Berenger de Tosny; while the greater part of the Abbot's land elsewhere was also held by him from the same Berenger. This may point to Berenger as having been the principal patron behind the projected foundation at Lastingham: he was the holder of an honour centred at Settrington on the other side of the Vale of Pickering from Lastingham, and therefore had a local interest.[10]

The historical evidence thus allows the building work at Lastingham to be dated to the years between 1078 and 1086, and suggests that the project enjoyed the patronage of a substantial nobleman. Chronologically it must take its place therefore as the second major Romanesque building undertaken in the North of England following the Norman Conquest — the first having been the rebuilding of the cathedral in York itself, begun probably around the mid 1070s. At Jarrow, Wearmouth and Hackness, the refoundation of which was also the result of the monastic mission following 1074, the early communities seem to have been content with restorations of the existing Anglo-Saxon churches, to which domestic offices were added as necessary. At Whitby (where presumably there was also a temporary early phase) and at St Mary's York the main building projects for the two abbeys commenced only in or following 1088–89. At Selby Abbey temporary timber buildings were used from 1069 until 1097, after which date stone structures were commenced.

The Church of St Mary

The fabric of the building project of 1078×86 is of interest not only on account of its chronological position in the development of Romanesque architecture in Northern England; it is important also as a rare surviving example of a monastic church of this period that was abandoned during construction, so that it is possible to see something of the stages in which such a church was built — although this is complicated by J. L. Pearson's neo-Romanesque restoration of the building in 1879 (Fig. 1).

The elements of the church that were begun in the first campaign included the crypt, underlying the main east arm; the apse and forebay comprising the main sanctuary of the upper church; a square presbytery bay to the west of this; and, immediately west again, the four piers of the crossing, which presumably was designed to contain the monastic choir. There is no surviving fabric of the presbytery aisles, nor of the transepts nor of the nave,

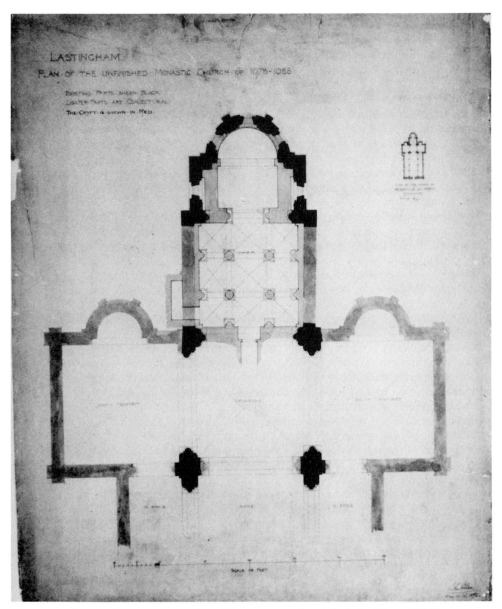

FIG. I. Reconstruction plan of Romanesque church by John Bilson (RIBA)

although it is reasonable to think that the foundations of at least parts of these were laid at the outset — and there are indeed reports of the nave foundations having been discovered in the churchyard.[11] It would seem, therefore, that when the monastic community moved to Lastingham they would have been able to use the essential liturgical parts of the church, though not without temporary partition walls and roofs dividing these off from the lateral areas and the superstructure not yet built.

The Crypt

The crypt is today the least altered part of the 11th-century fabric (Pl. IIIA). It comprises a square central chamber with groin vaults carried on four central columns, and to the east of this a narrow barrel-vaulted forebay leading to an apse with a half-dome. The main bays of groin vaulting have substantial ashlar transverse arches, and it was suggested by VCH that wall arches were also intended, but this seems doubtful.[12] Rather it appears that the groins were initially conceived to be considerably stilted in the corners of each bay (traces remain of this arrangement), but that subsequently this scheme was altered and the vaults were constructed in a shallower form. The arcs of the intended vault trajectory are visible on the walls in certain bays and these in no way agree with the trajectory of the present arcade and transverse arches. It therefore appears that the perimeter walls of the crypt were built to the height of the planned vault springing in the first season of work: then in the subsequent season the vault geometry was changed to the present scheme. It is to be noted that considerable fragments survive of the centring planks of the vault, and these would perhaps repay scientific examination.

The capitals of the crypt columns and responds are a most interesting series (Pl. IIIB). There is one well-formed 'Corinthianesque' capital of orthodox Norman type (such as occurs, for example, at St-Etienne in Caen), and others of related form but without the collar of upright leaves. However, one capital of 'Corinthianesque' form is more innovative: it has the collar of upright leaves replaced by a band of intersecting arcading. There are also some plain cushion capital forms, perhaps deriving from the Canterbury milieu: but one cushion capital has mitred angles and a small volute. The last form is developed further in the upper church where it is used predominantly. The type is paralleled in the clerestory of Blyth Priory (a decade or two later than Lastingham), and in some of the Lincolnshire parish church towers of the late 11th century (sometimes erroneously claimed as 'Anglo-Saxon'), and it is interesting to note this northerly distribution — within which Lastingham is the earliest example. Capitals of this type are also used in Normandy at Cerisy-la-Foret, where they top the shafts that divide the bays of the internal north elevation of the nave.

Access to the crypt today is through an archway in the middle of the west wall, approached down a flight of steps within the crossing, and at least the eastern face of this archway appears to be 11th-century. There is also, however, a narrow passageway leading out of the north-west corner of the crypt and turning eastward: possibly this would have led to steps up into the north presbytery aisle, but it is now blocked. If the western archway were the principal entry it would suggest that it was designed to provide access to the crypt from the choir, while leaving space on either side to pass from the choir up into the presbytery. The confining of the crypt to the space beneath the main vessel of the east arm is not a common type in major Romanesque churches in England, though it is paralleled at St George's, Oxford, and finds earlier precedent in the crypt of La-Trinité at Caen. The relationship to the probable crypt at York Minster is difficult to determine in view of the uncertainty about the details of the latter, but this may have had a chamber beneath the principal apse approached down long lateral passages.[13]

The Sanctuary and Presbytery

Turning to the upper church, the section that can be best examined today is the sanctuary, comprising the apse and its forebay, which are 11th-century work approximately to the level of the head in the windows (Pls IIIc & IIID). The original masonry is in roughly-dressed blocks of ashlar, cut in elongated shapes, and laid with thick beds of mortar between them. This ashlar seems to be used for the walling throughout the church, and in this contrasts with the extensive use of rendered rubble for walling at York Minster. At the same time, the elongated shape of the ashlars contrasts with the more normal squarish blocks that are standard in early Anglo-Norman Romanesque, such as at Lincoln Minster.

The apse is divided externally into three bays by pilaster buttresses, with a single window of two plain orders set in each bay. Internally these windows are again of two orders, but with the inner order carried on angle colonnettes. The forebay is wider than the apse, but narrower and lower than the presbytery. The side walls are carried on low arches at ground level, and these allow windows to light the crypt. Ground-level arches were used also at York Minster and Lincoln Minster, though for different purposes. The forebay is lit by single windows in the north and south walls, of a form similar to the apse windows, and an external string-course runs round the forebay and apse continuously at the level of the window sills. On the apse the string-course is billeted, but on the forebay it has an arcaded decoration on the south and an interlace decoration on the north side. The archway leading from the forebay to the apse is of two orders, with an angle colonnette to the outer one.

The evidence for the original presbytery is very fragmentary, with the exception of the archway leading from it to the sanctuary. This has substantial jambs with attached columns and volute capitals. The actual arch is of Pearson's rebuilding and is quite plain, but it is to be noted that an earlier 19th-century picture of the interior by John Jackson shows what appears to be a decorated outer order or hood-moulding (perhaps billeted?).[14] The north and south side walls of the presbytery are today pierced by 13th-century arcades. No part of these seems to be 11th century — not even the responds (despite the VCH plan) — and this may indicate that the original presbytery had solid side walls. On the other hand, this does not rule out an original plan with presbytery aisles, and it is to be noted that the east wall of the 13th-century north aisle is exceptionally thick, perhaps suggesting that it incorporates earlier work or stands on an earlier foundation designed for an apse.

The overall form of the east arm is closely similar to that published by Clapham for Whitby Abbey: to the east of the presbytery lay a narrow forebay before the apse.[15] At York Abbey there was no such forebay, but the main presbytery did project beyond the line of the flanking aisles.[16] At York Minster the main apse itself was deeply stilted and perhaps marked a step towards the Lastingham plan.[17] It is tempting to think that at Lastingham the forebay and apse were designed to provide specific architectural spaces for the high altar with a shrine to St Cedd behind (while Whitby could have catered similarly for the cult of St Hild) — though there is no evidence for whether the monks possessed, or thought they possessed, any of Cedd's relics (which certainly were claimed by Lichfield).

The High Vaults

The vaults of the eastern arm, comprising the apse semi-dome, the barrel vault of the forebay, and the quadripartite groin vault of the presbytery bay, are often dismissed as the inventions of Pearson's 1879 restoration, but there is evidence against this narrow interpretation.[18] During the annual meeting of the Royal Archaeological Institute held at Scarborough in 1895 a visit was paid to Lastingham church. The *Proceedings* record that

John Bilson described the church and also that 'in 1879 a complete "restoration" was carried out by Mr Pearson, who added stone vaults over the nave and chancel, in consequence, it is said, of the discovery of traces of their former existence'.[19] There is no direct record of Bilson's actual comments on the vaults, but it may be significant that in his reconstruction plans of the Romanesque church he shows high groin vaults in the presbytery, crossing and transepts (Fig. 1).[20] Further evidence for the former existence of high vaults, at least in the eastern arm of the Romanesque church, comes in a citation and faculty of 1877 which refers to the forthcoming restoration in considerable detail:

'To take down the picture and the modern dome [sc. 1828 baldachino] over the east end of the Chancel To take up the present floors of the Church and Crypt and to refloor the same to new levels To take off the whole of the roofs and parapets of the said Church and to reroof the same To rebuild the clerestory walls and to insert new windows in character with the ancient work To take down the Chancel Arch and to build a new one in character with the old work and to build new parapets to Nave [sc. presbytery] and Aisles To *restore the ancient groining of the nave* in place of the present ceiling *To restore the ancient barrel vaulting of the Chancel including the Apsidal East end* To open out and restore the three eastern windows of the Chancel now walled up . . .' (emphasis ours).[21]

The language is precise. The plans are to 'rebuild' the clerestory walls and 'insert new windows'. The chancel arch is to be taken down and replaced by a new one. The wording 'to restore the ancient groining of the nave', and 'the ancient barrel vaulting of the chancel including the apsidal east end' should therefore be taken at face value to mean that evidence for these existed prior to Pearson's restoration.

Thus it would seem that there was a high groin vault in the presbytery and a barrel vault in the forebay of Lastingham from the first. Although there is no mention of the semi-dome of the apse by this name, it is presumably referred to when the apse is specified; in any case the absence of such a vault is unlikely given the vaulted forebay and presbytery. There is no evidence that the crossing or transepts were vaulted as suggested by Bilson.

The Transept and Nave

To the west of the presbytery were implanted the four piers of the central crossing of the church. In the direction of the intended crossing arches the piers are of two orders on each face: the inner order has a dosseret and half column; the outer order a recessed angle column; and each column has a volute capital. The only arch carried by these piers is that on the east side of the crossing and this, in its present masonry, appears to have been built by Pearson. None the less, the springing point of the intended crossing arches of the 11th century is clear: all four arches were to be of the same height as the present east arch. This arch is quite low and can only be read in the context of a projected two-storeyed elevation for the arms of the building abutting it.

The west piers of the crossing are embedded in the present west wall of the church, but provide clear evidence for certain features of the intended nave design. On the west face of the piers are responds for the nave arcades: these are again of two orders, with attached half-columns and recessed columns, but the capitals are of trumpet-cushion form. On the south side of the south-west pier is also evidence for the respond of the arch from the south transept to the south nave aisle as intended: this was of two orders. The impost for the arch to the aisle was at a level higher than the nave arcades (but lower than the crossing arches) and this indicates a concern to keep the crowns of the arches at a uniform height, possibly, though not necessarily, to allow for vaulting over the aisles.

The bases of the attached columns throughout the upper church are of a variety of forms, but mostly with a rather shallow profile, suggesting derivation from the Anglo-Norman

double-cavetto form. Several have a more or less straight-chamfered profile with a central roll dividing the surface into two bands; while on the south-west pier is one with a band of interlace ornament.

Conclusions

In drawing some conclusions from this study, it may be observed first that it is somewhat difficult to explain the overall form of the building directly in terms of likely predecessors. This may be in part because much of our information about buildings of the first generation following the Conquest comes from the major cathedrals and abbeys that were planned from the start on a much larger scale than Lastingham, whereas many of the middle rank of new monastic foundations known to us are of later generations. Be that as it may, La-Trinité in Caen provides a general model for the adoption of a two-storeyed elevation for an important monastic church, while the type of crypt there also relates to that of Lastingham: but it is clear that there is more than one remove between the two buildings. An English foundation of approximately contemporary date to Lastingham that adopted a similar scale and a two-storeyed elevation for its monastic church was Elstow Abbey in Bedfordshire, though this bears little comparison in detail with the Yorkshire church. But if it were accepted that the two-storeyed elevation was a recognised possibility for a monastic church of appropriate rank and resources, perhaps it would not be necessary to look in individual instances for any more immediate model than the general experience of the masons: that is, any competent mason could design either two-storeyed or three-storeyed buildings as occasion demanded. This is perhaps not a very remarkable observation, but it does have an important implication in the present case: that is, that the question of the origins of masons can be addressed almost entirely by reference to the details of the design.

Various features that link Lastingham to a wider Anglo-Norman Romanesque tradition have been indicated above: the form of the compound piers; the 'Corinthianesque' and cushion capitals. It is thus clear that in a general way it belongs firmly within the tradition of Romanesque architecture that stems from Canterbury and Caen. At the same time, however, features have been analysed which seem to belong more to a regional context: the plan with a narrow forebay intervening between the presbytery and the choir; the form of capital that combines the cushion and volute. If we knew more about the details of the 11th-century York Minster we might see more clearly the first stage in the process by which an architectural mode introduced from outside the region almost immediately started to develop its own regional characteristics; but Lastingham is itself a witness to the phenomenon and important on that account.

As to the posterity of Lastingham, we are equally in a difficult position. The obvious place where influences might be expected are at St Mary's Abbey, York, and at Whitby Abbey, but in neither case do we have evidence for much more than the plan. Perhaps Abbot Stephen transferred his builders with him from Lastingham to York, perhaps he formed a new workshop drawing on that at the Minster: we do not know.

Whereas it remains difficult to assess the *general* significance of Lastingham in the development of Romanesque in the North of England, there remains one *specific* aspect of the design that can be assessed in a wider context. The probable existence of high vaults in the sanctuary and presbytery at Lastingham is relevant to the development of high vaults in Anglo-Norman architecture in general, and to the rib vaults at Durham Cathedral (1093–1133) in particular. There was a high vault in the eastern arm of St Alban's Abbey (1077–88)[22] and Bilson suggested that the presbytery of Remi's Lincoln (c. 1072×92) was also intended to be groin vaulted.[23] It is tempting to speculate on the former existence of

presbytery high vaults at Whitby Abbey and at St Mary's Abbey, York, but in neither case do we have evidence for the superstructure. However, we do know that high rib vaults were planned for the eastern arm of Durham from the first, and the sophisticated form of the rib vaults in the presbytery aisles there suggests that they were the product of a master experienced in vault construction.[24] Certain details of Durham suggest that the master mason was previously employed in the North of England, and possibly even at Lastingham. Both churches have a short forebay before the apse — a convenient scheme to accommodate the high altar in front of the shrine.[25] The form of the presbytery-aisle and transept-aisle responds at Durham, with a half shaft against a dosseret with flanking half shafts, is the same as the crossing responds at Lastingham. The tall, block-like plinths with single chamfers at Lastingham presage the presbytery arcade plinths at Durham. The trumpet-cushion capital appears in the intersecting arcade of the dado in the presbytery aisles at Durham. The responds of the crypt aisles at Lastingham, with the half shaft and dosseret created from a single block of stone, are the same as in the slype and chapter house blind arcades at Durham.

It may be that Tynemouth Priory (founded *c.* 1083×89 and with the new church partly built by 1093) acted as an intermediary between Lastingham and Durham in respect of certain details — although in general the plan and overall design of Tynemouth appears to be derived from the Romanesque architecture of the West and South-West Midlands in the 1070s and 1080s. Tynemouth shares a common type of plinth with Lastingham and Durham. In a stone store at Tynemouth there is a loose volute capital with a single row of upright leaves that comes close in form to one in the Lastingham crypt. Also it appears that the complexity of the arch moulding at Tynemouth presages the complexity of Durham.[26] Unfortunately the ruined condition and badly weathered surfaces of the standing masonry at Tynemouth make it impossible to ascertain its precise role in the sequence.

Add to the loss of Tynemouth that of Whitby and of the Cathedral and St Mary's Abbey at York, and it emphasises the importance of Lastingham as a surviving witness to the major Romanesque churches of the 11th century in the North East of England. Furthermore, if the presbytery groin vault at Lastingham is read as the product of Pearson's restoration, rather than of Pearson's fancy, then its significance to the prehistory of the vaults of Durham merits discussion in more than a regional history of Romanesque architecture.

REFERENCES

1. Symeon of Durham, *Historia Dunelmensis Ecclesiae* and *Historia Regum*, ed. T. Arnold (Rolls Series, 75, 1882–85), 108–13, 201–2.
2. Bede, *Historia Ecclesiastica Gentis Anglorum*, ed. C. Plummer (Oxford 1896), praef., III.23, III.28, IV.3, V.19.
3. Ibid., III.23 (p. 176).
4. Ibid., praef. (p. 7).
5. R. Bailey cit. in B. Hewitt, *The Ancient Crypt Church of St Mary, Lastingham* (Lastingham 1982); R. Bailey, *Viking Age Sculpture* (London 1980); J. Lang, *Corpus of Anglo-Saxon Stone Sculpture*, 3, *York and Eastern Yorkshire* (Oxford 1991), 167–74.
6. A. Hamilton Thompson, 'The Monastic Settlement of Hackness and its Relation to the Abbey of Whitby', *Yorks. Archaeol. Jnl.*, 27 (1924), 388–405.
7. W. Dugdale, *Monasticon Anglicanum*, ed. J. Caley et al. (London 1817–30), 3, 544–6.
8. Ibid., 545.
9. Ibid.
10. *VCH Yorkshire*, 2 (1912), 160–1.
11. *VCH Yorkshire North Riding*, 1 (1914), 526. This is the best published account of the church.
12. Ibid., 526–7.

13. D. Phillips, *Excavations at York Minster*, 2, *The Cathedral or Archbishop Thomas of Bayeux* (RCHM 1985). See also the review by R. D. H. Gem in *Antiquaries Jnl.*, 66 (1986), 457–9.
14. Published by Hewitt, op. cit. in note 5.
15. A. W. Clapham, *Whitby Abbey, Official Guide Book* (London 1952). More recent archaeological work has been carried out by G. Coppack which provides new evidence for the plan of the church.
16. J. Bilson, 'The Eleventh-Century East Ends of St Augustine's, Canterbury, and St Mary's, York', *Archaeol. J.*, 63 (1906), 106–16.
17. Op. cit. in note 12.
18. A. Quiney, *John Loughborough Pearson* (New Haven and London 1979), 132, regards the Lastingham (presbytery groin) vault as 'a complete falsification'.
19. *Archaeol. J.*, 52 (1895), 392–400, at 398–9.
20. RIBA Drawings Collection, ref. no. XBX15/3/(1) and (2).
21. Borthwick Institute, University of York (FAC 1877/2a, FAC 1877/2b). M.T. would like to thank Dr Christopher Norton for suggesting that he should contact the Borthwick Institute in connection with documentation on Lastingham.
22. C. R. Peers and W. Page, *VCH Hertfordshire*, 2 (1908), 484, 490.
23. J. Bilson, 'The Plan of the First Cathedral of Lincoln', *Archaeologia*, 62 (1911), 543–64, at 558.
24. On the Durham vaults see: J. Bilson, 'The Beginnings of Gothic Architecture, 2, Norman Vaulting in England', *Jnl. Roy. Inst. British Architects*, 6 (1899), 289–319, and discussion, 319–26; idem., 'Durham Cathedral, the Chronology of its Vaults', *Archaeol. J.*, 79 (1922), 101–60; J. Bony, 'Le projet premier de Durham: voutement partiel ou voutement total?', in *Urbanisme et architecture: études écrites et publiées en l'honneur de Pierre Lavedan* (Paris 1954), 41–9; J. James, 'The Rib Vaults of Durham Cathedral', *Gesta*, 22 (1983), 135–45; M. Thurlby, 'The Romanesque and Early Gothic Fabric of Durham Cathedral', in D. Pocock (ed.), *Durham Cathedral: a Celebration* (London 1993), in press; idem., 'The Purpose of the Rib in the Romanesque Vaults of Durham Cathedral' and 'The Romanesque High Vaults of Durham Cathedral', in M. Jackson (ed.), *Engineering a Cathedral* (London 1993), in press.
25. J. Bilson, 'Recent Discoveries in the East End of Durham Cathedral', *Archaeol. J.*, 53 (1896), 1–18.
26. W. H. Knowles, The Priory Church of St Mary and St Oswin, Tynemouth, Northumberland', *Archaeol. J.*, 67 (1910), 1–50. R. D. H. Gem gave a paper (unpublished) at the BAA Durham Conference in 1977 which is the basis for the comment here on the chronology and general character of the project.

The Romanesque Church of Selby Abbey

By Eric Fernie

This paper will examine the earliest material remains of Selby Abbey under the following three headings:

1 Documentary evidence.
2 Order of building.
3 Architectural affiliations.

DOCUMENTARY EVIDENCE

The Revd W. H. Scott's *Story of Selby Abbey*, of 1894, begins with the stirring exclamation 'Harold was dead!' One is hesitant to acknowledge the relevance of such an extreme instance of the dynastic model of history, but it is indubitably the case that Selby is a Norman foundation, for which even the legendary accounts provide no pre-Conquest history.

According to Simeon of Durham William the Conqueror founded the abbey at Selby in 1069,[1] so it was both an important establishment and one of the earliest in the north since the Viking invasions. The Charter, which survives in Dugdale, confirms this date and indicates that the dedication was to Christ, the Virgin and St Germanus, that is, the 5th-century bishop of Auxerre.[2] A history of the abbey written by a member of the house in the late 12th century adds that William's founding abbot was Benedict, a monk of Auxerre, who was sent by St Germanus, somewhat inexplicably, to Selby, bearing what was to become the abbey's chief attraction, namely one of the saint's fingers.[3]

The foundation appears to have flourished largely because Hugh, Sheriff of Yorkshire, was so impressed with Benedict's holiness.[4] The second abbot, another Hugh, held office from 1097 to 1123 and was responsible for the beginning of the present church (Fig. 1): 'The devout architect himself [i.e. Abbot Hugh] laid the foundations of the church as well as the monastic buildings in the place where the abbey now stands, for up to his time they had been of wood'.[5] As he built them 'further from the water where they are now', the church appears to have been erected on a site without a previous church or shrine to condition it.

There is no further documentary evidence relevant to the building history until the transfer of the property to the town by royal order in 1618.[6] Thereafter the fabric suffered from neglect, marked most dramatically by a collapse in 1690, which seems to have destroyed the crossing tower and the south transept.[7] An engraving of the church seen from the west published in 1655 shows the building without western towers, though it is not clear that they had ever been completed.[8] Programmes of restoration were undertaken at various times in the 19th century, including the excavation of the eastern arm in 1890–1.[9] In 1902 the central tower and the south arm of the transept were rebuilt and in 1906 the building was gutted by fire and all the roofs destroyed.[10]

ORDER OF BUILDING

In its present form the church consists of a long chancel of around 1300, the original crossing with one surviving arch (the northern one), and a largely modern tower, the

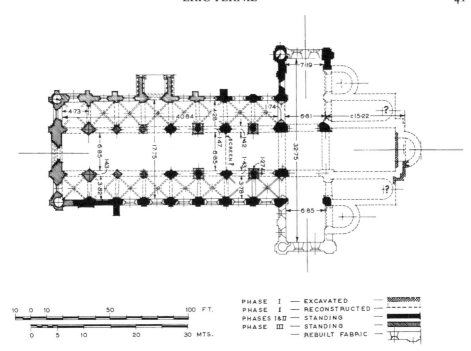

PHASE I — EXCAVATED
PHASE I — RECONSTRUCTED
PHASES I&II — STANDING
PHASE III — STANDING
— REBUILT FABRIC

FIG. 1. Plan, with eastern arm reconstructed on the basis of excavations shown in Hodges' plan of 1892

FIG. 2. Longitudinal section to north. I. Early Romanesque; II. Later Romanesque; III. Transitional; IV. Early Gothic

original north transept arm and a modern southern one, and a nave of three storeys and eight bays of alternating columns and piers, beginning Romanesque in style and developing (in a classic sequence rivalled only by the nave of Romsey) via Transitional to Early Gothic. This order of styles makes it clear that building progressed in the normal way from east to west. In describing the phases it will be simpler if the northern and southern elevations are dealt with separately, starting with the northern (Fig. 2).

North Elevation: Phase I: Early Romanesque

The first phase of building consists of the north arm of the transept, the piers of the crossing, and the first two bays of the north aisle wall.[11] On both interior and exterior these consist of plain walls relieved only by blind arches each of a single order (Pl. VA).

This phase contains two illustrations of the mason's craft in the period. The first is that the courses, which vary in depth, run unbroken for the full length of the phase, from the east end of the north wall of the transept to the third bay of the north aisle wall, indicating a well-developed ability to organise the supply of stone from the quarry in keeping with the design of the building (Pls VA and VB). The second is the revolution in the quality of stone cutting which has taken place between the earliest and latest parts of this single run of work. While maintaining the same overall height in the lowest five courses (to within .7 of a percentage point) as required by the unbroken run of courses, the blocks at the western end are deeper and the mortar joints finer, as is visible in Pl. VB and indicated by the figures in Table I.[12]

TABLE I

Masonry courses at the east and west ends of phase I. Figures in centimetres. See Pl. VB

North wall of transept			North aisle wall		
Course 5	23		25.5		
Joint	1.5		.03		
Course 4	26.5		27		
Joint	1.5		.05		
Course 3	22.5	Total 75.0	23	Total 75.58	
Course 2:	Plinth		Plinth		

North Elevation: Phase II: Later Romanesque

This is most obviously characterised by arches decorated with varying kinds of chevron, which was absent in phase I. Lateral chevron on the face of the arch occurs on the north arch of the crossing; chevron across the edge of the order occurs on the outer edge on the main arcade and gallery arches of the first and second bays in the nave; and point-to-point chevron is used on the inner order of the first and second bays of the main arcade (types A, B, and C respectively in Fig. 3; and Pl. IV.[13]

The surface of the stone and the size of the jointing suggest that piers 3 and 4 also belong in the second phase, despite the fact that they would have been separated from the main mass of the building as it stood at the completion of phase II.

One other observation concerning the masonry is relevant here, namely that the establishing of phases by stylistic features is supported by breaks in the coursing. There is a break at gallery level immediately to the west of the shaft rising from the second pier (Pl. IV), and a similar break in the north aisle wall in line with the second piers, already mentioned in connection with phase I (Pl. VIA). The combination of changes in features with breaks in the masonry suggests an important hiatus at this point.

North Elevation: Phase III: Transitional

This is characterised by keeled rolls and shafts, and the continued use of round-headed arches and one arch (number 4) with deeply undercut chevron. It consists of everything

FIG. 3. Chevron: A. Lateral on the face; B. Edge;
C. Point-to-point

A ——

B ——

C ——

westward from and including pier 5 and arch 3 of the main arcade, and from and including bay 3 at gallery level.

Within this simple outline the junction with the piers belonging to phase II, in bays 3 and 4, is extremely complex, not to say messy. It is perhaps best to begin with the capitals. Those of piers 1, 2, and 4 belong with phase II, but the capitals of pier 3 have much more in common with examples in phase III, like the capitals of pier 5. This is not as odd as it at first appears if one takes into account the fact that the piers alternate between a columnar and a compound form, so that piers 2 and 4 belong together, and the capitals of pier 3 simply go with those of pier 5 rather than those of pier 1.

Whatever the explanation, the material evidence indicates that the capitals of pier 3 belong with the third or Transitional phase, from which it follows that the arch of bay 3, which it helps to carry, must belong in the same or a later phase. It has been necessary to establish this in advance because north arch 3 is a very odd and potentially misleading hybrid (Pl. IV): its inner order has a slightly more undercut version of the point-to-point chevron found on arches 1 and 2; the middle order has lateral chevron on the soffit; and the outer order a keeled angle roll. The inner order is therefore an up-to-date version of an older type, the middle order is quite old-fashioned, and the outer unequivocally belongs to the Transitional style of phase III. The explanation for this state of affairs is either that the masons were feeling playful at this juncture, or that the voussoirs of at least the middle order

had been carved during phase II but were only erected, along with the other, newer, parts of the arch in phase III.

Arch 4 contains an interesting error. The inner order consists of deeply undercut directional chevron arranged so that the arrows of the design point west on the nave face of the order and east on the aisle face. Two contiguous voussoirs have however been inserted the wrong way round, creating a pair of lozenge shapes among the arrows. Presumably the voussoirs were placed face-down onto the woodden centering and the error only discovered when the centering was removed.[14]

North Elevation: Phase IV: Early Gothic

The clerestory differs from the gallery in having pointed arches and simpler mouldings, as well as being uniform from the east end of the nave to the west.

South Elevation

The phases are broadly the same in the south elevation. Phase I extends beyond the crossing to include the first bay of the main arcade, which is closely comparable with the adjacent arch between the transept and the aisle (Pl. VIB). These two arches are less plain than the blind arches in the north transept arm in that they have soffit rolls (not bonded to the second order), but they lack the chevron which characterises phase II. The piers supporting the first arcade arch, namely the southwest pier of the crossing and the first one in the nave, must clearly belong to the same phase as the arch or to an earlier one, and the character of the masonry and the size of the mortar joints suggest that pier 2 of the south arcade belongs with them.

Phase II consists of the arch of the second bay of the main arcade and the arches of the first and second bays of the gallery, with edge chevron across the order of the arch. There is a masonry break at gallery level just to the west of the shaft of the second pier, exactly opposite the break on the north side of the nave. Unlike the north aisle wall, the south aisle wall was built right to the west end without a break, presumably to accommodate the cloister; there is, however, a break in the upper parts, as bays 1 and 2 are the only ones in the south aisle to retain their original rib vaults, perhaps because they were the only ones actually built in the period. As on the north side, the character of the masonry suggests that piers 3 and 4 belong in this phase.

The junction with phase III occurs along the same line on the south side as on the north, but without any complexities at arches 3 and 4. West of bay 2 the gallery and clerestory are linked by free-standing shafts, clearly forming part of a single design, and since the clerestory is similar to that on the north, what is phases III and IV on the north must all form part of a single Early Gothic phase on the south.[15]

The Planned Character of the Break between Phases II and III

Opinion is divided on whether the breaks between these phases, on both the north side and the south, are the result of accident or design. Fowler for example says that 'there can be little doubt that work was stopped suddenly on the death of Abbot Hugh, as there was no preparation made for a pause'.[16] Whatever Fowler had in mind in making this statement, there is substantial evidence suggesting that a break was on the contrary intended at the west side of bay 2.

This consists in the fact that the break after bay 2 in the north and south aisles and in both the main arcade walls coincides with the remains of a screen visible at the second piers in

1867 and indicated on Hodges' plan in the same position (Fig. 1).[17] This evidence for the westernmost extent of the choir is consistent with the fact that the half-shafts on the nave faces of the crossing piers start only just below the base of the gallery, as if designed to allow for the presence of choir stalls. A temporary wall between the second pair of piers and a temporary roof over bays 1 and 2, resting on the floor of the unbuilt clerestory passage, would have made the clergy's part of the church ready for use long before the building was completed, while the crossing tower would have been buttressed by two bays of the nave in addition to the arms on the other three sides.[18] The distortion of the arches of the first bay on the north side of the nave (Pl. IV) could have been caused by the provision of insufficient buttressing during the years between phases II and III, or by the failure of the foundations of the north-west pier of the crossing, or by a combination of both. The clerestory must have been erected before the distortion began as it appears to have been affected by it and subsequently tidied up, probably at the same time as the gallery arch was filled in.[19]

Although the break between phases I and II lacks such a strong liturgical and structural rationale, it also occurs in a sensible place, at the top of the crossing piers before the arches were turned. This break and that between the second and third bays therefore appear to have been the result of planning rather than accident. This sort of constructional planning needs however to be distinguished from design planning, that is determining in advance what the building will look like. In this respect the masons of Selby Abbey seem to have been happy to introduce new forms almost without reference to what had preceded them in the fabric. The presence and absence of lozenges on the north and south cylindrical piers of the same bay is a good example of this wayward attitude to surface decoration (though the lack of decoration on the north pier could have been supplied when the building was painted, in which case the absence of carved lozenges would be the result of economic factors rather than attitudes to decoration).

The Claustral Buildings.

The building of the south wall of the aisle to its full length in phase II suggests the intention to provide a cloister and attendant ranges at as early a stage as possible. All the monastic buildings are however lost, apart from a few scars on the south-east corner of the south-west tower, an engraving of 1813 showing buildings to the south and west of the façade, a vague description of 1814, and a statement that the foundations of the chapter house were exposed, but not recorded, in 1867, none of which pieces of evidence give any indication of the age or style of the buildings.[20] A doorway survives in the south aisle wall which would have given access to the church from the cloister. This entrance is in a most unusual position, being situated in the second bay of the aisle, and not, as is more usual, in the first bay where it would line up with the east walk of the cloister. The only other instances of this location known to me are at the abbeys of Tynemouth, Dunfermline and Lindores. No obvious reason for the oddity presents itself at any of these sites except Dunfermline, where great care has been taken to stress the importance of the second bay of the nave, which appears to have housed the tomb of St Margaret. Nothing similar is known at Selby, and indeed it conflicts with the evidence for a choir screen on the west side of the second bay.

The lack of foresight of the builders is indicated by the fact that, despite their having constructed the aisle wall complete for the side of the cloister, the sill of the window in bay 3 has had to be raised to place it higher than the abutment of the roof of the walk.

The removal of the claustral buildings represents the biggest single step in the transformation of the foundation in post-Dissolution times from an abbey to a free-standing urban church complete with neo-Romanesque buttresses on the south face.

D

ARCHITECTURAL AFFILIATIONS

Selby is closely related to and dependent on the design of Durham Cathedral. The most striking parallel is the oddity of the fact that the three double bays of alternating columns and piers in the nave end to the west in a single bay and a bay for the façade towers, so as to place two major piers next to one another. The buildings also share the majority of their decorative features, most conspicuously the decorated columnar pier (with the lozenge design in the same place, on the easternmost pier of the nave), the polygonal scalloped capital, the soffit roll, and the tall plinth with a double-chamfered upper collar. The plainness of the earliest parts at Selby is presumably due to resources being more restricted than those at Durham, though it has to be admitted that even bearing this in mind the transept arm is rather old-fashioned for work of around 1100.[21] Conversely one can argue that phase II should be dated after 1133, on the grounds that the point-to-point chevron which characterises this phase is not used at Durham, which was completed in that year.

The family of Durham, of which the other members are the churches at Waltham, Lindisfarne, Dunfermline, Kirkby Lonsdale, and Tynemouth, can be divided into two

TABLE II
Widths of nave and aisles
All figures in metres
Above: the actual widths in bays 2, 3, 5 and 7; below: the calculated figures

North aisle	Wall	Nave	Wall	South aisle
Actual: 4.28	1.42 – – – 6.85 – – – 1.43			3.80
	– – – – – 9.70 – – – – – –			
	– – – – – – – – – – 17.75 – – – – – – – – – – –			
Calculated	– – – 6.85 – – –			X 1.4142=
	– – – – – – 9.69 – – – – – –			X 1.8284=
	– – – – – – – – – – 17.71 – – – – – – – – – – –			

groups, on the basis of their use or otherwise of shafts and pier decoration.[22] Selby and Waltham, both to the south, have shafts dividing their bays and a consequent vertical emphasis, while Lindisfarne and Dunfermline, both to the north, have no shafts and a horizontal emphasis.

All the buildings have some form of decoration on their columnar piers, and all have zigzags or lozenges, which only occur in the naves. Spirals, which occur in the eastern arm and transepts at Durham, and at the eastern end of the nave at Waltham and Dunfermline, appear to have performed an iconographic function as sanctuary markers.[23] There were no spirals at Lindisfarne and none survive at Kirkby Lonsdale, Tynemouth and Selby.[24]

The nave and aisles at Selby are internally 58 ft 3 ins (17.78 m) wide and Hodges gives the height of the nave to the eaves as 51 ft (15.54 m).[25] Theories of design in the Middle Ages recognised two proportions in particular between width and height, the equilateral triangle and the square, called respectively designing *ad triangulum* and *ad quadratum*. An equilateral triangle with a base of 58 ft 3 ins will be 50 ft 5 ins (15.37 m) high, and since all the measurements which Hodges gives are in whole feet Selby can justifiably be described as a design *ad triangulum*. Waltham and Dunfermline, on the other hand, are probable

examples of design *ad quadratum*, as their width is the same as their height, exactly at Dunfermline and approximately at Waltham.[26]

The widths of the nave and aisles and the thickness of the arcade wall are also determined by a proportion widely used by medieval builders, namely one to the square root of two or 1:1.4142, which is the proportional relationship between the side of a square and its diagonal.[27] The internal width of the nave multiplied by root-two equals the exterior width, and the external width of the nave multiplied by root-two equals that width plus the width of the aisle. Put in a different way, the internal width of the nave multiplied by root-two generates the thickness of the arcade walls, and the resulting dimension, the external width of the nave, multiplied by root-two generates the width of the aisle. The actual dimensions and the arithmetical calculations are laid out together in table II. Clearly there has been an error in the setting out of the aisles, but as it can be assumed that they were intended to be the same width, it is significant that their combined widths are what the calculation requires.

The foundations of the original eastern arm, excavated beneath the third bay of the Gothic chancel, establish the chord of the main apse some 50 ft (15.22 m) east of the crossing.[28] This is about 2 ft (.6 m) less than the equivalent of three bays of the nave, but the length could have been divided into two bays, or left undivided and with solid walls between main vessel and side chapels, as at St Albans. The side aisles or chapels terminated in walls which were straight on the exterior, but their interior shape is not known; Hodges proposes apses, forming the enclosed arrangement. This is a logical proposal given the existence of enclosed apses at Durham, but the reconstruction needs to be treated with caution given the frequency with which scholars have reconstructed chancels with the form on no evidence at all.[29]

Whatever shape the termination of the side aisles may have taken, there is no doubt that the main apse was very different from that at Durham. It is narrower than the chancel, as is normal, but it is so much narrower that it can barely have been larger than the apse originally attached to the eastern face of each transept arm. In addition the foundation of the east wall of the chancel is about twice as thick as that of the apse. These two factors taken together mean that the apse must have been a much less prominent feature than usual, and more like some of the designs of the west of England, such as that of Hereford Cathedral.

Conclusion

The Romanesque church is, then, one of the family of buildings directly dependent on Durham, with a *terminus post quem* of 1097, four years after the start of the cathedral, and all of its features (except for the small size of the main apse) following those of the larger building. Its particular interest lies more in what happened to it subsequent to its earliest phase: the constant updating of the design as the bays and storeys of the nave were constructed, the magnificent new eastern arm, and the post-Reformation alteration of the whole layout from a monastery into a piece of the nineteenth- and twentieth-century urban landscape.

ACKNOWLEDGEMENTS

It is a pleasure, as always, and now also since his untimely death a cause of sadness, to record my thanks to Don Johnson for drawing the figures. I am also very grateful to the Revd Michael Escritt and the staff at Selby for their help on my visits to the church.

REFERENCES

1. Simeon of Durham, *Historia Regum*, Rolls Series, vol. 2 (1885), 186, ch. 153: 'Anno MLXIX coenobium Sancti Germani de Selebi sumpsit exordium'.

2. W. Dugdale, *Monasticon Anglicanum*, 1 (London 1655), 371: 'Carta Willelmi Conquestoris de Prima Fundatione Abbatiae de Salebi...Benedicto Abbati devotissimo, coenobium in onore Domini nostri Jesu Christi, et beatissimi ejus genetricis et Virginis Mariae, et sancti Germani, Antissiodorensis [*sic*] episcopi in Salebya fundare concessi'.

3. Revd J. T. Fowler, 'Historia Selebiensis Monasterii', *Yorkshire Archaeological and Topographical Association: Record Series*, 10 (1890), 1–54, taken from Labbe's text published in Paris in 1657. Chapter 2, v: St Germanus sends Benedict on his mission 'cum digito suo'. I was pleased to learn at the Conference that the original manuscript of the *Historia* has been rediscovered and is now housed in the Bibliothèque National.

4. Fowler, *Historia* (1890), XIII: '...Vicecomitis Eboracensis Hugo....'.

5. Fowler, *Historia* (1890), XXVII: 'Ecclesiae quoque, sed et omnium officinarum regularium fundamenta in loco ubi nunc Abbatia, devotus architectus ipse locavit: nam usque ad suum tempus omne officinae ligneae fuerant...'. J. Burton, *Monasticon Eboracense* (London 1758), 405, calls the abbot Hugh de Lascy and says that he was confirmed in 1103. This identification has some circumstantial support in the number of grants made to the abbey by members of the de Lacey family, as recorded by Dugdale, *Monasticon*, 1 (1655), 371–3.

6. W. Dugdale, *Monasticon Anglicanum*, III (London 1821), 498: 'The conventual church of Selby was made parochial by the king's letters patent, dated 20 March, 16 James I, A.D. 1618'.

7. W. Dugdale, *Monasticon Anglicanum* (London 1718), 47: 'I am inform'd that this Church fell down in the Year 1690'.

8. Dugdale, *Monasticon*, 1 (1655), facing p. 372.

9. C. C. Hodges, 'The architectural history of Selby Abbey', *Yorkshire Archaeological and Topographical Association: Records Series*, 13 (1893), XXXIII and plan. George Gilbert Scott, *The Restoration of Selby Abbey Church* (Selby 1871), especially p. 8, a detailed statement of the programme of work proposed for the south aisle wall, which, according to the standing fabric, is largely what was carried out.

10. *Architectural Societies, Reports and Papers*, 26 (1902), LXXI, describes a visiting party passing under the central tower which was 'then being pulled down'. *Proceedings of the Society of Antiquaries of Newcastle upon Tyne*, 3rd series, 3 (1907–8), Pl. facing p. 4, showing the interior after the fire.

11. Hodges (1893), IX, writing before the fire of 1906 and the subsequent repair, describes the south-west pier of the crossing as original, the south-east as having been rebuilt using the original stones, after the fall of the tower, the north-east as partly destroyed by the new choir, and the north-west as having an original core with later additions. This description is still largely applicable; see Fig. 1.

12. The standard of the masonry at Durham is, as one would expect, of a substantially higher order; see Jean Bony, 'The stonework planning of the first Durham master', in *Medieval Architecture and its Intellectual Context: Studies in Honour of Peter Kidson*, ed. E. Fernie and P. Crossley (London 1990), 19–34. Another example of improvement in stone cutting is to be found in the transept of the cathedral at Winchester, where the original masonry of between 1079 and the 1090s can be contrasted with that of the piers rebuilt after the fall of the tower in 1107.

13. The terms used here for the different kinds of chevron are those devised by Deidre Wollaston and Ron Baxter for the British Academy's Corpus of Romanesque Sculpture in the British Isles and Ireland.

14. The westernmost piers of the nave rest on a separate course of stone standing proud of the floor. It is unclear whether this feature was intended to level the floor or has anything to do with two different phases of building.

15. Hodges (1893), XI–XVII, offers an analysis of the phasing which differs from this in a number of respects.

16. Fowler, *Historia*, 10 (1890), XI.

17. W. W. Morrell, *The History of Antiquities of Selby* (Selby 1867), 197: 'At the base of the second pillar may yet be seen the place where the original screen of the Norman choir would be placed'; Hodges (1893), XXXV, says that there is no trace of the rood loft.

18. E. Fernie, 'The use of varied nave supports in Romanesque and early Gothic churches', *Gesta*, 23 (1984), 107–17.

19. The eastern bay of the nave in the contemporary cathedral of Carlisle has suffered a comparable distortion.

20. Dugdale, *Monasticon*, III (1821), engraving of 1813 facing p. 484; John Chessel Buckler, *The Gentleman's Magazine*, 85 (2) (1815), 105–6, an account written in 1814: 'The principle buildings were on the west and south sides of the church. The barn and granary are yet remaining, but the great gateway was pulled down about twenty years since...The chapter house is a beautiful building, attached to the south side of the choir'; for the excavation see Hodges (1893), LV.

21. Hodges (1893), VII, considers some of the decorative features of Selby to be earlier than their equivalents at Durham.

22. J. Bilson, 'Durham Cathedral, the chronology of its vaults', *Archaeol. J.*, 79 (1922), 101; J. Bony, 'Le projet premier de Durham: voûtement partiel ou voûtement total?', in *Urbanisme et Architecture: Etudes Ecrites et Publiées en Honneur de Pierre Lavedan* (Paris 1954), 41–9; *idem.*, 'Durham et la tradition Saxonne', *Etudes d'Art Médiévale Offertes à Louis Grodecki* (Paris 1981), 79–92; S. Gardner, 'The nave galleries of Durham Cathedral', *Art Bulletin*, 64 (1982), 564–79; E. Cambridge, *Lindisfarne Priory and Holy Island* (English Heritage, 1988).

23. See E. Fernie, 'The spiral piers of Durham Cathedral', *Medieval Art and Architecture at Durham Cathedral* (Transactions of the annual conference of the British Archaeological Association, 1977), 1980, ed. P. Draper, 49–58, and especially 49 for the exceptional zigzag in the south arm of the transept; *idem.*, 'The Romanesque church of Waltham Abbey', *JBAA*, 138 (1985), 59–66; and *idem.*, 'The Romanesque churches of Dunfermline Abbey', *Medieval Art and Architecture in the Diocese of St Andrews* (Transactions of the annual conference of the British Archaeological Association, 1986), ed. J. Higgitt, 1994, 25–37.

24. Hodges (1893), x–xi, reports the existence in the upper part of the lantern of a triangular-headed window. Similar arches existed in the Romanesque fabric of St Paul's Cathedral, and the examples in the galleries of Dunfermline may be part of the 12th-century building. See W. Dugdale, *The History of St Paul's Cathedral* (London 1716), following p. 128.

25. Hodges (1893), IV.

26. For *ad quadratum* and *ad triangulum* see P. Frankl, 'The secret of the medieval masons', *Art Bulletin*, 27 (1945), 55–60, and for Waltham, Fernie, *JBAA* (1985), 66 and 68.

27. Frankl, 'Secret' (1945), passim.

28. Hodges (1893), fold-out plan.

29. E. Fernie 'Reconstructing Edward's Abbey at Westminster', in *Romanesque and Gothic: Essays for George Zarnecki* (Boydell and Brewer, Woodbridge, 1987), 63–7.

Observations on the Romanesque Crossing Tower, Transepts and Nave Aisles of Selby Abbey

By Stuart Harrison and Malcolm Thurlby

INTRODUCTION

The church of Selby Abbey forms a remarkable survival of the great Benedictine monastery to which the town of Selby owes its existence. The abbey was founded in 1069 by Benedict, a monk from Auxerre, who absconded from his own monastery and travelled to Selby, guided it is said by visions of St Germanus. Whatever the truth behind the visions, it is clear that the new abbey was situated on crown lands and soon obtained patronage from William the Conqueror and many of the newly established Norman lords. The early post-Conquest date of its foundation made it the first of the new Norman abbeys in the north, and no doubt the king was quite willing to grant lands to help this early outpost of the Norman church, one which may have helped to secure his grip on the north of England.[1]

The *Historia*, which recounts the foundation and early history of the abbey, tells how Hugh fitz Baldric built timber buildings for the monks, and promoted their cause with the king. Benedict ruled as abbot until 1096/7 when he resigned, disillusioned with life at the abbey. Professor Barry Dobson has suggested that the monks were preparing to migrate to another site in the early 12th century, and that a writ issued by Henry I stopped such intentions. Dobson raised several reasons why such a migration may have been contemplated: the unsuitability of the first site, the lack of substantial endowments after the initial flush of benefactions, and the competition from other monasteries, especially St Mary's Abbey at York. William Rufus proved to be a mixed blessing as a patron of Benedictine monasticism in Yorkshire; he tried to alienate the rights and property of Selby in favour of the archbishop of York, while at the same time patronising St Mary's Abbey at York.[2]

The abbey fortunes were restored by Hugh, the energetic second abbot (1097–1123). It was during his abbacy that work on stone buildings was started on a new site at Selby, and when he resigned in 1123 both church and monastic buildings were sufficiently advanced for occupation. Hugh's work remains today in the drastically altered transepts and crossing, and in the first bays of the nave. Subsequent campaigns completed the nave without western towers in a protracted programme which lasted into the early 13th century.

Following the Dissolution of the monasteries, the abbey church was acquired by the town, a position which was legalised in 1618. The monastic buildings were demolished and the church was probably allowed to fall into a gradual state of decay. The 12th-century crossing had been surmounted by a lantern tower which had been heightened by the addition of a belfry, possibly in the 13th century. This tower fell in 1690, largely destroying the south transept and damaging the south aisle of the presbytery. Such a disaster might easily have led to the abandonment of either the nave or presbytery, but remarkably the crossing was rebuilt in a style so close to the original that its partial rebuilding is not apparent to the casual observer. In 1702 work on rebuilding the tower with a new belfry was still in progress.[3] The tower was deemed to be in ruinous condition in 1902 and it was resolved that the belfry should be removed.[4] The tower had been underpinned by 1907, and on April 18 1908, it was reported that the contracts for the present tower were signed and that construction would be finished in about fifteen months.[5] Prior to this, restoration work

was done in 1871–3 under the direction of Sir George Gilbert Scott, and again in 1890–1 under J. Oldrid Scott.[6] In 1893 it was reported that the west front was showing serious signs of subsidence.[7] On 19 October 1906 the abbey was gutted by fire.[8] Restoration work was taken in hand immediately, again under J. Oldrid Scott, and was completed in 1909.[9] Work continued on the tower and, in 1911, on the rebuilding of the south transept, which had been ruinous since 1690.[10] The south transept was completed in 1912.[11] In 1935 the superstructure of the western towers was built.[12]

THE PRESBYTERY AND TRANSEPTS

The Romanesque presbytery was swept away in a late 13th-century rebuilding, but excavations in the 19th century revealed some of its details.[13] The footings of the old east end were discovered just east of the second pair of piers of the later presbytery. There was a thick east wall against which the excavators discovered part of the much thinner wall of the apse.[14] The east wall was traced far enough on the south side to establish that the aisle walls were square externally, but the form of the internal terminations was not determined. The proportions of the choir and its aisles suggest that it was divided into three bays which would allow for groin-vaults of square plan in the aisles, with square rather than apsidal east walls. Further excavations were made which revealed the northern springing for the south transept chapel. The north respond of the entrance arch to this chapel survived the fall of the tower and was incorporated in the 1911–12 rebuilding of the transept. On the west side of the transept the arch into the nave aisle survives and above this, close to the crossing pier, is part of the triforium (Pl. VIB). The heavy soffit roll and smaller semi-circular roll of the second order of the arch from the south transept to the south nave aisle are closely paralleled on the east face of the western crossing arch at Blyth Priory, after 1088, whilst the rolls of the second order are also found on the apse at Lastingham (1078–85). The triforium consists of a single respond base, shaft and cushion capital with the springing of a plain sub-arch and part of a large, unmoulded arch which springs from the continuation of the quirked chamfered abacus of the sub-arch capital, and would have enclosed two sub-arches. This design is much tighter than the sub-arcuated Romanesque gallery openings in the second bay of the nave, and projection of the remaining arc indicates that the whole arch was only about 2.2 m in width (Pls VIB and VII). Behind this masonry in the nave south gallery is a blocked round-headed opening which gave access to a triforium passage in the south transept.

The north transept retains far more original masonry than its southern counterpart, though much altered by the insertion of later arches and windows. The east wall has a pair of 14th-century arches which give access to the presbytery north aisle and the Lathom Chapel, the latter founded in 1476. To the north is a narrow Romanesque blind arch. Above the arcade the bays are separated by thin clusters of 14th-century triple shafts. The large clerestory windows have curvilinear tracery and a wall passage at their base. The whole design follows on from that of the rebuilt presbytery. At the edges of the east wall enough Romanesque masonry has survived to indicate the original horizontal divisions of the elevation. This is best seen at the north end where a later triple shaft marks the junction of the Romanesque and Decorated work (Pl. VIc). The base of the Romanesque triforium is marked by a slight set-back three courses below the present clerestory string-course, and a hole in the wall in which there is a Romanesque moulded base and shaft. Above is a chamfered string-course — the fourth course above the corbel of northernmost Gothic triple shaft — which marks the springing level of the triforium arches, and adjacent to the later wall shaft there are three voussoirs of the triforium arch. Above is another chamfered

string-course which defines the base of the clerestory. The springing of the clerestory arcade is marked by the next chamfered string-course and two voussoirs against the Gothic wallshaft.

The surviving strip of Romanesque masonry at the south end of the east wall is much narrower than at the north end but it still shows the springing of the original arch to the presbytery north aisle, the offset at the base of the triforium, and the string-course at the springing of the triforium arcade. These are all at a slightly lower level than the corresponding features at the north end because of settlement in the adjoining crossing pier.

The west wall of the north transept has the arch to the north nave aisle, altered from its original form, then a large plain round-headed arch in which there is an offset round-headed window, and finally a narrow blind round-headed arch. As on the east wall, the original triforium and clerestory have been replaced in the Decorated remodelling, but the Romanesque levels are preserved on a short section of the west wall adjacent to the north-west stairvice. The evidence here corroborates that on the east wall. Below and to the north of the corbel that supports the northernmost Gothic shafts at the end of the Gothic clerestory string is the set-off of the Romanesque triforium, the level of which is confirmed by the passage from the north-west stairvice and the sill of the refaced block arch to the passage across the terminal wall. The sixth course above the triforium set-off is the string of the Romanesque triforium-arch springer. This level is confirmed by the shaft and incised scalloped capital of the sub-arch of the west triforium just inside the entrance from the stairvice to the later clerestory passage. In a further eight courses there projects the Romanesque clerestory string and after six more the clerestory arch string. The level of the clerestory is also represented by a blocked opening from north-west stairvice.

The terminal wall of the north transept has been largely cut back for a 14th-century window which was subsequently replaced by the present one in the 15th century. The masonry below the windowsill is Romanesque and retains a string-course of that date. This indicates that the lowest tier of Romanesque windows was set at this level which corresponds with that of the single surviving Romanesque window in the west wall. Externally and internally the north wall is divided by a central pilaster which suggests that it was vertically sub-divided and therefore had two windows per level, as in the transept terminal walls at Winchester Cathedral, Ely Cathedral and Southwell Minster. The pilaster buttresses may have been joined at the top by blind arches in a similar manner to those in the east and west walls.

The original north-transept apse was demolished in the Decorated remodelling, although part of a rubble footing in the floor may mark the start of the Romanesque apsidal chapel. A section of the external wall of the Romanesque transept which is articulated with a tall, narrow blind arch, is enclosed within the chapel. The masonry is largely modern and replaced the original, it seems accurately, after the 1906 fire.[15] Above the roof of the Lathom Chapel there are the extreme north and south sections of the Romanesque string-course at the base of the clerestory, and single corbels which mark the top of the Romanesque wall (Pl. VID). As on the interior, the southern section of the clerestory string is slightly lower than its northern counterpart because of the settlement of the crossing tower. Below the southern section of string-course there are two angled flashlines which mark the Romanesque and a subsequent aisle roof. Their position shows that there could never have been windows to a Romanesque gallery in the presbytery and that the present presbytery north wall was built to the north of its predecessor. At the north end of the Romanesque clerestory there is a jamb and the northern half of a round-headed clerestory arch.

The exterior west wall of the north transept has a tall, narrow blind arch at the north end which is separated by a pilaster buttress from a larger arch which frames the round-headed

FIG. 1. Selby Abbey,
reconstruction, N transept
interior, E side

FIG. 2. Selby Abbey,
reconstruction, N transept
interior, W side

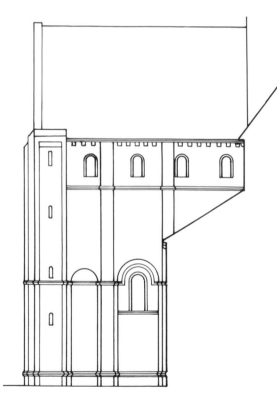

FIG. 3. Selby Abbey, reconstruction,
N transept exterior, E side

FIG. 4. Selby Abbey, reconstruction,
N transept exterior, W side

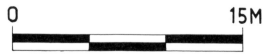

0 15M

window (Pl. VA). There is a chamfered string-course at the base of the window, and at the springing level a string-course with billet ornament which is arched over the window head. This string-course continues around the corner buttress on to the north wall where it is interrupted by the Perpendicular window. It reappears on the north-east buttress and continues along the east wall. At the north end of the west wall, against the stair-turret buttress, the bottom and top of the Romanesque clerestory are marked respectively by a chamfered string-course and a chamfered offset. At the south end the original junction with the nave clerestory survives and the short stub of the remaining wall has a corbel and eaves moulding.

The evidence of the Romanesque fabric in the north and south transepts indicates that they were similar in design and that whilst the north was extensively remodelled, the south retained more of its original features intact until the 1690 fall of the tower. Both transepts had triforium passages in their west walls and in the north transept this was carried around the north and east walls. The evidence for the form of the triforium arches in the south transept shows that they were not very wide and the similar, but less extensive, evidence in the north transept shows that the arches there would have been of similar proportions. Four such arches could have been accommodated in the east and west walls with only the third from the crossing being aligned with the arches below. The surviving lower walling shows that it is unlikely that any vertical bay division was employed, and the abacus which is continued as a string-course suggests that the arches were linked (Figs 1–4).

The lack of coordination between the rhythm of the triforium bays and those below is paralleled in principle, if not exactly, elsewhere in British Romanesque architecture. At Southwell Minster two windows in the west wall at both ground and triforium level face respectively the single arch to the chapel and a three-bay, tall arched triforium on the east wall. In the south transept at Hereford Cathedral there is neither vertical continuity nor close correspondence between the east and west elevations, and the same is true of Kirkwall Cathedral.[16]

In contrast to the uncoordinated ground and triforium bays, the surviving half arch on the exterior of the north transept east clerestory aligns with the position of the triforium arch below and indicates that they were purposely set together in formal bays. This demonstrates that the jamb belongs to a window and not, as Hodges suggested, the outer arch of a triplet in which the central one was pierced as a window.[17] The suggestion of a window is confirmed by the internal-arch springing which is concentric with it. The formal bay arrangement of the triforium arches matched with the clerestory windows directly above would allow for four windows, and it is surely more than coincidence that during the Decorated remodelling each side of the clerestory was robbed back to a line which coincides with the projected edge of each outer window. Internally the windows may have been linked in a continuous arcade, but the surviving string-course at the arcade springing is clearly an extension of the abacus from a jamb capital and indicates that, like the triforium, the windows were linked by a chamfered string-course.

The surviving sections of the Romanesque triforium and clerestory show distinctly plain forms — like the nave gallery and clerestory at Blyth Priory — which contrasts markedly with the eastern bays of the nave. The transepts were never intended to be vaulted, and the presence of a blocked doorway from the central tower into the north transept roof space shows that the transepts had flat ceilings.

THE CROSSING TOWER

After the collapse of the tower in 1690 the south-east crossing pier had to be completely replaced. The surviving original piers have a typical Romanesque form, distinctly elongated

on the east–west axis. The east and west faces have simple pilaster responds with shafts on the angles with scalloped or volute capitals. The north and south responds feature a similar pilaster which is corbelled at a high level. The pilasters are each supported by three corbels which are either moulded or carved with grotesque masks. The profile of the tower arches reflects that of the supporting pilasters on the soffit and inner orders, whilst the outer orders have chevron towards the crossing. The east crossing arch is rebuilt as is the southern one, except for the first six chevroned voussoirs from its western springing; the rebuilt sections have plain voussoirs. The north and west crossing arches survived the collapse of the tower and retain their original 12th-century masonry intact.

The crossing is now enclosed by a flat panelled timber ceiling which hides from view the Romanesque lantern stage of the tower, and forms the floor of the belfry ringing chamber. In this room can be seen the surviving sections of the north and west sides of the 12th-century lantern stage of the tower (Pl. XA).

Whilst the collapsed tower arches and the exterior of the tower were rebuilt as reasonably close copies of the surviving masonry, the interior above the crossing ceiling was rebuilt

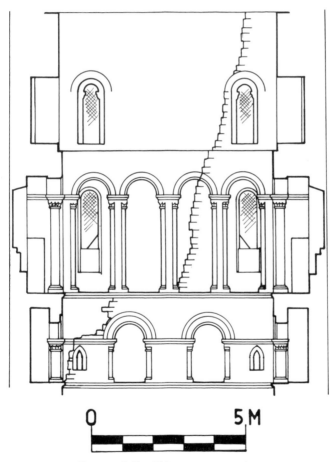

FIG. 5. Selby Abbey, reconstruction,
Romanesque lantern tower

with a brick facing to the rubble-cored wall. This use of brick internal facing clearly shows how much of the original tower survived the collapse. The north-west corner retains the spiral staircase which gave access to various levels of the tower, and this stands intact to the top of the Romanesque section. Flanking this staircase in the upper stage, one original window in both the north and west faces of the tower survives. Similarly in the lantern stage below, one window survives in each face. Unlike the windows of the upper stage, which are pierced through the solid wall, the lantern windows are fronted by an arcaded wall passage of which there remains one arch and the respond for the next in each face, though much restored. Indeed, all the masonry at this level has been heavily restored, possibly during the 1908–9 rebuilding of the upper stage of the tower. However, care has been taken to leave intact small sections of the original masonry in several places, such as part of a simple leaf capital in the north arcade of the lantern and a base in the west arcade of the gallery. The remains are sufficiently complete to show that the lantern originally comprised four open arches on each face, with a wall passage all round the tower (Fig. 5). Each outer arch was pierced at the back with a window which was set off-centre to the front arcade. This was in order to clear the steeply pitched Romanesque roofs which in fact partially cut across the sill of each window. Below the lantern is a gallery consisting of a pair of round-headed arches which have simple, unmoulded arch heads supported by engaged shafts and are linked by a continuous chamfered string-course which forms the abacus to the shaft capitals. These openings gave light to a passage in the thickness of the wall which must have passed around all four sides of the tower. Subsequently, small openings with monolithic pointed heads have been pierced through the passage wall flanking the original openings, possibly in an effort to admit additional light.[18]

The amount of 12th-century masonry which survived the collapse of the tower was relatively small and the decision to retain it during the rebuilding must have been largely motivated by the survival of the stair-turret at the north-west corner. This would have stood like a finger pointing skywards, buttressed by the surviving fragments of the west and north faces of the tower. Stabilising the surviving sections and building back up to these original walls cannot have been an easy task, and we must be thankful for the sympathetic way in which the reconstruction was undertaken.

English Romanesque lantern towers are relatively rare survivals, but Selby belongs to the type with two superposed passages derived from St Etienne at Caen, of which allied examples survive in England at St Albans Abbey, Norwich Cathedral, Romsey Abbey and Southwell Minster.[19] The articulation of the arcade of the first passage at Selby reads as a composite of St Albans and Southwell (Fig. 5). As at Southwell there are two arches on each side as opposed to three sub-divided arches at St Albans. But Selby lacks the rich decoration of the Southwell arches and in this regard is closer to St Albans with which it also shares the continuous string-course at the springing point of the arches. The second passage at St Albans opens to the interior through two plain, round-headed arches in the manner of St Etienne at Caen, whilst the windows at this level at St Albans were originally roundels.[20] The Selby design is more open with a continuous arcade inside and large round-headed windows set to either side of the nave and transept roofs. The latter feature is also found at Southwell, but there and at Winchester the apertures are much smaller. It is also significant that the basic format of the Selby lantern tower with the two superposed wall passages is repeated in the early Gothic one at Ripon Minster.[21] There the first passage is fronted with two pairs of plain pointed arches. In the lantern round-headed windows are set in the outer bays of the three-arched arcade which fronted the wall passage. The original belfry stage above the lantern at Ripon was removed within fifty years of its completion due to its unstable condition.[22]

THE CROSSING

Little is known of the 12th-century liturgical arrangements of Selby Abbey, but certain clues remain to give an indication of what must have formerly existed. The design of the crossing piers, in which the eastern and western arches are carried on corbelled responds, suggests that the choir stalls were located in the crossing area. This accords with the termination of the first campaign of construction at the second bay of the nave. Professor Fernie has pointed out the evidence for a screen across the nave between the second pair of piers, and this must surely account for the unusual position of the cloister doorway in the second bay of the south nave aisle.[23] Presumably it was so positioned to give direct access into the space between the rood screen and the pulpitum between the first pair of piers at the entrance to the choir. The corbelling of the eastern crossing piers indicates that the upper choir entrances must have been east of the crossing.

The lantern tower above the crossing would have increased the light level considerably. It seems likely that the chamber above the lantern was a belfry which would have meant that the bells would have been rung from the ground floor in the area between the stalls. Presumably in the 12th century the bells would have been relatively small and few in number. This arrangement was altered later by the heightening of the tower and the boarding in of the lantern stage to provide a ringing chamber. That the lantern and belfry formed part of the first campaign of building is suggested by the deformation of the junction of the eastern bays of the nave with the tower piers. This is confirmed by the form of the vault in the first bay of the nave north aisle. Here the vault web is raised above the outer order of the main arcade and has its own separate pointed wall arch. This contrasts with the first bay in the south nave aisle in which the vault web hugs the outer order of the main arcade arch and consequently the vault web reflects the same sinking towards the east as the arch (Pls VIIIA and VIIIB). The construction of the wall arch in bay N1 takes account of the deformation of the arcade which indicates that the north-west crossing pier had already sunk significantly by the early 13th century.[24]

Externally the tower presents a plain sombre appearance in its lower stages with the Romanesque windows of the lantern being simply moulded without jamb shafts. The windows of the belfry are more elaborate with jamb shafts and chevron in the arch heads. The staircase in the north-west corner is marked by a pilaster projection which has an engaged shaft in the angle, a feature absent from the other corners but which may have existed before the collapse. The rebuilding was carefully done and the four original windows copied so faithfully that the whole of the lower part of the tower appears to date from the Romanesque period.

THE NAVE

The plinth moulding in the original Romanesque sections of the south transept has a raised projecting course which is chamfered top and bottom in the manner of the plinth courses on the crossing, transept and nave piers at Durham Cathedral (Pls VIB and IXA). It is used at Selby on the original section of the west wall and on the interior of the north transept from the north respond of the arch to the east chapel through the north wall, on to the west wall, and along the north nave aisle wall as far as the break in bay 3. This design is used throughout the south nave aisle wall, which confirms Professor Fernie's observation that this wall belongs to the first phase of construction. It is also used for the crossing piers with the addition of a chamfered base course.

The plinths of the first two nave piers of the south arcade and, with small differences, the third and fourth piers of the south arcade and the first four piers of the north arcade are

different from the Durham-inspired plinths of the crossing piers (Pl. IXA). Their stepped
designs seem to be inspired by Anglo-Saxon models like Stow (Lincolnshire) and Hadstock
(Essex).[25] In this respect they conform to a tradition already established of reviving or
continuing pre-Conquest motifs at Durham, and one that was used and would continue to
be used elsewhere in England.[26]

The aisle responds have a stepped pilaster design with narrow outer sections and a broad
central section. This is ill-suited to the articulation of the transverse and diagonal ribs they
carry; this is especially evident in the respond between bays 1 and 2. The responds were
almost certainly designed for groin-vaults with broad transverse arches. The ribs were
introduced in phase 2. The rib profile in the vaults in the two eastern bays of the south nave
aisle has a simplified version of Durham mouldings which omits the hollow chamfer at the
sides of the rib. The same profile is found at Peterborough Cathedral.[27] At the back of the
incised main-arcade column the ribs are carried on stepped shafts in the manner of the
Durham choir aisles (Pl. IXA).[28] However, the arrangement at Selby is not simply a copy of
Durham, but rather a commentary on the model. At Durham the springers of both the outer
order of the main arcade towards the aisle and the diagonal ribs overlap somewhat. This
lack of clarity in the articulation did not please the Selby Master who therefore placed the
aisle-vault shafts further back on the column so as to better separate the arch moulding from
the rib springers. The profile of the transverse rib with two rolls separated by an angle fillet
continues the central element of the arcade respond and is paralleled in the soffit responds of
the west processional doorway at Durham.[29] It also appears on the east processional
doorway at Dunfermline Abbey, on the south doorway at Brayton (Yorkshire) just south of
Selby, and elsewhere.[30]

There is considerable deformation of the vault in the first bay of the south aisle (Pl. IXB).
This is due in part to the settlement of the tower, but there is also clear rotation on the angle
which has resulted in the skewing of the diagonals. The keystone has been replaced but the
south-east to north-west diagonals do not even come close to meeting. This indicates that
the ribs were not used constructionally; in other words they were not built first to support
the centering for the vault web. Rather, the entire vault was erected as one in the manner of a
groin-vault with the consequent movement.[31] Only the sector to the north and east of the
south-east to north-west rib of the vault is original; the opposite sector was rebuilt in brick
in G. G. Scott's restoration along with all but the two western bays of the south-aisle
vaults.[32] The rebuilt vaults all reuse the medieval ribs of which only those in bays S1 and S2
were completed in the Romanesque build. The others with the flat face and hollow
chamfered ribs with pointed transverse arches go with the early Gothic bays in the nave and
this is true of all the vaults in the north aisle.

The aisle windows were extensively remodelled in the late 13th century and none of the
Romanesque windows now survive. The aisle walls retain the string-courses which marked
the sill and springing level of the original windows. In the south aisle these were set within an
enclosing arch and consequently the window heads would have been concentric with them,
the height of the sills being marked externally by the string-course for the cloister roof. In the
north aisle the windows lack the enclosing arches and externally there is only a single
string-course at the level of the windowsills. The replacement windows have largely
destroyed any trace of the original windows, but in the eastern bay traces of the window
jambs and arch springings can be seen internally and externally. These show that the
windows must have been placed in pairs and may have had an oculus set between their
heads like the transept chapels at Fountains Abbey.[33]

The late 12th- and early 13th-century work in the Selby nave is a classic case of the delight
of English masons in design variations, some subtle, others obvious.[34] To a certain extent

the tradition of this aesthetic was already established in the two Romanesque eastern nave bays at Selby (Pl. VII). The mouldings of bay S2 are more elaborate than in S1; in S2 there are triple rolls separated by fillets in the soffit as opposed to a simple soffit roll in S1; and chevron is used on the outer order of S2 rather than a roll moulding in S1. The mouldings of S2 are repeated in the gallery bays S1 and S2, and N1 and N2. The chamfered chevron is also used on the outer orders of main arcade bays N1 and N2, but here the inner order uses point-to-point chevron. In this variety Selby conforms to an aesthetic that enjoyed considerable popularity in Romanesque England and is well represented in the north by the castle chapel at Newcastle and the north nave arcade at Hornby (North Yorkshire).[35]

The triple rolls with angle fillets presage a moulding which was to enjoy great popularity in early Gothic in the north of England, although whether the link is direct or the result of the external stimulus of northern France is a moot point.[36] In this regard it may be significant that the Selby moulding is close to the soffits of the tower bays in the narthex of Saint-Denis where the capitals of diagonal ribs are set lower than the arch capitals in the same way as on the western tower piers at Durham.[37] Furthermore, the differences among the profiles of the arches in the Saint-Denis narthex demonstrate the same love of variety as at Selby.[38] Is it possible that one of Suger's men was earlier employed in the north of England?[39]

CONCLUSION

Whether or not there is any link between Saint-Denis and Romanesque in the north of England, or even specifically with Selby, the range of detail differences throughout the Selby nave is a testament to the love of aesthetic variety in English architecture. The reconstruction of the earlier phase of work in the transepts and crossing tower illustrates the very different aesthetic, allied to the earlier post-Conquest work at Lastingham and Blyth, before the impact of the rich decoration of Durham Cathedral.

ACKNOWLEDGEMENTS

The authors would like to thank Professor Eric Fernie for kindly giving them the text of his paper on Romanesque Selby, and the vergers at Selby who provided access to the relevant parts of the building.

REFERENCES

SHORTENED TITLES USED

BILLINGS (1843) — R. W. Billings, *Architectural Illustrations and Description of the Cathedral Church at Durham*, London.

BILSON (1899) — J. Bilson, 'The Beginnings of Gothic Architecture, II, Norman Vaulting in England', *RIBA Journal*, VI, 289–326.

BILSON (1922), — J. Bilson, 'Durham Cathedral; the chronology of its vaults', *Archaeological Journal*, LXXIX, 101–60.

BONY (1939) — J. Bony, 'La technique normande du mur épais à l'epoque romane', *Bulletin Monumental*, XCVIII, 153–88.

BONY (1981) — J. Bony, 'Durham et la tradition saxonne', *Etudes d'art mediévales offertes à Louis Grodecki*, Paris, 79–85.

COBB (1980) — G. Cobb, *English Cathedrals: The Forgotten Centuries*, London.

CROSBY (1987) — S. Mck. Crosby, *The Royal Abbey of Saint-Denis from Its Beginnings to the Death of Suger*, 475–1151, New Haven and London.

DOBSON (1969) — R. B. Dobson, 'The First Norman Abbey in Northern England', *Ampleforth Journal*, LXXIV, Pt II, 161–76.

FERGUSSON (1984) — P. Fergusson, *Architecture of Solitude: Cistercian Abbeys in Twelfth-Century England*, Princeton.

FERNIE (1983) — E. Fernie, 'The Respond and the Dating of St Botolph's, Hadstock', *JBAA*, CXXXVI, 62–73.

FERNIE (1986) — E. Fernie, 'The Effect of the Conquest on Norman Architectural Patronage', *Anglo-Norman Studies*, IX, 71–85.

FOWLER (1893) — J. T. Fowler, *The Coucher Book of Selby. Yorkshire Archaeological and Topographical Association: Records Series*, 13.

HEARN (1983) — M. F. Hearn, *Ripon Minster: The Beginning of the Gothic Style in Northern England*, *Transactions of the American Philosophical Society*, 73, Pt 6.

HODGES (1893) — C. C. Hodges, 'The Architectural History of Selby Abbey', *Yorkshire Archaeological and Topographical Association: Records Series*, 13.

HOEY (1986a) — L. Hoey, 'Pier Alteration in Early English Gothic Architecture', *JBAA*, CXXXIX, 45–67.

HOEY (1986b) — L. Hoey, 'The 13th-Century Transepts of York Minster', *Gesta*, XXV/2, 227–44.

HOEY — L. Hoey, 'Piers Versus Vault Shafts in Early English Gothic Architecture', *Journal of the Society of Architectural Historians*, XLVI, 241–64.

JAMES (1983) — J. James, 'The Rib Vaults of Durham Cathedral', *Gesta*, XXII/2, 135–45.

JAMES (1993) — J. James, 'Multiple Contracting in the Saint-Denis Chevet', *Gesta*, XXXII/1, 40–58.

MACGIBBON and ROSS (1896) — D. MacGibbon and T. Ross, *The Ecclesiastical Architecture of Scotland*, 1. Edinburgh.

SCOTT (1871) — G. G. Scott, *The Restoration of Selby Abbey Church*, Selby.

SCOTT (1912) — W. H. Scott, *The Story of Selby Abbey*.

THURLBY (1993a) — M. Thurlby, 'The Building of the Cathedral: the Romanesque and Early Gothic Fabric', in *Durham Cathedral: A Celebration*, ed. Douglas Peacock, Durham, 15–35.

THURLBY (1993b) — M. Thurlby, 'The purpose of the rib in the Romanesque vaults of Durham Cathedral', in *Engineering a Cathedral*, ed. M. J. Jackson, London, 64–76.

THURLBY — M. Thurlby, 'Hereford Cathedral: the Romanesque Fabric', *BAA CT*. forthcoming.

THURLBY and KUSABA (1991) — M. Thurlby and Y. Kusaba, 'The Nave of Saint Andrew at Steyning: A Study of variety in design in Twelfth-Century Architecture in Britain', *Gesta*, XXX/2, 163–75.

VAN XANTEN, (1965) — D. T. Van Xanten, 'The Romanesque Church of St Albans', *Gesta*, IV, 23–7.

REFERENCES

1. Fowler (1893); Dobson (1969).

2. Dobson (1969), 173–4.

3. Hodges (1893), XXXII–XXXIII. The 18th-century belfry is illustrated in *The Builder*, XCI (1906), opp. 514; and Cobb (1980), 70–1.

4. *The Builder*, LXXXII (1902), 118, 403–4. On the pulling down of the tower, see Professor Fernie's paper above, note 10. On the state of the tower after the 1906 fire, *The Builder*, XCI (1906), 509.

5. Ibid., XCIII (1907), 448; ibid., XCIV (1908), 458.

6. Scott (1871); J. Oldrid Scott, 'Quotations from Report on the state of the building', *The Builder*, LVIII (January 4 1890), 9–10; 'Restoration Progress', ibid., LX (21 February 1891), 37, 154.

7. Ibid., LXV (30 September 1893), 240.

8. Ibid., XCI (27 October 1906), 475, 485–6.

9. Ibid., 502, 509, 532, 561–2, 577–8, 610; ibid., XCII (1907), 71, 512; ibid., XCIII (1907), 448, 709; ibid., XCIV (1908), 458; ibid., XCV (1908), 598; ibid., XCVI (1909), 767.

10. Ibid., XCVIII (1910), 619; ibid., C (1911), 215, 347.

11. Ibid., CIII (1912), 347.

12. Cobb (1980), 71.

13. Hodges (1893) provides a commentary on what was seen in the excavations and indicated on his plan the extent of the walling which was actually found. The excavation was undertaken during J. Oldrid Scott's restoration of the presbytery in 1890–1 ['Selby Abbey', *The Builder*, LXX (1896), 1–4, plan between 22 and 23]. Scott (1912), 44.

14. On the reconstruction of a low apse, see Professor Fernie's paper above.

15. The fire of 1906 apparently started in the Lathom Chapel and the stonework must have been heavily calcined which led to its subsequent replacement. The sensitive nature of the restoration is apparent in the replacement of capitals of 14th-century date which have been left uncarved. This treatment was also applied to the replacement of the Romanesque string-courses which lacks the billet moulding of the original.

16. On Hereford south transept, see *RCHM Herefordshire, I, South-West* (London 1931), 98–9, Pl. 112; Thurlby, 'Hereford'; on Kirkwall, see MacGibbon and Ross (1896), 259–92, Figs 227 and 235.

17. Hodges (1893), IX.
18. Hodges (1893), X, erroneously describes these arches as triangular.
19. Bony (1939), 164–5, Fig. 3. The St Albans crossing tower is discussed by Van Xanten (1965). The Daniel King engraving (1655) of Selby Abbey from the north is the only illustration of the crossing tower before the fall (Cobb (1980), 70).
20. Van Xanten (1965), 23–4, Pl. 8.
21. The Ripon lantern tower is illustrated in Hearn (1983), Pl. 30.
22. Stuart Harrison and Paul Barker, 'Ripon Minster: Its 12th-Century Form', forthcoming.
23. See Professor Fernie's paper above.
24. The treatment of the nave clerestory eaves parapets shows that stubs were built against the tower which ranged with those of the transepts. When the clerestory was completed these were extended and then carefully stepped up to heighten the clerestory and compensate for the settlement of the tower.
25. On Hadstock and Stow, see Fernie (1983).
26. Bony (1981); Thurlby (1993a), 21; Fernie (1986), 72–7.
27. Bilson (1899), 302–5.
28. Bilson (1922); Thurlby (1993b).
29. Billings (1843), Pl. XXXIX.
30. The Dunfermline east processional doorway is illustrated in the *Royal Commission on Ancient and Historical Monuments of Scotland, Counties of Fife, Kinross and Clackmannan* (Edinburgh 1933), Figs 218, 220–21.
31. James (1983), 139; Thurlby (1993b), 68–9.
32. Hodges (1893), XXXIII, reports that the vaulting over the six western bays of the south aisle was rebuilt. This does not accord with the evidence of the fabric above the vault.
33. The Fountains transept chapels are illustrated in Fergusson (1984), Pl. 12.
34. Pioneering studies have been made by Lawrence Hoey (1986a); (1986b), esp. 233–4; (1987).
35. Thurlby and Kusaba (1991).
36. For instance the early Gothic version of this moulding at Byland Abbey is often compared with Bellefontaine (Oise) [Fergusson (1984), Pls 70 and 94].
37. Bilson (1922), 141, Pl. IX 2; Crosby (1987), Figs 56, 57a and c.
38. Crosby (1987), 147, remarks that 'The differences among the profiles of these arches not only reflect the Saint-Denis masons' predilections for variety in visual effects but also are significant to the total effect of the different bays'.
39. John James has observed certain features in the Saint-Denis east end vaults which have more in common with English rib-vaults than those in the Paris Basin, and further that the mason who designed the rib-vaults in Suger's east end may have earlier worked in the vestibule of the chapter house at St Augustine's, Bristol [James (1993), 57, n55]. Although he may be at pains to establish these connections firmly — not least with St Augustine's, Bristol which was only founded in 1140 (Arthur Sabin, 'The Foundations of the Abbey of St Augustine at Bristol', *Transactions of the Bristol and Gloucestershire Archaeological Society*, LXXV (1956), 35–42) — they do highlight the potential importance of links between England and Saint-Denis.

E

Some Design Aspects of Kirkstall Abbey

By Malcolm Thurlby

INTRODUCTION

In 1147 twelve monks and ten lay brothers were sent out from Fountains under Abbot Alexander to found a daughter house at Barnoldswick which was to be built under the patronage of Henry de Lacy.[1] This settlement was unsuccessful and in 1152 the convent moved to Kirkstall where Alexander erected a church (basilica) and arranged humble offices according to the order.[2] Henry de Lacy's patronage was generous. He 'stood by [Abbot Alexander] now providing the fruits of harvest, now supplying money as the needs of the establishment required. He had part in providing the buildings, laid with his hand the foundations of the church, and himself completed the whole fabric at his own cost'.[3]

Construction of the present church probably started in, or soon after 1152. The 1159 gift of one mark for clothing for the abbot and a half mark for the purchase of oil for the sanctuary lamp probably indicates that the presbytery was completed.[4] The church was finished by 1177, the year of Henry de Lacy's death, and by the death of Abbot Alexander in 1182 all 'the buildings of Kirkstall were erected of stone and wood brought there, that is, the church and either refectory, the cloister, and the chapter and other offices necessary within the abbey, and all these covered excellently with tiles'.[5]

It is not surprising that the design of the church at Kirkstall owes much to Fountains (Fig. 1). The square-ended, aisleless presbytery, the use of three chapels with pointed barrel vaults off each transept, and the two-storey nave elevation, are all similar. However, the two churches are distinct in their proportion and massing and in architectural detailing.[6]

The 'Architectural Description of Kirkstall Abbey' by W. H. St John Hope and John Bilson published in 1907 still forms the basis for all research on the fabric.[7] Their study is in the form of two separate essays: St John Hope presents the history of the abbey and a detailed description of the church and the monastic buildings[8] and Bilson then places the fabric in the context of Cistercian architecture and emphasises the importance of Anglo-Norman antecedents for the design details.[9] It is this British Romanesque tradition that I wish to elaborate upon in this paper with particular reference to the following:

1. the lack of correspondence between the external and internal bay rhythm of the presbytery
2. the form of the crossing piers and arches
3. early English Romanesque survival/revival in:
 a) the crossing arches, transept chapel entrance arches, and the doorways to the church
 b) interlaced ornament
 c) the nave piers
4. the chapter house piers and ribs
5. the vaults: groins versus ribs

THE DESIGN OF THE PRESBYTERY

Externally the lateral walls of the Kirkstall presbytery are divided into three unequal bays by pilaster buttresses (Fig. 1, Pl. XB). This division is not adopted inside the presbytery; instead there are two quadripartite rib vaults of square plan plus a narrow barrel-vaulted bay at the

KIRKSTALL

FIG. 1. Kirkstall Abbey, plan (after Bilson)

west end (Fig. 1, Pl. XIA). This discrepancy between the internal and external bay rhythm
has been taken to suggest a change in plan. For Pevsner it was 'an indication perhaps that ...
the rib-vaulting had not yet been decided on when building started'.[10] Fergusson went
further in proposing that the original plan was for a barrel vault in the presbytery which was
then modified to the present scheme in a second campaign.[11] John Bilson found the design to
be 'curious' but at the same time he provided a plausible explanation for the placement of
the pilaster buttresses. He considered that 'The position of the westernmost buttress on each
side appears to have been determined by the east wall of the transept chapels, from the top of
which it rises, and the wall between the chapel and the buttress at the angle of the presbytery
is divided equally by the other buttress'.[12] The pilaster buttresses were therefore incorpor-
ated for aesthetic rather than for structural reasons. Quite apart from the desire to articulate
the junction of the presbytery and the transept chapels, the master mason was also
concerned to punctuate the presbytery wall next to the window. The articulation of
windows as separate bays on the exterior remains consistent throughout the church. That is
particularly evident on the south and east faces of the crossing tower. On both faces a
narrow central doorway, which originally gave access to the roof space, is flanked by a
single round-headed window. The separation between each of these arched openings is then

emphasised by a pilaster.[13] Similarly in the north and south walls of the transepts, the tripartite division of the windows is emphasised by pilaster buttresses.[14]

The transepts at Kirkstall are not vaulted and consequently they are of no help in considering this aspect of the presbytery. Attention must therefore turn to an analogous vaulted structure and here the original west bay of the presbytery and the south transept of Lindisfarne Priory are most relevant.[15] The west bay of the presbytery at Lindisfarne is covered with a quadripartite rib-vault, and yet because this bay contains two windows in the north and south walls the exterior is correspondingly subdivided. In other words there is a division on the exterior which is not reflected inside the presbytery. The south transept is similarly covered with a quadripartite rib-vault, but again on the exterior of the east wall there is an intermediate pilaster buttress. The position of this pilaster is determined by the junction of the south wall of the apsidal transept chapel in just the same way as the westernmost buttress in the Kirkstall presbytery is aligned with the transept chapel east wall (Pl. XB). In Romanesque architecture in northern England this use of the pilaster buttress as an aesthetic element, rather than a structural one, is emphasised with reference to the choir clerestory at Durham Cathedral. There pilasters are only used in alternate bays in spite of the fact that there was a springer of the original high rib vault in each bay.[16]

Fergusson's case for the intention to barrel vault the presbytery at Kirkstall rests on the great thickness of the side walls. Such reasoning is not altogether compelling; the substantial wall thickness simply indicates that there was an intention to vault from the first. The master mason demonstrated admirable caution in building walls that would be thick enough to ensure adequate support for the high vault.

Although the vault corbels and capitals do not course consistently with the walls, perhaps consistency should not be expected in such instances (Pl. XIB). Capitals and corbels frequently differ in height from regular masonry courses. Irregularities in coursing are therefore bound to occur.[17] This is certainly the case in the nave aisles, the chapter houses and parlour where vaults were planned from the first.[18] There is no reason to suspect that the presbytery was any different.

Corbels supporting rib vaults and vault shafts have a good pedigree in northern Britain.[19] They first occur on the west wall of the north transept of Durham Cathedral and are subsequently used in the south transept, nave and chapter house of that cathedral.[20] Under the influence of Durham, corbels support the ribs in the presbytery, crossing and transepts of Lindisfarne Priory.[21] Similarly, the design of the Durham chapter house vault responds influenced the aisle responds of the Rievaulx chapter house. At Rievaulx the transverse rib is carried on a capital atop a monolith carved in the form of a pilaster with an attached shaft, while the ogives are carried on corbelled capitals.[22] Here it is significant that the multi scalloped capitals are close to those at Kirkstall.[23] Also within a Cistercian context, the responds for the nave aisle transverse arches at Fountains Abbey are in the form of corbels.[24] And more closely related to the stepped plan of the Kirkstall corbels are those in the east guest house at Fountains.[25]

Fergusson maintained that changes other than the vault design differentiate the first and second phase of building. He suggests that the first campaign 'involved the construction of most of the choir, and the lower parts of the east transept chapels and flanking transept'.[26] In the second campaign he claims that 'the nave was widened by four feet, new vaults were built over the presbytery, and a crossing tower was introduced and raised'.[27] This sequence is open to a different interpretation. On the relative thickness of the presbytery and nave walls it is of paramount importance that the presbytery is vaulted while the nave is wood-roofed (Fig. 1). Given that a high vault was never planned for the nave, the nave walls were constructed two feet thinner than in the presbytery. The outer plane of the nave wall is

in line with the outer plane of the presbytery wall. It follows that the inner plane of the nave walls will each stand two feet outside the inner plane of the presbytery walls. Therefore the nave will be four feet wider than the presbytery. Clearly we are just dealing with the matter of having one section of the structure vaulted and the other wood-roofed rather than a change in plan. Moreover, Kirkstall is not unique among Cistercian churches in having presbytery walls thicker than those in the nave. The phenomenon is paralleled in Tintern II, and in this case it seems likely that the presbytery would have been vaulted.[28]

THE CROSSING

Contrary to Fergusson's claim that the crossing tower belongs to a second campaign of construction, it seems likely that it was planned from the first. Fergusson tells us that 'In the lower portions of the pier abutting the choir and transept chapel the cutting and coursing is somewhat irregular, while in the grouped attached shafts which stand in front of these portions they are regular'. He continues, 'In addition, the base moulding of the attached shaft just inside the presbytery is chopped back at the front face to allow for the insertion of the attached shafts. Higher up, changes in the string-courses and in the scalloped design of the capitals likewise bear witness to the changes made in this second campaign. Taken together these show that the attached shafts on the west face of both east crossing piers were applied as strengtheners for a crossing tower which was planned only after a fairly substantial amount of building had been carried forward on the presbytery'.[29] Although Fergusson concludes that the attached shafts on the west face of both eastern crossing piers were added to the original fabric, his description applies only to the north-east crossing pier. Turning to the south-east pier, the grouped shafts of the east respond of the south crossing arch course consistently with the core of the pier. Indeed, the coursing is consistent from the north respond of the north chapel of the south transept through to the presbytery side of the pier.[30] At this point there are differences for four courses above the plinth. These seem to result from the insertion of the credence (Pl. XIIA). Above this there are several stepped stones which may at first suggest a break in construction. However, examination of the internal south-east angle of the presbytery below the first string-course reveals a similar lack of coursing, but because the plinth continues uninterrupted through this angle we must conclude that there is no break in construction. By analogy, the same conclusion must be drawn for the south-east crossing pier. The same is also true for the north-east pier. There the irregularities are only on the west face and then only for seven courses above the plinth and in the eleventh course (Pl. XIIB). As for the plinth, it is not cut back as Fergusson suggests; rather it is stepped back so as to differentiate between the articulation of the outer order of the east crossing arch and the orders of the north crossing arch.[31] At the same time it steps down to correspond with the one step down in floor level from the presbytery to the transept.

The question of differentiation in articulation leads to the consideration of the narrow barrel vault at the west end of the presbytery (Pl. XIA). Initially it may seem rather unusual, but upon closer examination it shows the Kirkstall Master to be most sensitive towards the placement of arch mouldings. The mouldings of the east crossing arch are concentrated on the face of the arch with just a single roll at the eastern extremity of the narrow barrel. This contrasts with the north and south crossing arches in which emphasis is placed on the stepped mouldings of the soffit. The west crossing arch has both the soffit and outer orders moulded. The distance between the east and west mouldings of the east crossing arch is the same as the thickness of the other crossing arches which in turn is the same as the walls of the crossing tower. The difference in the placement of the mouldings is therefore to be explained

by the desire to elaborate the face of the entrance arch to the presbytery. By contrast, the mouldings of the north and south crossing arches are intended to carry the eye through from the nave to the presbytery arch.

THE INFLUENCE OF EARLY ROMANESQUE DETAILS

Jamb and arch design

It is significant that in designing the arches from the transepts to the nave aisles the master mason employed an analogous solution to the one adopted for the east crossing arch (Pl. XIIIA). This made use of the shaft for the support of the main mouldings of the soffit, while the secondary roll towards the bay is carried on a multi-scalloped corbel in just the same way as in the east crossing arch.

The responds of the transept chapel entrance arches and the north and south crossing arches follow the same design. In each case the profile of the jamb is continued above the capital in the moulding of the arch (Pl. XIA). The same principle, although with different details, is applied to the inner orders of the east and west processional doorways and the north and west nave doorways.[32] The profile of the latter with two rolls separated by an angle fillet is very interesting with regard to the northern Romanesque tradition. It appears in the west processional doorway at Durham Cathedral, on the back of the first pier of the south nave arcade at Selby Abbey, and is popular in Yorkshire doorways.[33] However, the principle of the same profile being used for the soffit and the inner order of the jambs may be traced back to an earlier Romanesque tradition in England of which the chancel arch at Wittering (Northamptonshire) is a good example.[34] I would not make quite so much of this early Romanesque analogy were it not for other details at Kirkstall that seem to hark back to a pre-Conquest tradition. The inclusion of interlacing ornament on some capitals, bases, a corbel and the piscina is well-known.[35] Whether or not it directly refers to a pre-Conquest source is a moot point, but there can be no doubt that it conforms to a pre-Conquest tradition.[36] The display of mouldings on the face of the eastern crossing arch coupled with the single roll framing the recessed soffit is allied to the crossing arches at Stow (Lincolnshire) (Pl. XIA).[37] The hood moulds of the east and west processional doorways and the west doorway continue down past the level of the capitals to frame the jambs.[38] Such an arrangement is common in pre-Conquest doorways, windows and major arches.[39]

The Nave Piers

Most important for our purposes is the design of the first six piers of the nave (Pl. XIIIB). Bilson sees the Kirkstall nave piers in the tradition of the great cylindrical piers of Gloucester, Tewkesbury and Southwell.[40] More immediately he refers to the nave piers at Fountains Abbey which, like Kirkstall, have octagonal capitals.[41] The latter feature once again should be seen in connection with the northern Romanesque tradition developing from the columnar piers in Durham Cathedral.[42] In more recent pier types in the north there is a growing interest in complexity of form with the addition of shafts to the core of the pier. At the back of the Fountains nave piers there are two shafts which flank the transverse arch of the aisle and support the rear order of the main arcade arch. At Louth Park Abbey some of the nave piers had a circular core with four attached shafts.[43] A similar form, albeit with detached rather than coursed subsidiary shafts, is used in the dormitory undercroft at Rievaulx Abbey and this design is related to some of the piers in the crypt of York Minster which was probably commenced soon after Archbishop Roger of Pont l'Eveque took office in 1154.[44] Furthermore, in the York crypt one pair of piers is composed of four lobes each

slightly over a quarter circle with courses shafts on the main axes in between.[45] More directly akin to the Kirkstall piers are the octofoil piers in the southern section of the east guest house at Fountains Abbey.[46] But by far the closest parallels for the Kirkstall nave piers are the mid-11th-century nave and crossing piers at Great Paxton (Huntingdonshire).[47] In both places the piers comprise lobed forms with each lobe separated from the next by an angular fillet or a thin roll. Specifically, at Great Paxton the responds of the east crossing arch use angular fillets between the lobes. By contrast, in the responds of the north and south crossing arches thin rolls divide the lobes. The variety continues in the nave piers with rolls used in the east piers and angular fillets in the west piers. It is just this differentiation between rounded and angular elements that the Kirkstall Master takes up and adapts so playfully. In each of the first four piers of the nave there is an alternation of angular and rounded punctuations between the lobes, but they are not dispersed identically in each case. Instead there is a change from pier 2 to pier 3 whereby the rolls and angle fillets trade places.[48] Then, in pier 4S the form of pier 2S is repeated thereby creating an alternating rhythm. However, on pier 4N the disposition of rolls and fillets is the same as on 3N. The fifth and sixth piers bring more changes; in 5S and 5N there are only angular elements between the lobes, while in 6S and 6N only rolls are used. The remaining three piers are twelve-clustered shafts.[49]

VARIETY IN PIER DESIGN

While the forms of the Kirkstall nave piers are not found elsewhere, the principle of variety in pier design gains popularity in 12th-century England.[50] The main arcade piers of Peterborough Cathedral choir match on the north–south axis but a different design is employed for each pier from east to west.[51] Also in East Anglia, the former choir arcade at Orford and the nave arcades at Whaplode (Lincolnshire) and Ramsey (Huntingdonshire) employ the same principle, while in the nave of the Cluniac priory at Castle Acre we encounter a seemingly more bizarre design.[52] Here, as at Peterborough and Orford, the piers match north to south, but unlike these two churches each pier is not symmetrical. Instead symmetry is achieved with reference to the bay. Thus the west side of pier 1 matches the east side of pier 2; the west side of pier 2 matches the east side of pier 3 and so on. In the nave of Rochester Cathedral we return to the principle of the symmetrical pier with matching forms in the north and south arcades but with constant design changes from east to west.[53] The same principle is encountered in the nave of Selby Abbey, in the crypt of York Minster, and, seemingly under the influence of the York crypt, in the Kirkstall chapter house.[54]

One of the Kirkstall chapter house piers is composed of the cluster of eight detached shafts around a central core. It has no one specific model, but the basic constituents for its design are already present in the north of England. On the one hand, in the York crypt there are the piers with a circular core and detached shafts on the main axes. Then, at the entrance to the north-east and south-east transepts in the York crypt, there are piers composed of four detached shafts.[55] When the concept of detached shafts is allied with the octofoil piers in the east guest house at Fountains Abbey it is not hard to imagine a creative designer being able to conceive the Kirkstall chapter house pier in question.

The profile of the Kirkstall chapter house ribs derives from Archbishop Roger of Pont l'Eveque's work at York. The heavy keeled roll flanked by thin rolls is paralleled exactly in ribs from Roger's choir aisles which were reused in the Minster vestry. Archbishop Roger's York Minster crypt also provides the source for the chevron flanked soffit roll in the arch from the north transept to the north nave aisle (Pl. XIIIA).[56]

RIB VAULTS VERSUS GROIN VAULTS

The use of pointed barrel vaults in the transept chapels at Kirkstall is, of course, inherited from Fountains. However, in contrast to the Burgundian-inspired transverse barrel vaults in the nave aisles at Fountains, the nave aisles at Kirkstall, like the presbytery, have rib vaults of an Anglo-Norman heritage.[57] Given this use of rib vaults in the presbytery and the nave aisles, as well as the chapter house, the parlour, the dormitory stairs and the lay brothers range, the use of groins in the dormitory undercroft at Kirkstall may seem unusual, not to say archaic (Pl. XIIIc). However, this arrangement is paralleled in two other Cistercian houses in Yorkshire, at Rievaulx and Byland. In all three cases the dormitory undercroft is contemporary with the other buildings in the east range. The selective use of groins also occurs in a northern Cistercian context in the west range at Furness. But the juxtaposition of groins and ribs was not confined to the Cistercian order in 12th-century England. At Worcester Cathedral ribs are used in the chapter house and yet in the undercroft of the refectory we find groins. At Christ Church, Canterbury, under the patronage of Prior Wibert (1153–67), the water tower and upper storey of the Treasury were constructed with rib vaults. However, the walkways connecting the water tower to the church and the great cloister, and the undercroft of the Treasury, are groin vaulted. In the west range at Chester Cathedral ribs are used in the former slype and the chapel of St Anselm above the slype. The remainder of the range, however, is groin vaulted. The same juxtaposition of a rib-vaulted slype and groin-vaulted cellar is found at Norton Priory (Cheshire). Similarly in secular architecture, in the keep at Castle Rising a rib vault is used in the sanctuary of the chapel while the undercroft of the chapel is groin vaulted. It is therefore clear that at Kirkstall and the allied cases examined the rib is used as an aesthetic rather than as a structural device.[58]

CONCLUSION

Our observations have confirmed Bilson's suggestion that the design of Kirkstall Abbey church belongs firmly within a British Romanesque tradition. This tradition is apparent not only in the use of motifs such as scalloped capitals and in the constructional aspects of the rib vaults, so carefully analysed by Bilson, but also at a more conceptual level in the design variety in the crossing arches and the nave piers. At the same time, however, parallels with the work at Archbishop Roger's York Minster indicate that Kirkstall is by no means a conservative building. Indeed the nave piers and the precocious chapter house pier with eight detached shafts look forward to the richly shafted piers which are so characteristic of early Gothic in the north.

ACKNOWLEDGEMENTS

I should like to thank John Ward, Head Mason of Kirkstall Abbey, for facilitating my unlimited access to the abbey on numerous occasions. Research for this article was made possible through a generous grant from the Social Sciences and Humanities Research Council of Canada.

REFERENCES

SHORTENED TITLES USED

BILSON (1907) — John Bilson, 'The architecture of Kirkstall Abbey Church, with some general remarks on the architecture of the Cistercians', *The Publications of the Thoresby Society*, XVI (1907), 73–140.
BILSON (1909) — John Bilson, 'The Architecture of the Cistercians, with special reference to some of their earlier churches in England', *Archaeological Journal*, LXVI (1909), 185–280.

BOASE (1953) — T. S. R. Boase, *English Art 1100–1216* (Oxford 1953).

BROWNE (1847) — John Browne, *The History of the Metropolitan Church of St Peter, York* (London 1847).

CHERRY (1978) — Bridget Cherry, 'Romanesque Architecture in Eastern England', *JBAA*, CXXXI (1978).

CRUDEN (1986) — Stewart Cruden, *Scottish Medieval Churches* (Edinburgh 1986).

FERGUSSON (1970) — Peter Fergusson, 'Early Cistercian Churches in Yorkshire and the Problem of the Cistercian Crossing Tower', *Journal of the Society of Architectural Historians*, XXIX (1970), 211–21.

FERGUSSON (1975) — 'The South Transept Elevation of Byland Abbey', *JBAA*, 3rd Series, XXXIV (1975), 155–76.

FERGUSSON (1979) — Peter J. Fergusson, 'Notes on two Cistercian engraved designs', *Speculum*, LIV (1979), 1–17.

FERGUSSON (1984) — Peter Fergusson, *Architecture of Solitude: Cistercian Abbey in Twelfth-Century England* (Princeton 1984).

FERNIE (1983) — Eric Fernie, *The Architecture of the Anglo-Saxons* (London 1983).

HALSEY (1986) — Richard Halsey, 'The earliest architecture of the Cistercians', in Norton and Park (1986), 65–85.

HAMILTON THOMPSON (1986) — A. Hamilton Thompson, *Lindisfarne Priory* (London, HMBCE 1986).

HÉLIOT (1968) — Pierre Héliot, 'La nef de Pogny et les piles fasciculées dans l'architecture romane', *Mémoires de la Société d'Agriculture, Commerce, Science et Arts du Département de la Marne*, LXXXIII (1968), 80–92.

HOEY (1986) — Lawrence Hoey, 'Pier Alternation in Early English Gothic Architecture', *JBAA*, CXXXIX (1986), 45–67.

HOEY (1989) — Lawrence Hoey, 'Pier Form and vertical Wall Articulation in English Romanesque Architecture', *Journal of the Society of Architectural Historians*, XLVIII (1989), 258–83.

KIDSON (1965) — Peter Kidson, Peter Murray and Paul Thompson, *A History of English Architecture* (Harmondsworth 1965).

NORTON AND PARK (1986) — *Cistercian Art and Architecture in the British Isles*, ed. Christopher Norton and David Park (Cambridge 1986).

ST JOHN HOPE (1907) — W. H. St John Hope, 'Kirkstall Abbey', *The Publications of the Thoresby Society*, XVI (1907), 1–72.

ST JOHN HOPE and BILSON (1907) — W. H. St John Hope and John Bilson, 'Architectural Description of Kirkstall Abbey', *The Publications of the Thoresby Society*, XVI (1907), 1–140.

TAYLOR and TAYLOR (1965) — H. M. Taylor and Joan Taylor, *Anglo-Saxon Architecture* (Cambridge 1965).

TAYLOR (1977) — H. M. Taylor, *Anglo-Saxon Architecture*, III (Cambridge 1977).

THURLBY (1988) — Malcolm Thurlby, 'The Romanesque Priory Church of St Michael at Ewenny', *Journal of the Society of Architectural Historians*, XLVII (1988), 281–94.

THURLBY (1989) — Malcolm Thurlby, 'Observations of the Twelfth-Century Sculpture from Bridlington Priory, *BAA CT* (1989), 33–43.

TROLLOPE (1873) — Edward Trollope, 'The Architectural Remains of Louth Park Abbey', *Associated Architectural Societies Reports and Papers*, XII (1873–4), 22–5.

WEBB (1956) — Geoffrey Webb, *Architecture in Britain: The Middle Ages* (Harmondsworth 1956).

WILSON (1986) — Christopher Wilson, 'The Cistercians as "missionaries of Gothic" in Northern England', in Norton and Park (1986), 86–116.

REFERENCES

1. St John Hope (1907), 2–3.
2. Ibid., 3.
3. Ibid.; Fergusson (1984), 48.
4. Ibid.
5. St John Hope (1907), 3–4; Fergusson (1984), 48–9.
6. Fergusson (1984), 48, 49; David Walsh, 'Measurement and Proportion at Bordesley Abbey', *Gesta*, XIX/2 (1980), 110–12.
7. St John Hope and Bilson (1907), 1–140.
8. St John Hope (1907), 1–72.
9. Bilson (1907), 73–140. See also, Bilson (1909), especially 222–39, 241–75. Bilson's emphasis on the importance of the Anglo-Norman tradition for Kirkstall is taken up by Boase (1953), 135–8; Webb (1956), 45, 47, 82; Kidson (1965), 67; *B/E Yorkshire West Riding*, 2nd edn revised by Enid Radcliffe (1967), 24–5, 340–7.
10. *B/E Yorkshire West Riding*, 341n.
11. Fergusson (1984), 49.
12. Bilson (1907), 112; Bilson (1909), 229.
13. St John Hope (1907), Figs 12, 20, 23; Bilson (1907), Fig. 61.

14. St John Hope (1907), Figs 17, 20, 23.
15. The original presbytery at Lindisfarne comprised the one square bay and a semi-circular apse to the east. The apse was subsequently destroyed and the presbytery was extended by two further square bays to the east: Hamilton Thompson (1986), 8, 12 (plan), 15 (interior to west). *B/E Northumberland* (1957), Pl. 17b.
16. An analogous selective use of pilaster buttresses occurs at Brinkburn Priory (Northumberland). They are used between the windows on the north and south walls of the presbytery, on the transept chapels, on the west wall of the north transept and the north nave aisle (semi-octagonal buttresses, which turn into keeled half-shafts in the upper stage, are used between the windows on the east front). However, they are absent from the east clerestory of the transepts and the north clerestory of the nave, nor are they used between the windows on the transept terminal walls, nor on the south transept west wall and the south nave wall. Fergusson (1984), Pl. 18.
17. Fergusson (1984), 49, believed that the presbytery vault was inserted because of 'the extensive scarring in the masonry'. However, the scarring is most pronounced in sections of the lateral walls far from the vault; it seems to be the result of patching in restoration.
18. The irregularities in the coursing of the capital of the north vault respond of the chapter house are clearly seen in St John Hope (1907), fig. 26.
19. Halsey (1986), 79, has convincingly refuted Bilson's claim that the use of corbels was 'extremely common in Burgundian architecture and it is one of the motifs most frequently imported by the Cistercians into other countries' [Bilson (1909), 259]. Halsey points to the use of corbels for the crossing arches at Tewkesbury Abbey and Selby Abbey, for groin vaults in the ambulatory chapels at Norwich Cathedral and for rib vaults in the nave and chapter house at Durham Cathedral.
20. John Bilson, 'Durham Cathedral: the chronology of its vaults', *Archaeol. J.*, LXXXIX (1922), 101–60. That the high-vaults of the north transept at Durham were intended from the first, see Malcolm Thurlby, 'The Romanesque and Early Gothic Fabric', in *Durham Cathedral: A Celebration*, ed. Douglas Pocock (Durham 1993), 15–35. The transverse arches of the Durham chapter house vault are supported on shafted responds which rise from the ledge above the dado. The diagonal ribs are carried on carved corbels. The details are all renewed but the elements reflect the original [R. W. Billings, *Architectural Illustrations and Description of the Cathedral Church at Durham* (London 1843), Pl. LII].
21. Hamilton Thompson (1986), Pl. 15; *B/E Northumberland*, Pl. 17b. Durham-influenced corbels occur in the presbytery and apse at Dalmeny (Lothian), in the apse at Leuchars (Fife), and in east responds of the choir arcades, and the choir and nave aisles at Kirkwall Cathedral, in the gatehouse at Prudhoe Castle (Northumberland), in the presbytery at Warkworth (Northumberland), in the nave of Lincoln Cathedral as vaulted by Bishop Alexander, and in the presbytery at Stow (Lincolnshire).
22. The Rievaulx chapter house aisle responds are illustrated in Norton and Park (1986), Pls 12 and 13. The form of the monolith in these responds is derived from the dado arcade of the Durham chapter house.
23. Halsey (1986), 84, states that 'So many details of the (Rievaulx) chapter house and the east range can be paralleled in the early work at Kirkstall that the same master or workshop can be suggested'.
24. Fergusson (1984), Pls 11 and 34. Similar corbels are used at Rievaulx Abbey in the parlour and the dormitory undercroft; at Byland Abbey in the parlour, and dormitory undercroft, the refectory undercroft and in the lay brothers range [Fergusson (1984), Pl. 35]; and at Middleham Castle (Yorkshire) in the west cellar. Early examples of semi-octagonal corbels occur in the lay brothers range of Jervaulx Abbey [Fergusson (1984), Pl. 36] and in the slype, chapter house and west guest house at Fountains Abbey.
25. Fergusson (1979), 32, Pl. 4, where he gives a date of *c.* 1155. W. H. St John Hope, 'Fountains Abbey', *Yorkshire Archaeological Journal*, XV (1900), 388 dates the East Guest House 'soon after the fire of 1147'; R. Gilyard-Beer, *Fountains Abbey*, 6th edn (London HMSO), 1978, 69–70, offers a date shortly after mid-century. Just three of the vault capitals in the east guest house are scalloped; the remainder are chalice or waterleaf like those from the choir of Archbishop Roger's York Minster. Is this a case of the Cistercians as 'missionaries of Gothic' [Wilson (1986)], or the Cistercians keeping up with Archbishop Roger?
26. Fergusson (1970), 217.
27. Ibid.
28. Alfred Clapham, *English Romanesque Architecture after the Conquest* (Oxford 1934), 79 n1; Halsey (1986), 72, 73.
29. Fergusson (1970), 217–18.
30. The lower section of the north respond of the north chapel of the south transept is rebuilt and does not course through with the south-east crossing pier.
31. The responds of the east crossing arch at Furness Abbey are similarly differentiated from the east responds of the north and south crossing arches [Fergusson (1984), Pl. 49]. At Kirkstall Fergusson observes that there are 'changes in the string-courses and in the scalloped design of the capitals' between the first and second campaigns [Fergusson (1970), 218]. It is true that such changes do occur but they are not the result of different campaigns of construction. The only changes in the string-course are in the termination of the

internal presbytery string — the height of which is determined by the sill of the north and south presbytery windows — next to the responds for the soffits of the north and south crossing arches. Had these strings continued they would have smashed into the arches of the transept chapels. Where similar conflict would have occured in the south wall of the south transept, the string of the triforium sill is terminated at the south-east angle of the transept. Nor does this string continue on to the west wall of the south transept. Furthermore, on the exterior of the north transept terminal wall the string at the sill of the lower windows continues on to the north-west buttress but does not continue on to the north-east buttress. It is therefore clear that the Kirkstall Master was not concerned with consistency in the application of string-courses. On the scalloped capitals, given the great variety in types, so carefully analysed by John Bilson [(1907), 128–31], any changes in design should be read in connection with the concept of aesthetic variety in capital detail rather than indicating different phases of work. Such variety was common at this time: e.g. York Minster crypt, Selby Abbey nave; Bolton Priory choir dado arcade, Bridlington former cloister arcade [Thurlby (1989); Malcolm Thurlby and Yoshio Kusaba, 'The Nave of St Andrew at Steyning and Design Variety in Romanesque Architecture in Britain', *Gesta*, xxx/2 (1991), 163–75].

32. Bilson (1907), Figs 88–91.
33. E.g. The south doorways at Brayton and Healaugh.
34. Taylor and Taylor (1965), 678–80, Fig. 625.
35. J. T. Irvine, 'Notes on Specimens of Interlacing Ornament at Kirkstall Abbey', *JBAA*, xlviii (1892), 26–30; Bilson (1907), 127–8. On the interlaced design of the tracery of the former east rose at Kirkstall see the reconstruction by Stuart Harrison in this volume.
36. Fergusson (1984), 49 n. 75, suggests that 'The closest parallels to the Kirkstall interlace occur in contemporary manuscripts and in the capitals at Southwell'.
37. Taylor and Taylor (1965), Figs 292 and 585. In contrast to the Kirkstall east crossing arch, the crossing arches at Stow have mouldings on both sides. There is an excellent illustration of the Stow crossing arches in Robert Stoll, *Britannia Romanica* (Vienna and Munich 1966), Pl. 189. Opinions differ on the date of the Stow crossing arches. Fernie (1983), 127, indicates that attribution to Wulfric around 1055 or to Remigius around 1090 are both possibilities. However, he considers that 'the relationship between the crossing arches at Stow and the profile of the niches on the facade of Remigius's cathedral at Lincoln makes the latter date more likely'. On the other hand, Taylor and Taylor (1965), 589–90, opt for a pre-Conquest date 'by comparison of the mouldings with those of Bosham, and by constrasting them with the early Norman work of the west front of the cathedral at Lincoln'. The Taylors' contrast of the Stow mouldings with Remigius's work at Lincoln is hard to follow. It is true that the Lincoln and the Stow mouldings are not identical, but there is a strong family resemblance between them. However, this does not necessarily mean that they both date from about 1090. Lincoln Cathedral was commenced between 1072 and 1075, and the mouldings in question may well reflect the work of twenty years before at Stow.
38. St John Hope (1907), Figs 15, 22, 53.
39. Taylor (1977), 928–38. According to Baldwin–Brown the use of stripwork over round openings was 'one of the commonest and most enduring features of Saxon buildings' [G. Baldwin–Brown, *The Arts in Early England, 2. Anglo-Saxon Architecture*, 2nd edn (London 1925), 225, quoted by Taylor (1977), 929]. Taylor lists twenty-two examples of stripwork round doorways (ibid., 932–3).
40. Bilson (1907), 110; Bilson (1909), 227.
41. Fergusson (1984), Pl. 10.
42. Columnar piers with octagonal capitals related to Durham Cathedral occur in the following: Tynemouth Priory, nave; Dunfermline Abbey, nave [Cruden (1986), Pl. 8]; Kirkwall Cathedral, choir [Cruden (1986), Pl. 38]; Kirkby Lonsdale (Cumbria), nave [*B/E Cumberland and Westmoreland* (1967), Pl. 75]; Selby Abbey, nave (*B/E Yorkshire West Riding*, Pl. 19).
43. Trollope (1873), Pl. ii, Fig. 6.
44. Norton and Park (1986), Pl. 21; Browne (1847), Pls xx, xxi and xxii.
45. Ibid., Pls xvii, xviii, and xix. Piers composed of four lobes with coursed angle shafts carrying the diagonal ribs occur in the crypt of St Mary's, Warwick.
46. See above, note 25. These Fountains piers are monolithic and have round and keeled shafts carved from the single stone.
47. Taylor and Taylor (1965), 484–8. Fernie (1983), 129–34, is especially important for the European context of the Great Paxton piers.
48. Piers S1, N1 and N2 are new.
49. The exact juxtaposition of the shafts at Kirkstall is unique but twelve-shafted cluster piers are also used in the presbytery and north transept at Byland Abbey [Fergusson (1975), 155–76, esp. 161–5], in the transepts at Dundrennan Abbey (Kirkcudbrightshire) [Peter Fergusson, 'The Late Twelfth Century Rebuilding at Dundrennan Abbey', *Antiquaries Journal*, lii (1974), 232–43] and in Bardney Abbey south transept [Harold Brakspear, 'Bardney Abbey', *Archaeol. J.*, lxxix (1922), 1–92]. Fergusson (1984), 50, observes that 'Around

1140 fasciculated piers appear in north-east France — for instance, at Berteaucourt-les-Dames (Somme) (Pl. 27), Heuchin (Pas-de-Calais), Pogny (Aube), and Selincourt (Somme)'; see also, Heliot (1968). Of these Heuchin provides the only twelve-shafted pier.

50. Hoey (1986), 45–7; Hoey (1989).

51. Hoey (1989), 274–5, Pl. 17.

52. For Ramsey nave see *RCHM Huntingdonshire* (1926), Pl. 114; for the nave of Castle Acre, Cherry (1978), 12–14, Figs. 6–7; Hoey (1989), 278 n. 107. Trollope (1873), 23, suggests that the nave piers at Louth Park 'were not all alike'; see also, Fergusson (1984), 132.

53. Hoey (1989), 279–80, Fig. 26.

54. For Selby nave see *B/E Yorkshire West Riding*, Pls 18–19; for York Minster crypt, Browne (1847), Pls XII and XXVII. In the Rievaulx dormitory undercroft there is an alternation between coursed columnar piers and piers with a monolithic round core with four detached shafts.

55. Ibid., Pl. XII.

56. Ibid., Pl. XIX. A rib fragment from Louth Park has a keeled roll flanked by hollows [Trollope (1873), Pl. IV, Fig. 4].

57. Bilson (1907), 117–23; Bilson (1909), 233–9. On the role of Rievaulx as the intermediary between Burgundy and Fountains see Halsey (1986), 80–2.

58. For further discussion of aesthetic and iconographic uses of the rib, see Thurlby (1989), 293.

Kirkstall Abbey: The 12th-Century Tracery and Rose Window

By Stuart Harrison

The east end of Kirkstall Abbey forms the most intact example of a mid-12th-century Cistercian presbytery in this country, retaining not only its sedilia and aumbry but also its high vault. In a move to update the appearance of the building in the 15th century the design of the east wall was radically altered by the introduction of a massive perpendicular traceried window and the original fenestration was effectively destroyed (Pl. XIVA).

The design of the original 12th century window arrangement, in the east front, was first explored by W. H. St John Hope. He suggested that in the 12th century the main feature of the front was a large circular window which had four flanking oculi, surmounting a lower tier of three tall round-headed windows. Examination of the front shows that Hope correctly identified the external curved blocked openings (Pl. XIVB), clearly visible at the margins of the later window, as former oculi and that there exists similar internal evidence to show that these must have been pierced as windows. Similarly, sufficient original stonework survives to show that his identification of a lower tier of three windows was correct. Although no physical trace of a large circular window forming the principal feature of the front survives, it seems clear that this was the most likely form of fenestration. Hope's reconstruction drawing of the most likely appearance of the front, as outlined above, can therefore still be accepted as valid but there remains the problem of the form of the tracery which must have filled the circular window.[1]

Fortunately it has recently proved possible to identify a sufficient number of pieces of 12th-century plate tracery amongst the loose architectural detail on the site to make a tentative reconstruction of the window design.[2] The considerable number of tracery fragments which have survived all have similar decorative motifs and the air of a common origin, although it is apparent from the variations in mouldings and thickness, that elements of more than one type of feature are represented. The heaviest sections of tracery form three distinctly different types of component. First are three pieces which must have formed the rim sections of a circular window six metres (20 ft) in diameter (Pl. XIVC). Each has a curved rim upon which is set a large protruding circular boss, with an eccentrically set base seating for a spoke. The external face is decorated with massive interlace ornament, formed by multiple roll mouldings. This ornamentation sweeps around the external rim and interlocks to form a knot, which has a moulding orientated towards the spoke which the circular boss supported. Quite noticeably, the spoke seatings are eccentrically placed and sections which feature left-hand and right-hand orientated decoration survive, indicating that the rim sections were grouped in pairs or alternated. Internally the stones have large rebates for glazing and in places retain the holes and lead packings for the iron pins which retained the glazing frames in place (Pl. XIVD). Two of the stones have a pronounced chamfered moulding worked on the internal face, but the third lacks this feature. This indicates that the tracery may have been set flush with the internal wall face and had a hoodmould over its upper half.

The second type of tracery component consists of several sections of curved spokes which are rebated internally for glazing and have multiple roll mouldings externally (Pls XIVC and XIVD). Some of the broken bed joints show evidence of the former presence of metal

dowels, indicating that the tracery partially relied on metal reinforcement for stability. Only short lengths have survived but these are sufficiently intact to establish the radius of curvature of the spokes.

The third type of tracery component (Pl. XVA), of which two large pieces survive, forms the junction or intersection of several spokes and although damaged, the form of its external decoration and the stubs of its broken spokes are sufficiently intact to establish its former complete appearance.[3] The main feature is a section of a ring three metres (10 ft) in diameter, which intersects with two spokes converging together, towards the centre of the circle. At the point where these two spokes merge is a joint which has a stepped face (Pl. XVA). This is quite an important feature because it must have been intentionally introduced to reduce the possibility of rotational displacement in the tracery.[4] Internally the two surviving examples are rebated for glazing (Pl. XVB), whilst externally they have the familiar multiple moulded decoration. This, like that on the rim sections, is designed to form an interlace pattern.

From these surviving sections it is possible to make a very tentative reconstruction of the window design. It seems clear that the left-hand and right-hand rim sections must have alternated around the periphery of the window and supported the curved spokes (Pls XIVc and XIVd). These in turn can be shown to have supported the inner ring of tracery, formed by the surviving intersections (Figs 1 and 2). None of the tracery from the centre of the window has been identified and its most probable form has to be deduced from the interlace pattern and the position of the step jointed supports within the inner ring of tracery. The interlace indicates that the moulding most probably alternated at each tracery junction, so that it appeared to carry over or under the intersecting piece. The reconstruction drawings (Figs 1 and 2) are those shown at the York conference in which the central section of the tracery continues the theme of interlace across the window. Since the conference Kenneth Beaulah has suggested an alternative tracery pattern for the centre of the window (Fig. 3) which forms a plausible design. Whilst this scheme forms a logical pattern and may be closer to the actual tracery pattern employed it is difficult to reconcile with the stepped tracery joints mentioned above. The reconstruction of the window outlined above is exactly the right size to fit the circular window proposed in Hope's reconstruction drawing of the front, and this seems its most likely source (Fig. 4).

The several other sections of tracery which have survived are of smaller scale and are more fragmentary but show several interesting features. One piece, which has multiple roll mouldings and glazing rebates, is clearly the terminal from a foil (Pl. XVc), which besides being pierced towards its centre, also featured glazed spandrel sections. Unfortunately the piece is too fragmentary to show any joint faces, so it is impossible to establish with certainty how many lobes the whole foil contained. Besides this piece there are several very fragmentary tracery intersections which resemble those of the rose window. They feature similar interlace mouldings but are unfortunately too fragmentary to enable reconstructions of their full form to be made. One large piece may have formed a rim section from a window. It has a large circular panel, somewhat similar to the rim sections of the rose window, decorated with interlace mouldings, but with two spoke supports (Pl. XVd).[5]

Although the sheer size and scale of the rose window tracery makes it virtually certain that it originated in the east front of the church, there are several other possible sources for the remaining sections of plate tracery. It seems highly likely, for instance, that the main east gable featured some form of window to light the space above the high vault. This may well have contained some form of tracery pattern. Unfortunately the 15th-century rebuilding of the gable and subsequent restorations have obliterated any trace of the 12th-century arrangements.

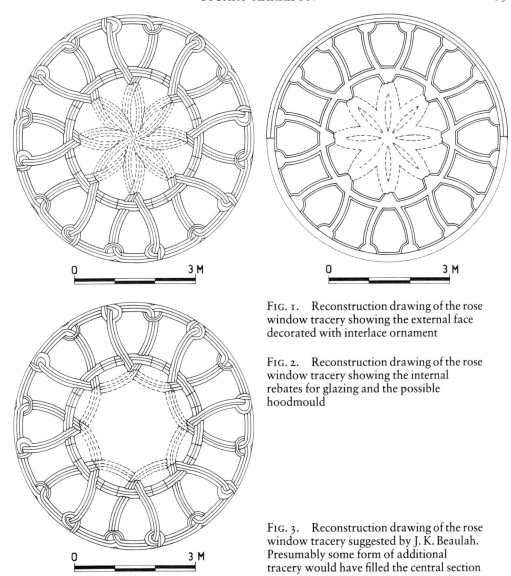

0 3 M

0 3 M

0 3 M

FIG. 1. Reconstruction drawing of the rose
window tracery showing the external face
decorated with interlace ornament

FIG. 2. Reconstruction drawing of the rose
window tracery showing the internal
rebates for glazing and the possible
hoodmould

FIG. 3. Reconstruction drawing of the rose
window tracery suggested by J. K. Beaulah.
Presumably some form of additional
tracery would have filled the central section

In the north transept gable are traces of a 12th-century window of unusual form
(Pl. XVE).[6] This appears to have been basically a square opening which had foiled sides. The
surviving remnants show multiple roll mouldings around the external rim, similar to the
rose window tracery, and the size of the aperture suggests that the window would have
featured plate tracery.

The west gable of the church was also reduced in pitch during the 15th-century
renovation of the building. Two large 12th-century windows were retained, with the
addition of tracery, but the upper part of the elevation was drastically altered. The margins
of the elevation, on both the exterior and interior,[7] retain large shafts and capitals which

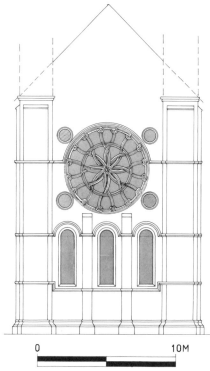

Fig. 4. Reconstruction drawing of
the east elevation of the presbytery
showing the original window
arrangement and the rose window
tracery (after Hope)

Fig. 5. Outline reconstruction drawing of
the inside of the west front showing the
12th-century arrangement of the gable with
rerearch and circular window

formerly supported relieving arches which carried the original gable. The height at which
these arches were set shows conclusively that the internal ceiling of the nave was of timber
barrel form. On the inside, just above the round-headed windows, is the lower rim of a
blocked circular window. The projected internal outline of this window, when seen in
relation to the external relieving arch shows that its actual pierced aperture was much
smaller than the diameter of the surviving rim section suggests. In this respect it may well be
that it was the source of the foiled piece of tracery, because when reconstructed as a
quatrefoil it is about the right size to fill the circular aperture (Fig. 5).

Whatever the source of these various fragmentary pieces of tracery, they share with the
rose window a systematically applied use of interlace decoration. The presence of interlace
at Kirkstall has been known for many years and was first explored in detail by J. T. Irving in
1892.[8] Interlace occurs upon the impost of the piscina in the presbytery, a capital in the
north transept, a corbel supporting the western crossing arch and on one of the pier bases in
the north arcade of the nave. Whilst these form interesting decorative motifs in their own
right, it can now be shown that they are but minor echoes of the much larger scale interlace
decorating the plate tracery features of the main facades of the church.

The reconstruction of the rose-window tracery outlined above shows that it was a remarkable structure, one which appears to have been unique in the context of 12th-century English architecture. Comparison with the contemporary west front and rose window at Fountains Abbey shows distinct design similarities between the two buildings. At Fountains the main fenestration consisted of a tier of three tall round-headed windows which were surmounted by a rose window six metres (10 ft) in diameter. Recent work by English Heritage has revealed that the rose window was flanked by at least two oculi, similar to those employed at Kirkstall.[9] The tracery employed was in the form of a wheel with twelve spokes which supported round-headed arches, with a quatrefoil at the centre. The technique of construction was completely different to that employed at Kirkstall and does not appear to have used any metal dowels.

Differing construction details are to be expected in the design of rose windows because the three extant and the seven fragmentary examples which have recently been identified all show dissimilar techniques.[10] Whilst they are all basically wheel designs with radiating spokes, Kirkstall is fundamentally different in that its spokes are curved, giving a radically different appearance to the window. Similarly, it dispenses with the arch and supporting column spoke which is so prominent a feature of the other known windows, substituting instead the continuous linear pattern of an endless run of interlace moulding. The evidence of flanking pierced oculi, at Kirkstall and Fountains together with the example at Vaux-De-Cernay noted by John Bilson,[11] shows that this was a common rose window design feature. In later rose windows such as those at Byland Abbey and York Minster the designs have evolved further and the oculi have been replaced by paterae panels set around the window rim.

Despite this normal aspect of the Kirkstall design, overall the tracery formed a radical and possibly revolutionary departure from the accepted pattern of established rose window design. Where this idea originated is impossible to establish but it seems certain that it was not taken up after its initial employment at Kirkstall, or developed further. In this respect it must be seen as a failure. Either it was looked on by contemporaries as a quirk of one particular master, or the traditional spoked design was already too firmly entrenched within the repertoire of masons and their patrons to dislodge. It may be that the use of curving elements of tracery was simply too advanced for its use to become widespread in mid-12th-century England.

ACKNOWLEDGEMENTS

The research into the 12th-century window tracery at Kirkstall was funded by Leeds City Museums and I would like to thank Peter Brears for his help throughout the project and John Ward, formerly head mason at the abbey, for help in moving the stonework. Dr Glyn Coppack kindly read and commented on an early draft of this paper.

REFERENCES

1. W. H. Hope, 'Kirkstall Abbey', *Thoresby Society*, XVI (1907), 25, Fig. 18.
2. The history of all the pieces of tracery so far identified, together with many other loose architectural fragments from the site can be traced with some certainty. Early photographs (Hope, Fig. 62) and a comment by John Bilson, 'The Architecture of the Church of Kirkstall Abbey', *Thoresby Society*, XVI (1907), 132n1, show that in the early years of this century they were in the chapels of the north transept. Subsequently, in the 1950s, they were walled up in a vestry which adjoins the south transept of the church. They were removed and laid out in the transept a few years ago and have now been placed in secure storage. Early photographs

suggest that prior to the restoration of the abbey in the 1890s the carved stone was scattered in several dumps around the abbey buildings (Hope, Figs 49, 53, 54).

3. The surviving pieces indicate, by the broken stubs which show the former presence of spoke arms (Pl. IV), and by the nature of the external decoration (Pl. III), that the tracery section was symmetrical in form when complete.

4. All circular windows which feature radiating tracery suffer inherently from the danger of rotational displacement. When this occurs and the central section of tracery starts to rotate, the whole or part of the window is likely to collapse.

5. J. T. Irving, 'Notes on Specimens of Interlacing Ornament, which occur at Kirkstall Abbey, near Leeds, Yorkshire', *JBAA*, XLVIII (1892), Fig. F1.

6. Hope, Fig. 8. The remains of this gable feature clearly show that Hope (p. 12) incorrectly identified the original opening as 'a pointed oval window'.

7. Hope, Figs 19, 65, 68, 69.

8. Irving, 26–30. Irving identified and illustrated (Fig. F) several pieces of the window tracery and although this must have been known to Hope, he does not appear to have realised that the tracery originated from the eastern rose window. Perhaps he thought that because the window had been destroyed in the 15th century no tracery could possibly have survived to the present day. The survival of rose window tracery at Fountains Abbey, under similar circumstances, indicates that at both sites it was stored somewhere for possible reuse in a future building project.

9. During consolidation work on the west front of Fountains in 1986, archaeological recording by Judith Roebuck, directed by Dr Glyn Coppack, showed that the tracery from the 12th-century rose window had been used in the building of the late-15th-century gable of the front. It proved possible to recover one example of each tracery element present and from these I was able to reconstruct the design. The section of oculus which was recovered was of circular outline with cusping. Sufficient survived to show that it formed part of a small circular opening which had octofoil cusping around the rim. Attached to one side was stepped jointing to allow it to be coursed into the surrounding wall face. The former existence of at least two such features can be demonstrated by another similar foiled cusp not removed from the west gable which had decoration applied to the terminal.

10. For a summary of the surviving windows and those which have recently been reconstructed see S. A. Harrison and P. N. Barker, 'Byland Abbey, North Yorkshire: The West Front and Rose Window Reconstructed', *JBAA*, CXL (1987), 134–51.

11. J. Bilson, 'The Architecture of the Cistercians, with special reference to some of their earlier churches in England', *Archaeol. J.*, LXVI (1909), 230, Pl. VII.

The Priory of The Holy Trinity, York: Antiquarians and Architectural History

By David A. Stocker

INTRODUCTION

In the rush to study the architectual history of the Minster and St Mary's Abbey, York's other monastic church, that of the Benedictine priory of the Holy Trinity in Micklegate, has been relatively ignored.[1] This is unjust. Physically the monastery dominated the south-west bank of the Ouse (Fig. 1) — the priory church was over 210 ft long (i.e. it was of similar size to Hexham or Kirkstall) and in its institutional history, also, it is a house of some significance.

It is the important pre-Conquest monastery on this site which has received most attention recently.[2] But, although the few pieces of solid evidence for the pre-Conquest monastery are becoming very familiar, the mass of evidence for the post-Conquest Benedictine priory has been disregarded and it is with this evidence for the post-Conquest monastic church that this paper is concerned.[3]

The history of the alien Benedictine priory begins with the foundation charter in 1089 in which Ralph Pagnell gave to the monks a large land holding in Lincolnshire and Yorkshire, but then gave the whole newly founded institution to the abbey of Marmoutier outside Tours. Consequently, the abbot of Marmoutier had the sole right to appoint the prior of the York house. Many alien Benedictine houses were foundations of little substance and dwindled away before the Reformation,[4] but Holy Trinity was not one of these. It was of sufficient importance for both the Archbishop (in the 12th and 13th centuries) and the Crown (in the 14th and 15th centuries) to be worried at their lack of control over it and both parties instituted several inquiries into the house's management. The issue of control was not settled until 1426 when Holy Trinity was one of the small number of alien houses granted denizenisation and set up as institutions independent from their continental parents. These controversies have meant that the house is relatively well documented and also, obviously, they demonstrate that the value of the house was sufficient to merit concern. The value in financial terms was given at the Dissolution as £196 17s. 2d., £169 9s. 10d. net., which meant that Holy Trinity almost escaped dissolution in 1536 as a 'great monastery'. This, then is not an inconsequential house, and its architectural history is well worth our attention.

The stimulus for this re-examination of the priory remains (the early 19th-century appearance of which is shown in Pl. XVIA) is provided by the reappearance of three manuscript notebooks which are now housed in the library of the York Institute of Advanced Architectural Studies.[5] These notebooks were compiled by the York architect and antiquarian Walter Harvey Brook between 1892 and 1911. Brook, who was a parishioner of Holy Trinity, devoted much of his spare time to research into its history and fabric.[6] He was a lifelong friend of John Solloway, rector of Holy Trinity between 1895 and 1910 and both the author of the history of the monastery and the sponsor of the thoroughgoing restoration of the church between 1902 and 1906. Although Solloway and the architect Brook were the dominant figures behind this restoration, the work was undertaken by the office of Charles Hodgson Fowler in Durham. Even so, the surviving papers from that architects' office make it clear that their role were merely giving practical

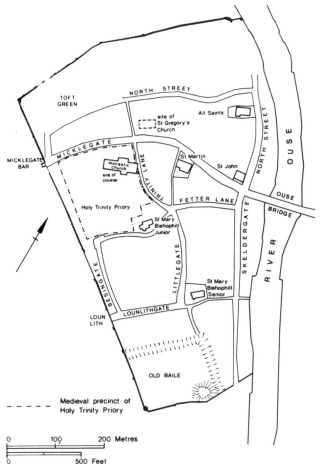

FIG. 1. Holy Trinity Priory,
York: location plan. (From
C. M. Briden and D. A.
Stocker, *The Tower of
St Mary Bishophill Junior* in
L. P. Wenham *et al.*, *St Mary
Bishophill Junior and
St Mary Castlegate*, *The
Archaeology of York*,
Vol. 8/2, London 1987)
*Copyright: York Archaeological
Trust for Excavation and
Research*

shape to Brook's and Solloway's ideas, and, because of this, the restored church is a
scrupulous re-creation of parts of the priory church based on the researches of the two local
antiquarians.[7]

The three notebooks encapsulate this research. The first two contain detailed information
in the form of annotated sketches, measured drawings, watercolours and newspaper
cuttings regarding both the excavations undertaken in the monastic choir (in 1899)
(Pl. XVIIA) and in the north transept (1904) and the investigation of the standing fabric of
the nave prior to the Hodgson Fowler restoration. The third volume contains a little
information about the church but is largely concerned with the building known as Jacob's
Well, a former ale-house to the east of the rectory which was acquired and converted to a
parish room between 1905 and 1909.

The documented history of the convent is of no great use in our analysis of the early
history of the priory fabric. It provides us with no dates for building or consecration of any
11th-century church, but the priory is amongst those buildings recorded as having been
destroyed by the great fire which affected much of York in 1137.[8] What type or date of

building that was we cannot say — there is no surviving fabric of that date visible in the present building, but it is probable that a fragment from what is said to have been a tympanum, was set within it.[9] Commentators have agreed that this is an 11th-century piece but it is not possible to say whether it comes from the church of the pre-Conquest monastery, or from an Anglo-Norman building which replaced it soon after Ralph Pagnell's refoundation in 1089.

Most writers, including Brook, have made the assumption that rebuilding began immediately after the 1137 fire and that work proceeded from the east end westwards. In fact there is no evidence to suggest that there was any building work on the site as early as c. 1140; rather, the evidence from the excavations in the choir and from the surviving remains suggests that the choir was rebuilt *in toto*, in a single campaign, later in the 12th century. This may suggest, in turn, that the pre-Conquest church (perhaps altered and enlarged in the late 11th century) was not completely destroyed by the fire.

THE MONASTIC CHOIR

We can deduce quite a lot about the plan of the choir (Figs 2 and 3). Parts of the south and east walls still survive which show that it was a large building — occupying the whole area between the surviving church and Trinity Lane. The walls which can be seen today in backyards, sheds and garages are considerably refaced and, with the exception of scars marking the position of a door in the centre of the south wall, they are entirely featureless. Brook recorded a slight chamfered plinth on the exterior face of the wall, but this is no longer visible. Although these two walls are not easy to date independently there can be little doubt that they do mark the lines of the medieval choir walls, if only because of their great thickness.

We can be much less certain of the line of the north wall of the choir. It was never excavated, but Solloway claimed that it survived in the cellar of the present rectory. The south wall of the rectory cellar is indeed built of well squared blocks, with 12th-century tooling, and may be a length of 12th-century walling *in situ*. It seems to be at approximately the right depth below the modern ground surface and in approximately the right position, if we presume that the choir had a north aisle of similar dimensions to the south. But it has not proved possible to plan it accurately relative to the buildings above and around it, so its exact alignment remains uncertain. The wall already existed within the fabric of the previous rectory, built in 1639, and when that was demolished to make way for the present building in 1897, Solloway observed the relationship of the old wall to the standing church, concluded that it was the north wall of the medieval choir and ensured that it was preserved in the new house.[10] Until its exact position can be properly surveyed, however, all that can be said is that it may be a 12th-century wall, that it is in a plausible position for the north wall of the north choir aisle, and that Solloway, who saw it revealed in 1897, thought this was what it represented.

If this is the north choir aisle wall, however, either it did not extend right up to the known east wall of the central and southern vessels, or the allegedly medieval building of Jacob's Well is not as old as has been claimed. Figure 3 shows how the reconstructed north aisle of the choir overlies the southern range of the House. Jacob's Well is a much altered building (and many of the alterations are described in volume III of Brook's notes),[11] but clearly it was originally two structures, a hall-house set gable end to the street and an extension to the south along the street front, which now incorporates the famous carved timber porch moved here in 1905. The building is probably that mentioned in 1549 when it was inhabited by Christopher Petty, a former priest of the Nelson chantry, one of the wealthiest in the

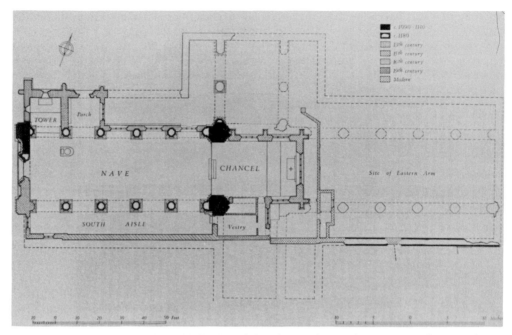

FIG. 2. Holy Trinity Priory, York: plan of church according to the RCHME (*The City of York, Vol. 3: South-west of the Ouse*, London 1972). The interpretation, both of the layout and of the church and of the date of its components is disputed in this paper
Crown copyright

priory. From this reference Solloway concluded that the building had been provided by the chantry endowment in 1474 as a house for its priests.[12] There is, however, absolutely no suggestion of any such connection in the chantry documentation and there is no reason why the building could not date from the mid-16th century. Certainly the southwards extension of the hall-house need be little earlier than the first reference to there being two tenements on the site (1562), whilst the larger house could also be of post-Dissolution date, erected, perhaps by the grantee of the site in 1543, Leonard Beckwith. The presence of Jacob's Well, then, is not a serious barrier to the otherwise reasonable presumption that the plan of the priory choir was a simple aisled rectangle.

The interior space defined by the surviving fragments of the choir walls is now almost wholly occupied by the rectory garden. Ground level in the garden is now some 2 m above that in the yards to the south and south-east and most of the build-up consists of demolition rubble and other debris presumably derived from the choir itself (Pl. XVIB). Our only information about its internal layout comes from the account in the notebooks of the excavations of February and March 1899. Of course, the term excavation is barely applicable by modern standards, although the standard probably did not fall very far short of work on some other Yorkshire monastery sites cleared at the same time. The technique at Holy Trinity was simply to estimate from the surviving south-west crossing pier where the south choir arcade should be and dig down until some traces of it were found, after which it was followed eastwards. We have detailed records of only two choir pier bases found in this way, the two westernmost, but we know that a third (the next to the east) was also

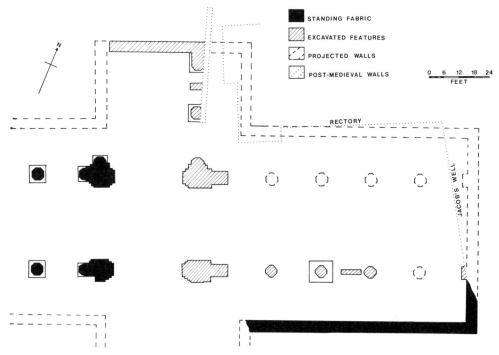

FIG. 3. Holy Trinity Priory, York: simplified plan of monastic choir and north transept
showing information from the excavations of 1899 and 1904 recorded in Brook's notebooks
and the interpretation of those results given in this paper
Drawing: author

excavated and there is also a sketch of what must be the base of the south-east respond. It is
possible, in fact, that the intervening pier base (the easternmost) was also excavated without
records being made.[13]

From the notebooks it is clear that the south arcade was of five bays carried by piers
standing on quite small sub-bases of octagonal plan with alternate long and short sides. The
second pier base from the west was set upon a large slab of stone which was probably
originally at floor level. Below the pier bases there was probably a sleeper wall, which seems
to have been found under the east respond but misinterpreted further west as a Roman road
surface. We know absolutely nothing about the north arcade but, if the assumptions made
about the north aisle wall above are correct, then one must have existed and there is no
reason to suppose it different from the south.

In between the second and third piers from the west in the south arcade the excavators
found a rectangular mass of masonry, which had clearly stood above original floor level and
which has been variously interpreted as a tomb chest, screen base or a sedilia.[14] The floor of
the aisle and the central part of the choir was evidently paved with red, apparently
undecorated, tiles but they were not recorded in any detail.

What can be said of the date and architectural context of this large structure? Firstly, the
architectural fragments which litter the whole site fall into only two broad periods, a large
early 13th-century group which can be associated with the nave, cloister and transepts and a
second group, almost as large, which dates from the second half of the 12th century.[15] The

FIG. 4. Holy Trinity Priory, York:
architectural fragments from 1899 choir
excavations. A represents three near-identical
examples and B a single example of capital
types. C represents a number of fragmentary
bases
Drawings: author

FIG. 5. Holy Trinity Priory, York:
architectural fragments from 1899
choir excavations. A represents
eight near-identical examples and B
a single example of capital types.
C is a single example of a nook-
shaft base and D and E are cross-
sections through the two types of
vault rib represented on the site
(total four examples)
Drawings: author

most decorative pieces in the later 12th-century group are five fragments which form either
two orders of the same door, or two different doors, each decorated with elaborate acanthus
foliage designs and clearly connected with the 'Yorkshire Romanesque School' of sculpture.
Also from a decorated door (perhaps from the same door) is a fine nook-shaft capital
(Pl. XVIIB) decorated with acanthus foliage in the same style and now reset in the wall of the
porch. Although we have no evidence to suggest where exactly on the site the first five
fragments were found, the capital, at least, seems to have come from the choir excavations
and, even in the most minimal interpretation, they indicate that work of the top quality was
undertaken somewhere on the site between *c.* 1160 and *c.* 1180.

In addition to these six fragments, there is a group of three chalice capitals from nook
shafts and four waterleaf types, mostly from blind arcades or similar features, and four shaft
bases of the same Transitional character (Figs 4 and 5). This group of fragments, most of
which were found during the 1899 excavation, suggest that parts of the choir (at least) had
Transitional detailing of perhaps 1170–80.

More direct evidence for the date of the choir, however, can be found in the surviving
north-west tower. This tower was built in 1453 by the parishioners of St Nicholas' who used

the priory nave (or part of it) as their parish church.[16] The new bell tower contains many reused stones, and these include the three belfry openings which are clearly reset windows of the later 12th century (Pl. XVIIc). The nook shafts here have very similar chalice capitals to examples found during excavations in the choir. We have several references to the renovation of the monastic choir between 1446 and c. 1470[17] and it seems quite likely, therefore, that new bell tower reused windows (perhaps clerestory windows) from the priory choir which were replaced at this time. Consequently we can suggest that, up until the mid-15th century, the choir had windows of the later 12th century. Also from the excavations in the choir came three voussoirs from vault ribs of a well-known later 12th-century type.[18] They are too small to have come from a high vault spanning the central space of the choir, but they are of a suitable size to have come from the aisles of the building.

There are no fragments which strongly suggest a date in the 1140s, rather, the evidence of the architectural fragments and that extrapolated from the surviving belfry openings in the north-west tower, suggests that the large five bay choir was built in the second half of the 12th century, probably between c. 1170 and c. 1190. If its construction was a consequence of damage caused by the fire in 1137 then the start of work must have been delayed for a generation.

A date in the 1170s or 1180s is supported by a comparison with what we know of contemporary buildings in later 12th-century Yorkshire, in plan type as well as detail. The choir of Holy Trinity evidently belongs to the group of large, rectangular east ends of the second half of the 12th century defined by M. F. Hearn.[19] According to Hearn, the earlier English examples are from the southern province, but the idea of the rectangular termination, and the liturgical arrangement which they were designed to accommodate (as Hearn has subsequently argued), were promoted in the province of York by Roger of Pont l'Eveque, Archbishop between 1154 and 1181.[20] The rectangular termination at Byland, built probably c. 1165–75, has received a lot of attention and has been generally related to Ripon Minster, but the central role which the new choir at the Cathedral at York itself must have played in setting this distinctive trend has not yet received the treatment it deserves. There is no reason to doubt that the rebuilding work at the choir of York Minster had started by the mid-1160s and that the ground plan was already set out by this date. Although the details of the undercroft of the Minster choir, which is the only part to survive intact, are rather backward-looking (with heavy columns of the Durham type, albeit enlivened with shafts en-délit), what is known of the upper parts of the choir proper suggest that it was of a much more advanced design, with compound piers, deeply moulded pointed arcade arches and waterleaf and chalice capitals.[21] In fact, as has been observed, its appearance may have been quite similar to the surviving choir at Ripon, the only near-complete work of Roger of Pont l'Eveque which has come down to us and which was probably begun about 1175.[22]

Our knowledge of the choir at Holy Trinity is probably too limited for it to be crucial in this important debate about the origin of the northern Gothic and about the centrality of the Minster choir. Here I propose merely to highlight the similarities between the Holy Trinity choir and others in the group with the aim of establishing it as a member of that group. First, Holy Trinity has the familiar rectangular eastern termination similar to the others in this group. Our knowledge of the east wall is too imperfect to allow us to say for certain that it was a cliff-wall east end as has been suggested at the Minster rather than a single storey ambulatory of the type which existed at Byland, but the former is perhaps the more likely. The plan of the surviving sub-bases at Holy Trinity can also be paralleled by some of those in the undercroft of the Minster choir and indeed by those in Transitional buildings elsewhere (e.g. Temple Church, London). Secondly the details which have survived from the Holy

Trinity choir all find their closest parallels within this group. In particular, the chalice capitals, the waterleaf capitals with tightly rolled tips to their leaves (or with no rolled tips at all), the vault ribs, and the shaft bases with their extended and flattened lower *tori* which are often bound with a vertical fillet — all these are details which can be directly paralleled in both John Browne's engravings of the architectural details of Roger's Minster choir[23] and in the surviving fragments which have reappeared all over York in recent times.[24] Furthermore, a case can be made that much of the work of the so-called 'Yorkshire Romanesque School' of sculpture also owes its patronage to the cosmopolitan churchmen attracted to the Minster by Archbishop Roger[25] and certainly much of the acanthus sculpture in Roger's choir is directly comparable with the fragments from the Holy Trinity doorway. The architectural moulding fragments also find parallels in most other members of the group. For example, B in Fig. 5 finds exact parallels in the rerearches of the south-west tower windows at Old Malton Priory, whilst the waterleaf capitals (A and B in Fig. 4) without rolled tips to their leaves were found in the late 12th-century infirmary cloister at Rievaulx Abbey.[26]

THE CROSSING AND NORTH TRANSEPT

Further confirmation that the Holy Trinity choir should be dated *c.* 1170–90 can be gathered from the western crossing piers. Both north-west and south-west crossing piers survive almost up to the springing of their arches, although they have been somewhat disguised by later alterations. The crossing was a space of some 23 ft sq. and the crossing tower above was usually referred to as a *campanile*. These references also refer to its collapse in a storm in 1551, after which bells were amongst items presented to the Court of the Surveyors General,[27] so we can safely presume that it was a central bell tower. However, the form of the crossing piers, which are undecorated on the sides facing towards the central vessel but decorated on the other three, make it clear that, at Holy Trinity as at many other Benedictine houses, the choir stalls extended through the crossing and into the eastern nave. This being so, the bells were probably rung from an upper chamber, as in any other arrangement the bell ropes would hang down between the choir stalls. We can presume, then, that the tower was not only large on plan but also of some considerable height. There are no signs of substantial damage to the nave arcades adjoining the crossing, so when the tower fell in 1551, it probably fell towards the east, on top of the choir. The eastern arm had evidently gone by 1603 and we have seen that already by 1562 buildings may have covered at least a part of its site. It may be that the fall of the central tower so damaged the choir that during the early 1550s much of what remained was removed, even though stone was still being taken from the site as late as the Restoration.[28]

 The jambs of the surviving north and south crossing arches are decorated with paired half-shafts constructed in courses with the piers. The half shafts are separated and side by side, and this feature reminded Brook, and others subsequently, of the crossing of St Bartholomew's, Smithfield and consequently the crossing tower was dated to *c.* 1100. This cannot be the case, however, because these half-shafts have bases of the same type as those excavated in the choir, with extended lower *tori* bound by fillets and overhanging their sub-bases (which have their upper edges dressed with a hollow chamfer). The plinths on which the piers stand are also clearly of later 12th-century type with an angle roll following closely the section of the pier above. These must be bases of the 1170s–80s and must indicate that this crossing tower was built in the same campaign as the choir itself. Although paired shafts of this type do look somewhat archaic in this Transitional context, exactly similar shafts are found in the *in situ* parts of Roger of Pont l'Eveque's undercroft at the

Minster (in the western responds of the main arcades for example), where similar roll mouldings along the edges of plinths also occur. The crossing piers, therefore, provide yet another stylistic connection between the choir and crossing at Holy Trinity and the Minster choir.

It is not clear how the new choir and crossing at Holy Trinity related to the presumed earlier churches on the site. Evidently transepts were intended in the new church of the 1170s–80s but there is no evidence to indicate whether such transepts were to be replacements of earlier ones. Similarly, no information was recorded during the investigations at the turn of the century regarding the shape, character, or location of any earlier structures on the site of the present nave, although it is likely that there was some older structure here to which the new choir was (temporarily) attached before the present nave was constructed.

Before the nave was built (or rebuilt), however, we can observe a marked gap in the building programme of some ten or twenty years and when work did resume, probably c. 1200, it was in a new style. This second campaign included the arch into the north transept, the five bay nave and the west front, perhaps the south transept and parts of the cloister including the cloister arcade.[29] It is possible, indeed, that work went ahead on the conventual buildings during the temporary halt of work on the monastic church and that the church was finished only after the conventual buildings were substantially complete.

The north transept is now represented only by the single respond which is clearly a later addition to the north face of the north-west crossing pier. The respond is identical to those in the nave — a half octagon with a simple moulded cap and a water-holding base standing on a broad square sub-base. But what does the respond represent? Is it the southermost element in a west arcade in the transept or is it merely the southern respond of the arch from the nave north aisle into a transept without a western arcade? Brook and Solloway excavated here in March 1904 and stated that they had found evidence that the transept had a western aisle.[30] However, once the sketchy records are collated, there appears only a single drawing of the critical trench. Where Brook stated several times afterwards that he had found evidence for a pier base, the drawing shows only a badly damaged mass of masonry which had been disturbed and robbed during subsequent grave-digging. There are no records at all of any excavations in the area of the supposed northern respond of the arcade. The trench following the north wall stopped just short of the critical point and once again the central part of the north wall was clearly damaged by grave-digging. Brook did, however, recover the position and fabric of the respond to the eastern arcade, which seems to have survived in much better condition, no doubt due to its position right on the boundary of the post-Dissolution graveyard and half underneath the rectory garden wall. This garden wall, however, had not protected the presumed pier base in the centre of the east arcade — the masonry here was badly robbed, and although we have enough information to calculate the pier's position, we have no evidence for its shape. In between this pier and the north respond the excavators came across a mass of mortared rubble lying east–west, below what they considered to be floor level. Once again the records are poor and the feature somewhat damaged, but given its size, shape and position (in front of a transept chapel altar) it may have been the substructure for a tomb of some sort, or even the remains of a mortared cist. But equally it might have been part of the foundations of the earlier transept sealed below later fabric.

Neither Brook nor Solloway seem to have been as proud of their 1904 investigation as they were of that in the rectory garden in 1899. There are only two photographs and one watercolour recording the event in the notebooks and the records are much less detailed and coherent. They may have been disappointed by their discoveries. By contrast with the choir,

here they found badly damaged or robbed walls, which had to be teased out between the burials in the still-active graveyard. They could not follow their walls for the satisfying distances possible in the choir both because of the graves and because of the churchyard pathways and garden walls which restricted the site. The notebooks convey no sense that Brook understood what he had found here (as he had in the choir) and, because of this, we should look critically at all the evidence for the plan and the date of the north transept. Despite Brook's and Solloway's statements, no satisfactory evidence was *recorded* for the transept having had the western aisle which has been shown on all subsequent plans. Western transept arcades are unusual at any date in even the most significant churches and the records of the 1904 dig can, and probably should, be interpreted in a much more orthodox way — i.e. the masonry which Brook interpreted as the base of a pier in a western arcade is better interpreted as the damaged and robbed foundation for the west wall of a conventional transept without a western aisle, at least until further information is forthcoming.

But if we do away with the theory that the surviving respond represents an arcade, by suggesting it is merely part of the arch from the nave north aisle through the west wall of the transept, then we can no longer use the respond to date the transept, because it would be merely an alteration to a pre-existing transept necessitated by the new nave. Thus, we must also be aware that the transept, need not belong to the *c.* 1200 campaign either. We can't really pursue the date and plan of the transept any further, without better quality information than we have to hand, although we would be unwise to propose an unusually large transept with a western aisle or to make dogmatic statements about its date.

THE NAVE

The five-bay nave of the priory church was used (either in whole or in part) throughout the medieval period as the parish church of St Nicholas and it is because of this parochial use that it survived the Dissolution.[31] It has not come down to us intact, however. Prior to 1682 (perhaps during the recorded repairs in 1625,[32] the aisle walls, triforium and clerestory were demolished and the north and south arcades and western crossing arch were walled up to create a small, low, but serviceable box (Pl. XVIA). At some time, presumably when the upper storeys of the nave were removed, the medieval west front was also demolished (leaving only enough masonry as would buttress the north-west tower on its south-west side). The building survived in this condition until the dingy south aisle was added in 1849–50, followed by the gloomy chancel in 1886–7.[33] The extensive restoration work undertaken by Charles Hodgson Fowler, under the guidance of Solloway and Brook between 1904–6, was concerned mainly with the rebuilding of the west front, the re-establishment of the western bay of the medieval nave and with the reconstruction of the north aisle. The notebooks do not contain very detailed records of the excavation work done at this time — although they contain many more photographs (by this time it seems that Brook's brother Stanley had acquired a camera), there are fewer sketches and measured drawings.[34] It is clear, however, that Brook excavated in both the western bay of the nave and in the area now occupied by the north porch (i.e. in the medieval north aisle) and that he maintained a watching brief over the contractors as they lowered the floors in the remainder of the nave. In fact much of what he discovered during these exercises could have been surmised from the surviving fabric. He did, however, discover the remains of an elaborate doorway of two orders in the second bay from the west in the north aisle and from the *in situ* shaft-bases and from other fragments he was able to reconstruct the fine doorway of *c.* 1220–30 which is now the outer door of the present porch (Pl. XVIID).[35]

At the west end Brook dug trenches both inside and outside the surviving north jamb of the large west door, although he found little which was unexpected. The west door north jamb was completely replaced by Hodgson Fowler, but it is clear from Brook's records that it is an almost exact copy of what had been there before.

Brook also began the campaign (which only ended some twenty years ago) to purchase a strip of land around the northern and eastern sides of the north west tower, and to remove the lean-to sheds which had been built up against it following the Dissolution. Once these buildings had been removed it proved possible to open up and restore the two original early 13th-century lancets which originally lit the north western corner of the north aisle but since the construction of the parish belfry over this corner of the aisle in 1453 have lit its lower chamber.

Once the restoration of 1904–6 was complete it was again possible to appreciate the solid grandeur of the nave with its blocky octagonal piers sitting on their slight water-holding bases, yet supported by their massive square sub-bases. The simplicity of the design is continued by the minimal mouldings in the octagonal capitals and the simple chamfering in the arcades. A simple horizontal string passes over the very slender shafts marking the bay divisions and no doubt originally answering ties in the roof. Neither the nave nor the aisles seem to have been vaulted.

For the upper parts of this elevation we have to draw our information from the one surviving bay at the west end on the north side (Figs 6 and 7). Here, the fact that the parishioners of St Nicholas built their 1453 bell tower on top of the north-west corner of the north aisle has meant that the complete nave elevation has been preserved in this one bay because it doubles as the southern wall of the tower. This whole elevation was left outside after the west front had been demolished in the 17th century and it suffered from exposure to the weather (Pl. XVIIIA) until the restoration of 1904–6 when the lower parts were again taken inside the building. Now the triforium can be seen from inside the nave but the clerestory can only be inspected from the new nave roof.

In marked contrast to the main arcade, the detailing on the clerestory is profuse. It consists of three equal arches, moulded, shafted and decorated with nailhead, which occupy the whole available space in the bay (Fig. 7). On the exterior elevation, however, there is only one window opening (again with moulded head and shafted jambs) which corresponds to the central opening in the internal arcade, although separated from it by a broad clerestory passage.

Unfortunately the triforium in this westernmost bay of the nave may not help in establishing the original nave elevation because this bay is probably not representative of the triforium in the remainder of the building. Prior to the construction of the tower in 1453 the north-west corner of the nave seems to have had a most unusual feature at triforium level — an upper floor chamber. This feature was first described by Brook in his main published work on the church.[36] The evidence for an upper chamber over the western end of the north aisle is in three parts (illustrated in Fig. 6). First, rising behind the attenuated blind arcade at the triforium level when viewed from the nave is a clearly contemporary relieving arch. The same relieving arch can be seen through the wall in the north elevation and the remains of the springing of a corresponding arch are visible in both north and south sides of the wall in the eastern spandrels of the second main arcade bay from the west. These relieving arches obviously indicate a desire to strengthen the nave elevation at triforium level in these first two bays. Furthermore it is likely that the simple design of the triforium arcade at this level also reflects the need for structural solidity at this point — it has been reduced in size to occupy only about a third of the available space and is merely a superficial decoration of the blank wall. We should not take this design as representative of the remainder of the nave

FIG. 6. Holy Trinity Priory, York:
nave north elevation. This is a
reconstruction of the western end of
the north face of the main elevation
showing the position of the first floor
chamber over the north aisle. Note
the blind arcade (now partly
concealed in the later north-west
tower) and the location of the east
wall supported on the corbel on the
second pier from the west
Drawing: author

FIG. 7. Holy Trinity Priory,
York: nave north elevation.
This is a reconstruction of the
western end of the south face
of the main elevation
Drawing: author

triforium level. Secondly, on the north side of the wall at triforium level, now visible in the
first floor chamber of the tower, is a blind arcade of much the same type as that in the
triforium proper (and with similar mouldings) except that it runs continuously along the
surviving wall and clearly continued into the next bay to the east. This arcade would have
originally been of sixteen arches within the first two bays of the nave and was evidently
intended to decorate the south wall of a chamber above the north aisle roof (it can have no
other function). Thirdly, evidence that the chamber only occupied the space over the first
two bays in the aisle is provided by the capital of the second pier from the west in the north
arcade which has a large corbelled extension on its northern side to take a major arch across
the north aisle at this point. This arch would, presumably, support the eastern gable end of
the chamber.

Whilst there can be little doubt that the chamber existed until it was replaced in this position by the tower in 1453, it is more difficult to guess at its original use. Comparably elaborate chambers over the aisles of churches are rare but there are other examples such as St Mary's Beverley or St Mary the Virgin, Oxford, both, however, non-monastic contexts. Perhaps the closest parallels are the chambers over the western ends of the nave aisles at Much Wenlock and Brinkburn Priories. The chamber at Brinkburn is imperfectly known (and has now been restored away altogether) but it is uncertain whether this was an original feature, as were those at Wenlock and Holy Trinity or a later addition.[37] Various suggestions have been made for the use of the Brinkburn chamber as a library or a storeroom and the same sorts of uses have been proposed at Holy Trinity. But at Holy Trinity this type of utilitarian explanation is unsatisfactory, first because the chamber was clearly one of some importance to have merited such decoration and, secondly, because it was separated from the remainder of the convent by the parochial nave and would therefore have been an inappropriate and inconvenient site for most monastic domestic purposes.

The chamber at Wenlock was put forward by Rose Graham as a rare English example of an elevated chapel dedicated to St Michael.[38] In her study she noted that Much Wenlock, being a senior daughter of La Charité-sur-Loire, had close connections with an area where similar aerial chapels to St Michael are relatively common, the dioceses of Mâcon and Nevers.[39] Holy Trinity was, of course, the senior daughter of another important monastery from precisely this same region, so, although there is no firm evidence of the aerial cult of St Michael at Marmoutier, it is a possibility that the Holy Trinity chamber might have been intended as a chapel dedicated to St Michael.

But a further possible explanation arises out of Richard Morris' suggestion that the whole purpose behind the donation of the monastery in 1089 to Marmoutier was to make an elaborate act of recognition of the early connections between the pre-Conquest monastery, which Morris notes is the best candidate for that celebrated in Alcuin's famous poem, and Tours, where Alcuin eventually became abbot.[40] If Pagnell's refoundation was itself intended to evoke the monastery celebrated by Alcuin, then it may also be possible that the layout of the refounded priory church should recall in some way Alcuin's famous description of the 8th-century church; *plurima diversis retinens solaria tectis, quae triginta tenet variis ornatibus aras.* 'It has numerous *upper chambers* with various roofs and contains thirty altars with various ornaments' (my italics).

We cannot now tell how this chamber over the western end of the north aisle was expressed on the west front though it was clearly not carried up as a tower, as the first clerestory window on the north side was glazed. The west front was probably a symmetrical design with the central block, corresponding to the nave, pushed forward a metre or so relative to the aisle west walls. This central block was boldly defined by two very large buttresses, the northern of which has survived and contains a newel staircase. The buttress is decorated with a row of three original niches, a pair on the west front and a single one facing north. These niches, now badly decayed, were trefoil-headed — the first time such arch-heads occur in the building. They may have been intended for statuary.[41]

Between the two buttresses at ground level, the large west door was flanked by blind arcading (Pl. XVIIIA), which was not restored as separate bays in 1904–6, but was converted into a sedilia. The deeply moulded and shafted jambs of the west door, with their shaft rings and deeply moulded capitals, are all copies of the original jambs, although the moulding sequence in the head is the invention of Hodgson Fowler's mason. Brook's calculations of the width of the door and the depth of the jamb led him to estimate, apparently correctly, that, unless the door arch was semi-circular (most unlikely at this date of course) the apex of the arch must have penetrated into the zone above. The main tier of

windows has been restored as three lancets, with two more narrow blind arches in between, and this is probably reasonable. The north jamb of the northernmost lancet survived to be recorded by Brook and the sill levels, shafting and interior dog tooth are all replicas of what had survived. We have no information about the upper part of the elevation, although we can probably presume that it was occupied by a pair of lancets.

The west front obviously represents the latest architectural design and detailing in the building. It clearly belongs in spirit with the elaborate clerestory and, in its employment of bands of large, fleshy, pointed dog tooth it is closely related to the north door. The west front, clerestory and north door, with their profuse decoration, are mature Early English in style and appear conceptually different from the solid, dignified, arcades. There are also clear differences in the mouldings used in the bases and in the shapes of the sub-bases which make the two parts easy to distinguish. The differences are sufficiently marked to allow the suggestion that the nave, although begun perhaps *c*. 1200 (or even slightly before), was not finished until well into the 13th century. It may not have been completed until the 1240s, as there are several references to the donation of oaks between 1235 and 1250, and the Abbot of Marmoutier took the highly unusual step of making a personal visitation of the monastery in 1237; an event which might have been connected with a consecration of part of the church.[42] It seems possible then, that there was a gap both in date and in design between the building of the main arcade designed *c*. 1200 and built soon after, and the upper parts of the elevation and the west front, which are probably of the 1220s or 1230s.

The source for the design of the lower parts of the nave elevation, should be sought amongst buildings such as the western extension to the nave at Tynemouth Priory, the nave at Calder Abbey, the crossing and nave at Lanercost Priory, the nave at St Cuthbert's Darlington and Brinkburn Priory, all of which belong to the generation between 1190 and 1220.[43] All of these buildings share with Holy Trinity an interest in simple octagonal piers with minimal capital and base mouldings and double or triple chamfered arches. The piers all stand on very pronounced sub-bases, although only certain of the sub-bases at Brinkburn and Lanercost are square in plan like those at Holy Trinity. These buildings all have simple elevations with pronounced horizontal stresses and reduced or non-existent vertical bay divisions. This group of buildings, then, provide a marked contrast with the flamboyant 'proto-gothic' of the previous generation to which the Holy Trinity choir belonged. The connecting thread may be simply that these are all moderate-sized houses compared with the first rank institutions of the previous generation and so this architecture of austerity might just represent economic prudence. But we should, perhaps, bear in the mind the possibility that it represents an aesthetic reaction to the profusion of the northern proto-gothic before a decorative tendency gets underway once again with the mature Early English style.

The second phase of work on the nave at Holy Trinity, including the clerestory, north door and west front, belongs to the mature Early English style and, as the priory choir had done, it takes its decorative ideas directly from the Minster. The clerestory with a row of equal arches filling the whole of the available space in each bay is an obvious expedient in buildings without vaults (it occurs, for example, at Whitby Abbey during these years), but the design is shown to perfection in the Minster transepts. Several of the details used on the west front at Holy Trinity are in fact directly borrowed from the Minster transepts of *c*. 1220–40. Both Minster transepts employ a similar enlarged dog tooth to that used at Holy Trinity and the north transept (but not the south) also has decorated string-courses using a zig-zag design of alternating laurel leaves. This rather unusual motif turns up in the decorative niches on the west front of Holy Trinity and confirms the connection between the two buildings in the 1220s and 1230s.[44] Many other parallels can be drawn for the second

phase of work on the nave at Holy Trinity but there is a particularly close resemblance with the north transept at St Augustine's Hedon (Pl. XVIIIA). Not only do the two buildings share a similar disposition of lancets, but both have a central door rising up into the register of lancets above. Furthermore, both have almost identical trefoil-headed niches in the enlarged buttresses and the north doorways in both buildings are virtually identical. But the motif of the central door rising up into the register above could be derived from the Minster south transept south door (which, prior its restoration in 1871–80, was surmounted by a gable which broke the sill line of the windows above) and other details (the trefoil-headed niches for example) could also owe their origin to this dominant source. The north transept at Hedon, however, does give a clear idea of the original appearance of the west front at Holy Trinity (although the gable at Hedon is also renewed) and the correspondences of design and detail are so close that the two buildings must be closely related.

CONCLUSION

The rediscovery of the notebooks recording the excavations and restorations undertaken between 1895 and 1910 allows us to re-evaluate the standing remains of this medium-sized monastic church. It cannot compete with the senior Benedictine house in York for prominence but we can now say that both its choir of the 1170s and 1180s and its nave of a generation or two later were in touch with, even if not in the forefront of, the most advanced architectural ideas in contemporary Yorkshire.

ACKNOWLEDGEMENTS

I am grateful for help on specific points from Dr E. Cambridge, Dr G. Coppack, Mr R. Morris and Dr D. Tweddle. Prof. Barrie Dobson helped a naive post-graduate enormously with his support and understanding whilst Dr C. Wilson inaugurated, supervised and encouraged the work at every turn; this paper owes him a considerable debt. I would also like to record my gratitude to the Rev. H. Fall, sometime rector of Holy Trinity who gave me free access to the church and other buildings and to my wife, Dr M. Stocker, who helped with virtually everything.

REFERENCES

1. The most important published accounts of the buildings are J. Solloway, *The Alien Benedictines of York...* (Leeds 1910) (hereafter Solloway 1910); Royal Commission on Historical Monuments, *The City of York Volume III. The City South-west of the Ouse* (London 1972) (hereafter RCHMY III); W. H. Brook, 'A Survey of the Existing Remains of the Priory Church of the Holy Trinity, Micklegate, York', *The Reliquary*, January 1895, 26–32; (W. H. Brook) 'Holy Trinity Priory', *Archaeol. J.*, XCI (1934) 376–9; D. A. Stocker, 'An Architectural and Archaeological History of the Benedictine Priory of the Holy Trinity Micklegate, York', unpublished MA thesis, University of York, 1979 (hereafter Stocker 1979). The paper is a substantially rewritten version of the last.
2. In particular there have been three recent contributions: D. Palliser 'York's West Bank: Medieval suburb or urban nucleus?'; *Archaeological Papers from York. Essays in honour of M. W. Barley*, eds P. V. Addyman and V. E. Black (York 1984), 101–8; R. K. Morris, 'Alcuin, York and the Alma Sophia', *The Anglo-Saxon Church, Papers on History, Architecture and Archaeology in honour of H. M. Taylor (CBA Research Report 60)* eds R. K. Morris and L. A. S. Butler (London 1986) 80–9; L. P. Wenham, R. A. Hall, C. M. Briden and D. A. Stocker, *St. Mary Bishophill Junior and St. Mary Castlegate (The archaeology of York Vol. 8/2)* (London 1987).
3. Stocker 1979, Chs 2 and 3; *The Victoria History of the Counties of England, The County of Yorkshire, City of York*, ed. P. M. Tillott (London 1961), 360–1, 374–6; Solloway 1910, Ch. 1; J. Solloway, 'The Monks of Marmoutier', *Annual Report of the Yorkshire Archaeological Philosophical Society*, 1903, 57–83 (hereafter

Solloway 1903), 28; T. Stapleton, 'Historical details of the Ancient Religious Community of Secular Canons in York prior to the Conquest of England, having the name of the church of the Holy Trinity...', *Memoirs illustrative...of the Annual Meeting of the Archaeological Institute of Great Britain and Ireland held at York July 1846...* (London 1848); K. Harrison, 'The Saxon Cathedral at York', *Yorkshire Archaeological Journal*, 39 (1956–8), 436–44.

4. D. Matthew, *The Norman Monasteries and their English Possessions* (Oxford 1962). The best account of the documentary history of Holy Trinity will be found in Solloway 1910. See also *VCH* (op. cit. note 3).

5. University of York, Institute of Advanced Architectural Studies Library, Cat. 941.274 and their 'Index' by D. A. Stocker, Cat. 941.274(a). Hereafter referred to as 'Brook Notes'. These notebooks were first brought to my attention by Dr C. Wilson who supervised my work on them in 1978 and for whose help in this whole project I am most grateful.

6. W. Foot-Walker, *W. H. Brook, Architect of York 1864–1943. A catalogue to exhibition at Byre Art Gallery, Glaisedale, North Yorkshire, April–May 1975* nd. (1975).

7. University of York, The Borthwick Institute of Historical Research, Hodgson Fowler Papers HF/3, 1–205; Brook Notes passim. W. H. Brook, 'Notes on the Fabric of the Priory Church of the Holy Trinity, Micklegate, York', unpublished notes dated 14 June 1933, York Public Library, Y/492.7411.

8. J. H. Harvey, 'The Fire of York in 1137', *Yorkshire Archaeological Journal*, 41 (1963–6), 365–7.

9. W. G. Collingwood, 'Anglian and Anglo-Danish sculpture at York', *Yorkshire Archaeological Journal*, 20 (1909), 149–213. I am grateful to Dr D. Tweddle for his comments on these fragments.

10. Solloway 1910, 14.

11. The most useful account of these buildings is contained in RCHMY III, 109, though some details need to be revised in the light of Brook Notes, III.

12. J. Solloway, '"Jacob's Well", Trinity Lane, York', *Reports and Papers of the Associated Architectural Societies*, 26 (1901–2), 529–37. Brook Notes, III, ff. 20–32.

13. Brook Notes, II, f. 30v. Solloway says (1903, 28) that five piers were uncovered. One photograph (Borthwick Institute RXii HTM51) shows a hole dug over the position of the third pier from the west in the south arcade but does not show what was found in it.

14. Brook Notes, II, f. 36v–37r; Solloway 1910, 15; RCHMY III, 13.

15. These fragmens are catalogued in detail and discussed in Stocker 1979, Appendix: 'A catalogue of a group of stone fragments in and around Holy Trinity Priory, Micklegate, York' (pp. 95–135).

16. For the relationship of St Nicholas to Holy Trinity see Stocker 1979 Ch. 8. The document, from the Register of Archbishop Booth (f. 385r), granting the parishioners permission for the new building is printed in the *Surtees Society*, LVII (1871–2), 273, and is discussed at length in Solloway 1910, 268 ff.

17. These are mainly wills discussed in A. Raine, *Medieval York* (York 1955), 227–30. They include those of John Bempton (1446), Alan Robynson (1459/60), Henry Morton (1466) all of which leave money to the fabric of the new choir. In 1471 the convent sold a large quantity of lead to the Minster (Solloway 1910, 283) which may indicate that work was drawing to a close by this date.

18. Stocker 1979, Appendix, section 3.

19. M. F. Hearn, 'The Rectangular Ambulatory in English Medieval Architecture', *Journal of the Society of Architectural Historians*, XXX (1970), 187–208.

20. M. F. Hearn, *Ripon Minster; the Beginning of the Gothic style in Northern England. (Transactions of the American Philosophical Society), 73, part 6* (1983), section 3.

21. The main participants in this debate in recent years have been P. Kidson, P. Murray, and P. Thompson, *A History of English Architecture* (Harmondsworth 1965), 69–70; P. Fergusson, 'Byland Abbey: the South Transept Elevation', *JBAA*, 37 (1975), 155–76; *idem. The Architecture of Solitude: Cistercian Abbeys in Twelfth Century England* (Princeton 1984); M. F. Hearn, op. cit. (note 20 above); C. Wilson, 'The Cistercians as "Missionaries of Gothic" in Northern England', *Cistercian Art and Architecture in the British Isles*, eds C. Norton and D. Park (Cambridge 1986), 86–116; S. Harrison and Paul Barker, 'Byland Abbey, North Yorkshire: The West Front and Rose Window reconstructed', *JBAA*, 140 (1987), 134–51. A useful summary of the debate will be found in L. Hoey, 'Piers versus vault shafts in early Gothic architecture', *Journal of Society of Architectural Historians*, LXV/3 (September 1987), 241–64. The available evidence for dating the work at the Minster choir is in E. A. Gee, 'Architectural History until 1290', *A History of York Minster*, eds G. E. Aylmer and R. Cant (Oxford 1977), 121–7.

 The details of the architectural history of the upper choir remain to be gleaned and correlated using the four principal sources. First, there are the accounts of the excavations following the fire of 1829 and (especially) the plates illustrating the architectural fragments found then, in J. Browne, *The History of Metropolitical Church of St. Peter, York*, 2 vols (York 1847). Second, there are the results of several excavations undertaken in the late 1960s and early 1970s by the Minster Archaeology Unit. These are unpublished as yet but the important collection of architectural fragments from the choir can be viewed in the storeroom of the Yorkshire Museum. Also of importance is the collection of approximately 200 pieces from the excavation on

the site of the College of the Vicars Choral (excavated between 1973 and 1981 by York Archaeological Trust). It seems that when the major college buildings were being rebuilt in stone at the end of the 14th century the Vicars obtained large quantities of rubble from the demolition of the Minster choir, then taking place just across Goodramgate. These pieces have been written up but the report is still awaiting publication (D. A. Stocker, 'The Architectural Evidence', *Excavations at the Bedern* (York Archaeological Trust Unpublished Archive Reports). Third, there is much important information to be gathered from the many architectural fragments from the choir which were reused in the fabric of the present Gothic building; not only those which were used as rubble in the foundations and which are now visible in the western crypt, but also those, like the fragments in the eastern crypt and in the Zouche chapel complex, which were reused as architectural features. Fourth, there are many collections of architetural fragments, mostly in gardens, dotted in and around York which contain significant fragments both from the choir and from Archbishop Roger's palace hall — an important related building. Most of them are fragments removed from the·fill of the 12th-century undercroft after the first fire of 1829, when worked stone was evidently dispersed by the cartload. The more important groups of these fragments are probably those still in the vicinity of the Minster, in the gardens of Grey's Court, the Deanery and the Purey-Cust nursing home, but there are several other collections including that in the garden at Myton Hall. All these sources must be used in any attempt to reconstruct the appearance of the upper choir; there is little point in dealing with any single source in isolation. A single account employing all the evidence is badly needed. Until such an account is available any discussion of the origins of northern Gothic or its relationship with Cistercian architecture will be hamstrung.

22. J. A. Cunningham, 'The Architectural patronage of Hugh du Puisset and Roger de Pont l'Eveque', unpublished MA report, University of London, 1976; M. F. Hearn, op. cit., note 20.

23. J. Browne, *The History of the Metropolitical Church of St. Peter, York* , 2 vols (York 1847).

24. Chalice capitals, waterleaf capitals of these types and bases with flattened lower *tori* were found in both the recent excavations at the Minster and at the College of the Vicars Choral, and can be found in several of the garden collections (see note 21 above).

25. E.g. L. A. S. Butler, 'The labours of the Months and "The Haunted Tanglewood"; aspects of late twelfth-century sculpture in Yorkshire', *A Medieval Miscellany in honour of Prof. John le Patourel* (Leeds 1984), 79–85.

26. Personal communication from Dr G. Coppack.

27. 'The Breviary of John Vavasour', York Minster Library MS xi M.10; *Acts of the Privy Council 1552–4*; Solloway 1910, 322.

28. Stocker 1979, Ch. 4 note 50. Masonry taken from the site included the fine late 12th-century door purchased by Sir Arthur Ingram in 1630 and still to be seen reset in the facade of the Ingram Almhouses in Bootham. It is not known from where on the site this doorway came, but an origin in the claustal buildings is perhaps most likely. RCHM, *The City of York Vol. IV*, 49–50, also C. Gilbert, 'Ingram's Almshouses York', *York Historian*, 1 (1976), 31–5.

29. A double capital, simply moulded and almost certainly from the cloister arcade, came to light during the excavations in the nave in c. 1904. This capital dates from c. 1200 (Stocker 1979 appendix section 2, no. I.xiv).

30. Brook Notes, ii, f. 94v., f. 97r. etc.; Solloway 1910, 16.

31. See the analysis of the apparently conflicting evidence for the site of the parish church of St Nicholas Micklegate in Stocker 1979. Ch. viii.

32. Borthwick Inst. Cause Papers 1625 (CPH/1753) lists contributors to the unspecified repairs to the church at that date.

33. Solloway 1910, 29; Borthwick Inst. PRY/HTM, box 44–50.

34. Brook Notes, i, 18–26, 56, 70–3, 114 etc.

35. In addition Brook claimed to have found 'clear evidence' that the north aisle floor was originally raised on a step (as it is, for example, at Brinkburn Priory) York City Library MS Y942.7411. f. 2r. and 2v. There is, however, no evidence at all for his statement in the notebook records.

36. See footnote 1 above.

37. J. C. Hodgson, *A History of Northumberland*, 7 (Newcastle 1904), 454–504; A. B. E. Clark, *Brinkburn Priory (Dept. of Environment handbook)* (London 1982).

38. R. Graham, *Much Wenlock Priory (Dept. of Environment handbook)* (London 1965).

39. Mgr. Crosnier, 'Le Culte Aerien de Saint-Michel', *Bulletin Monumental*, xxviii, 692–700; J. Valléry-Radot, 'Notes sur les chapelles hautes dediées à Saint-Michel', *Bulletin Monumental*, lxxxviii, 453–78.

40. See above footnote 2.

41. In 1978, a hitherto unknown item of figure sculpture was discovered in the church. It is in three magnesian limestone fragments which have been recently broken and which, together, make up a very badly weathered male torso. The figure holds a book in his right hand and a wand or sword in his left and may have represented an apostle or a prophet. The drapery suggests a date around 1200 and it bears general comparison with the

figures from St Mary's Abbey, York (C. Wilson, 'The original setting of the Prophet and Apostle figures from St. Mary's Abbey, York', *Studies in Medieval Sculpture*, ed. F. H. Thompson (London 1983), 65–78, note 17). The flattened back and its differentially weathered condition suggested that the statue was set in an exterior position, perhaps in a niche. The piece was found by the author in a cleaner's cupboard — there is no information regarding how it came to be there and, strictly, there is no evidence to confirm its connection with Holy Trinity. The sculpture is now undergoing conservation.

42. *Calendar of Close Rolls 1234–7*, 315, 432; 1237–42, 264; 1251, 270; 1254–6, 140; Dom. E. Martene. 'Histoire de l'abbaye de Marmoutier...', *Mémoires de la Société d'Archéologie de Touraine*, 2 vols (Tours 1876), 212 etc.

43. For Darlington see J. A. Cunningham, 'Hugh of le Puisset and the church of St. Cuthbert Darlington', *Medieval Art and Architecture at Durham Cathedral (BAA CT 1977)* (London 1980), 163–9. For Tynemouth, R. N. Hadcock, *Tynemouth Priory and Castle (Dept. of Environment handbook)* (London 1952). (Although the plan in this booklet marks the nave extension as 1220–50, the text implies — as the evidence indeed suggests — that the extension is contemporary with the presbytery i.e. of *c.* 1200. I am grateful to Dr E. Cambridge for his help with this point). For Brinkburn see footnote 36 above. For Calder Abbey the basic account is still N. Pevsner, *The Buildings of England; Cumberland and Westmorland* (Harmondsworth 1967), 84–7. For Lanercost Priory a general account is contained in J. R. H. Moorman, *A Guide to Lanercost Priory* (Carlisle 1945).

44. The motif also occurs on the west fronts of Darlington and Lanercost, where again the profusion of decoration on the west fronts is in contrast with the simplicity of the naves behind.

The 13th-Century Choir and Transepts of Rievaulx Abbey

Lawrence R. Hoey

The 13th-century choir and transepts of Rievaulx Abbey are the best preserved and visually most impressive part of one of the most important monastic sites in Britain. Whether seen from the bottom of the Rye Valley, towering above the less well preserved remains of the cloister buildings and 12th-century nave (Pl. XIXA), or glimpsed from the 18th-century terrace above, through tree cuttings specifically sighted on it, the 13th-century east end of Rievaulx commands the attention of all visitors to the site. It is surprising, then, that scholars have paid little serious attention to 13th-century Rievaulx and that a number of archaeological and art historical problems remain unresolved.[1] These include the sequence of construction and the presence of various anomalies in the design that can be explained only poorly through traditional methodologies of diachronic formal progression, problems of reconstruction involving particularly the flying buttresses, the historical motivations behind the rebuilding, its date, and its larger significance within the context of the Early English Gothic style in the north. This essay can hardly hope to offer definitive answers to all these questions, but hopes at least to open the discussion.

Rievaulx was founded in 1131 as the first Cistercian house in the north of England. It was founded directly from St Bernard's Clairvaux to be the advance guard of a general Cistercian colonisation of the north.[2] The importance of its 12th-century church for Cistercian architecture has been the subject of several recent scholarly investigations and need not be reiterated here.[3] The 12th-century church had a typical Cistercian plan, with an aisleless, square-ended presbytery, transepts with three eastern chapels each, and a long nave of nine bays. The nave had a two-storey elevation with a simple clerestory without a wall passage set above plain square piers fronting on aisles vaulted with the transverse barrel vaults derived from the Cistercian home territory of Burgundy. The monks' choir would have stood in the crossing and east nave bays, with the lay brothers' choir to the west of it. Although the 12th-century church at Rievaulx was considerably larger than its Cistercian predecessors in England, it was, like them, simply built and austerely decorated as one would expect of a building with such direct connections to Bernard's Clairvaux.[4] There are no signs of any accommodation with the indigenous Anglo-Norman style in the 12th-century church at Rievaulx, in contrast to its successors at Fountains and Kirkstall.[5]

The same cannot be said of the east range of cloister buildings erected at Rievaulx in the middle years of the 12th century where scalloped capitals and more elaborate pier forms begin to appear. By the last decade of the century, when the refectory was reconstructed in its present form, the Gothic style had been accepted by the monks of Rievaulx as it had been in other Cistercian monasteries.[6] The spacious main hall of the Rievaulx refectory is lit by multiple lancet windows set in a delicate interior arcade of *en délit* shafts, foliate capitals, and moulded arches. Nothing could be further from the heavy and unarticulated Rievaulx nave of a half-century before. The size, quality, and up-to-date style of the late 12th-century refectory reflect Rievaulx's position as one of the richest and most populous houses in the north of Britain by 1200.

Nevertheless, it is still something of a shock to turn from the 12th-century architecture of Rievaulx to the early 13th-century rebuilding of the church. The new choir extends a full seven bays from the east crossing piers and was vaulted throughout in stone (Fig. 1). It

boasts a three-storey elevation thickly articulated in the contemporary Gothic style of northern England (Pl. XXA). The size and richness of this work make clear, as does no other surviving church, that the Cistercians had abandoned their early architectural restraint and austerity by the early 13th century.

DESIGN ANOMALIES AND THE SEQUENCE OF CONSTRUCTION

A cursory glance at the 13th-century Rievaulx elevations will not reveal any glaring disparities in design. The three stories are similarly proportioned throughout the building and their heavy articulation with multiple shafts and arch mouldings gives a satisfyingly consistent texture to the entire design. A closer look will show some notable inconsistencies, however. In the choir, the westernmost gallery bay differs from all the others by its possession of an overarch and the vault shafts over the four eastern pairs of piers rise from the gallery sill, while their counterparts over the two western pairs of piers rise from lower corbels in the arcade spandrels (Pl. XXB). In the transepts there is a similar contrast between the east elevations of the north and south arms, the north with the shorter shafts and the south with the longer (Pls XXIA and XXIB). The clerestory designs of these two elevations are also noticeably different, as are their counterparts on the west walls of the transepts.

Faced with such visible differences, architectural historians generally resort to explanations involving chronological changes in master masons or pauses in construction. The aforementioned design changes at Rievaulx can be made to fit such a chronological sequence without too many difficulties, but the careful observer of the Rievaulx fabric will soon find other variations much more difficult to integrate into any coherent scheme of chronologically distinct phases. The presence of these discordant features may lead us ultimately to question the universal validity of the theory that sees changes in design as necessarily the result of a new campaign or master. The least bewildering of these variations is found in the designs of the Rievaulx piers (Pl. XXIIA). The Rievaulx piers are an unusual variant of the northern clustered pier, with finer subdivisions and a more complex outline than is typical. There are two types of pier at Rievaulx: one type (A on Fig. 2) has four filleted shafts in the cardinal directions and a triple group consisting of a keeled shaft flanked by smaller round ones in each diagonal; the other (B in Fig. 2) has the same diagonal groups, but the cardinal shafts are more sculptural, with the appearance of a fillet sunk between two round shafts. The latter type (B) has a round plinth while the former (A) has an octagonal one and in type A the shafts of the pier are contiguous, while in type B they are separated by small hollows. These two pier designs alternate in the five eastern bays of the Rievaulx presbytery, while the simpler pier is used alone for the two western bays of the choir and the east arcades of both transepts. It is worth a preliminary note here that the alternating piers of the eastern arm correspond to the sill-based vault shafts and that the change to uniform piers corresponds to the introduction of spandrel-based vault shafts (Pl. XXA and Fig. 2). In the transepts, however, the equation breaks down, because arcades of uniform piers support walls articulated with both types of shaft (Pls XXIA and XXIB).

The truly troublesome flies in Rievaulx's architectural ointment are its arch mouldings and aisle rib profiles. (The placement of these is best understood by reference to Fig. 2). There are three types of arch moulding at Rievaulx. The predominant form (a) in the choir has a soffit order with two nibbed rolls separated by a central hollow; above each roll is an arris and then a further nibbed roll (Pl. XIXB). The second order exhibits a fillet between two rolls. This motif is a reduced version of the subdivided cardinal shafts of pier B, and is used in other early 13th-century Yorkshire buildings as well.[7] The third order consists of three rolls separated by hollows. On the south side of the choir are two arches (the fourth

and fifth from the east) with an identical outer order, but otherwise completely different profiles (b). The soffits of these arches have three filleted rolls separated by broad hollows (Pl. XIXc).

The transepts use a variant of the main choir arch mouldings, the only difference lying in the second order, where the fillet between two rolls has been replaced by a hollow between two rolls. This subtly different profile (a_1) is used for the outer two arches of both transepts, but for the inner arch springing from the crossing pier the south transept has the standard choir moulding (a) while the north transept has an arch combining a and a_1. This last is an extraordinary affair where the southern half of the arch and the west face of the northern

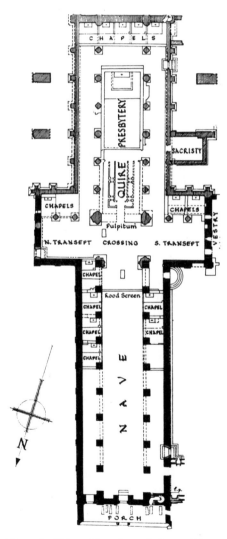

FIG. 1. Rievaulx Abbey. Plan, from C. Peers, *Rievaulx Abbey*
(Courtesy of English Heritage)

half use the standard moulding *a* while the remaining east face of the northern half has the filletless second order of the transepts' a_1. Where fillet and hollow meet at the arch apex the mason has placed an ironic (?) sprig of foliage (Pl. XXIIB).

The rib profiles of the Rievaulx aisles also come in three types (Fig. 1). The most common (1) has a flattened arris between two filleted rolls, a profile reminiscent of the second order of the main arch moulding *a*. This rib was used for all the bays of the north choir aisle, and for the eastern and two western bays of the south choir aisle. The westernmost bay of the latter (the bay common to both choir and transept aisles) is actually as much a hotch-potch as the inner arch of the north transept. One of the four ribs of this bay (or at least its springer, which is all that remains) has a different profile. This is the south-west rib, and its profile substitutes a hollow for the arris of the choir rib. This second rib profile is used consistently for the vaults of the outer two bays of both transepts. The omission of the fillet is of course similar to the transformation of the second arch order that takes place in the transepts. The remaining four bays of the south choir aisle were covered with ribs of three filleted rolls (2), a profile quite close to the soffit of the two aberrant south arcade arches.

These, then, are the changes and variations that must be accounted for in any chronological sequence postulated for Rievaulx. Is such a sequence possible?

Before making the attempt it might be worth reviewing what the only two previous scholars to have treated the 13th-century work at Rievaulx in any detail, William St John Hope and Nikolaus Pevsner, have said about the building sequence. Both Hope and Pevsner place the beginning of construction in the north transept arcade.[8] Hope believed the south transept arcade was begun about the same time, but that the upper south transept is later than the north and in fact was still unfinished when the presbytery was begun at its east end.[9] Hope gives no reasons for this sequence, although he remarks how 'The manner in which the thirteenth-century work replaced the older work piecemeal, instead of the latter being taken down first to make way for it, is exemplified in an interesting manner in the new building.'[10] Pevsner is almost as vague, although he does mention the presence of nailhead in the north and its absence in the south, and that the north arcade corbel has rudimentary stiff-leaf, while the south respond is 'fully developed'.[11] Pevsner also states that the south transept system of wall articulation 'is the later solution and the one adopted in the chancel'.[12] The discrepancy in wall articulation may also lie at the base of Hope's scheme, although neither author is explicit about the implications of this difference for the building sequence.

Putting the beginning of construction in the north transept seems a very odd thing to do. The normal *modus operandi* in such cases of eastward expansion was to lay out the new work beyond the old and to build as much as possible before having to interfere with the old church, which could thus continue to serve the monks' liturgical needs. There was no reason not to follow this scheme at Rievaulx. Furthermore, the junction of 12th- and 13th-century work in the Rievaulx transepts is unusually sloppy. The end walls of both 12th-century transepts survive as high as the sills of the 13th-century lancet windows, and on the north the line between the two builds straggles down to the west of the north-east buttress, crosses it, and peters out a few feet above ground level in the north wall of the north-east transept chapel (Pl. XXIIc). The west walls of the 12th-century transepts are almost entirely preserved, although now topped by 13th-century clerestories.[13] Neither transept arcade ends in a full respond, but in the awkward corbels that Pevsner compared to establish the north's chronological precedence (Pls XXIA and XXIB).[14] All this gives the appearance of being the end, rather than the beginning, of the 13th-century reconstruction, an end perhaps brought unexpectedly and unwillingly on the builders by the shortage of funds.[15] The 13th-century chapel vault in the north transept north-east corner provides another piece of

evidence for the transepts being the last part of the 13th-century work. The east window there is placed too close to the corner shaft and the north side of the window hoodmould gets lost in the web of the vault. The placement of the east exterior buttress at this corner, to the north of the line of the 12th-century transept end wall, suggests that the 13th-century north wall was planned to go slightly to the north of the existing wall, which would have allowed room for the window and chapel vault, as well as for a full arcade respond (Fig. 1). In the event, the 13th-century builders had to effect as quick and economical a junction with the original work as they could. In fairness to Hope, it may be that the amount of rubble still filling the building in 1914 made it impossible for him to see that the slovenly junction between east and north walls in the north transept was unlikely to be the start of an ambitious campaign of reconstruction.

If the evidence of the transepts adduced above suggests a beginning for the new work in the normal place to the east of the 12th-century sanctuary, how can we account for the design discrepancies listed above? For the changes in wall articulation and pier design within the eastern arm the answer is, very easily. We have already seen that the alternating pier shapes of the four eastern bays correspond to the use of sill-based vault shafts. It is easy to see that these are the four bays that could be built while the 12th-century east end was left standing, and to postulate that after the 12th-century sanctuary was demolished and work continued westward the design was changed to one of uniform piers and spandrel-based vault shafts.

The discrepant arch and rib mouldings in the choir are not so easily disposed of, but the following constructional sequence could account for them. First the outer periphery wall was laid out on north, east, and south sides, extending as far as the east walls of the 12th-century transepts.[16] How high these walls rose is impossible to know; very little of them survives except at the east end. Next the four sets of east piers were erected as well as the arches above them, with the exception of the fourth arch from the east on the south side. The aisle vaults adjoining the four north bays, as well as the eastern springers for the easternmost bay on the south side, which shows the same arch profile, could then have been built. It is difficult to say how much of the northern elevation might have been constructed in this first phase; the necessary minimum has to include the arcade spandrels without any vault shafts.

After the eastern parts of the old church were removed, the choir arcades could have been extended west to the crossing piers, with the exception of arches four and five on the south side. Similarly, the aisle vaults on the north side could have been completed to the west, as well as the two western bays of the south aisle, which share their rib profile.[17] It was during this work that pier alternation was abandoned and spandrel-based vault shafts were introduced.

The north side must have remained in advance of the south during this work, because in order to preserve the logical sequence of profiles, the arches four and five of the south arcade and the accompanying four bays of vaulting (2–5) with ribs related in profile to those arches must postdate the establishment of the new patterns of pier rhythm and wall articulation at the west of the choir, as this latter work adheres to the original arch and rib profiles. The builders of Rievaulx may have left this curious gap in the south arcade and aisle as long as possible to facilitate the dragging of stone, wood, and other materials from the masons' and carpenters' lodges which probably lay away from the monastic buildings to the (liturgical) east and south of the new work (as they still do). The narrow valley at Rievaulx would have made this route the only feasible one for bringing up materials and by the time the south aisle arcade and vaults had to be completed so work could proceed, a new master, or at least template, may have arrived on the scene.

The upper stages at Rievaulx show no obvious breaks in stonework, and work must have proceeded in an uninterrupted fashion from east to west, perhaps being completed on the north even before the south arcade was completed. An east to west direction is most clearly demonstrated by the anomalous overarch in the western bay of the gallery (Pl. XXB). Pevsner thought this bay was built first, 'to buttress the central tower', but it seems more likely the opposite is true and that it was the last to be built.[18] Builders in the Middle Ages often had difficulties laying out an accurate sequence of bay lengths while an older building lay in the way of the proposed reconstruction, and the result at Rievaulx was a distinctly shorter western bay.[19] The enclosed gallery arch appears to be a response to this diminution in length. In the normal gallery bays each main arch is articulated in three orders, which results in the centre pier of each bay having to accommodate six shafts. In the western bay the third order is carried over as the enclosing arch, and the two arches beneath are articulated in only two orders, which results in a narrower centre pier with only three shafts. Thus the loss of bay length is accommodated without lessening the thickness of the wall or without losing the consistency of triple shafted outer jambs to each bay. In the transepts, where the bay widths are consistently narrower than in the choir, the two arches per bay are not subdivided and each is articulated in only two orders. Here the 12th-century spacing of the transept chapels in effect determined the 13th-century gallery design.

Although the discussion above may seem to explain the constructional sequence of the Rievaulx choir according to traditional methodologies of linear change, the situation becomes much stickier when we turn to the transepts and try to accommodate their designs in a similar 'logical' fashion. As we have seen, both transepts use the uniform pier of the west two bays of the choir, but their arcade arches lack the second order fillet of the choir arches, and the transept rib profiles differ from their fellows in the choir in a similar manner. As we have also seen, the bays common to both choir and transept aisles, those adjoining the crossing piers, are a muddle with regard to arch and rib profiles. On the north side, the vault ribs in this bay are all identical to those in the choir aisle.[20] This means that the rib springers above the first transept pier north of the crossing accommodate two different profiles (Pl. XXIID). Whoever carved this springer was anticipating a change in moulding, although it is difficult to decide in which direction work was moving. If the new moulding in the transept had been established before the common bay was vaulted one might surmise that an attempt was being made to keep all the vault profiles of the north choir aisle consistent. Against this concern for consistency can be set the variety in the south choir aisle. On the other hand, having the north transept arcade constructed before that of the western choir bays allows one to explain the use of gallery-sill based wall shafts in the north transept. To preserve a linear direction in explaining design change, the spandrels of the north transept must predate those of the west choir bays. That in turn means that the new arch moulding is invented while the old one has still to be used in completing the choir arcade. The mongrel arch (Pl. XXIIB) that bounds the west side of the common aisle bay against the north crossing pier could have come about from either direction: if the transept arches to the north were constructed before it, but there were earlier springers rising from the crossing pier, then whoever cut the west voussoirs decided to match the old springer while whoever cut the east continued to use the new shape. Perhaps the voussoirs had been cut beforehand and it was decided not to waste them. This seems more likely than to assume that while work was moving out from the crossing the master suddenly decided to change template in mid-arch.

In the corresponding bay on the south side of the crossing common to both choir and transept aisles there is a different muddle. Here both north and west arches have the original choir profile, and one could again assume work moving in either direction. The vault of this bay, however, evidently had one rib (the south-west) with the new transept profile, while the

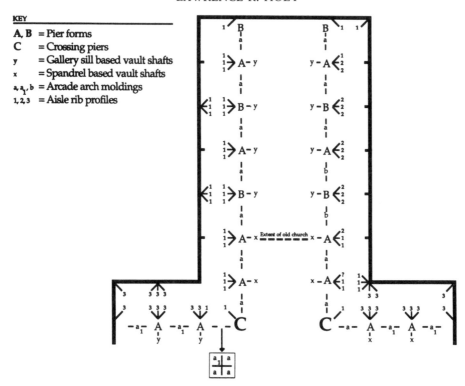

FIG. 2. Rievaulx Abbey. Schematic plan of the east end

other three retained the old choir form (Fig. 2). This is difficult to interpret in any way. If the builders of the south transept were linking up their work with earlier work in the south choir aisle, one would have to assume they didn't care enough about matching the rib profiles to carve a multi-profile springer as they do on the north side, or that they had pre-cut rib voussoirs to use up as they may have had arch stones on the north. In any case, the keystone of this vault must have been a peculiar sight.

So how, after all this, do the transepts fit chronologically with the sequence adduced above for the choir? The easiest model would be to assume construction moving outward from the crossing piers after the completion of the choir. The sloppy junctions of the transept arcades with the 12th-century outer transept walls would support such a sequence, as would the use of a single pier type (already established in the west choir) and the change to a slightly different (simpler, actually) rib and arch profile in the outer two bays of each arm. The reservations expressed above over the inner transept bays would not in themselves be weighty enough to cast serious doubt on this sequence.

What can cast serious doubt on it is the presence of wall shafts of contrasting lengths in north and south transepts (Pls XXIA and XXIB). If we are following a linear sequence to the transept outer walls, we are faced with a conundrum. In order to fit the north transept vault shafts in a linear sequence they must predate those in the west choir, but such a sequence upsets the order of arch and rib mouldings between the north choir aisle and north transept aisle. The sequence of arch mouldings could be theoretically, if improbably, preserved by envisioning the west choir arcade arches constructed without spandrels and presumably still

centred, while the north transept arcade is completed to gallery sill. Even such a tortuous sequence could not explain the change in rib profiles, because the vaults would never be constructed before the arcade spandrels, which serve to weight the arches and provide a firm bulwark against the internal thrust of these same vaults.

So one cannot have it both ways: if construction proceeded from the crossing outward, the north transept wall articulation represents a conscious throwback to an earlier scheme; if the transept arcades predate the west choir, then one has to accept the continuing or revived use of an older template after a new one has come into use.[21] The latter solution might seem preferable because the differences between mouldings are visually insignificant to the average viewer in comparison with the arrangement of vault shafts or gallery openings. The north transept would then predate the west choir, while the south could follow it. The present writer, however, would still prefer a sequence outward from the crossing piers to the outer transept walls. The ackward junctions described above, in the east corners of both transepts but especially the north, are hard to explain in any other way. In addition, the variation in transept clerestory designs suggests the end, rather than the beginning of a campaign of construction, in contrast to the uniform system in the choir. Each of the four interior clerestories differs from the others. The simplest is the west clerestory of the north transept where the single window openings are surrounded by continuous double chamfers. The west clerestory of the south transept adds similarly moulded blind arches on either side of the window openings to form continuous arcades in front of the wall passage. The east transept clerestories show a similar increase in complexity from north and south: the north has a single broad opening in each bay (Pl. XXIA); essentially a contracted version of the main choir clerestory, while the south has side arches to its window arch, all of them ostentatiously articulated with vertical nailhead (Pl. XXIB). All this seems to indicate a simple chronological development from north to south,[22] and indeed it may, but there is, as usual at Rievaulx, a problem with this sequence. This concerns the exterior of the north transept west clerestory (with the simplest interior design) which has two trefoiled blank arches flanking the window openings, the only example of such forms anywhere in the 13th-century work (Pl. XXIIc).[23] The exterior of the south-west clerestory, by contrast, has no blank arches at all, much less trefoiled ones.

Whatever the sequence of construction in the upper transepts may have been, the conspicuous design of the exterior of the north transept clerestory may be the result of a consideration too often ignored in analyses of medieval architecture: relative visibility. The main gateway to the abbey in the Middle Ages was to the (liturgically) north-west of the church and for the visitor descending the steep hill into the valley, the transept west wall would have been the most prominent part of the new church, rising well above the 12th-century nave and lying closer to the viewer than the south transept clerestory, which would have been partially hidden from view by the nave roof. There is no way to prove this theory, of course, but another discrepancy in clerestory design at Rievaulx suggests the same explanation. The exterior of the south choir clerestory (Pl. XIXA) displays blind arches flanking each set of double lancets while the north clerestory exterior omits the blind arches (Pl. XXIIIA). The south side of the choir was visible by monks from the monastic buildings, by visitors from the abbot's house, and by anyone travelling along the valley below. The north side, hard against the steep hill, would have been seen by few people, before the construction of Rievaulx Terrace reversed matters. In both cases the masons may have been working to a specific brief to embellish those parts most in the public view.

The 13th-century church at Rievaulx, then, provides a pointed refutation of the universal applicability of the methodology that sees a linear chronology in changes of detail or design. From the moulding muddles in the bays adjoining the crossing piers, which are impossible

to explain in any linear scheme, to the blatant discrepancies in wall articulation, gallery design, or transept clerestories, the architecture at Rievaulx shows a considerable tolerance for imprecision and variety. Whether the latter was consciously sought at Rievaulx, as in the contrasting transept elevations, pier forms, or vault shaft lengths,[24] is impossible to say. What can be said is that changes and variety in design in medieval buildings must be considered from different points of view, including linear chronological change, a conscious search for variety, relative visibility, or simple carelessness resulting from a lack of overall control, before attempting any conclusions.[25]

THE CHOIR FLYING BUTTRESSES

Before considering the broader historical and architectural context of Rievaulx, there is one further archaeological problem to be considered. The Rievaulx choir was vaulted in stone and these vaults were secured by flying buttresses. Two questions need to be answered: were the buttresses part of the original campaign or added later, and did they originally buttress every bay or only every other bay?[26] Only two flyers survive today, on the north side of the choir between the second and third, and fourth and fifth bays from the east (Pl. XXIIIA). These consist now of only a single course of voussoirs but early photographs show more masonry atop the western one.[27] Presumably, the raking dripmould surviving on the vertical aisle buttress immediately above the passageway opening indicates the original upper limit of flyer masonry ascending, as usual, in a straight line to the clerestory wall.[28] This is the pattern at Lincoln and Beverley (not enough remains at Fountains to draw firm conclusions there). Although it is difficult to tell without accurate drawings, the pitch of the buttress seems steeper at Rievaulx than in either of these buildings. These two flyers survive because they were originally reinforced by another set of lower, secondary flyers, set beyond the aisle walls, whose bases remain on the hill to the north. The canted heads of these secondary flyers also remain embedded in the surviving primary *culées* (Fig. 15). Similar bases for secondary flyers exist in corresponding positions to the south of the choir, but there *culées*, aisle wall, and primary flyers have all disappeared.[29] An additional question to the two posed above concerns these secondary flyers: are they contemporary with the choir or later additions?

To return to the first questions, there is nothing in the masonry of the primary flyers at their junction with the vertical buttresses to suggest they are later additions to the choir. Their junction with the clerestory buttresses is more problematic, however. A number of these buttresses on the north side show shallow mortise-like holes at a consistent height (about five or six courses above clerestory sill line) that matches the height of the two surviving flyers (Pl. XXIIIA).[30] This suggests there were primary flyers originally for each bay, as one would normally expect. Presumably the ends of the arches of the flyers had a knob or tenon to fit into these shallow holes. It is a tenuous connection, however, and there is no sign above the holes of any attachment for the additional masonry above the arches that has now disappeared. Perhaps this was normal practice in constructing English flying buttresses; it is after all impossible to tell how they are attached where they still survive. The evidence of mortise holes against the clerestory buttresses on the south side of the choir, it should be said, is much more ambiguous than on the north.[31] Nevertheless, it seems likely that the Rievaulx choir originally had flying buttresses between each bay and that these were contemporary with the church, making Rievaulx one of those relatively rare English buildings designed from the first with this French feature.

The secondary buttresses appear to be later additions, although it is difficult to say when they were added.[32] It is hard to imagine them as part of the original plan, and their

placement every other bay also suggests they were built to counter some specific deformation. The choir walls probably began to bulge in the centre as a result of vault pressure, where they were not braced by the east facade or the transepts and crossing. Indeed, the walls of the Rievaulx choir continue to lean outwards and have provided modern caretakers with plenty of opportunity for consolidation work, even without the vaults.[33]

HISTORICAL AND ARCHITECTURAL CONTEXT

No documents illuminate the reasons for rebuilding the east arm at Rievaulx or the dates of its construction. Determination of the latter is generally by comparison with other early 13th-century projects in the north with equally fuzzy documentation. While establishing the precise historical situation and absolute dates surrounding the rebuilding at Rievaulx may be impossible, there is much to be gained from an analysis of its design in the context of early Gothic architecture in northern England.

The history of Gothic architecture in England could be illustrated almost exclusively, particularly in its early phases, by the reconstructions and expansions of the east ends of earlier Romanesque churches. From Canterbury, Rochester, or Winchester in the south to York, Hexham, or Carlisle in the north, the fashion for enlarged east ends gave steady employment to master masons working in the new style. Rievaulx fits directly into this broad trend that was characteristic of all the major affiliations: secular, Benedictine, Cistercian, or Augustinian. Reasons for these rebuildings varied; cathedrals, minsters, or Benedictine churches often had patron saints in need of more splendid architectural settings for their shrines, but this was not an issue for Cistercian or Augustinian houses. Two further reasons are frequently cited for expansions in these orders: the need for more altar space for an increasing number of ordained monks required to celebrate mass daily,[34] and a desire to move the liturgical choir eastward out of the nave in order to accommodate larger numbers of monks and (in Cistercian houses) lay brothers.

The need for new altars does not seem to have been much of a motivating factor at Rievaulx because the new choir plan allowed for a net gain of only two altars, against the new east wall. Calculating the number of monks or lay brothers at Rievaulx is impossible for the early 13th century, although we hear of 140 monks and 500 lay brothers under St Ailred at the height of Cistercian enthusiasm in the mid-12th century.[35] While these numbers may be inflated, the years of Ailred's abbacy may well have seen the maximum population of the abbey in the Middle Ages, and given that the east arm was not rebuilt for another 60 or 70 years it seems unlikely that a burgeoning monastic population lay behind the architectural expansion of the early 13th century. It is of course likely that the liturgical choir at Rievaulx was moved into the new east arm directly upon its completion. The choir stalls were certainly east of the crossing at the time of the Dissolution in the 16th century, and it seems *a priori* likely that they had been moved there in the 13th century, but the example of Fountains provides a cautionary note, for there the monastic choir stayed in its old position in spite of the provision of a grand new east end in the early 13th century.[36]

Practical reasons for the architectural expansion at Rievaulx may then have to take second place to the less tangible, but extremely powerful need almost all religious establishments in the Middle Ages felt for a physical embodiment of their own self-importance. Cistercians were of course supposed to be immune to such pride, but by the early 13th century their houses had become rich and powerful, and their architecture had shown signs of departing from an original austerity long before the rebuilding of Rievaulx. Byland Abbey was the seminal building in this regard for the north of England. Begun in the 1170s and complete by about 1200, Byland was longer than any previous Cistercian

church, had an aisled choir with eastern chapels instead of the previously canonical square sanctuary, and was constructed throughout with a three-storey elevation, another first for the Cistercians in England.[37] Its design and detailing was as fashionably Gothic and up-to-date as any building in the north at that date. Byland must have made many a northern Cistercian abbot or Augustinian prior cast anxious glances at the modest structures typical of the 12th-century reform movement. It was an irony, perhaps still well remembered at Rievaulx c. 1200, that during their difficult and peripatetic early history the Byland monks had been forced to move from a site near Rievaulx because their bells had disturbed the latter's inhabitants.[38] The church built by these wanderers had now set a new standard for monastic and even secular churches in the north.

Rievaulx does not follow directly on Byland, however, but on more recent Cistercian projects of the very early 13th century. Jervaulx Abbey, perhaps begun in the 1180s, is important as showing the first 'cliff wall' eastern facade in a Cistercian church, a feature subsequently adopted at Rievaulx.[39] At Meaux, a new church was begun in 1207, and although we know virtually nothing of it Meaux may have been closely related to the most important Cistercian project of those years, the eastern extension of Fountains Abbey of 1204–40.[40] The Fountains reconstruction included not only an aisled presbytery of five bays, but also the famous Nine Altars Chapel extending across the east end of the building as a second transept. Fountains was Rievaulx's greatest rival for Cistercian primacy in the north, and it may not be fanciful to see an architectural rivalry between the houses stretching back almost to their earliest years.[41] The 12th-century nave of Fountains, for example, begun a few years after Rievaulx's, is eleven bays to the latter's nine and has more developed piers, capitals, and arch mouldings. The Fountains east range, dating to the 1160s, is similarly more advanced in detail than the equivalent buildings at Rievaulx of a decade earlier. The Fountains chapter house has some of the earliest Gothic features anywhere in the north, and the refectory of c. 1180 has large lancets and a Gothic spaciousness that may have helped inspire the reconstruction of the refectory at Rievaulx. Whatever satisfaction the Rievaulx monks may have felt in their more splendid and stylish frater could soon have turned to apprehension as the foundations of the ambitious new east arm were laid out at Fountains. Their answer to this latest piece of Fountains architectural bravado may have been the present choir.

Before pursuing this comparison further, two other projects particularly relevant for Rievaulx must be introduced. The first is Kirkham Abbey, an Augustinian house founded before Rievaulx in the 12th century by the same patron, Walter l'Espec.[42] The patronage of the two houses remained linked in the early 13th century under L'Espec's successors, the de Roos family, whose seat was at Helmsley Castle, only two miles from Rievaulx. Robert de Roos, who died in 1227, made Kirkham the burial church of his family, and the rebuilding of its eastern arm may well have been the result of his largesse.[43] To what extent the work at Rievaulx was also financed by Robert is impossible to know, but the common patronage must have made each house well aware of what took place at the other. Kirkham was not the only Augustinian house rebuilding its east end on a grand scale in the first half of the 13th century, and Bridlington and Gisborough must be considered in this comparison as well, however fragmentary our knowledge of their architecture.[44]

The second rebuilding directly comparable to Rievaulx took place at Whitby Abbey at much the same time. Whitby was a Benedictine house of great antiquity with a Romanesque fabric of the late 11th century.[45] Equally ancient Benedictine houses at Coldingham and Tynemouth had rebuilt their choirs in the new Gothic style in the late 12th century and the Whitby monks doubtless felt the need to emulate or rival these houses as well as nearby Gisborough or Bridlington. Unfortunately neither Whitby nor Kirkham are

datable by documents and their precise chronological relationship to Rievaulx is hard to establish.

The plan chosen at Rievaulx, with a sheer east wall and no ambulatory, was used at both Kirkham and Whitby and was common to many other northern churches in the early 13th century and later. Such sheer east walls make possible the grand facade compositions so beloved of northern masons (Pl. XXIIID). Tiers of tall lancets can be found in innumerable northern buildings of the time, but what sets Rievaulx somewhat apart is the absence of any rose window in the east facade of the choir or in either transept terminal wall. As the researches of Stuart Harrison have made increasingly clear, rose windows were very popular in northern early Gothic, not least in Cistercian buildings.[46] Byland had a grand example in its west facade, and Fountains had one in both west and east facades.[47] Augustinian Guisborough and Kirkham both had roses, the former in the west facade and the latter in the east.[48] The east ends of secular Ripon and Beverley Minsters most likely had roses, while the south transept of York Minster retains its still.[49] Of Rievaulx's contemporaries, only Whitby, Bridlington and Southwell lacked roses.[50] Why this departure from recent Cistercian tradition at Rievaulx?

Circular windows have never been easy to integrate into the linear grid mentality that characterises so much of Gothic architecture, and one might argue that a particular sensitivity to the disruptive possibilities of such windows led the Rievaulx master to eschew them. Other features in the Rievaulx design to be noted below strengthen the case for seeing consistency of texture as a particular trait of the Rievaulx master. (On the other hand, we have already seen that consistency of *design* is not exactly a Rievaulx speciality). The stepped pattern of the middle triad of lancets at Rievaulx, made necessary by the vault line within, allows them to be seen in a continuous pedimental composition with the upper windows of the aisle end walls. Similarly, the three lower lancets match their adjacent fellows in the aisles in having jambs articulated with three orders of detached shafts.[51] A less charitable interpretation might see the absence of roses at Rievaulx as a *result* of their use at Byland and Fountains, an attempt to avoid direct comparisons while creating an equally impressive design. Two other features at Rievaulx support this idea of a conscious distancing from earlier Cistercian designs, and particularly the new east end at Fountains.

Detached shafts play a relatively minor role at Rievaulx, being used primarily for the jambs of ground floor windows and gallery openings. Piers, vault shafts, and clerestory openings make no use of them. At Fountains, on the other hand, shafts of contrasting grey Nidderdale marble played a major role where they articulated aisle walls, clerestories, and the main elevations in the form of vault shafts (Pl. XXIVA). They were even used in one of the presbytery pier designs. This Lincoln-inspired tradition can also be found at Beverley and York, but it plays no role at Rievaulx, which seems quite consciously to adhere to an indigenous northern tradition of coursed piers and shafts, a tradition strikingly different from the southern connected architecture at Fountains.[52]

The second aspect of Rievaulx's design that may have been chosen in conscious opposition to Fountains is its three-storey elevation. This may seem a strange claim, given the ease with which the Rievaulx elevation can fit with northern contemporaries or predecessors such as Hexham, Tynemouth, Jedburgh, Whitby, or York, but it is less strange viewed in a Cistercian context. Earlier Cistercian buildings had been designed in two storeys, including the nave at Rievaulx itself. Three-storey elevations appear tentatively in the transepts of Roche and Kirkstead, but it is Byland which first exhibits a consistent three-storey elevation in all parts of the building. Even Byland had a much less emphatic middle storey than the richly articulated gallery at Rievaulx. The vogue for three-storey Cistercian elevations was shortlived, running from Byland through (probably) Jervaulx to

Croxden and Rievaulx (although there may well have been others now lost to us).[53] Later Cistercian patrons preferred the two-storey elevations of Netley and Tintern.[54] Fountains itself was extended in two storeys to prevent any discordance in height between the new work and the old nave and transepts.[55] Is it possible then, given how unusual the choice of three full storeys at Rievaulx is in a Cistercian context, that the monks were particularly concerned to outdo Fountains by adopting the standard northern elevation, particularly given their inability to match the lateral expansion of the Fountains Nine Altars?

This line of speculation might be taken one step further. The monks at Fountains forced their architect to adhere to an anachronistic two-storey scheme because they·wanted a harmonious building and had no intention of rebuilding the nave and transept of the 12th century church. Does the three-storey elevation at Rievaulx then imply the opposite? Did the Rievaulx monks envision a complete rebuilding of their church that would have, among other things, put Fountains still further in the shade? It is impossible to know for sure, and certainly the idea has been abandoned by the time the east transept elevations had been completed, as can be seen from the wholesale incorporation of the lower parts of the 12th-century terminal and west transept walls into the new work. Money had clearly run out, and the old nave was left standing until the Dissolution, although there were clearly modifications made to it, particularly to the windows.[56] Kirkham makes an interesting parallel to Rievaulx because there a new east arm of very high ambition was left overawing a modest 12th-century nave without aisles. There is again no proof, but it seems more than likely that the Kirkham canons had hoped for a complete rebuilding, only to be stymied by the decline in monastic fortunes in the later Middle Ages.

Although the Rievaulx elevation fits well in a general sense into its local Yorkshire context, a closer examination reveals a number of interesting deviations. For example, the Rievaulx piers depart significantly from the standard eight-shaft cluster used in so many early Gothic buildings in the north, being essentially sixteen-shaft clusters whose small subdivisions result in a consistency of texture quite different from the more robust eight-shaft pier. The closest parallels to the Rievaulx piers are two piers in the east transepts at Beverley Minster, and an anomalous pier in the south transept at Jervaulx, but in both these cases the more extravagant piers stand in special positions, surrounded by more mundane forms.[57] At Rievaulx the extravagant forms are standard, rather than exceptional, and are made still more extravagant by being designed in two variants that alternate in the east end of the presbytery. The sense of texture these piers convey is continued in the thick arch mouldings at Rievaulx, which actually contain profiles (the fillet sunk between two rolls) related to the piers themselves. Although there is not direct visual continuity between these forms it may be that the Rievaulx master desired a closer correspondence between his piers and the broad, but finely divided arch mouldings typical of Early English than was possible with the broader shafts of standard octofoil clusters.

Another unusual feature of the Rievaulx elevation is a persistent duple rhythm, visible in the gallery, clerestory, and aisle windows (Pl. XXIVB). The two subdivided openings of each Rievaulx gallery bay bear a superficial resemblance to the galleries at Canterbury and St Hugh's choir at Lincoln, but their larger scale relative to the rest of the elevation and especially their heavy mouldings and shafts belie this comparison and fit them more securely into a northern context. Most of Rievaulx's northern counterparts, however, had a more centralized gallery design with two units under an overarch, either centred in a blank wall or blind arcade as at Ripon, Byland, Furness, Brinkburn, or Tynemouth, or taking up the entire bay, as at Hexham, Jedburgh, or Arbroath. At York and Whitby the inner arches are themselves subdivided, but the unifying overarch remains. The anomalous western gallery bay at Rievaulx discussed above shares this design, but the standard pattern at Rievaulx

H

lacks any overarch and so provides a double stress above each arcade arch. This design allows for a complete symmetry between the centre and outer jambs of each arch, but its rationale must lie in the grouping it made with the clerestory and the now-destroyed aisle windows.[58]

The clerestory in the Rievaulx choir has two lancet windows in each bay which open to the interior through a single large arch. This unscreened opening is itself flanked by a blind arch on either side. The jambs of the large arch rest almost directly above the apices of the gallery arches below, while the tongue of wall dividing the outer clerestory lancets lines up with the middle gallery jamb, whose spandrel quatrefoil helps lead the eye across the clerestory passage floor that sets these elements in different planes. Framed by vault shafts and formeret, the upper two storeys of the Rievaulx elevation form a subtly unified binary unit with a strong central division rising from the apex of the arcade arch.

This Rievaulx clerestory is an unusual design in Early English Gothic. For vaulted buildings, the standard unit was generally a tripartite affair with a central window screened towards the interior by a stepped arrangement of shafted arches. In unvaulted buildings, of which there were many in the north (Jedburgh, Whitby, and York come readily to mind), there would be a continuous clerestory arcade of equal arches, open or blank. The only other clerestory with two lancets per bay is at Southwell, but unlike Rievaulx, there is a heavy interior clerestory screen at Southwell.[59] A more interesting comparison is with Cistercian Netley, in far Hampshire. Netley, founded in 1239, has a clerestory of three lancets rather than two, but there is an even larger arch than at Rievaulx opening the full width of the bay to the church interior.[60] The design at Netley postdates Rievaulx's and has little else in common with it, but the comparison is an intriguing one, given the shared Cistercian affiliation.

Originally, the double rhythms of the upper choir elevation at Rievaulx would have been echoed by double lancets in each bay of the aisle, at least on the north side.[61] There, two shafted lancets would have been separated by a spandrel quatrefoil matching the arrangement in the gallery.[62] Any monk looking across the top of the opposite choir stall would have been in a position to see this careful concordance between aisle wall and main elevation. The vault responds dividing the aisle bays provide yet another example of the Rievaulx master's concern for consistency, for they reflect exactly the complex section of the pier facing them (Pl. XXIVc). The destruction of so much of the aisle wall has made it impossible to know if the alternation of the eastern piers was also reflected in their responds, but one would like to think so.[63] Duplicating the pier section so precisely in the respond is by no means typical in English Gothic, particularly given the complexity of the template involved, and must be put down as more evidence of the concern for consistency of texture that underlies so much of the Rievaulx design.

This consistency is established primarily by architectural means, through the similarity of piers with responds or with the arches they support, and through the correspondence of openings and arch groupings in various parts of the elevation. While the sunk quatrefoils used in the gallery and aisle walls play a role too, architectural decoration at Rievaulx does not much figure in the building's impact. There is, it is true, much nailhead in the upper two storeys, but nothing like the obtrusive dogtooth of the York or Southwell main arcades. Most striking is the absence of foliage sculpture, although the building's present ruination is misleading, because the vault bosses of both aisles and high vaults were carved with foliage.[64] Capitals were all moulded, however, and one might be tempted to claim that here, at least, we have a lingering piece of Cistercian restraint. Unfortunately for this theory, Cistercian Byland had plenty of foliated capitals, while Benedictine Whitby and secular Beverley and Southwell also use exclusively moulded capitals. It may have been their

expense that determined their absence at Rievaulx or it may be that foliated sculpture was considered too ungeometrical and distracting to fit easily into the moulded aesthetic of Rievaulx, and the architect subsequently banished it to the distant vaults.

High vaults over the east arm at Rievaulx, not to mention the flying buttresses that support them, also set this building apart from many of its neighbours and contemporaries.[65] The north was strangely deficient in the provision of high vaults; even grand buildings such as York Minster or Glasgow Cathedral lacked them.[66] Of York's subminsters, Beverley and Southwell had them and they were planned, but not built at Ripon.[67] Among the grander monastic churches Whitby, Hexham, Jedburgh, Dryburgh, and probably Kirkham were not vaulted; only Augustinian Holyrood, closely following its model at Lincoln, and the presbytery at Tynemouth, are known to have been vaulted. Cistercian churches had a more varied record; Roche and Kirkstead were vaulted early on, but Byland and Furness were not. Jervaulx may have been and Fountains certainly was, and it may again have been the impetus of Fountains, complete with flying buttresses as it was, that convinced the monks of Rievaulx that they, too, needed a vaulted church. The flying buttresses derive ultimately from Lincoln, although they are also to be seen at Beverley as well as Fountains. As in both these latter cases the vaults at Rievaulx sprang from a tas-de-charge, but in contrast to the high level spring at Fountains and Beverley, the Rievaulx vaults spring from the clerestory sill level more typical of English Gothic.[68]

So how, finally, does Rievaulx as a whole compare to its contemporaries in the north, and what can we say about its more general position in English Gothic? The loss of such important buildings as Gisborough, Bridlington, and Kirkham makes such an assessment difficult, but enough others survive to formulate a tentative answer.[69] There has been much ado in these pages about the institutional rivalry between Rievaulx and Fountains and its possible architectural ramifications. While this argument about motivation must rest only on historical probabilities, the clear differences in the two designs point to an important division in northern Gothic in the 13th century. At Fountains, the architectural language of Lincoln Cathedral, the pre-eminent representative of the Early English style first formulated at Canterbury, is much in evidence, particularly in the form of detached marble shafting, but also in the use of dado arcades and clerestory screens. Fountains is unusual as a Cistercian translation of the florid Lincoln style, but this is also present, in varying degrees, in Augustinian Holyrood and the secular churches of York Minster, Beverley Minster, and the Nine Altars Chapel at Durham Cathedral. Whether its rejection was conscious or not, the style of Lincoln makes no appearance at Rievaulx. Rievaulx, rather, can be seen as a product of what could be called the indigenous style of northern early Gothic. This style, exemplified by c. 1200 in designs such as the Jedburgh nave or the Hexham choir and transepts, was essentially a Gothic reworking of the traditional Romanesque thick wall, with clustered piers, complex mouldings, expansive gallery designs, and more often than not, wood roofs. It is perhaps best characterized as a moulded style very far indeed from the skeletal scaffolding of a Laon, but also distinct from the shafted, colouristic style of a Lincoln and its progeny. While this style had as one of its important historical components 12th-century Cistercian architecture, it is by no means exclusively a Cistercian invention, and it is in many ways far from Cistercian ideals of austerity, certainly by c. 1200. Thus, it is unlikely that there was any institutional bias at Rievaulx in favour of this style because it was Cistercian. While the Lincoln/Fountains style may have been seen as particularly opulent, there was nothing restrained or cheap about the 13th-century design at Rievaulx. Indeed, apart from Rievaulx, the other surviving examples of this style in the north in the first half of the 13th century are all non-Cistercian foundations: Benedictine Whitby, and secular Southwell Minster and Glasgow Cathedral.

Comparison of Rievaulx with each of these is instructive, but it is the Whitby comparison that illuminates the special quality of Rievaulx most clearly (Pl. XXIVD). The Whitby choir is as richly moulded as Rievaulx and the later north transept arguably more so, but in other ways Whitby is more conservative. Whitby uses the standard eight-shaft clustered piers, the standard gallery overarch, standard single lancet aisle windows, and standard triple corbeled aisle responds. It is unvaulted and uses the standard band clerestory that goes with most wood roofs in the north. The designer of Rievaulx, by contrast, has rethought each of these elements in an innovative way while still keeping within the overall parameters of the 'moulded' style. It is harder to cast Rievaulx so clearly as the 'progressive' design in comparison with Southwell or Glasgow, both of which make their own original interpretation of this moulded style. Southwell retains the standard northern pier form, but this becomes part of a unique two-storey elevation with a stone vault that is hard to compare directly with Rievaulx. Glasgow shares more affinities with the Yorkshire abbey, particularly in its complexly textured piers and arch mouldings, its lancet facade without a rose window, and its three-storey elevation including a gallery with double units.[70] Perhaps the unique plate tracery of the Glasgow choir aisles represents a further development of the double lancets at Rievaulx. While the choir of Glasgow is wood-roofed, the vaulted lower church provides spatial complexities undreamed of at Rievaulx. Together, Rievaulx, Southwell, and Glasgow can represent the vitality of this northern style in the first half of the 13th century.

Mention of Southwell and Glasgow must bring us at last to the vexed question of the date of the 13th-century work at Rievaulx. The Southwell choir was rebuilt from 1234, Glasgow from about 1242. There would probabaly be general agreement that these projects postdate the inception of work at Rievaulx, just as the beginning of the rebuilding at Fountains sometime between 1204 and 1211 predates it. Previous estimates of the date of the design of Rievaulx have hovered about 1225, although there is no reason it could not have been begun as early as c. 1215.[71] Whitby is similarly undatable, and the fact that it is more conservative than Rievaulx does not necessarily mean it is earlier. In the end, the individuality of all of these buildings makes dating them by traditional stylistic comparisons a distinctly unprofitable enterprise.[72]

Was Rievaulx in any way influential on later buildings? The local Yorkshire evidence would indicate not. There seems a distinct hiatus in construction in the north in the third quarter of the 13th century, doubtless a well deserved and financially imposed break from the frenetic activity of earlier years. By the time activity begins again, say at York or Gisborough in the 1280s and 1290s, Rievaulx was too out of date to have much influence. The major project spanning these years, the Durham Nine Altars (1242–80), is firmly part of the southern Lincoln tradition. Rievaulx, like so many other English medieval buildings, is better seen as a very individual statement in a loosely shared and surprisingly flexible language rather than a link in some inexorable chain of development.

ACKNOWLEDGEMENTS

I would like to thank Professor Peter Fergusson and Dr Glyn Coppack, who kindly read versions of this article and offered valuable comments and suggestions, and Mr George Katsekes for his help in preparing Fig. 8. I need particularly to thank Mr Stuart Harrison, whose deep knowledge of northern English Gothic is matched only by his generosity in sharing it. His name will appear frequently in the following notes, but his enthusiasm and commitment to his work and the great help he has rendered me need special acknowledgement here.

REFERENCES

1. The most detailed account of the 13th-century eastern arm of Rievaulx remains that of W. St John Hope in *The Victoria County History of Yorkshire* (London 1914), 494–9. There are also important descriptions by N. Pevsner, *The Buildings of England: Yorkshire, The North Riding* (Harmondsworth 1966), 301–3, and C. Peers, *Rievaulx Abbey* (London 1967), 5–7. For the documentary evidence see J. Atkinson, ed., *Cartularium Abbathiae de Rievalle*, Surtees Society, DXXXIII (London 1889). For descriptions of the abbey at the Dissolution see G. Coppack, 'Some Descriptions of Rievaulx Abbey in 1538–9: The Disposition of a Major Cistercian Precinct in the Early Sixteenth Century', *Journal of the British Archaeological Association*, CXXXIX (1986), 100–33.
 The church at Rievaulx is laid out north–south instead of the usual east–west because of the shape of the valley. All directions in this article will follow the conventions of most writers on Rievaulx by assuming a normal east–west orientation for the church.
2. The best account of the founding of Rievaulx is P. Fergusson, *Architecture of Solitude: Cistercian Abbeys in Twelfth-Century England* (Princeton 1984), 31–8. Monks from Rievaulx had founded new Cistercian houses at Warden, Melrose, Dundrennan, Revesby, and Rufford by 1150.
3. See ibid., and R. Halsey, 'The earliest architecture of the Cistercians in England', in C. Norton and D. Park, eds, *Cistercian Art and Architecture in the British Isles* (Cambridge 1986), 77–82.
4. The earlier churches at Waverley, Tintern, and Fountains were considerably smaller. Ibid., 65–77.
5. For Fountains and Kirkstall see Fergusson, *Architecture*, 42–51, and Halsey, 'Earliest Architecture', 75–83.
6. The most recent discussion of the refectory is P. Fergusson, 'The twelfth-century refectories at Rievaulx and Byland abbeys', in C. Norton and D. Park, eds, *Cistercian Art and Architecture in the British Isles* (Cambridge 1986), 160–7, who sees two campaigns of 1175–85 and c. 1200.
7. Related but not identical forms can be found in the York Minster south transept and the choir of Beverley Minster. For York see L. Hoey, 'The 13th-Century Transepts of York Minster', *Gesta*, XXV/2 (1986), 233; for Beverley see C. Wilson, 'The Early Thirteenth-Century Architecture of Beverley Minster: Cathedral Splendours and Cistercian Austerities', *Thirteenth-Century England*, III (1991), plate 19.
8. Hope, *VCH*, 496; Pevsner, *North Riding*, 301.
9. Hope, *VCH*, 497.
10. Ibid.
11. Pevsner, *North Riding*, 301.
12. Ibid., 301–2.
13. In the north transept the 13th-century builders removed the tops of the 12th-century windows and rebuilt the wall from the arch springers, while in the south the 12th-century windows are entirely preserved.
14. Ibid., 301. To oppose the stiffleaf of one to the moulded shape of the other as an indication of date seems unwarranted. Pevsner did not mention the foliated vault bosses, although one survives in the north transept north chapel (very worn, to be sure).
15. Dr Glyn Coppack has informed me that when the building was scaffolded a few years ago and he was able to examine the upper parts of the fabric at close hand, he discovered a marked deterioration in the quality of the workmanship in the transepts that also suggests funds were running out and the monks were in a hurry to get things finished.
16. Mr Stuart Harrison has pointed out to me a masonry break at the junction of the south choir aisle wall with the east wall of the south transept. This is best seen on the interior, just west of the westernmost aisle vault respond against the south aisle wall of the choir. On the exterior there is a heavy chamfered buttress occupying the re-entrant angle of the two walls, and the junction of this buttress with the south transept east wall also shows some irregularities of coursing. Below the level of the window sill string-course these take the form of a kind of indented straight joint, while above that level is a more typical stepped joint. Confounding any interpretation of these joints as representing a significant pause in construction is the continuity of the coursing of the plinth moulding and the first two courses of wall above it between the choir and south transept walls. It does not seem to me then, that this break can be used to argue that the rebuilding of the transepts was not part of the monks' original intention, but a second thought after the choir was well under way. The proper interpretation would have the lower part of the new transept wall laid out against the 12th-century transept east wall at the same time that the new east arm was laid out. The choir aisle walls were built to full height before the older transept walls were demolished and their replacements built, however, and the two 13th-century parts were joined in a slightly haphazard way. The north transept also shows clearly that the new wall was built flush against the foundations of the old, although the loss of all the upper courses of the equivalent junction of the north aisle wall of the choir with the north transept east wall makes it impossible to say if a similar procedure was followed there.
17. The problem with having these latter two bays vaulted at this point is that the northernmost one's north-east corner consists of a springer block that includes the new rib profile 2 for the diagonal rib of the bay adjoining to the north; the same was presumably true for the opposing aisle wall respond, now lost. In other words, the

change in aisle rib profile between the second and third bays east of the crossing would have had to have been foreseen when the former was vaulted.

18. Pevsner, *North Riding*, 302.

19. The clerestory in this bay also provides evidence of the narrower width. Because the wall arches have to rise more sharply there is less room for the flanking blind arches, and their capitals must be set at a noticeably lower level to fit them in.

20. Although the profiles are identical, Mr Stuart Harrison has drawn my attention to another puzzling irregularity in this bay. The diagonal rib springing from the north-east crossing pier seems flanked by rolls that rise at different trajectories suggesting separate, extra ribs. This evidence for tiercerons is particularly clear to the right, or north-west, of the diagonal rib. The absence of the diagonally opposite north-east corner of this bay makes the pattern of ribs difficult to reconstruct. There is no evidence for similar additional ribs springing from the south-east crossing pier. Perhaps the northern vault in question was repaired later in the Middle Ages. On the other hand, extra ribs are not unknown at ackward junctures in Early English Gothic in the north. Examples include the north-east aisle bay of Whitby Abbey and the junction of north transept and north choir aisle at Dryburgh, although in neither of these cases is the extra rib properly a tierceron. Both would technically be considered irregular five-part vaults.

21. The choir of Beverley Minster and the transepts of York Minster provide other northern examples of a puzzling variety of arch mouldings. See L. Hoey, 'Beverley Minster in Its Thirteenth-Century Context', *Journal of the Society of Architectural Historians*, XLIII (1984), 214; and idem., 'Transepts', 233.

22. Pevsner, *North Riding*, 301, attempted to use the presence of nailhead in the hoods of the north transept arcade arches and its absence in those of the south transept as evidence of chronology. Unfortunately for this theory, the upper storeys of both transepts are full of nailhead, so we would have to erect another convoluted sequence of use, abandonment, and reuse to make nailhead an indication of chronological development.

23. The refectory door has an odd trefoiled arch set under a round arch.

24. Variety seems to have played an important part in Early English design. See L. Hoey, 'Pier Alternation in Early English Gothic Architecture', *Journal of the British Archaeological Association*, CXXXIX (1986), 45–67.

25. There are also sometimes iconographical or functional factors to consider. At Rievaulx one could argue that the use of alternating piers in the presbytery was meant to enhance the importance of that most sacred space surrounding the high altar and to distinguish it from the less exalted area of the monks' choir stalls or the transepts. Canterbury Cathedral provides an analogous situation where the piers of the presbytery exhibit more complex designs and a more complex (dis)order than those in the monks' choir. The change in wall articulation at Rievaulx of course corresponds to the end of pier alternation, but it is difficult to see how the same shorter shafts might 'enhance' the sacred space in the same way the pier alternation does.

26. Hope, *VCH*, 497, is ambiguous about the date of the flyers, but seems to imply that they are contemporary with the choir, while Pevsner, *North Riding*, 303, claims they are 14th century, as does Peers, *Rievaulx*, 7.

27. This is visible for the west flyer in an undated photograph in the Victoria and Albert Museum, Rouse Collection, X697. I want to thank Mr Stuart Harrison for this reference.

28. Mr Harrison has now identified fragments of the upper parts of these flying buttresses, which he hopes to reconstruct on paper. Both he and Mr Neil Cameron have suggested to me that the present etiolated appearance of these flyers may be due to some judicious 18th-century rearrangement or even deconstruction designed to enhance the site's picturesque possibilities.

29. The western base on the south side is coterminous with the wall of the sacristy which Peers, *Rievaulx*, 7, sees as 14th century.

30. These holes are clearest on the third, fifth, and sixth buttresses from the east on the north side.

31. The surfaces of the south side clerestory buttresses are more abraded than those on the north. The evidence for mortise holes of approximately the same height as on the north side is clearest on the east and west buttresses.

32. Hope, *VCH*, 497, assigns them no definite date, while Pevsner, *North Riding*, 303, and Peers, *Rievaulx*, 7, claim them as 14th century, as they do the high flyers as well. None of these authors considered the possibility that the outer flyers were added later than the inner, as a result of structural problems.

33. Extensive work was done in the 1920s, when a concrete reinforcing ring was added to the choir. I want to thank Mr Stuart Harrison for this information. The building has been scaffolded and consolidated further in the 1980s.

34. For the fashion for increased altar space see N. Coldstream, 'Cistercian Architecture from Beaulieu to the Dissolution', in C. Norton and D. Parks, eds, *Cistercian Art and Architecture in the British Isles* (Cambridge 1986), 147.

35. See Fergusson, 'Refectories', 161.

36. C. Peers, 'Two Relic-holders from Altars in the Nave of Rievaulx Abbey, Yorkshire', *The Antiquaries Journal*, I (1921), 276, suggests the removal of the choir may have taken place in the second half of the 14th century when the demise of the lay brothers led to a rearrangement of the nave. See also Coldstream, 'Cistercians', 145–6.

37. For Byland, see Fergusson, *Architecture*, 69–90, and S. Harrison and P. Barker, 'Byland Abbey, North Yorkshire: The West Front and Rose Window reconstructed', *Journal of the British Archaeological Association*, CXL (1987), 134–51.
38. Fergusson, *Architecture*, 69–80.
39. Ibid., 84.
40. See Wilson, 'Beverley', 180–7. For Fountains, see also R. Gilyard-Beer, *Fountains Abbey*, 2nd ed. (1986), 23, and P. Draper, 'The Nine Altars at Durham and Fountains', in *Medieval Art and Architecture at Durham Cathedral: The British Archaeological Association Conference Transactions*, III (1980), 78–80.
41. The comparative income of the northern Cistercian houses is hard to calculate in the early 13th century, but by the Dissolution Fountains had far overtaken its rivals, with a yearly income of £1,115 to Rievaulx's £278, Jervaulx's £234, and Byland's £238. In 1291 Rievaulx had an income of £291. See *The Victoria County History of Yorkshire*, III (London 1913), 152.
42. For Kirkham, see G. Coppack, *Abbeys and Priories* (London 1990), 47–52.
43. Ibid., 52. Robert de Roos was a figure of considerable importance in the reign of John and the minority of Henry III. See *The Dictionary of National Biography*, XVII, 216–9.
44. Virtually nothing of the 13th-century church at Gisborough survived the fire of 1289. Recent excavations and work on the architectural fragments should enhance our knowledge of the site. Pending their publication, see R. Gilyard-Beer, *Gisborough Priory* (London 1981). There are no dates associated with the 13th-century rebuilding of Gisborough, but it was a large church of a richly endowed foundation, and must have been an important statement of early 13th-century Gothic in the north. There is no documentation for the 13th-century rebuilding of Bridlington either, and the entire east half of the church has disappeared. Some information can be gleaned from Commissioner Richard Pollard's description of the 16th century. This is printed in W. Dykes, 'On the Priory of St. Mary at Bridlington', *Associated Architectural Societies Reports and Papers*, III (1854), 40–54.
45. There is no detailed study of the architecture of Whitby. See A. Clapham, *Whitby Abbey* (London 1952), and Coppack, *Abbeys*, 41–5.
46. Harrison and Barker, 'Byland'.
47. Ibid., and for Fountains see G. Coppack, *Abbeys: Yorkshire's Monastic Heritage* (York 1988), 29, no. 242.
48. The evidence for the roses at Fountains and Gisborough is presented by Stuart Harrison in his paper on Kirkstall Abbey in this volume. For Kirkham see his reconstruction of the east facade in Coppack, *Abbeys and Priories*, 51.
49. For Ripon see M. Hearn, *Ripon Minster. The beginning of the Gothic Style in Northern England* (Philadelphia 1983), 25; for Beverley see Wilson, 'Beverley', 191, n. 45, and for York see Harrison and Barker, 'Byland', 145–6.
50. At Whitby and Southwell, still standing, this is self-evident (there is a small rose in the mid-13th-century north transept gable at Whitby). At Bridlington the evidence comes from Pollard's description. See the discussion of this in Dykes, 'Bridlington', 46.
51. The surviving jamb of the north aisle east window indicates that it was closer in height to the centre window than its southern counterpart, which has a noticeably lower arch spring.
52. On the differing mixtures of northern and southern features at Beverley, York, and Fountains see Hoey, 'Beverley Minster', 209–24, and *idem.*, 'Transepts'.
53. Coldstream, 'Cistercian', 149.
54. Ibid., 150–1.
55. Wilson, 'Beverley', 188–9. English Gothic architects seem rarely to have raised their new Gothic elevations higher than the Romanesque parts to which they were joined, however they may have rearranged the storeys. Such is the case at Worcester, Winchester, Southwell, and St Alban's. The Gloucester choir is a notable, if late, exception.
56. The evidence for this consists of late medieval corbels or head stops. See Coppack, *Abbeys: Yorkshire's...*, 26, no. 207; 27, nos 216, 226; 28, no. 228. It is not clear if these represent a major rebuilding of the 12th-century clerestory or a more modest campaign of modernizing windows. It is tempting to see these later reworkings as weak substitutes for the complete rebuilding the monks may have originally hoped for.
57. For the Beverley piers see Hoey, 'Beverley', 214, and Fig. 9. These have sixteen shafts without the Rievaulx differentiation in diameters between the heavy cardinals and the slimmer diagonals. The keeled diagonal at Beverley is more prominent than at Rievaulx. The Jervaulx pier has both cardinals and diagonals subdivided into triplets, giving it twenty-four sections altogether. The cardinal shafts have an odd grooved moulding resembling lips to set them apart still further from Beverley and Rievaulx.
58. Reading the elevation is made a little difficult now by the absence of all the gallery inner shafts. These were purposefully ripped out at the Dissolution, doubtless to get at the valuable lead used to secure them. See Coppack, 'Descriptions', where the Inventory made at the Suppression makes constant reference to 'The lede to the Kyng'. Whitby appears to have received similar treatment.

59. Southwell is essentially a two-storey elevation, with the interior clerestory screen shielding a lower passage as well. The design thus bears few other similarities to Rievaulx.

60. At Netley the upper storeys are again combined as one, and details of piers, arch mouldings, and vault ribs have nothing to do with Rievaulx. Nevertheless it is legitimate to wonder if the open clerestory at Netley may not have had a predecessor at Beaulieu and perhaps a cousin at Hailes, and that the Rievaulx designer knew of this new Cistercian fashion in the south, although only Beaulieu could really predate the design at Rievaulx. There is another group of buildings with clerestory passages and unscreened windows that includes Canterbury, Fécamp, and a whole series of Burgundian buildings such as Notre-Dame in Dijon or Semur-en-Auxois, but it is hard to see how there would be any connection between this group and Rievaulx.

61. On the south side only the west and east bays of the choir aisle survive, and these have single lancets flanked by blind arches, a design also seen in the east wall of the south transept. The logical inference then, is a design of single lancets for the entire choir aisle. It is just possible that the end bays differed from those in the centre, but this seems unlikely. Such a difference in design cannot readily be explained by relative visibility, as was the case with the two exterior clerestory designs because the north aisle exterior would have been obscured by the hill and the south by the monastic buildings. One is left with the unpalatable realization that this difference is yet another one of the peculiar design irregularities at Rievaulx that cannot easily be fit into any traditional sequence of construction. The easiest way to do this would be to claim a change of plan very early in the construction of the choir 'envelope' wall, and then the continued use of the south wall form in the later east wall of the south transept. Double lancet aisle windows are not uncommon in Early English Gothic, appearing, for example, at Lincoln, Salisbury, Winchester, and in the north at York (the transepts), Carlisle (choir aisles), Bridlington (nave and choir aisles) and Whitby (north transept east chapels). Stuart Harrison also reconstructs them in the Kirkham choir aisles in Coppack, *Abbeys and Priories*, 51.

62. Fragments of these quatrefoils remain *ex situ*. See for example Coppack, *Abbeys. Yorkshire's...*, 28, no. 227.

63. Unfortunately for this theory, the surviving south aisle respond at the west end has the same section (B) as those two surviving further east in the north aisle. These latter were both opposite piers of B section in the alternating sequence of the presbytery, but the former faced a pier A of the western choir. This could be taken to mean that all the aisle wall responds may have displayed the same section based on the more complex pier B, or it may mean that when the aisle walls were laid out an alternating series of piers was planned for the entire length of the east arm and alternating responds were built accordingly; in such a system a B would be expected for the west respond of the south aisle. When the west choir piers were constructed alternation had been abandoned, but the responds remained to illustrate the original intention.

64. A number of aisle bosses survive *ex situ*, for one of which see Coppack, *Abbeys. Yorkshire's...*, 9, no. 5; one also remains in place in the north transept north chapel. Mr Stuart Harrison has identified three high vault bosses, one in a private house in Rievaulx village, and two currently adorning the Ionic temple podium on Rievaulx Terrace.

65. The high vaults at Rievaulx have the same profile (a) as the outer bays of the transept aisle, another indication that the latter were the last low vaults to be turned.

66. These may have been planned for the York south transept; see Hoey, 'Transepts', 235.

67. For the intention to vault Ripon, see Hearn, *Ripon Minster*, 13–26.

68. For the unusual springing levels at Beverley and Fountains see Wilson, 'Beverley', 188–90.

69. As mentioned above, Bridlington may have joined Rievaulx in rejecting the use of rose windows, and in the adoption of double lancets in its aisle walls. Those lancets remaining in the nave north aisle wall are very far from Rievaulx in their thin articulation, however. Kirkham may also have shared such double lancets with Rievaulx (see note 59), but otherwise differed from Rievaulx in its use of standard eight-shaft clusters, foliage capitals, and complex shafted external buttresses. Beyond that it is difficult to go; it is not yet clear if Kirkham was, or was meant to be, vaulted in stone.

70. Richard Fawcett has compared the two buildings in *Glasgow Cathedral*, Edinburgh, 1985, 28.

71. Hope, *VCH*, 496, places the work in the 'second quarter of the thirteenth century'; Pevsner, *North Riding*, 302, dates it *c.* 1225; Peers, *Rievaulx*, 6 'about 1230'; and Coldstream. 'Architecture', 147, to *c.* 1220.

72. Dr Glyn Coppack has suggested to me that the abrupt cessation of work at Rievaulx might be the result of Robert de Roos' death in 1227 and the division of his lands between two sons. Robert became a Knight Templar at the end of his life and this may also have distracted his attention from the Cistercians. On the other hand there is no direct evidence for Robert's involvement in the rebuilding at Rievaulx, nor, for that matter, any evidence that his son William would not have continued his father's hypothetical patronage. Although William did not inherit his father's Northumberland and Scottish lands he was still a powerful and wealthy lord of the north, as were his descendants. (For the history of the de Roos family see the work cited in note 43). Mr Stuart Harrison believes he has evidence for a tierceron vault in the crossing at Rievaulx, presumably put up at the conclusion of the 13th-century work. Such a vault would fit more comfortably in the 1240s or later, than to shortly after 1227.

The East Window of Selby Abbey, Yorkshire

By David O'Connor and Henrietta Reddish Harris

ARCHITECTURAL SETTING, GLAZIERS AND PATRONS

The church of Our Lord Jesus Christ, the Blessed Virgin Mary and St Germanus at Selby is one of the great monastic buildings of Yorkshire. At the Reformation the Benedictine abbey was among the wealthiest houses in the county, surpassed only by St Mary's Abbey, York and Fountains. Its conventual buildings have disappeared virtually without trace, but the church, which was granted full parochial status in 1618, has continued as a place of worship, despite the destruction of the original south transept when the central tower collapsed in 1690 and severe damage to the interior caused by fire in 1906. The art and architecture of Selby remain comparatively little studied, although, as a surviving monastic church, it is clearly a building of some importance.[1]

For the stained glass historian the Abbey has real attractions. While most of the monastic glazing of medieval Yorkshire lies buried under ground or is devitrifying in boxes at Fortress House, it is still possible to see some if it *in situ* at Selby. It is ironic, given the destruction at the Reformation, that some of the finest examples of English 14th-century glass-painting, the east window at Gloucester, and the glazing of the Lady Chapel at Bristol Cathedral, the Latin Chapel at Christ Church, Oxford and the choir clerestory at Tewkesbury, survive in what were originally monastic contexts. The glazing of the choir at Selby would have joined this list had the east window there remained intact, but in 1906–9 it was replaced by a copy which was based fairly closely on the original and was so skilfully executed that for years much of it has been accepted as original medieval glass.

The founding of Selby Abbey by the monk Benedict of Auxerre in about 1069 has been seen as a significant event in the history of northern monasticism.[2] Of the stone church begun around 1100 by his successor, Abbot Hugh, and completed towards the end of the century, only the north transept, tower and nave survive.[3] Nearly all the abbey's surviving glass, indeed much of the information on lost glass too, relates to windows in the new choir constructed from about 1280 to 1340 in place of the original Norman east end.[4] Since Hodges's pioneering work on the architecture, Nicola Coldstream has re-examined the choir, placing it in its regional context and arguing for a two-phase building campaign.[5]

The first phase, from about 1280 to 1300, in a Geometrical style much influenced by York, saw the construction of the aisle walls, including windows nII to nVIII, the blind traceried-windows sVI and sVII (the similar windows sVIII and sIX are 19th-century replacements in bays destroyed in 1690) and the lower part of the sacristy. After difficulties of a political and financial nature, a second campaign in the 1320s and 1330s saw the completion of the interior of the choir and sacristy, including windows sII–sV, the entire clerestory (NII–NVIII, SII–SVIII) and the huge window in the east gable (I). Coldstream sees less influence from York in these parts of the building, but there are links with Beverley and Howden, and the reticulated and flowing tracery of this second phase are closely related to the Decorated style of Lincolnshire and Nottinghamshire, especially the tracery of the seven-light east window (Pl. XXV) with its convergent mouchettes around a central vesica.[6]

A study of both the masonry and the glazing of this window is hampered by lack of documentation. John Harvey dated the stonework to *c.* 1330, and attributed the design, along with other major works in the north, to the York mason, Ivo de Raghton, who worked for Archbishop Melton in 1331 and is thought to be responsible for the Minster

west window.[7] The Selby attribution has not been presented in detail and is rejected by Coldstream.[8]

Documentary evidence is also lacking for the glass, although Haslop claimed that the five marks owed to magister Johannes Pictor in 1342, presumably the Master John le Peyntour who owned property in Selby about 1349, showed that glass-painters were working in the Abbey at this time.[9] As *pictor*, not *vitrearius*, there is no particular reason to associate John with glazing; he is much more likely to have been painting altarpieces, sculpture or vaults. The style of the east window glass suggests that it was executed by glaziers who were working at the west end of York Minster around 1339. A similar date for Selby is supported by the armorial glass from the choir aisles and clerestory. Two of the men whose shields are no longer extant, Oliver Ingham and Stephen Wallis, died without issue in 1344 and 1347 respectively, by which time the whole of the choir glazing is likely to have been complete.[10]

There is no evidence for the patronage behind the east window. By the 19th century the bottom section was extremely damaged and no donor figures or inscriptions were recorded by visiting antiquaries, who simply noted the conventional heraldic border designs and the royal arms in panels F1 and F2. Harvey implies the patronage of Archbishop Melton, who naturally showed concern for the fabric during his visitations.[11] It is more likely, however, that the window was commissioned by Abbot John of Heslyngton (1335–42) or his successor, Geoffrey de Gaddesby (1342–68), and the community, although, given all the heraldry in the other windows of the choir, it may have been paid for by corporate secular and monastic patrons.

Heraldic display was an important feature of the choir glazing. The antiquaries Glover and Dodsworth, who visited Selby in 1584 and 1620, give only sketchy accounts, but Dugdale's extremely full description, written in 1641, shows the position of every shield clearly.[12] Each choir aisle window contained six shields, three in the main lights and three in the tracery, except for nVIII and sIII, which had four and seven respectively, and nIII–nVIII where arms are only recorded in the tracery. Each clerestory window consisted of quarry-glazing crossed by a band of four shields.[13] In its heraldic glazing Selby choir must have emulated York Minster nave, but of the one hundred and twelve shields recorded in the 17th century, only eighteen survive today, and some of these are totally restored.[14] The shields provide a roll of arms honouring the abbey patrons, major northern families like Clifford, Lucy, Neville, Percy and Warenne, and local benefactors including D'Arcy, Eure, Plumpton, Stapleton and Thweng.

POST-MEDIEVAL HISTORY OF THE WINDOW

In the period following the Suppression, the Selby stained glass is mentioned in heraldic notes made by Glover in 1584, Dodsworth in 1620 and Dugdale in 1641. Heralds and antiquaries rarely record non-heraldic glass, but in 1657 Elias Ashmole saw 'In the north window, the history of Joseph', Old Testament scenes which presumably once filled the large 15th-century north transept window (nXI), and also says that 'in the Est window is the roote of Jessy'.[15]

Nathaniel Johnston's more detailed description of 1670 includes valuable information on the original design and layout of the east window:

There are seven partitions or pains, and in every row eight pictures desient, each habited according to their degrees, and branches prettily drawn to every one, to shew their succession. The middle pane or partition, is bordered about with crowns, and the two panes on either side with lyons passant; the two next on each side, with squirrels, upon filbert branches; the two outmost with chalices arg, or rather or; above, in the middle, is the crucifixion. In two places are the Crowns of England; and in others angels, and naked penitentiaries in many places.[16]

Besides giving a general impression of the design and iconography of the window, Johnston confirms the original order of the border designs. He saw eight figures in each light, where now there are ten, but the bottom rows had probably already suffered damage. His reference to crowns of England, rather than armorials, was probably a slip of the pen.

From 1670 on the window was subject to neglect, gradual decay and, ultimately, destruction by fire, a depressing process which would be tedious to rehearse in detail.[17] In 1815 J. C. Buckler wrote that 'in the last century this window contained the genealogy of Christ, but only a few scattered fragments of this interesting collection of glass now remain'.[18] This description sounds a little exaggerated because five years later Bernard Clarkson, who intended to publish a history of Selby, commissioned the archaeological draftsman, William Fowler, to produce engravings of eight of the panels (Pls XXVIIA–XXVIIIB), Sarasam (1f), Herod (9c), St John the Evangelist (2g) and St Paul (10g) from the main lights, and three resurrection panels and a devil from the tracery (D2, H2, M2 and O2).[19] The panels chosen appear to have been in excellent condition, a state confirmed by the two originals to survive, panels 2g and H2 (Pls XXVIIIE–XXIXB).

More glass disappeared after a music festival in 1827 when a gallery was erected in front of the window and a few years later when wind and hail caused further damage. The situation had become so critical by 1845 that the main-light glazing was taken out and stored in boxes in the church.[20] When Gilbert Scott was restoring the choir in 1864, William Wailes of Newcastle, the eminent glass-painter, examined the glass and proposed 'to effect a thorough and genuine restoration of the ancient design of the window, at a cost of £600', but nothing was done until William Liversidge, churchwarden and benefactor, reopened the issue in 1871.[21] The antiquary, James Fowler, grandson of William, the engraver, responded in an open letter, stressing the importance of the glass and pledging support from the Yorkshire Archaeological Society in cataloguing it.[22] In the light of future events it is regrettable that this project was never fully realised. Fowler made notes on the tracery-lights, and began to examine the panels in store, but found 'that the glass was in so lamentable a state of decay and confusion, I could not dare to look at more than two or three pieces, lest I should injure or still further disarrange it'.[23] He went on to publish an important article on the window in 1879, promoting the idea of restoration and providing an invaluable foundation for future historical studies.[24]

It was not until 1890 that with financial support from Liversidge work began on the restoration. The tracery-lights were removed that year, and together with what was left of the main-light glazing, were dispatched to London to the firm of Ward and Hughes, then directed by Thomas Curtis.[25] According to Curtis the window 'was in a chaotic ruin when I first had it, and it took me years to evolve order and endless research and consultation with several archaeologists to get the original scheme reproduced'.[26] The sketch-design for this restoration, exhibited at the Royal Academy in 1892, hangs in the Abbey.[27] By October 1891 the completed window was back in place, and although little of the glass inserted at this time has survived, the restoration was evidently skilfully executed and aesthetically pleasing.[28]

According to Pritchett, following the 1891 restoration twenty-four of the sixty-seven main-light figures were original and presumably much of the original tracery-light glazing had been retained.[29] Two missing figures, Jesse (1c-1e) and David (2d), were copied from the Jesse at Shrewsbury (Pl. XXXIA), following comparisons made by Fowler, but most of the others were adaptations of original designs. Curtis's research was not that thorough and basic errors were made with the general layout of the main-light glazing.

The restored window had been in place for only fifteen years when on 20 October 1906 the interior of the Abbey was gutted by fire and the wooden vault of the choir and the

choirstalls completely destroyed (Pl. XXXIB).[30] First reports on the east window were optimistic, but by the end of the year Curtis, who was brought back to work on the glass, was writing to the vicar, Maurice Parkin: 'I very much regret to say that the entire window is fractured into small pieces, which renders it entirely impossible for any of the material to be used again. The window will have to be done entirely afresh'.[31] It is clear from his correspondence with Curtis and John Oldrid Scott, the architect responsible for the restoration, that Parkin was reluctant to publicise their decision to replace the entire window, and subsequent confusion over the extent of replacement has continued to the present day. Abbey guidebooks produced after the fire played down the damage, and in an influential county guide J. E. Morris stated that 'the E. window was badly damaged by the fire, but has since been restored; and is said to contain (as the writer was told by one of the workmen who were actually replacing it) perhaps fifty to seventy per cent. of old glass'.[32] According to Gerald Cobb 'only about a third of the figures in the Jesse Tree are ancient, although the Last Judgment in the tracery of the window may be more authentic', while Pevsner, whose views are quoted in the current Abbey guidebook, wrote that the window 'though much restored, is memorable work of c. 1330'.[33] This failure to distinguish between original glass and modern replacement seriously undermines the most recently published account of the window which describes much of the glass in the east window as medieval while ignoring the two original panels in the sacristy.[34]

In 1908 Parkin had written to Scott:

'News has just reached me that the secret about the E. window being completely destroyed is out and is known to Mr. St. John Hope and *others* of his class of critics. They are asking, I am told, what is to be done with the damaged glass? Someone I think has suggested that it go to S. Kensington Museum. I am writing to ask your advice as to whether I shall take any notice of this or let it slide and leave things to work themselves out? I am just issuing a new hand book to Selby Abbey with a Chapter on the E. window and if you think it would be wise I could put into the text a sentence telling the world that all the original glass was destroyed by the fire, or I can leave it out and let things alone. *What do you think?* In any case will you please let Curtis know that he is not to suffer an atom of the old damaged glass to be broken or perish. It is important that it should be *jealously* preserved and guarded and *we* can decide later what to do with it'.[35]

Several sources say that the damaged glass will go to the Victoria and Albert Museum, but there is no record of such an offer having been made.[36]

Ward and Hughes completed work on the second restoration of the window in the summer of 1909 and produced what is really a very clever fake. Figures like Samuel (Pl. XXVIIIc), which at first sight looked pitted and corroded, turn out to have been antiquated with acid and paint. Whatever the vicar's original intentions the majority of the glass had disappeared without trace. Curtis returned some of it to Selby, as there are three fire-damaged panels in the sacristy, two of which, Judah and St John the Evangelist (Pls XXVIIID and XXVIIIE) are 14th-century, and the third, St John the Baptist, a Ward and Hughes panel of 1891. A fourth panel (Pl. XXVIIIF), on loan to the Ely Cathedral Stained Glass Museum, which also represents the Baptist, replicates the two Baptist figures still at Selby (I 10b and Sac. sII 1b). The figure is by Ward and Hughes, but the scroll and other pieces are 14th-century, and the lack of crazing suggests that the restorers probably removed some old glass when they first worked on the window in 1891.

Two more original fire damaged panels, the resurrection of a king and of an abbot or bishop (Pls XXIXA and XXIXB), were identified in 1979 at Dorchester Abbey, Oxfordshire. More recently three original kings from the Jesse, Achaz, Amaziah and Jothan (Pls XXIXc–XXIXE), removed from Selby some time between 1845 and 1891, have been found at the Walker Art Gallery, Liverpool.

Given Maurice Parkin's strict instructions about the preservation of the medieval glass, the survival of only eight original panels, four of which had been removed prior to the fire, is extremely disappointing. Besides most of the original tracery-light glazing, there should be some twenty-two fire-damaged main-light figures awaiting discovery, as well as any glass removed before or during the restoration of 1891.[37]

SUBJECT MATTER

Although the present window dates from 1909, with some authentic material to work from, the eight original panels, Fowler's engravings, and antiquarian notes on the glass, it is possible to discuss the original layout and iconography with a little more confidence.

The principal subject of the main lights is a Jesse (Pl. XXVIB), a genealogical tree depicting Christ's earthly ancestors, who included the kings of Judah, and his spiritual ancestors, the Old Testament prophets and patriarchs. The theme was extremely popular in the liturgy, drama and art of the Middle Ages and, following Abbot Suger's Jesse window of c. 1140–4 at Saint-Denis, was commonly represented in glass.[38] There are numerous English examples from the 14th century, including well-known windows at Bristol, Ludlow, Madley, Mancetter, Oxford, Shrewsbury, Wells, Winchester and York.[39] The popularity of the theme can probably be connected with increasing emphasis on the cult of the Virgin, and many of the English examples occur either in churches and chapels dedicated to her or in association with Marian altars. The inclusion of a Jesse in the most important window at Selby is easy to explain; the Abbey is partially dedicated to her, and the post of Keeper of the choir or altar of the Blessed Mary can be traced back to the 14th century.[40]

Kings of Judah, along with other ancestor figures, are placed in the tree in the three central lights (c-e), where they sit or stand, holding sceptres and scrolls, around a central panel (10d) of the Virgin and Child, the stem and flower of Isaiah's prophecy concerning Jesse.[41] Twelve of the twenty-eight panels in this section were medieval in 1891 and eight of these, Manasseh, Hezekiah, Amon, Josiah, Jechonias, Jacob, Mary and Joseph are mentioned in the genealogies of Christ in Matthew 1 and Luke 3.[42] The other four included Zedekiah, whose original scroll perhaps read Zadok, and Jehoiakim, although the original inscription recorded for this figure suggests that Joachim, father of the Virgin, may have made a rare appearance in the tree. The extraordinary feature of the Selby Jesse is the inclusion of Herod the Great or Asconolita and his son, Herod Antipas or Tetracha. The former is mentioned in Matthew 2 as the king reigning when Christ was born, and the latter in Luke 3, the genealogical chapter, as ruler of Galilee at the time of his baptism. Fowler's engraving of Herod the Great (Pl. XXVIIB) and Pritchett's diagram confirm that both these rulers were in the original scheme and suggests that whoever designed the scheme was not a biblical scholar. H. T. Kirby concluded that 'Perhaps in all England there is nothing quite so paradoxical: a beautiful Jesse Tree to begin with made absurd and meaningless by the utterly unrelated inclusion referred to ... So much for Selby. Its inclusion was a digression, and was only made to point out how easily beauty and absurdity can be intermingled'.[43]

Little is known about the original choice of the prophets who now stand in the first two lights holding their names on scrolls. In the present window there are eighteen such figures but originally there were twenty of which only three can be positively identified, the major prophets Isaiah, Jeremiah and Ezechiel, who survived until the fire. Daniel, the fourth major prophet, was almost certainly there originally, as very probably were the twelve minor prophets inserted in 1891.

Ward and Hughes added figures of Abraham (1a) and Samuel (1b), and figures which were originally prophets, Sarasam (1f) and St Jude/Judah (4f) now appear in the sixth light.

The identity of Sarasam, engraved by Fowler (Pl. XXVIIA), remains a mystery, although it has been suggested that the name is an obscure form of a name given to one of the three magi.[44] The original Judah panel is in the sacristy (Sac. sIII 1b), but the inscription is modern and the identity problematic.

The present arrangement of the prophets cannot follow the original design. Half of them appear in the tree in light b, in their usual position immediately left of the kings, but in 1891 the others were put under canopies in light a, rather than in light f, immediately to the right of the kings, where they would be included in the tree and balance the other group. Pritchett's diagram shows that after 1891 none of these first light prophets was in original glass, and the engraving of Sarasam (Pl. XXVIIA), who is shown facing left within a Type B squirrel border, establishes that he was on the right of the window light f. In the original window the five central lights (b-f) would have formed a symmetrical Jesse Tree, with the kings and ancestors in the middle three openings flanked by a pair of lights containing prophets just like a traditional five-light Jesse.

What was exceptional about this window were the outer lights (a and g) in which twenty saints were represented, standing or sitting under canopies, on either side of the Jesse. Because of errors made by the restorers eight of these saints are now in light f where they make an unprecedented appearance within the tree itself. The engravings of St John the Evangelist and St Paul (Pls XXVIIc and XXVIID) establish that saints were a feature of the medieval design and, although the original St John (Pl. XXVIIIE) has lost its borders, by showing both figures within Type A borders and facing left, Fowler confirms their original provenance on the right of the window in light g.

Among the seven medieval saints reused in 1891 were Peter, Paul and John the Evangelist, suggesting that the restorers rightly included all twelve apostles in their reconstruction.[45] As the latter is shown writing his gospel, rather than standing and holding an eagle and palm, the usual iconography for St John as a single figure or as part of an apostle group in York glass of the 14th century, it is almost certain that the four evangelists were there, Matthew and John as part of the apostle series, with similar figures of Mark and Luke as in the window today.[46] Fourteenth-century panels of Gregory the Great and Jerome, destroyed in the fire, confirm that the four doctors of the church were also included.

Such a combination of apostles, evangelists and doctors, presumably chosen for their typological and symbolic associations with the Old Testament prophets, would account for eighteen of the twenty figures in the outer lights, leaving two spare spaces for Benedict and Germanus, original figures which were reused in 1891. For monks of his order Benedict was an obvious choice, and particularly devotion was shown to Germanus at Selby because of his role in the foundation of the monastery. It was Germanus who had appeared to Benedict of Auxerre instructing him to go to Selby, and the saint's finger, which Benedict took with him, became a treasured relic of the monks who celebrated two feast days in his honour.[47] Had the designer of the east window decided to fill all seven lights with a Jesse, forty prophets would have been needed, but by combining the Jesse with saints, the monks were able to honour both their patrons, the Virgin and St Germanus, as well as the founder of their order, all within one single opening.

During the 14th century there were basically three alternatives when it came to glazing Jesse Tree tracery lights. The most obvious solution was to extend the tree upwards, as at Bristol, Ludlow and Madley, and fill the potentially awkward shapes with heads of kings, prophets, foliage or even heraldry.[48] In other windows, like the northern Jesses at Cartmel Priory (Pl. XXIXF) and Morpeth (Pl. XXXA), New Testament themes connected with the Virgin and Child, the Annunciation, Nativity, Presentation and Adoration, were used, an association previously found in certain Jesses on the Beatus pages of English manuscripts

including the Gorleston Psalter of *c.* 1310–20.[49] Selby represents a third option. The Crucifixion is included, a symbolic extension of the tree below which is also found at Bristol and Wells and in some of the illuminated Beatus pages, but the main subject, like that of the roughly contemporary Jesses at Wells Cathedral, St Denys, York, and several later 14th-century examples, is the Doom.[50] This combination of Jesse and the Last Judgment does not seem to have been inspired by manuscripts, and its popularity with glaziers working on very large windows may have had something to do with the flexibility, adaptability and dramatic nature of the theme. There were perfectly good theological reasons for such an approach which made visible the liturgical readings for Advent which linked Christ's first coming, and the prophecy behind it, to the second coming when he would descend as judge.

Fowler's engravings and subsequent written sources suggest that there are good reasons to believe that the present tracery (Pls XXVIA and XXVIc) follows the original design and like most monumental Dooms is largely based on Matthew 24 and 25 and I Corinthians 15. At the top, blessing and displaying his wounds, Christ is seated in judgment, flanked by angels holding the instruments of the passion and blowing trumpets. Beneath him St Michael weighs souls while lower down devils drive the damned into hell and angels lead the blessed into heaven. In many of the panels in the bottom section the dead rise from tombs with incised covers; men, a few women, laymen and ecclesiastics, some crowned or mitred suggesting that all conditions of society will be summoned to appear before the judge.

Similar representations can be found in the tracery of the Jesse Window and the adjacent clerestory windows at Wells, and in the poorly preserved Doom in the south rose of Lincoln Cathedral, a window with architectural affinities to Selby.[51] Perhaps the best parallels for the Selby Last Judgment panels are to be found in the flowing tracery of the east window of Carlisle Cathedral (Pl. XXXB), a work with York connections, much restored by William Wailes in 1856.[52] The main-lights of this window are now by Hardman and date from 1861 and the subject matter of the original is not known, but given the dedication of the Cathedral to the Virgin Mary, it is highly probable that a Jesse once filled part of the nine-light window beneath the Doom.

STYLE AND DESIGN

It has been suggested above that the Selby east window was painted by the leading York workshop of the 1330s and 1340s, and we conclude with a few remarks about this attribution. Although an assessment of style is hampered by the extent of restoration it is still clear that the Selby window is particularly close to the glazing in the west wall of York Minster, the great west window itself (wI), commissioned from Master Robert (Kettlebarn?) by Archbishop Melton in 1338/9, and the flanking windows (nXXX and sXXXVI) associated with Thomas de Bouesdun.[53] These glaziers produced a large body of work in York itself, in the Minster and parish churches, in various sites in Yorkshire including Acaster Malbis, Beverley Minster, Lockington and Nether Poppleton, and probably in areas further afield.[54]

In colour and technique Selby is virtually identical with the glass in York, well known for its rich pot-metal colours, brilliant effects in yellow stain and high quality painting and stickwork.[55] If the original Selby panels do not quite match the technical brilliance of the Minster west window this may reflect the different status of the churches and the donors.

The Selby figure style has all the elegance of Master Robert's work, as a comparison between the bishop at Dorchester (Pl. XXIXB) and St Peter from the Ascension in the York west window (Pl. XXXD) should demonstrate. The softly modelled head-types, with

narrow eyes and flowing hair, follow the same conventions, indeed the head of the Christ child (Pl. XXXc) from the north-west window at York (nXXX 3b) is virtually identical with the original head of St John at Selby (Pl. XXXE).

Architectural features and canopy designs confirm these links. The Selby St John (Pl. XXXE) is seated on a three-dimensional architectural throne similar in type to those in the Nativity and Coronation of the Virgin in the York west window, and the detail of the small hinged door in the side of John's throne can also be found in canopies from a Master Robert scheme now dispersed among several windows of York Minster.[56] The narrow canopy shafts and tiny leaf capitals at Selby are typical features of Master Robert designs, and the elaborate ribbed vault above the Selby St John is similar to the vaulting over the archbishops in the York west window.[57]

One distinctive feature of some of the Selby canopies is a simple crocketed arch decorated with a continuous pattern of quatrefoils, a design seen in the canopy in the engraving of St Paul (Pl. XXVIID). This same design occurs in a St James the Great panel, now in the east window of St Michael le Belfrey, York (I 1e) but probably originally in the Minster.[58] The tomb of the king at Dorchester (Pl. XXIXA) has a cusped recess, quatrefoil parapet and incised grave-cover similar to the tomb in the Resurrection at York.[59]

Decorative designs and ornamental repertoire suggest that the Selby glass was produced in York. All the rinceaux background designs in the Selby east window can be found in the west wall of York Minster except for the spade-shaped leaf (Type 1), which does, however, appear in panels belonging to the dispersed scheme mentioned above.[60] Every border design is repeated in the York west wall except for the squirrels (Type B), a design which was used in other windows by this workshop at Lockington and Dewsbury.[61]

Although iconographic comparisons can be made between Selby and other 14th-century Jesses and Dooms, in its style and overall design Selby stands apart from the West Country Jesses and the Midlands group proposed by Woodforde.[62] Perhaps not surprisingly the closest parallels with Selby are two contemporary northern Jesses attributed to the All Saints North Street workshop from York, the east window of Morpeth, Northumberland (Pl. XXXA), much restored by William Wailes in 1859, and the remnants of the east window of the Harrington Chapel at Cartmel Priory, Cumbria (Pl. XXXB).[63] The extremely poorly preserved Jesse at St Denys, York may well have been a fourth member of this northern group.[64] At Morpeth the treatment of the vine and the way the prophets are placed within it are identical to Selby, and the arrangement at Cartmel is similar but with the prophets placed in pairs. Firm dates are not available for any of these windows, but it is possible, given the relationship between the All Saints North Street glass and Master Robert's work, that the smaller windows were modelled on Selby.[65] Another model may have been the Jesse postulated for Carlisle Cathedral, if it ever existed. In design the Carlisle Doom is close to Selby and although it is in poor condition and severely restored it also appears to be stylistically related to York.[66]

On a few occasions during the conference in York it was the provincial nature of artistic production for monasteries in Yorkshire that was stressed. Provincialism is not a feature of the Selby glass. The high artistic quality of the work produced by York glaziers in the second quarter of the 14th century has been mentioned on many occasions and comparisons have even been made with royal glazing schemes such as St Stephen's Chapel, Westminster of 1349–52.[67] The origins of Master Robert's style are probably to be located in northern France, in Paris and Normandy, and comparisons have been drawn between his work in York and miniatures in those English manuscripts which are thought to be particularly French in style, the Queen Mary Psalter group (after 1320?), and five full-page miniatures in a monumental style added by the so-called Majesty Master to the Psalter of Robert de Lisle

before 1339.[68] At Selby the panel of St John the Evangelist (Pl. XXVIIIE) is reminiscent of the Majesty Master's St John in design, style and iconography.

Once it is established that there is now not a single piece of 14th-century glass in the Selby east window it would be easy to devalue the work and consider it unworthy of serious attention. Nothing could be further from the truth. Not only is there much to admire in the 1909 restoration, which shows glass-painting skills which are all too rare today, but there is a complex historical record preserved in the window which sheds light on its original appearance and design, its iconography and style, as well as its function and reception in the past. The original window is often elusive and for the most part approachable only at one or two stages removed, but it was clearly a work of major importance, and like the Abbey itself it has been undervalued for too long. It can only be hoped that more of the medieval panels will eventually come to light.

SUMMARY CATALOGUE

A set of photographs taken by David O'Connor has been added to existing prints in the Corpus Vitrearum Medii Aevi Archive at the NMR. The window and the panel numbering system is that used by the CVMA. For the application of this system to Selby see the ground plan and the plan of the east window (Figs 1 and 2). The inscriptions, which are in Lombardic capitals, have been recorded according to CVMA conventions, with original medieval letters, as opposed to restored and modern letters, italicised:

() Expanded abbreviation
[] Letters inferred or difficult to read
/ Indicates a significant lead line
... Indicates probable number of missing letters

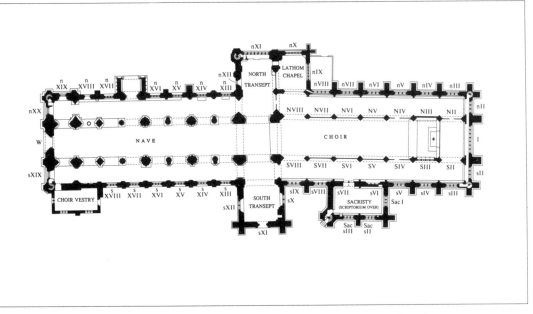

FIG. 1. Selby Abbey, plan showing position of windows, excluding plain glazing in clerestory of transepts and nave

FIG. 2. Selby Abbey, east window: key to numbering of panels

SELBY ABBEY

EAST WINDOW (I) *h* approx. 11.59m *w*5.49m (Pl. XXv and Fig. XXVIB)

Seven-light Decorated window with prophets and saints in lights a and g, Jesse Tree in b-f and a Last Judgment in the flowing tracery. The present window dates from 1906–9 and is entirely the work of Ward and Hughes of London, being a reproduction of the firm's 1891 restoration of glass of *c.* 1340, replaced after damage in the fire of 1906. Surviving panels which were in the window before the fire appear later in the catalogue.

All the main-light panels measure approximately *h*0.67m *w*0.64m, except for those in row 1 to which inscriptions measuring *h*0.10m have been added, and the canopy and foliage panels in row 11 which are approximately *h*0.35m. It has not been possible to measure the tracery-lights.

Border designs:

Lights a and g, Type A: alternating yellow castles and white and yellow-stained covered cups on red patterned backgrounds.
Lights b and f, Type B: confronted pairs of pink and purple squirrels eating nuts and seated on white and yellow-stained leafy stems on blue and red patterned backgrounds.
Lights c and e, Type C: yellow lions *passant guardant* on red patterned backgrounds.
Light d, Type D: yellow crowns on blue patterned background.

Background designs:

Lights a and g: Type 1: blue curling spade-leaf rinceau.
Lights b, d and f: Type 2: red curling-frond rinceau.
Lights c and e: Type 3: blue kidney rinceau.
These designs are also used in the tracery lights along with four others:
Type 4: maple-leaf rinceau.
Type 5: trefoil rinceau.
Type 6: ivy-frond rinceau.
Type 7: quatrefoil-cross diaper.
An inscription runs across the base (1b-1f):
TO THE GLORY OF GOD AND IN/AFFECTIONATE REGARD FOR THE ABBEY/ THIS WINDOW WAS RESTORED BY/WILLIAM LIVERSIDGE ESQ JUSTICE/OF THE PEACE OCTOBER 1891.

1a. Abraham

Bearded prophet in yellow robe, white mantle and red hat, holding scroll: ABRAHAM. Cartoon similar to 3g and 9g, and figure as 4b.

1b. Samuel (Pl. XXVIIIc)

Bearded prophet in white robe, blue tunic and green hat, holding scroll: SAMVEL. Cartoon similar to 7c and 9f.

1c-1e. Jesse

Reclining, bearded figure in blue robe, yellow mantle, green hose, purple shoes and pink and white hat, sleeping on grassy bank, head supported by pillow, with tree growing from his chest. Copy of the Jesse in St Mary's, Shrewsbury (Pl. XXXIA) which was engraved by William Fowler.

1f. Sarasam

Bearded prophet in green robe and blue mantle over head, holding scroll: SARASAM. Cartoon as 6c and 8b, and figure as 5a. Fowler engraving of original panel (Pl. XXVIIA) which survived until fire.[69]

1g. St Benedict

Nimbed, tonsured abbot in purple habit, holding crozier and scroll: BENEDICT. Original panel survived until fire.

2a. Joel

Bearded prophet in yellow robe and red mantle, holding book and seated at lectern inscribed JOEL. Cartoon similar to 6g.

2b. Isaiah

Prophet in blue robe and green hat, holding scroll: YSAYAS:. Cartoon as 4c and 7e, and figure as 7a. Original panel survived until fire.

2c. King Solomon

Bearded and crowned king, in yellow robe and red mantle, holding sceptre and scroll: SALOMON. Cartoon as 9e and similar to 8f.

2d. King David

Crowned king in green robe and yellow mantle, sitting on throne playing harp. Inscription below: DAVID. Copy of David in the Jesse window at St Mary's, Shrewsbury (Pl. XXXIA).[70] Similar figure in 8d.

2e. King Rehoboam

Bearded figure in yellow robe and hat and red mantle, holding scroll: ROBOAM. Cartoon as 3e, 5b and 9c.

2f. St Jerome

Nimbed cardinal in red robe, cope and hat, holding book. Scroll by side: IERONIMVS:. Original panel survived until fire.

2g. St John the Evangelist

Nimbed figure in yellow robe and purple mantle, holding quill pen and knife, and sitting at lectern, inscribed IOHANNES, with eagle above. Cartoon similar to 8a. Copy of original panel, Selby, Sac. sII 2b (Pl. XXVIIIE) engraved by Fowler (Pl. XXVIIc).

3a. Hosea

Bearded and bald prophet in green robe and white mantle, holding book and scroll: OSEE. Cartoon similar to 10g and figure as 9b.

3b. Jeremiah

Bearded prophet in yellow robe and hat and light blue mantle, holding scroll: IEREMIAS. Cartoon similar to 4e. Original panel survived until fire.

3c. King Asa

Bearded and crowned king in red robe and purple mantle, holding sceptre. Scroll by side: ASA. Cartoon as 6e.

3d. King Abijah

Bearded and crowned king in blue robe and yellow mantle, sitting on throne, holding sceptre. Scroll by side: ABIAS. Cartoon as 7d.

3e. King Achaz

Bearded figure in yellow robe and hat and green mantle, holding scroll: ACHAZ. Cartoon as 2e, 5b and 9c. It is different from the original figure of Achaz in Liverpool (Pl. XXIXc).

3f. St Augustine of Hippo

Nimbed and mitred archbishop in green, purple, white and yellow vestments, including pallium, blessing and holding cross-staff. Scroll by side: AUGVSTINVS. Figure as 10a.

3g. St Simon

Nimbed, bearded and barefoot apostle in yellow robe and green mantle, holding saw. Scroll by side: SIMON:ZELOTES. Cartoon similar to 1a and 9g, and figure similar to 4b.

4a. Obadiah

Bearded and barefoot prophet in green robe and yellow mantle, holding quill pen and knife, sitting at lectern inscribed ABDIAS. Cartoon similar to 8g.

4b. Ezekiel

Bearded prophet in blue robe, white mantle and green hat, holding scroll: EZEKCHIEL. Figure as 1a and similar to 3g and 9g. Original panel survived until fire.

4c. King Ozias

Bearded and crowned king in yellow robe and green mantle. Scroll by side: OZIAS:. Cartoon as 2b and 7e and figure as 7a.

4d. King Joram

Bearded and crowned king in pink robe and green mantle, sitting on throne, holding sceptre. Scroll by side: IORAM. Cartoon as 6d.

4e. King Jotham

Bearded figure in red robe and mantle and yellow hat, holding sceptre and scroll: JOATHAM. Cartoon similar to 3b. Present design unrelated to original figure in Liverpool (Pl. XXIXe).

4f. St Jude

Nimbed and bearded figure in yellow robe, blue mantle and hat, holding scroll: JVDAS. Copy of the original panel, not an apostle but a prophet (Judah?), in Selby Sac. sIII 1b (Pl. XXVIIID).

4g. St Luke

Nimbed and bearded evangelist in yellow robe, red mantle and white hat, sitting at lectern inscribed LVCAS, with winged ox behind him. Cartoon similar to 6a.

5a. Amos

Bearded prophet in red robe and purple mantle, holding scroll: AMOS. Figure as 1f, 6c and 8b.

5b. Daniel

Bearded prophet in purple robe, yellow mantle and green hat. Scroll by side: DANIEL. Cartoon as 2e, 3e and 9c.

5c. King Manasseh

Bearded and crowned king in yellow robe and red tunic, holding sceptre and scroll: MANASES:. Cartoon as 5e and similar to 7b. Original panel survived until fire.

5d. King Hezekiah

Bearded and crowned king in pink robe and blue mantle, sitting on throne, holding sceptre. Scroll by side: EZECHIA[S]. Cartoon as 9d. Original panel survived until fire.

5e. King Jehoshaphat

Bearded and crowned king in green robe and yellow tunic, holding sceptre and scroll: JOSAPHAT. Cartoon as 5c and similar to 7b.

5f. St Gregory the Great

Nimbed pope in green cope and yellow tiara, holding patriarchal staff and book. Scroll by side: GREGORIVS. Original panel survived until fire.

5g. St James the Less

Nimbed and bearded apostle in white robe and purple tunic, holding club and scroll: JACOBVS MINOR. Figure similar to 7f and 10e.

6a. Jonah

Bearded prophet in yellow robe, green mantle and white hat, sitting at lectern inscribed: JONAS. Cartoon similar to 4g.

6b. Micah

Bearded prophet in green robe, blue mantle and yellow hat. Scroll by side: MICHÆUS. Cartoon as 8c and 8e.

6c. Amon

Bearded prophet in green robe and red mantle holding scroll: AMON:. Cartoon as 1f and 8b, figure as 5a. Original panel survived until fire.

6d. King Josiah

Bearded and crowned king in yellow robe and blue mantle, sitting on throne, holding sceptre. Scroll by side: IOSIAS. Cartoon as 4d. Original panel survived until fire.'

6e. King Jechonias

Bearded and crowned king in red robe and yellow mantle, holding sceptre. Scroll by side: IECONIAS. Cartoon as 3c. Original panel survived until fire.

6f. St Ambrose

Nimbed and mitred bishop in blue, white and yellow mass vestments, blessing and holding crozier. Scroll by side: AMBROSIVS.

6g. St Mark

Nimbed and bearded evangelist in robe and green mantle, holding book and sitting at lectern inscribed MARCVS, with winged lion above. Cartoon similar to 2a.

7a. Nahum

Bearded prophet in yellow robe, red mantle and green hat, holding scroll: NAHVM. Figure as 2b, 4c and 7e.

7b. Habbakuk

Bearded prophet in blue robe, yellow tunic and hat, holding scroll: HABAKAC. Cartoon similar to 5c and 5e.

7c. King Zedekiah

Bearded and crowned king in green robe and red tunic, holding sceptre and partially obscured scroll: [SEDECH]IAS. Cartoon similar to 1b and 9f. Original figure, inscribed SEDECHIAS, survived until fire.[71]

7d. King Jehoiakim

Bearded and crowned king in red robe and green mantle, sitting on throne, holding sceptre. Scroll by side: IOACHIM. Cartoon as 3d. The original figure survived until the fire.[72]

7e. Salathiel

Figure in pink robe, green mantle and yellow hat. Scroll by side: SALATHIEL. Cartoon as 2b and 4c, and figure as 7a.

7f. St Thomas

Nimbed and bearded apostle in yellow robe, white and yellow-stained mantle, white bonnet and blue hat, holding set square and glove. Scroll by side: THOMAS. Cartoon similar to 10e, figure similar to 5g.

7g. St Bartholomew

Nimbed, bearded and barefoot apostle in red robe and yellow mantle, holding flaying knife and scroll: BARTHOLOMEVS. Cartoon similar to 9a.

8a. Zephaniah

Prophet in green robe and purple mantle, holding quill pen and knife, and sitting at lectern inscribed SOPH[O]NIAS. Cartoon similar to 2g.

8b. Haggai

Bearded prophet in green robe and light blue mantle, holding scroll: AGGAEVS. Cartoon as 1f and 6c, and figure as 5a.

8c. King Azariah

Bearded and crowned king in pink robe and yellow mantle. Scroll by side: AZARIAS. Cartoon as 6b and 8e.

8d. King Zorobabel

Crowned king in blue robe and yellow mantle, sitting on throne, holding sceptre. Scroll by side: ZOROBABEL. Figure similar to 2d.

8e. King Abiud

Bearded and crowned king in red robe and yellow mantle. Scroll by side: ABIVD. Cartoon as 6b and 8c.

8f. St Philip

Nimbed and bearded apostle in blue robe and yellow mantle, holding cross-staff and scroll: PHILLIPVS. Cartoon similar to 2c and 9e.

9g. St Matthew

Nimbed, bearded and barefoot evangelist in green robe and red mantle, holding quill pen and knife, sitting at lectern inscribed MATHEVS, with blessing hand above.[73] Cartoon similar to 4a.

9a. Zacharias

Bearded prophet in red robe, white mantle and green hat, holding scroll: ZACHARIAS. Cartoon similar to 7g.

9b. Malachi

Bearded, bald and barefoot prophet in purple robe and green mantle, holding book and scroll: MALACHIAS. Figure as 3a and similar to 10g.

9c. King Herod the Great

Bearded and crowned king in green robe and red and yellow mantle, holding scroll: HERODES:ASCALONITA. Cartoon as 2e, 3e and 5b. Fowler engraving of the original panel which survived until the fire (Pl. XXVIIв).

9d. King Helkiah

Bearded and crowned king in yellow robe and green mantle, sitting on throne, holding sceptre. Scroll by side: HELKIAH. Cartoon as 5d.

9e. King Herod Antipas

Bearded and crowned king in pink robe and green mantle, holding sceptre and scroll: HEROD TETRACHA:. Cartoon as 2c and similar to 8f. Original panel survived until fire.

9f. St Andrew

Nimbed and bearded apostle in yellow robe and green tunic, holding large saltire cross. Scroll by side: ANDREAS. Cartoon similar to 1b and 7c.[74]

9g. St James the Great

Nimbed, bearded and barefoot apostle in white robe and red mantle, holding pilgrim staff with flask attached. Scroll by side: IACOBUS:MAJOR. Cartoon similar to 1a and 3g, figure similar to 4b.

10a. St Germanus of Auxerre

Mitred archbishop in red, green, white and yellow vestments, including pallium, blessing and holding cross-staff. Scroll by side: GERMANVS. Figure as 3f. Original panel survived until fire.[75]

10b. St John the Baptist

Bearded figure in yellow robe and blue mantle. Scroll by side: IOH(ANN)ES:BAPTISTA. There are two earlier versions of the panel; the one at Ely (Pl. XXVIIIf) contains some original glass, while that in Selby Sac. sII 1b dates from 1891.

10c. Jacob

Bearded prophet in yellow robe and hat, and red mantle, holding scroll: IACOB. The original panel survived until the fire.

10d. Virgin and Child

Nimbed and crowned Mary in yellow robe, blue mantle and white veil, sitting on throne, and holding on her knee the cross-nimbed Christ in white robe. Original panel survived until fire.

10e. Joseph

Bearded figure in yellow robe, red tunic, white bonnet and green hat, holding glove and scroll: IOSEPH:. Cartoon similar to 7f, figure similar to 5g. Original panel survived until fire.

10f. St Peter

Nimbed and bearded apostle in blue robe and yellow mantle, holding key. Scroll by side: PETRVS:. Original panel survived until fire.

10g. St Paul

Nimbed, bearded and bald apostle in green robe and purple mantle, holding naked sword and book. Scroll by side: PAVLVS:. Cartoon similar to 3a, figure similar to 9b. Fowler engraving of original panel which survived until fire (Pl. XXVIId).

11a. Canopy

Extension of canopy in 10a, with a row of light blue crenellation surmounted by small white gable with yellow crockets and finial. Pierced cusps on either side with decoration in yellow stain. Cartoon as 11g.

11b. Foliage

Extension of tree below with white and yellow-stained stem curling upwards and terminating in leaf. Pierced cusps as 11a. Cartoon as 11f.

11c. Foliage

As 11b but with minor variations. Cartoon as 11e.

11d. Foliage

Vertical white and yellow-stained stem with leaves, linking tree in 10d with cross in G1. Pierced cusps as 11a.

11e. Foliage

As 11c.

11f. Foliage

As 11b.

11g. Canopy

As 11a.

TRACERY LIGHTS (Pls XXVIA and XXVIc)

A1, A2. Foliage

Yellow medallion with flower surrounded by red maple leaves.

B1, B2. Foliage

Yellow medallion with blue oak leaves on red Type 2 background.

C1-C6. Plain Glazing

Small triangular openings in red, white and yellow stain with painted medallions in C3 and C4.

D1. Resurrection of Pope

Cleric in yellow chasuble, with pallium and tiara, holding cross-staff and rising from tomb. Red Type 2 background. Cartoon as D3.

D2. Resurrection of Man

Bearded man in white shroud rising from tomb. Red Type 4 background. Cartoon as D4. Fowler engraving of original panel (Pl. XXVIIE).

D3. Resurrection of Pope

As D1 but with Type 1 background.

D4. Resurrection of Man

As D2.

E1. Roundels

Two roundels, yellow sun beneath green rose. White Type 3 background. Pierced cusps with decoration in yellow stain.

E2. Roundels

As E1 but with yellow-stained architectural design beneath red flower.

F1. Arms of Selby Abbey

A shield, *Sable 3 swans argent beaked and membered or*, on blue stem and leaf background. Cusps as E1. Original panel had disappeared by 1879 but in 1819 Powell noted royal arms here.[76]

F2. Arms of England

As F1, but shield, *Gules 3 lions passant guardant in pale or*, as in original panel which survived until fire.

G1. Crucifixion

Cross-nimbed Christ in yellow loin cloth, and with crown of thorns, hanging on green cross inscribed: IESVS, flanked by two yellow-stained angels emerging from clouds. Red Type 6 background. Cusps as E1.[77]

H1. Resurrection of King

Bearded and crowned king in yellow robe and purple mantle, holding sceptre and rising from tomb. Blue Type 2 background. Copy of original panel at Dorchester Abbey, I 5b (Pl. XXIXA), with minor variations.

H2. Resurrection of Abbot or Bishop

Mitred cleric in yellow chasuble, rising from tomb. Blue Type 7 background. Copy of original panel at Dorchester Abbey, I 5e (Pl. XXIXB), with minor variations. Fowler engraving (Pl. XXVIIF).

I1-I4. Plain Glazing

As C1-C6.

J1. Resurrection of King and Man

King as in H1 but with blue mantle, facing half-length figure in white robe and blue mantle with hood. Red Type 5 background. Cartoon as J2.[78]

J2. Resurrection of King and Man

As J1, but with Type 2 background.

K1. Resurrection of Priest or Monk

Tonsured cleric in white shroud, rising from tomb. Red Type 2 background. Cartoon as K4.

K2. Resurrection of Man

Bearded figure in white shroud, rising from tomb. Red Type 1 background. Cusps as E1. Cartoon as K3.

K3. Resurrection of Man

As K2, but with Type 5 background.[79]

K4. Resurrection of Priest or Monk

As K1, but with Type 5 background.

L1-L4. Plain Glazing

As C1-C6.

M1. Angel

Nimbed, winged and barefoot angel in yellow robe and white mantle, hands conjoined and covered. Blue Type 5 background. Cusps as E1.[80]

M2. Devil with Soul

Horned and hairy yellow devil with green wings, carrying naked man. Background as M1. Cusps as E1. Fowler engraving of original panel (Pl. XXVIIIA).

N1. Holy Spirit

White cross-nimbed dove flying downwards. Blue Type 5 background. Cusps as E1.

O1. Resurrection of Woman

Figure in white robe and wimple, rising from tomb. Red Type 2 background. Cartoon as O2.[81]

O2. Resurrection of Woman

As O1, but with yellow robe. Fowler engraving of original panel (Pl. XXVIIIB).

P1. Heaven

Architectural structure with crocketed gable, buttress, crenellation and towers, containing nimbed angel wearing alb and holding portative organ, all in white and yellow stain. Blue Type 1 background.

P2. Hell

Emerging from blue cauldron and surrounded by flames, is a monstrous red hell mouth, with scaly, hairy body and large eye, swallowing naked soul. Green Type 2 background.[82]

Q1. Angel with Saved

Nimbed and winged angel in blue robe, standing behind six smaller naked men and women.[83] Red Type 5 background. Cusps as E1.

Q2. Devils with Damned

Two hairy horned and winged red devils chaining two naked men and a woman. Yellow Type 3 background. Cusps as E1.

R1. St Michael

Nimbed and winged archangel in blue robe and yellow mantle, holding pair of scales containing two naked souls. Red Type 1 background. Cusps as E1.[84]

S1. Trumpeting Angel

Nimbed and winged angel in green robe and yellow mantle, emerging out of clouds and blowing trumpet. Blue Type 5 background. Cartoon as S2.

S2. Trumpeting Angel

As S1.

T1. Angel with Instruments of Passion

Nimbed and winged angel in blue robe and yellow mantle, holding spear and three nails. Red Type 5 background. Cusps as E1. Cartoon similar to T2.[85]

T2. Angel with Instruments of Passion

As T1 but angel holding green cross, and what is probably a sponge in white cloth.[86]

U1. Sun

Three yellow roundels depicting the sun between two architectural designs. Red Type 2 background.

U2. Moon and Stars

Sickle moon and three stars in yellow. Background as U1.

V1. Christ in Judgment

Cross-nimbed and bearded Christ in purple mantle, sitting on yellow rainbow and displaying wounds. His feet rest on an orb showing sea, earth and sky. Blue Type 5 background. Cusps as E1.[87]

W1. Cherubim

Six-winged white and yellow-stained nimbed angel in alb and scarf. Green Type 2 background. Cartoon as W2.

W2. Cherubim

As W1.

SACRISTY

The three east window panels now in the Sacristy were in a museum collection in the chamber above, known as the Scriptorium, when John Kent became Vicar of Selby in 1952.

They were rescued by the Abbey architect, George Pace, who placed them, sandwiched between sheets of modern glass, in the Sacristy when it was refurbished as a War Memorial Chapel in the early 1960s.[88] All three panels were shown in the exhibition Abbeys: Yorkshire's Monastic Heritage, held at the Yorkshire Museum, York, in 1988, but they were not included in the catalogue.

Sac. sII

1b. St John the Baptist h0.68m w0.47m

A Ward and Hughes panel of 1891, similar to those in the east window (I 10b) and at Ely (Pl. XXVIIIF), but without borders. It was badly cracked in the fire. The glass has been antiquated by painting on both surfaces.

2b. St John the Evangelist (Pls XXVIIIE and XXXE) h0.67m w0.47m

Original 14th-century panel engraved by Fowler (Pl. XXVIIc) and restored by Ward and Hughes in 1891, and copied in the present east window described above (I 2g). Badly damaged in the fire, the 14th-century glass is fire-crazed, 19th-century pieces cracked and borders removed. The murrey mantle has quite heavy exterior corrosion. Back painting is used to model the head and drapery.

 Most of the panel is original, but restorations include the saint's left hand and foot, the lower section of robe, three pieces of mantle, the right post of the chair, the base of the lectern and part of the inscription: IO/HA/I/NNES. The quatrefoil band at the base is restored in the left corner and beneath the feet, and in the canopy the lower sections of both shafts, the two central pieces of the vault, and the top right quatrefoil are restored.

Sac. sIII

1b. Judah? (Pl. XXVIIID) h0.68m w0.47m

Original 14th-century panel, restored by Ward and Hughes in 1891, and replaced by the copy in I 4f described above, having suffered fire damage and lost its borders like the previous panel. There is quite heavy pitting on blue and yellow, and a little on some white glass. Yellow stain is used on pale-blue glass to produce a green lining to the mantle and a brim for the hat. Back painting occurs on drapery. Most of the panel is original, the restorations including the head, nimbus, feet, scroll and about a quarter of the stem and leaves.

 Because of the restored inscription the original identity of the figure is problematic. In the exhibition he was labelled as St Jude, after the copy in I 1f, but the nimbus is modern and the setting indicates a prophet or patriarch from the Jesse.

DORCHESTER ABBEY, OXFORDSHIRE

Two original tracery-light panels from Selby were glazed into the east window of Dorchester Abbey by Dennis King in 1969. They were presented by the Revd Harold Best, Vicar of Dorchester (1960–76), who was given them when Rector of Drayton St Leonard, Oxfordshire (1953–60), where they were found by a churchwarden in the attic of the former rectory.[89] After their publication in the Corpus Vitrearum, when they were described as of unknown provenance, David O'Connor established the link with Selby.[90]

EAST WINDOW (I)

5b. Resurrection of King (Pl. XXIXA) *ho.*51m *wo.*33m

The original of I H1 at Selby. For a full description see the Corpus Vitrearum catalogue entry.[91] All the glass appears to be original, but it was badly cracked in the fire and Dennis King replaced mending leads by edge-gluing.

5e. Resurrection of Abbot or Bishop (Pls XXVIIF and XXIXB) *ho.*51m *wo.*33m

The original of I H2 at Selby. For a full description see the Corpus Vitrearum catalogue entry.[92] Condition as 5b.

ELY CATHEDRAL STAINED GLASS MUSEUM

St John the Baptist (Pl. XXVIIIF) *ho.*67m *wo.*65m

This panel is on loan from Dennis King of Norwich who acquired it some thirty years ago from Hugh Salmond of the London glass firm Hetleys, to whom it had been bequeathed by Thomas Curtis. It contains some of the original glass from a panel replaced in 1891 by the copy now in Selby Sac. sII 1b and, when that was damaged in the fire, by that presently in I 10b. It was considerably restored by Ward and Hughes, presumably around 1891, and the entire figure is modern. Original pieces include the scroll, about a third of the stem, foliage and background, and five of the squirrels in the Type B borders.

LIVERPOOL, WALKER ART GALLERY (NATIONAL MUSEUMS AND GALLERIES ON MERSEYSIDE)

Three original main-light panels from Selby were discovered by David O'Connor in 1987 when Philip Nelson's collection of stained glass, acquired by Liverpool Museum in 1953, was transferred from storage at Speke Hall to the main museum site. The card index to the collection contains no information on provenance, and it is not known how Nelson came by the panels. The glass is in quite good physical condition, but the leading is weak and the panels are in need of conservation.

1. King Achaz (Pl. XXIXC) *ho.*71m *wo.*61m

Bearded and crowned king in red robe and pot-metal yellow mantle and shoes, holding a sceptre and scroll: *ACHAZ:REX*. Blue Type 3 background; Type A borders. Mostly 14th-century apart from the 19th-century head based on panel 2. Lower part of figure distorted and patched with old glass; sleeves, stem of sceptre and piece of Type 1 background reused 14th-century. The figure faces right and was probably originally in light c. It is not closely related to Achaz in I 3e.

2. King Amaziah (Pl. XXIXD) *ho.*69m *wo.*64m

Bearded and crowned king in murrey robe, green mantle and pot-metal yellow shoes, holding sceptre and scroll: *AMASI/A/S:RE/X*. Blue Type 3 background with several Type 1 insertions; Type C borders but with all lions facing left. Lower part of figure distorted and robe patched with green drapery from another figure; one piece of stem missing. The figure

faces right and was probably originally in light c. Amaziah is not included in the present east window.[93]

3. King Jotham (Pl. XXIXE) h0.68m w0.58m

Bearded and crowned king, in green robe, pale blue mantle with yellow-stained lining and blue shoes, sitting on mainly blue throne with yellow diapered cushion. He holds a sceptre and scroll: *IOTHAN/REX:*. Red Type 2 background; borders made up of Type A covered cups on red between gold fleurs-de-lys on blue. The figure is badly distorted and the robe, stem of sceptre and throne patched with 14th-century glass. The head is modern but in an early 15th-century style, the crown inside out, and several pieces of stem and leaves are restored. The panel, originally in light d, is unrelated to the modern Jotham in I 4e.

ACKNOWLEDGEMENTS

We are particularly grateful to the Revd Michael Escritt, former vicar of Selby, for allowing us access to all parts of the Abbey and for permission to reproduce photographs. Thanks to Peter Gibson and the staff of the York Glaziers Trust it was possible to examine the sacristy panels in their workshop. We would also like to thank Michael Archer, Bernard Barr of York Minster Library, Sarah Brown, Lionel Burman of Liverpool Museum, Dr William Cole, Prof. Barrie Dobson, Dennis King and Hugh Murray, the latter in particular for advice on heraldry and help with photography. Graham Reddish very generously sponsored the publication of the photographs, as well as the two plans which were drawn by Andy Donald. Plates XXXVIIIA, B were reproduced by kind permission of the Dean and Chapter of York and Plates XXIXC, D and E were reproduced by kind permission of the Trustees of the National Museums and Galleries of Merseyside (Walker Art Gallery).

REFERENCES

1. For the historical background see VCH *Yorkshire*, III, ed. W. Page (London 1913), 95–100 and the short account, which includes a critical bibliography, in R. B. Dobson, *Selby Abbey & Town* (Selby 1969a). Finance and organisation, including the upkeep of the fabric, are discussed in John H. Tillotson, *Monastery and Society in the Late Middle Ages. Selected account rolls from Selby Abbey, Yorkshire, 1398–1537* (Woodbridge 1988). For the art and architecture see W. Wilberforce Morrell, *The History and Antiquities of Selby* (Selby 1867); C. C. Hodges, 'The Architectural History of Selby Abbey', in J. T. Fowler (ed.), *The Coucher Book of Selby* II, *Yorkshire Archaeological and Topographical Society Record Series*, 13 for 1892 (1893); I*–LVII*, reprinted in *Yorkshire Archaeological Journal*, 12 (1893), 344–94; and B/E *Yorkshire: The West Riding*, 2nd edn (1967), 435–42.

2. The traditional account of the early history of Selby, written by one of the monks in 1174, *Historia Selebiensis Monasterii* (Paris, Bibliothèque Nationale, MS 10940), is included in J. T. Fowler (ed.), *The Coucher Book of Selby* I, *Yorkshire Archaeological and Topographical Association Record Series*, 10 for 1890 (1891), 1–54. I. S. Neale (trans.), *A History of Selby Monastery to 1174 A.D.* (Selby 1984) is based on this edition. The controversial evidence surrounding the abbey's foundation is evaluated in R. B. Dobson, 'The First Norman Abbey in Northern England. The Origins of Selby: a Ninth Centenary Article', *Ampleforth Journal*, 74 (1969b), 161–76.

3. For the Romanesque church see Eric Fernie's paper in these Transactions.

4. Apart from payments for the glazing of the new west window in 1413–14, accounts refer only to repairs to windows in the church and conventual buildings; Tillotson, 77, 209–10 and 224. The choir glazing and glass in the sacristy and scriptorium is catalogued in Henrietta Reddish, 'East Window and Heraldic Glazing of the Choir, Selby Abbey, North Yorkshire' (unpublished M.A. thesis, University of York, 1985). There is also medieval glass in two nave windows; sXV A1, where a medallion, supposedly representing the arms of Warenne, has been patched with 14th-century grisaille and canopy fragments, and nXV to which 14th-century armorials from Ellerton, Yorkshire, were transferred in 1984.

5. N. Coldstream, 'York Minster and the Decorated Style in Yorkshire: Architectural Reaction to York in the First Half of the Fourteenth Century', *Yorkshire Archaeological Journal*, 52 (1980), 89–110, partly based on

her 'The Development of Flowing Tracery in Yorkshire 1300–1370' (unpublished Ph.D. thesis, University of London 1973).

6. Coldstream (1980), 106–7 compares the window to Hawton (Nottinghamshire), Heckington, Sleaford and Algakirk (Lincolnshire).

7. J. Harvey, 'Architectural History from 1291–1558' in G. E. Aylmer and R. Cant (eds), *A History of York Minster* (Oxford 1977), 157–8 and his *English Mediaeval Architects: A Biographical Dictionary down to 1550*, 2nd edn (Gloucester 1984), 238–9.

8. Coldstream (1980), 109–10.

9. G. S. Haslop, 'The Fourteenth Century Fire at Selby Abbey', *Yorkshire Archaeological Journal*, 39 (1958), 451–4.

10. The heraldic glass is discussed in Reddish, ch. v. The arms of Ingham were in NIV and Wallis in nVIII and NII.

11. Harvey (1984), 239.

12. Reddish, ch. v, quoting mainly R. Glover, *The Visitation of Yorkshire 1584–5* ed. Joseph Foster (1875); Roger Dodsworth, *Yorkshire Church Notes 1619–1631*, ed. J. W. Clay, *Yorkshire Archaeological Society Record Series*, 34 (1904), 77–85; BL, Loan MS 38, fols 187–189v: Sir William Dugdale's Book of Monuments: York Minster Library, MS L1 (10), James Torre, 'Churches Peculiars within the Diocesse of York' (1691); and John Burton, *Monasticon Eboracense and the Ecclesiastical History of Yorkshire* (York 1758).

13. The remnants of such a scheme can be seen in the colour plate of SIII in Dobson (1969a), 40.

14. The steady loss of heraldic glass since 1641 is charted in Reddish, 48–50. Many panels disappeared when the tower collapsed in 1690.

15. Oxford, Bodleian Library, MS Ashmole 784, fols 34–34v.

16. Quoted in Burton (1758), 407–8.

17. For a full account see Reddish, ch. 11.

18. J. C. Buckler, 'Modern State of Selby Abbey, Yorkshire', *Gentleman's Magazine*, 35, pt. 2 (1815), 105–6.

19. For this artist see J. T. Fowler (ed.), *The Correspondence of William Fowler, of Winterton, in the County of Lincoln* (Durham 1907); P. Binnall, 'William Fowler: Artist and Antiquary', *Journal of the British Society of Master Glass-Painters [JBSMGP]*, 11 (1928), 176–82; and DNB XX, 89–90. Fowler issued the engravings himself in a small edition dated December 1820, which we reproduce from copies in York Minster Library, and a larger coloured version dated 25 January 1822. There are copies of both sets in the Print Room at the Victoria and Albert Museum (R.13 a. E5414 to E5426–1903).

20. Morrell, 202; J. Fowler, 'The Great East Window, Selby Abbey', *Yorkshire Archaeological Journal*, 5 (1879), 331–49 [p. 332].

21. Morrell, 201. For Wailes see Martin Harrison, *Victorian Stained Glass* (London 1980), 18–19, 26–9 and 83.

22. J. Fowler, 'The Great East Window of the Abbey Church, Selby', *Selby Times*, 25 February 1871.

23. Fowler (1879), 332–3. His original notes, 'East Window of Selby Abbey', are in London, Council for the Care of Churches, Canon Binnal Collection.

24. Fowler (1879). As restoration work began he also wrote a series of articles on the iconography of the window for *The Selby Times*, reprinted as James Fowler, *Representations of the Tree of Jesse and of the Last Judgment, Specially in Reference to the Great East Window of the Abbey Church, Selby* (Selby 1890).

25. For this firm see Harrison, 37–8 and 83.

26. Letter from T. Curtis to Revd M. Parkin, 22 October 1906; York, Borthwick Institute of Historical Research, PR. SEL 150 (4).

27. It is reproduced in J. P. Pritchett, 'Selby Abbey Church', *JBAA*, 48 (1892), 7–99 and 285–91 [p. 287] and in a supplement in *The Builder*, 24 September 1892.

28. The restoration was commended in a supplement to *The Selby Times*, 13 October 1891.

29. The latter are identified in a diagram in Pritchett, 286.

30. For the fire see Charles H. Moody, *Selby Abbey: A Resumé 1069–1908* (London 1908), ch. v and Gerald Cobb, *English Cathedrals: The Forgotten Centuries. Restoration and Change from 1530 to the Present Day* (London 1980), 64–73.

31. Report of 31 December 1906; Borthwick Institute, PR. SEL. 150 (4). Correspondence about the second restoration of the east window is included in Reddish, Appendix III.

32. Joseph E. Morris, *The West Riding of Yorkshire*, The Little Guides (London 1911), 459.

33. Cobb, 66; B/E *Yorkshire: The West Riding*, 2nd edn (1967), 442 and 647 quoted in Henry Farrar, *Selby Abbey* (Selby 1989), 20.

34. Barbara Palmer, *The Early Art of the West Riding of Yorkshire: A Subject List of Extant and Lost Art Including Items Relevant to Early Drama*, Early Drama, Art, and Music Reference Series, 6 (Kalamazoo 1990), 287–90 and individual entries in the Subject List.

35. Letter of 6 August 1908; Borthwick Institute, PR. SEL. 149.

36. We are grateful to Michael Archer of the Victoria and Albert Museum for this information.

37. Two small panels of 14th-century fragments, consisting of decorative pieces, grisaille, rinceaux and foliage from Selby Abbey choir, are in Dr William Cole's collection. They were apparently given, after the fire, to William Liversidge, the benefactor who financed both restorations of the east window.

38. For the origins of Jesse imagery see Arthur Watson, *The Early Iconography of the Tree of Jesse* (London 1934). There is a brief survey of Jesse windows in Britain in H. T. Kirby, 'The "Jesse" Tree Motif in Stained Glass. A Comparative Study of Some English Examples', *Connoisseur*, 141 (February 1958), 77–88, reprinted in *JBSMGP*, 13 (1960–1), 313–20 and 434–41.

39. For 14th-century examples and references to further literature see C. Woodforde, 'A Group of Fourteenth-Century Windows showing the Tree of Jesse', *JBSMGP*, 6 (1937), 184–90, and M. Q. Smith, *The Stained Glass of Bristol Cathedral* (Bristol 1983), 52–64. The Midlands material is reassessed in Peter Newton, 'Schools of Glass-Painting in the Midlands 1275–1430', 2 vols (unpublished Ph.D. thesis, University of London 1961), I, ch. 4 and pages 299–305, and the iconography and style of Lincolnshire Jesses, particularly Gedney, are discussed in Penelope Hebgin-Barnes, 'The Thirteenth and Fourteenth-Century Stained Glass of Lincolnshire', 4 vols (unpublished D.Phil. thesis, University of York 1990), I, 159–61 and 222–6. For a detailed discussion of the Selby iconography see Reddish (1985), ch. III.

40. For this office see Tillotson, 231–5. The position of the altar, a matter of some debate, is discussed in Hodges, LIV*–LV*. If the claims that the eastern bay of the choir functioned as a Lady Chapel are correct, the inclusion of a Jesse in the window immediately above the altar there would make the iconography even more specific.

41. Isaiah 11. 1–2.

42. Pritchett, 286.

43. Kirby (1961), 434.

44. Hodges, XLII*.

45. Pritchett, 286.

46. For representations of St John see Clifford Davidson and David O'Connor, *York Art: A Subject List of Extant and Lost Art including Items relevant to Early Drama*, Early Drama, Art, and Music Reference Series, 1 (Kalamazoo 1978), 126, 129–31 and 138.

47. Tillotson, 217–8 and 244.

48. Smith (1983), 52–3 and 75–7 and plates between pp. 16–17 and 32–3; E. W. Ganderton and J. Lafond, *Ludlow Stained and Painted Glass* (Ludlow 1961), 4–8 and Pls 1 and 2. For the Madley Jesse see the forthcoming article by Sarah Brown in the Hereford volume of BAA CT.

49. The Cartmel glass (sII) of *c*. 1330–40 has not been properly published but the panel of Gabriel from the Annunciation is included in the exhibition catalogue *Europe Gothique* (Paris 1968), 131–2. For the Morpeth east window see L. C. Evetts, 'Medieval Painted Glass in Northumberland', *Archaeologia Aeliana*, 20 (1942), 91–104 [pages 99–102] where it is wrongly dated to the late 14th century rather than *c*. 1330–40. For the psalters see H. Helsinger, 'Images on the *Beatus* Page of Some Medieval Psalters', *Art Bulletin*, 53 (1971), 161–76. The Beatus page in the Gorleston Psalter (BL, Add. MS 49622, f.8) is reproduced in colour in Richard Marks and Nigel Morgan, *The Golden Age of English Manuscript Painting 1200–1500*, Pl. 19.

50. At Wells the Last Judgment scenes in the east window tracery dating from *c*. 1340–45, extend into the traceries of the adjacent windows NII and SII; J. Armitage Robinson, 'The Fourteenth-Century Glass at Wells', *Archaeologia*, 81 (1931), 85–118 and Pls XLIII and XLVII–XLVIII, and R. Marks, 'The Mediaeval Stained Glass of Wells Cathedral', in *Wells Cathedral: A History*, ed. L. S. Colchester (Shepton Mallet 1982), 132–47 and Pl. 68. For St Denys, York, nII see RCHME, *City of York*, v (1981), 17.

51. D. J. King, 'The Glazing of the South Rose of Lincoln Cathedral', BAA CT, VIII (1986), 132–45.

52. R. S. Ferguson, 'The East Window, Carlisle Cathedral', *Transactions of the Cumberland and Westmorland Antiquarian Society*, 2 (1876), 296–312 and Thomas French and David O'Connor, *York Minster: A Catalogue of Medieval Stained Glass: The West Windows of the Nave*, Corpus Vitrearum Medii Aevi Great Britain, III/I (Oxford 1987), 22 and Pl. 29b.

53. French and O'Connor.

54. Ibid., 18–23.

55. Ibid., 12–14.

56. For example in York Minster SIII 4e. For a brief discussion of this dispersed glass see D. O'Connor and J. Haselock, 'The Stained and Painted Glass', in G. E. Aylmer and R. Cant (eds), *A History of York Minster* (Oxford 1977), 378–83 and French and O'Connor, 19. The thrones in the west window are illustrated in French and O'Connor, Pls 3 and 5b.

57. French and O'Connor, Pl. 9.

58. J. A. Knowles, 'The East Window of St. Michael-le-Belfrey, York', *Yorkshire Archaeological Journal*, 40 (1962), 145–59.

59. French and O'Connor, Pl. 11.

60. For the rinceaux designs in the west wall of York Minster see French and O'Connor, 7 and Pl. 19.

61. For the York west wall border designs see French and O'Connor, 7–8 and Pl. 20.

62. Woodforde (1937).
63. For the Jesses see above note 49. Works by the All Saints workshop are mentioned in French and O'Connor, 20.
64. See above note 50.
65. There is a more detailed discussion of this problem in Reddish, ch. IV.
66. See above p. 123 and note 52, and French and O'Connor, 22.
67. French and O'Connor, 22.
68. For the manuscript comparisons see French and O'Connor, 23 and Pl. 31 (b) and Lucy Freeman Sandler, *The Psalter of Robert de Lisle in the British Library* (London 1983).
69. For the problems over the identity of this figure see above p. 121.
70. Kirby, Pl. 5.
71. Hodges, XLI*.
72. Fowler (1879), 333 and Hodges XLI*. The former simply recorded seeing a label IOACHIM, and the restorers have followed his suggestion that this probably referred to King Jehoiakim rather than Joachim, father of Mary, who might have been included in the genealogy out of devotion to the Virgin.
73. Fowler (1879), 335 records a figure with this inscription.
74. An image of St Andrew is mentioned in the Sacrist and Keeper of the Fabric's accounts of 1446–7; Tillotson, 224.
75. Germanus is, with the Virgin Mary, patron saint of Selby, and the middle finger of his right hand, stolen from the shrine at Auxerre by the founder and first abbot of Selby, Benedict, was one of the abbey's great treasures. Although he is now represented as an archbishop, in reality he was sixth bishop of Auxerre (418–48), and the original panel, which survived the fire, depicted him holding a crozier; Hodges, XLI*. An image of the saint is mentioned in the Sacrist and Keeper of the Fabric's accounts of 1446–7; Tillotson, 219 and 222. Representations in English glass are rare, but there are probably two others from the 14th century. One is an unidentified bishop saint of *c.* 1315–26 at Stanford-on-Avon, Northamptonshire, where the manor and church, which had an altar dedicated to him, were Selby possessions; Newton I (1961), 250–2. He is also represented in glass of *c.* 1380–6 at New College, Oxford; C. Woodforde, *The Stained Glass of New College, Oxford* (London 1951), 84.
76. Fowler (1879), 336; Leeds, Yorkshire Archaeological Society Archives, MS 294, Revd D. Powell, 'Church Notes', II (1819).
77. Fowler (1879), 335 describes about a third of the panel as extant.
78. Fowler (1879), 339–40 describes the kings in both panels as having yellow robes.
79. Fowler (1879), 340 describes as extant, part of the tomb, the background and border.
80. Fowler (1879), 343 describes the angel as 'ministering to and assisting one rising from a grave'.
81. Fowler (1879), 339 describes the original robe as yellow.
82. Already damaged when described in Fowler (1879), 343.
83. Fowler (1879), 343 only records two souls.
84. Fowler (1879), 341 describes about a third of the angel as extant.
85. Fowler (1879), 338 describes only half the angel as extant.
86. Fowler (1879), 338 says that only half the figure was extant. He mentions the cross, but not the other object, which was almost certainly the crown of thorns.
87. Fowler (1879), 336–7 describes half the panel as extant.
88. Letter from Revd J. Kent to H. Reddish Harris, 5 September 1985.
89. Letter from Revd H. Best to H. Reddish Harris, 1 April 1985.
90. Peter A. Newton, *The County of Oxford: a Catalogue of Medieval Stained Glass*, Corpus Vitrearum Medii Aevi Great Britain I (London 1979), 82–3 and Pl. 30 (a) and (c).
91. Ibid., 82.
92. Ibid., 83.
93. A figure 'represented as a patriarch, in green tunic and blue cloak wrapped over his head' was identified by Fowler as Amaziah on the basis of an inscription MASAIAS; Fowler (1879), 334. This sounds like a description of Sarasam in I If.

A Northern English School? Patterns of production and collection of manuscripts in the Augustinian Houses of Yorkshire in the twelfth and thirteenth centuries

By Anne Lawrence

Argument continues concerning the condition of Yorkshire in the decades following the Harrying of the North, but Domesday Book does seem to make one thing clear: the absence of any significant degree of monastic settlement. In 1086 St German's, Selby, was still establishing itself, having been founded under the patronage of the Conqueror himself, apparently during his harrying of Yorkshire, in 1069–70; and even St Mary's, York, later to become one of the wealthiest houses in the North, was apparently still a small community based at St Olav's church (royal patronage and further lands came in 1088). Thus, for some decades after the Conquest, as in the late Saxon period, the only ecclesiastical lords with Yorkshire landholdings of significant size were the archbishop of York and the bishop of Durham. These estates were not, apparently, much diminished in size by the Conquest, but were considerably reduced in value. The lands of the archbishop were estimated at about half their pre-Conquest value.

This fall in value is by no means restricted to the holdings of ecclesiastical lords, but is very widespread in Yorkshire, as described in Domesday.[1] Indeed, it is particularly strongly marked in the king's own estates. These comprised about 20% of Yorkshire, a proportion in line with that in the rest of the country after the Conquest. In 1066 these lands had represented about 20% also of the value of the county; but in 1086 they appear to make up only about 4% of its value, as well as holding only about 4% of its population. In general, both falling values, and estates apparently wholly waste, are unevenly distributed, not only between the holdings of different lords, but also within the holdings of individuals. Moreover, the whole question of 'waste' manors is extremely difficult, as the Domesday commissioners seem to have been unable to obtain any information for some areas and in others, as Maitland points out, estimates of the number of teams 'that could plough' a given estate may be wholly hypothetical.[2] Despite these problems for interpretation, it is clear that the effects of the devastation of 1069 and 1070 were severe, and it appears that Yorkshire was still slowly recovering in 1086. It has been estimated that, of nearly 1,900 villages recorded in Domesday, over 1,100 were either depopulated or described as containing some wasteland.[3] Moreover, another 400 were significantly underpopulated and understocked, in relation to their stated capacity; and only about fifty seem to show a population and value unchanged from T.R.E. The level of depopulation suggested by Domesday is illustrated by the fact that, even in the Vale of York (which contained some of the best agricultural land) there was an average population of only two men and one plough team per square mile.

Thus, the conditions in Yorkshire at the end of the 11th century do not appear propitious for the establishment of a flourishing and widespread monastic culture of the traditional kind; and indeed the development of monasticism in Yorkshire followed very distinctive lines during the 12th century. This development was largely carried out by two groups new in England: the Augustinian canons and the Cistercians. Of the two, the first to begin to settle were the Augustinians, drawing their members at first from southern England, as had

the 11th-century settlers in the Benedictine houses further north. It is with the houses of these canons that this paper will be particularly concerned, as the manuscripts of the Cistercians have been discussed elsewhere.[4] These houses form an especially interesting group, as they seem to have had the patronage of Henry I, and of a number of the members of his court, as well as of Thurstan, archbishop of York. Indeed it is possible that Henry I's confessor, Athelulf, is identifiable as the first Prior of Nostell (1122).

It seems clear that the period of rapid Augustinian settlement coincides both with the period of consolidation of a new 'Norman' aristocracy in the North; and with efforts by this aristocracy to reorganise their estates. As stated before, Domesday's figures for both the population and the values of Yorkshire manors are very difficult to interpret, and are the subject of complex arguments. Indeed, Maitland observed that the Yorkshire jurors appeared to use the existing estimates of carucates for geld as the basis for their estimates of the number of ploughlands, and therefore 'the Yorkshire figures are, of all Domesday, least likely to represent the actual amount of cultivated land'.[5] However, even Maitland was prepared to state that, by the reign of Henry II, the Yorkshire economy had made a considerable recovery.

This level of recovery supports the idea of some deliberate policy on the part of the lords, and indeed T. A. M. Bishop argued that Domesday Book can give considerable evidence of deliberate moving and resettling of peasants, from both inside and outside Yorkshire, by 'improving' lords. Moreover, he suggested that the areas in which this resettlement and redevelopment appears most advanced in Domesday fall into two distinct types: good farming land held by powerful lords or sub-tenants; or areas of military and strategic importance.[6] In such circumstances, it is perhaps not surprising that there is also some evidence for the imposition of heavier labour obligations. Finally, Domesday also demonstrates the existence in Yorkshire of about fifty villages which were apparently over-populated and overstocked in relation to their estimated capacity. These 'overstocked manors' are difficult to interpret, but again appear to demonstrate that some kind of redevelopment was already under way in the late 11th century.[7]

A pattern of deliberate redevelopment and re-organisation of settlement and land use, then, makes it probable that the royal, aristocratic and episcopal patronage of the Augustinians should be seen as part of a broader movement. Augustinian houses had several characteristics which might have been of special value in Yorkshire.[8] First, they needed fewer resources than Benedictine abbeys. Second, they could be expected to undertake some pastoral duties, something which might make them attractive in a region where the numbers of functioning churches had been reduced. Third, it seems that, in southern England at least, there was some expectation that they would undertake educational responsibilities. That the Augustinians were especially favoured in Yorkshire is suggested by the absence of their houses further north — there was apparently no support for them in Durham.

Once started, the Yorkshire Augustinian movement developed rapidly. The first foundations came in 1113–14, and were Hexham (supported by the archbishop) and Bridlington (supported by Walter de Gant). The latter was one of Henry I's 'novi homines', an important landholder in the East Riding and Lincolnshire, who had been given the soke of Bridlington a little earlier. These were followed in the 1120s by Guisborough, founded by Robert de Brus; Bolton, founded by William Meschin and his wife; Kirkham, founded by Walter L'Espec, one of Henry I's mainstays in the North; and Worksop, founded by William de Lovetot. Drax was founded in the 1130s by William Paynel, with the support of the archbishop; and, lastly, Newburgh was founded in 1145.

This list makes clear the level of court support for the Augustinians in the first half of the 12th century, and contrasts with the Conqueror's and Rufus', support for Benedictine

houses in Yorkshire. Few of these patrons were exclusive in their support (for instance, L'Espec also founded the Cistercian house of Rievaulx) but there is further evidence which suggests that certain regions of Yorkshire were felt to be especially suited to these houses. There is a considerable correspondence between the areas where the Augustinian houses were founded, and the regions in which the majority of the so-called 'overstocked manors' were to be found.[9] Kapelle points out that these manors were in relatively secure locations, had apparently not been laid waste in 1069–70, and that most of them had demesne land.[10] Thus, these manors were presumably capable of increasing in productivity and value; and the Augustinian houses might contribute further to the re-establishment of settled communities under their new lords.

In very broad terms, then, the foundation of the Augustinian priories represents a particular phase in the settlement of Yorkshire, and in the expansion of monastic life there. They came later than the great Benedictine houses of Selby, St Mary's and Pontefract; but overlap to some extent with the foundation of the Cistercian abbeys. Given their small size and relatively remote locations, the acquisition of book collections might well have posed special difficulties. They would need to be provided from the outset with at least the basic liturgical books; almost equally urgent would presumably be copies of the Augustinian rule, with the other works necessary for the regular life. A little later might come a need for books for the instruction of recruits, and, if there was an expectation that the canons would preach to the laity, or even run a school, a broader range of works would be needed. Unfortunately, no documentary evidence survives on how such books were obtained, or whether they were produced by members of the houses themselves.

Fortunately, there is clear evidence, both in the Augustinian Rule itself, and in a 12th-century treatise from Bridlington, about the use and production of manuscripts in these houses. The Rule assumes the presence of books, not only for the liturgy, and for reading aloud during meals, but also for devotional reading on a daily basis. Moreover, it is made clear that the books are to be the property of the community, not of individuals, and that they are to be under the care of an official, who is to hand them out, and presumably receive them back.[11]

The Bridlington treatise, published as *The Bridlington Dialogue*,[12] gives a good deal of information on how these regulations were interpreted in at least one Yorkshire house. The *Dialogue* is an exposition of the Rule, written as from a master to a disciple, and is almost certainly the work of Robert, known as 'the Scribe', who became Prior of Bridlington *c.* 1147–50.[13] He was the compiler of glosses on Exodus, on the Minor Prophets and on St Paul, the latter being popular in the 12th century, to judge from the number of surviving copies of it.[14] It seems likely that Robert had contacts outside Bridlington itself, as he states that the commentary on the Minor Prophets was compiled at the request of Gervase, abbot of Louth Park. This Gervase had been sub-prior of St Mary's, York, and was one of the founding members of Fountains. Unfortunately, Robert does not mention where he obtained copies of such works as those of Lambert of Utrecht and Anselm of Laon, on which he drew for his own glosses.

However, Robert's success as a compiler suggests access to a library well stocked with both patristic works and later commentaries, and his glosses suggest especial knowledge of the works of St Augustine. The autobiographical remarks in the Prologue to the *Dialogue* do not make it wholly clear that this work was done at Bridlington, but there is no mention of any significant study before he came there, and there is a suggestion that he was involved with Bridlington from the time of Wickmann, the first prior.[15] If this is the case, then the contact with Cistercian houses is interesting, and corroborates other evidence of intellectual contact between Cistercians and Augustinians, which will be discussed later.

On the question of the production of manuscripts within the Augustinian houses, one very valuable passage occurs in Robert's discussion of suitable work for the canons. At the top of the list comes 'Reading, expounding and preaching the Word of God before the brethren, and practising for divine worship by reading'. This is followed by 'preparing parchments for the scribes, writing, illuminating, ruling lines, scoring music, correcting and binding books'.[16] Such a list suggests an organised production of books, contributed to by the canons, although there is some suggestion that the 'scribes' form a separate group. Later, Robert confirms the importance he attaches to books and to reading, arguing strongly against those who suggest that St Augustine intended reading to take place during only one hour a day, and even stating that the Superior might modify the Rule's stipulation that 'Anyone who asks for a book at the wrong time is not to have it'.[17] It is an interesting possibility that such assertions reflect an argument amongst the Yorkshire Augustinians at this time on the question of reading and studying.

There is, then, evidence for the copying and writing of texts in at least one Yorkshire Augustinian house, and for the emphasis placed there on devotional reading, and on the exposition of scripture. This raises the questions of how books were obtained for copying, and how scribes and illuminators were trained. Unfortunately, the surviving books from Bridlington, which might give some answers to these questions, are few. However, Bridlington books of both the 12th and 13th centuries do show a continuing interest in good, fully glossed copies of texts, and in the carrying-out of copying within the house. Altogether, some seven manuscripts survive from the relevant period. These include glossed copies of the Gospels of Mark and Luke, and a glossed copy of the Apocalypse, with a Commentary which was originally part of the same volume.[18] These are in clear, skilled bookhands of the mid to later 12th century, with considerable care taken in both ruling and copying to produce a clear arrangement of the glosses around the main text, although no academic apparatus or special signs are given. The layout of the Gospel of Mark, now British Library MS Harley 50, is the most complex, whilst its script is latest in appearance. The hands used in these manuscripts are all skilled and clear but, whilst there is generally uniformity in script and layout within each volume, there is no apparent attempt to produce a set of manuscripts of uniform style. Thus, they suggest the work of a number of skilled scribes, but with no real attempt at a 'house style'.

In their decoration, however, these manuscripts are more uniform. Like contemporary manuscripts from the English Cistercian houses, they generally lack rubrication and display script at the beginning of the text. Initial decoration is also very restricted, and is often slightly clumsy in appearance in contrast to the script; this is especially the case with the glossed copy of Luke's Gospel, now Oxford, Bodleian Library MS Fairfax 15. However, the decorated initials which do occur use several colours, unlike those of the Cistercians, and their stylised foliage motifs are smaller and less complex than those found in contemporary Yorkshire Cistercian initials.

Other Bridlington manuscripts suggest an interest in historical, as well as theological works, as there are surviving copies of the works of Geoffrey of Monmouth and William of Malmesbury. Of these, the most impressive is Oxford Bodleian Library, MS Bodley 357, a copy of William of Malmesbury's *De Gestis Pontificum Anglorum*. As with the manuscripts discussed above, the script is clear, and the vellum and ruling good. But this book is larger in format, and the initials are both more numerous and more accomplished, both in the use of stylised foliage, and the handling of pen scrolling. Finally, yellow paint is used here, whereas the other Bridlington books use only the more frequent red, green and blue. It thus seems probable that this manuscript was not made at Bridlington, or at least that it involved work by a professional.

The books discussed so far have suggested the presence of skilled scribes at Bridlington, and a capacity to produce good copies of texts, without any complex decoration. The number of manuscripts is too small for any real conclusions about the questions of whether there was a 'house style'; but it does appear that there was more concern for clarity in layout, and restraint in decoration, than for uniformity in style. There is some evidence that manuscripts on a rather less grand scale were also produced at Bridlington, however, and of a kind which again suggests that copying was carried out by a number of the canons. This comes from Oxford Bodleian Library, MS Digby 53, a small volume containing a collection of poetic works by Serlo, and a rather miscellaneous range of other items, each in a different hand, and with its own ruling pattern . The contents include a treatise on rhetoric, again suggesting literary interests. Here also the decorated initials are rather plain, and not distinctive in their motifs. Thus, there is some suggestion of collaboration by several members of the house, or at least a gathering-together of items produced by several hands.

Of all the Bridlington manuscripts, the one which makes use of a distinctive motif in its decorated initials is another copy of the work of William of Malmesbury, now British Library Cotton MS Claud. Av, ff. 46–135. This is rather different in its script from the books discussed so far, and its vellum is also unusual. On folio 84v it has a 4-line initial C, in red with blue decoration (Pl. XXXIIA). The central element in the latter is a distinctive 'split petal', found in books from Durham, and the Yorkshire Cistercian houses, and strongly indicating a link with books from at least one of these Northern centres. It thus seems at least possible that Bridlington obtained this book, or its exemplar, from one of the other Yorkshire houses, or perhaps from Durham. Indeed, the best source of good texts would probably be the latter, whose library was already impressive.

Finally, it may be suggested that the library of Bridlington was itself quite extensive, in areas according with what has already been outlined. The evidence for this is the list, found on f48v of B.L. MS Harley 50, of 'libri magni armarii'. The list contains some seventy-seven major titles, as well as some forty works listed as 'Parvi libelli'. The titles are set out in groups, the first one starting with the works of Gregory the Great, then going on to the commentaries of one Robert, presumably Robert of Bridlington himself. These consist of several besides those still extant, including one on the Apocalypse, which may explain the extensive glosses and commentary in the Ripon manuscript. The next group contained principally the works of Ambrose and Isidore, whilst a separate group is called 'Libri Glosali' and includes what may be the surviving Mark and Luke. Still another group includes works by Anselm and historical works, amongst others. However, perhaps most interesting is the largest group, headed 'Libri Hugonis'. This opens with the works of Hugh of St Victor, but is much more varied than the other groups, including works by Rabanus, Smaragdus, Cassian and Gregory Nazianzen. There are also further works on the monastic life, a number of Vitae, and a Bestiary, as well as other more obscure works. Finally, the inclusion of a Priscian suggests that at least some of these may have been books for teaching.

All of this taken together suggests considerable activity in the copying, collecting and use of books at Bridlington. Overall, an impression is given of care for both text and script, but less taste for decoration. An interesting possibility is that this represents some disapproval of decoration, comparable to that of the Cistercians, but again the evidence is not sufficiently clear. What such a level of activity does suggest, however, is that Bridlington was in contact with sources of both texts and, possibly, professional scribes. Here, the occurrence of the 'Northern' split-petal motif is of considerable interest. This seems to occur earliest in books produced at Durham, which would possibly be the best source of exemplars in this period. However, it was also much used by the Cistercians, and contacts between the Augustinians and the Cistercians were close in this period. Besides Robert's

own friendship with Gervase, Waltheof of Kirkham was in contact with Ailred of Rievaulx; and William of Newburgh was in contact, a little later, with abbot Ernald of Rievaulx. It is also documented, in John the Prior's *History of the Church of Hexham*, for 1142, that it was Cuthbert, prior of Guisborough, and Waltheof of Kirkham who supported William of Rievaulx and Richard of Fountains in accusing William, archbishop elect of York, of simony. (William's supporters were primarily Benedictines, but did not include Durham.) Finally, personal contacts between Rievaulx and Durham existed, in the form of those monks who, like Maurice the sub-prior in 1137, had moved to the Cistercian house.

In order to examine this question of a network of contacts amongst the newer Yorkshire houses, and between them and Durham, it is necessary to turn to surviving books from other Augustinian houses, and to compare them against the evidence from Bridlington. Perhaps the most interesting case is that of Newburgh, where, as has already been stated, there was intellectual contact with Rievaulx. The individual most concerned was William of Newburgh, who was brought up in the house, and died there *c.* 1198.

Some Cistercian houses had already produced foundation narratives, but it seems possible that historical writing was discouraged as part of the Cistercians' broad disapproval of original writing by their members. At the least, it appears that William was encouraged in his work by abbot Ernald of Rievaulx, and that he obtained information from both Rievaulx and Byland. His work suggests a familiarity with chronicle material deriving from Durham, and compiled there *c.* 1148–61.[19] Whether this came direct from Durham or via the Cistercians, is unfortunately not clear, but in any case the impression of a network of literary and intellectual exchanges, perhaps involving the lending and copying of books, is reinforced. Newburgh was certainly less well-connected at court than other Augustinian houses, and it is not likely that such material would come through secular patrons. That William was in contact with other ecclesiastics is suggested by the fact that he is conversant with current church politics, and is able to cite an abbot, an archdeacon, and a monk, at least, as informants in his chronicle.

Unfortunately only two Newburgh manuscripts survive from the relevant period. Of these, perhaps the most striking is British Library MS Stowe 62, an early 13th-century copy of William's own work (Fig. 1). As he probably completed the original in 1198, this is an early copy, and it has a contemporary Newburgh ex libris. Its script and initials both suggest Cistercian influence, though it seems unlikely that it was made in a Cistercian house, as the initials are in three colours. Like the Bridlington William of Malmesbury, its initials use the distinctive split petal, though in a more complex way, and in combination with a three-lobed bud motif which is the second main component of the Cistercian stylised foliage decoration.

The other Newburgh manuscript is British Library MS Arundel 252, an early 13th-century copy of Ivo Carnotensis, and is different in appearance. It is smaller, and written throughout in a small, spiky, early-Gothic script. Its provenance is given by an early Newburgh ex libris; and again it has certain similarities to Cistercian manuscripts. It is plain in appearance, its initials having minimal decoration only, and the range of colours is very close to those found in Yorkshire Cistercian manuscripts: red, acid green, pale blue and dull yellow. Of the initials, the only one with any significant decoration is a six-line-high C on folio 6v. and this is surprisingly unCistercian in design. It does not use the split petal form, and the hollow of the letter is filled with regular, repeating elements, in a symmetrical pattern, unlike the rather more flowing designs in Cistercian initials. Indeed, the nearest parallels to this letter are found in some roughly contemporary manuscripts from St Mary's, York, which show the same symmetrical repetitions of small, tightly-handled elements. However, it is difficult to judge whether this parallel is of any significance, as there are no

FIG. 1. Drawing of intial from B.L. MS Stowe
62, fol. 59r

distinctive motifs, and the surviving manuscripts from both Newburgh and St Mary's are
few. A house as wealthy and influential as St Mary's would appear a likely source of books,
but in fact there is little evidence of literary or intellectual activity there, and it has been
suggested that it did not endow a scriptorium.[20] If this is correct, then there is little
possibility of St Mary's acting as a stylistic influence for other houses, and all that can be
suggested is that there is some evidence here of a 'local' style, which had some impact on
both houses.

Cistercian connections are again strong in the case of Kirkham, since its founder, Walter
Espec, also founded Rievaulx, and St Waltheof, Prior of Kirkham c. 1140–7, left to become
a Cistercian. That he did not reject the Augustinians is suggested by Ailred of Rievaulx, who
wrote that Waltheof later came to regard the Augustian Rule as preferable. Further, the
Rievaulx Cartulary preserves a draft agreement, never put into action, to make Kirkham
Cistercian. Interestingly, this agreement makes special mention of the stained-glass
windows, but not of books, perhaps suggesting that the latter, unlike the former, were taken
for granted, and not thought of as a problem in any such change.

Kirkham, like Guisborough, does not seem to have produced an historian until the 16th
century, but it is clear that it had powerful contacts. This being so, it seems most likely that a
group of its surviving manuscripts could have been gifts, as they are both more extensively
and more confidently decorated than any of the other Augustinian books discussed earlier.
The manuscripts are now British Library MS Arundel 36 (containing Possidius' 'Life of St
Augustine'), Add. 38817, containing works by Bede, Cotton Vespasian B xi folios 84–125
(Aelred's Life of Edward the Confessor) and Royal 13 A XXI folios 151–92 (short works by
Jerome and Cassiodorus). The last two were originally part of the same volume as Arundel
36. They appear to be products of the same workshop, being related in vellum, ruling
pattern, script and decoration and, to judge from a contemporary note at the end of the
Cassiodorus text, to represent the interests of one individual. Unusually amongst these
Yorkshire manuscripts, they contain initials formed from the twisting bodies of dragons;

and, even more surprisingly, Arundel 36 contains a series of marginal drawings of heads, done in clear, confident ink drawing (Pl. XXXIIв). In appearance, these are rather elongated and heavy-jawed, showing a preference for the three-quarter view, and are reminiscent of a figure style found in 12th-century luxury manuscripts, often attributed to professional illuminators. The nearest northern parallels are in books from Durham such as Durham, Dean and Chapter Library, MS B II 7, or, showing an even more marked, round shouldered elongation of the figures, the Bible of Hugh de Puiset (Durham MS A II 1).[21]

A link with Durham is again suggested by the repeated occurrence of the split-petal motif in the minor initials and by the fact that neither of the other two surviving Kirkham books from this period shows similar motifs or quality of execution. Thus, although the exact method by which these books came to Kirkham is unknown, there is evidence that Yorkshire Augustinian houses might be the recipients (or even purchasers) of high-quality books, whilst at the same time maintaining some level of writing and copying, presumably by the canons themselves, within the houses.

In the case of Guisborough there is again evidence of some link with Durham. This comes largely from British Library MS Arundel 218, a collection of excerpts from Gregory and Augustine made by Alcuin and Bede. This manuscript is written in one hand throughout, although it is not completely regular, and its initials are of a type not found in manuscripts from the other Augustinian houses. They are rather freer and sketchier in execution than usual, and make use of a foliage motif found in 12th-century Durham manuscripts in large numbers. This is the motif named by Mynors as the 'clove-curl', and it is found here in an elaborated version, again frequent in Durham books, where small curved strokes of colour are added to the basic motif (Pl. XXXIIc). The sketchiness of execution of the initials in the Guisborough manuscript, however, together with the appearance of the script, seems to suggest that Arundel 218 is not a product of the Durham scriptorium itself. It may thus be suggested that it was copied from a Durham book and that its copier imitated the style of the initials in the exemplar. However, it is not possible to support this with evidence from other Guisborough manuscripts, as there are too few to suggest a pattern, and the two in the Cotton collection in the British Library have been too badly damaged by fire.

Such scarcity is, as will be clear from all the foregoing evidence, a characteristic of these manuscripts which makes their interpretation with any certainty difficult. However, it is the argument of this paper that certain patterns of both production and collection of manuscripts in these Augustinian houses do begin to appear, and that they support the outline of a fascinating picture of the development of scholarly and artistic activity in Yorkshire in the later 12th century, paralleling the county's gradual economic revival, and linked to its increasing importance in ecclesiastical affairs.

First, the majority of these Augustinian houses appear to have had book collections capable of supporting considerable scholarly activity. Second, in some houses at least a considerable importance appears to have been attached to such activity. Third, they all seem to have taken pains to acquire books for daily religious reading, as well as for the liturgy (unfortunately, there is no conclusive evidence on schools and school books). Finally, there seems to have been an expectation that both copying and illuminating texts would go on inside the houses themselves; together with an openness to gifts or purchases from other sources. In this connection, however, it is interesting that the Augustinians, unlike the Cistercians, do not appear to have produced their own parchment. Characteristically, the parchment used in these Augustinian books is smooth, white, with regular edges and few holes; but also very varied in thickness and tone. All this suggests purchase, and it seems that suppliers were to be found, at least in York. It is true that Robert of Bridlington writes of 'preparing parchment for the scribes', but this need mean no more than pumicing and

whitening the surface, and trimming it to the required size. Ink is generally of good quality, with different tones used for main texts and glosses, but pigments are few, mostly restricted to the basic red, green and blue, and often rather uneven in texture. There is no gold or silver, suggesting either a lack of funds for such expensive materials, or a Cistercian-like avoidance of them. Further, whilst the manuscripts suggest the presence of a number of skilled scribes, only those of Kirkham make any use of either human figures or dragon-initials, and, as has been seen, most of the initials suggest the work of rather inexperienced hands.

Finally, comparisons with manuscripts from other houses seem to suggest some dependence on the Yorkshire Cistercian abbeys, as well as Durham, and, to a lesser extent, a regional style found also at St Mary's, York. All this produces a picture of a rather self-contained Northern monastic community, with the houses of the newer orders linked to one another intellectually, and artistically, as they were also in matters of ecclesiastical politics. The picture cannot be complete, but nevertheless there was clearly considerable activity in building up good libraries, containing books of recognisably 'Northern' style, in these Yorkshire houses.

REFERENCES

1. A full account of the Yorkshire Domesday is given by W. Farrer, 'Introduction to the Yorkshire Domesday', *Victoria County History of the County of York*, ed. W. Page (London 1912), Vol. II, 133–90.
2. F. W. Maitland, *Domesday Book and Beyond*, 3rd edn (London 1960), 423. Detailed discussions of the condition of Yorkshire in this period are given by T. A. M. Bishop, 'The Norman Settlement of Yorkshire', *Studies in Medieval History presented to F. M. Powicke* (Oxford 1948), 1–14; and by J. Le Patourel, 'The Norman Conquest of Yorkshire', *Northern History*, VI (1971), 1–21. A further argument is given by W. Kapelle, *The Norman Conquest of the North* (N. Carolina and London 1979), 158–90.
3. Bishop, 2.
4. See especially C. Norton and D. Park (eds), *Cistercian Art and Architecture in the British Isles* (Cambridge 1986), and C. R. Cheney, 'English Cistercian Libraries: the first century' in his *Medieval Texts and Studies* (Oxford 1973), 328–45.
5. Maitland, 492.
6. Bishop, 10.
7. Kapelle, Ch. 6, passim.
8. For a full discussion of the foundation of the English Augustinian houses, see J. C. Dickinson, *The Origins of the Austin Canons and their Introduction into England* (London 1950), 91–130.
9. There is a map of the distribution of 'overstocked manors' in Kapelle, 168. This may be compared with the map of ecclesiastical Yorkshire in *VCH Yorks*, III (frontispiece).
10. Kapelle, 166–73.
11. The bans on individual ownership of anything are in Chs IV and XIV. The official in charge of the books is mentioned in Ch. XV.
12. *The Bridlington Dialogue*, translated and edited by a religious of C.S.M.V. (London 1960).
13. *Bridlington Dialogue*, VII–IX.
14. There is a brief analysis of the work of Robert of Bridlington in B. Smalley, *The Study of the Bible in the Middle Ages* (Oxford 1952), 51 and 60–1.
15. *Bridlington Dialogue*, VII–VIII.
16. Ibid., 154.
17. Ibid., 163–4.
18. For identifiable Bridlington manuscripts, see N. R. Ker, *Medieval Libraries of Great Britain*, 3rd edn (London 1964), 12–13. Lists for the other Augustinian houses discussed here are also given.
19. For a fuller discussion, see J. Taylor, *Medieval Historical Writing in Yorkshire*, St Anthony's Hall Publications No. 19 (York 1961), 10–12.
20. Ibid., 14.
21. Both are reproduced in R. A. B. Mynors, *Durham Cathedral Manuscripts* (Oxford 1939). Plate 42 shows folios 10v and 34v of B II 8; Pl. 44 shows heads of Adam and Woden on folio 140 of B II 35, containing a historical text datable to 1166; and Pl. 49 shows three historiated initials from Durham A II 1, the Puiset Bible.
22. Ibid., 7–8.

THE PLATES

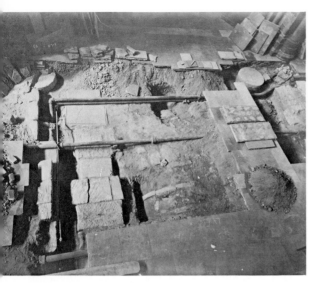

IA. Exposure of the Wilfridian crypt's roof below the Cathedral's crossing in 1930. View from the choir screen looking westwards

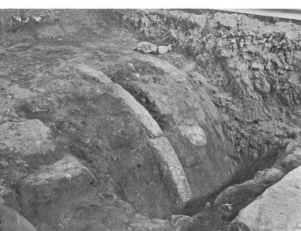

IB. Top surface of vault ribs in the roof of the Wilfridian crypt, exposed in 1930s, looking towards the north-east

IC. Ribs in the demi-vault over the Wilfridian crypt's western ante-chamber, exposed in 1930s, looking towards the north-east

IIA. Stone drum from the foundation bounding the crypt's north side, photographed in
1981. Scale unit: 0.1m
Photo: York Archaeological Trust

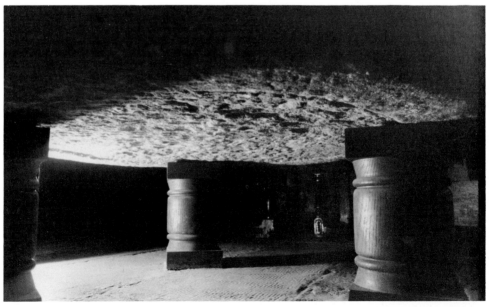

IIB. Shallow seating on the smaller face of the stone drum, photographed in 1981
Photo: York Archaeological Trust

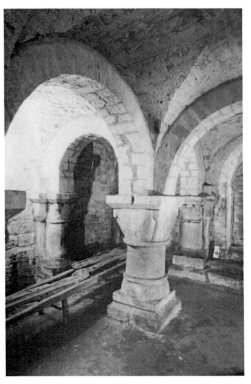

IIIA. Interior of the crypt

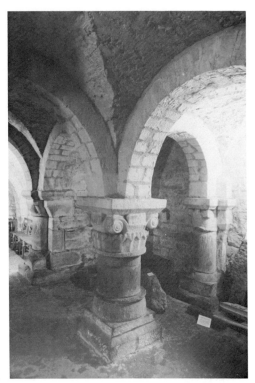

IIIB. Details of crypt capitals

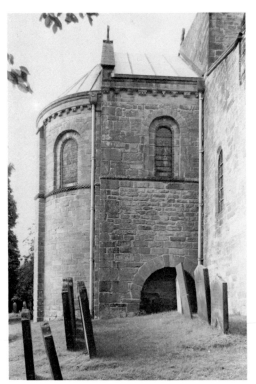

IIIc. Exterior of main apse

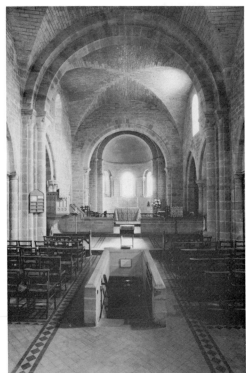

IIID. Interior of church looking east

Photos: Malcolm Thurlby

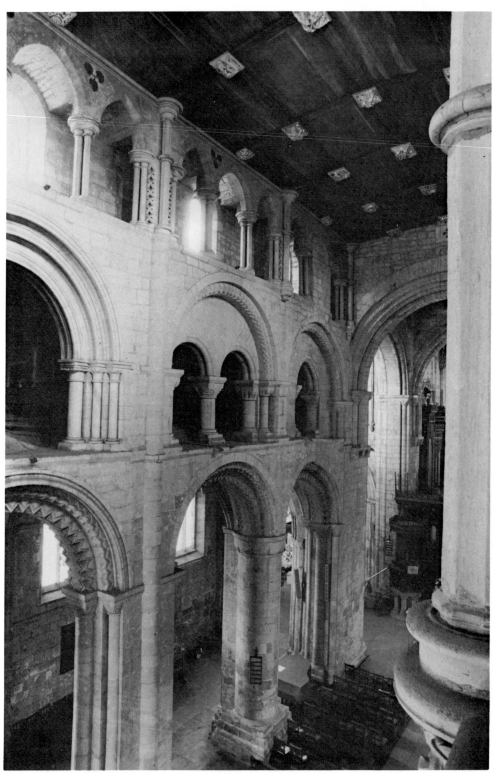

IV. Nave, interior: north bay 1 shows the distortion of the arches, and two kinds of chevron,
point-to-point on the inner order of the main arcade arch, and edge chevron on the outer
order and in the gallery. North pier 2 shows the masonry break to the west of the shaft, and
the keeled angle-roll on arch 3 alongside the chevron mouldings
Photo: Malcolm Thurlby

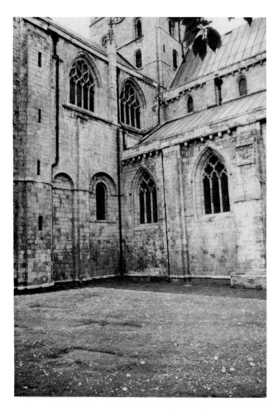

VA. North arm of the transept, exterior: west wall. The masonry break in the wall of the north aisle is visible near the right-hand edge of the picture
Photo: Malcolm Thurlby

VB. Masonry courses, exterior: left: east end of the north wall of the transept (i.e. at the easternmost surviving part of phase I); right: in bay 3 of the north aisle of the nave (i.e. at the west end of phase I, which coincides with the west end of phase II in the main arcade walls)
Photo: Eric Fernie

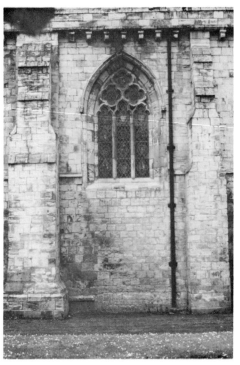

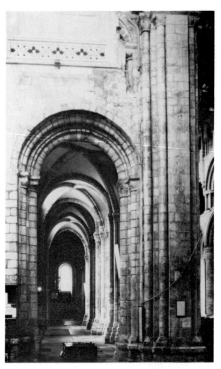

VIA. Selby Abbey north nave aisle, third
bay from the east

VIB. South arm of the transept,
interior: west wall, arch into the
south aisle of the nave

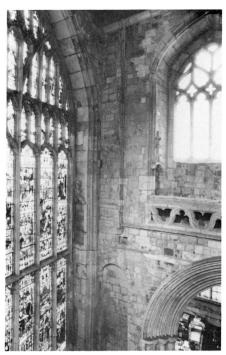

VIC. Selby Abbey, north transept,
interior, north-east corner

VID. Selby Abbey, north transept,
exterior, clerestory

Photos: Malcolm Thurlby

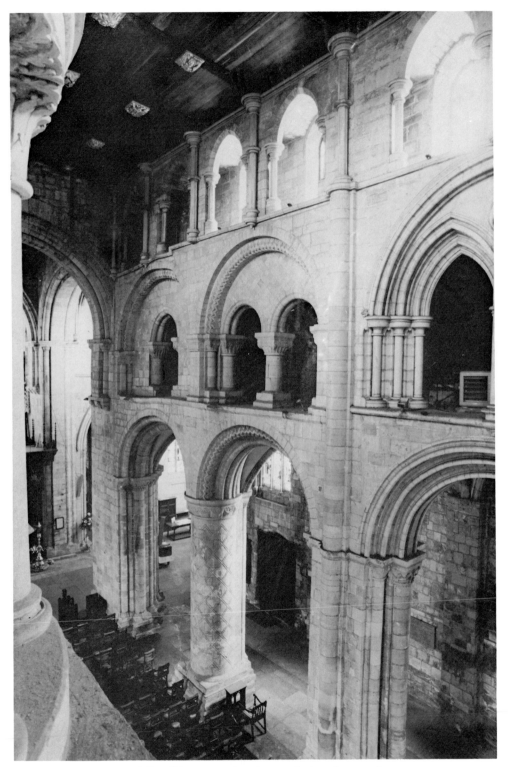

VII. Selby Abbey, nave, interior, south elevation, east bays
Photo: Malcolm Thurlby

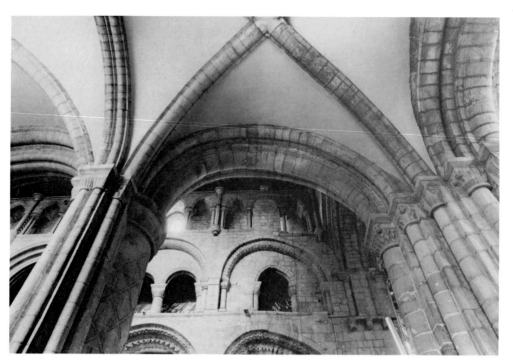

VIIIA. Selby Abbey, south nave aisle, bay 1, vault to north

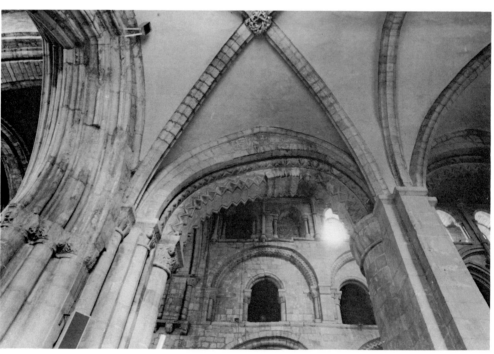

VIIIB. Selby Abbey, north nave aisle, bay 1, vault to south
Photos: Malcolm Thurlby

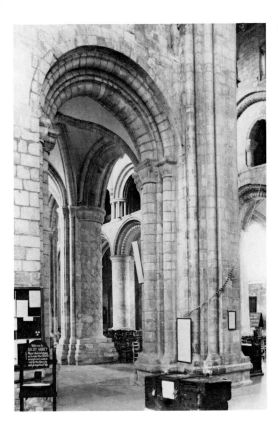

IXA. Selby Abbey, south nave arcade from south transept

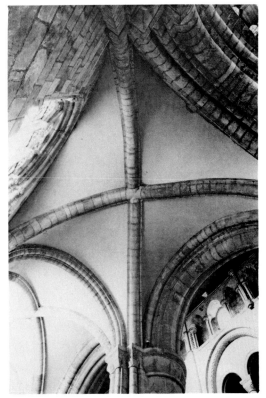

IXB. Selby Abbey, south nave aisle, bay 1, vault

Photos: Malcolm Thurlby

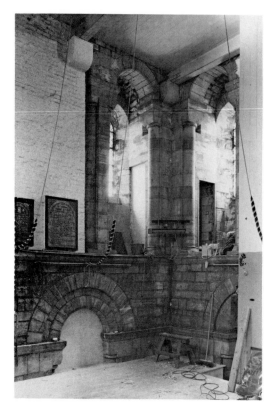

Xᴀ. Selby Abbey, lantern, interior to north-west

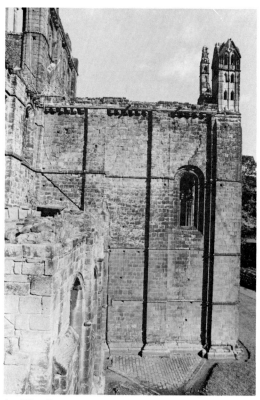

Xʙ. Kirkstall Abbey, presbytery, exterior
from south
Photos: Malcolm Thurlby

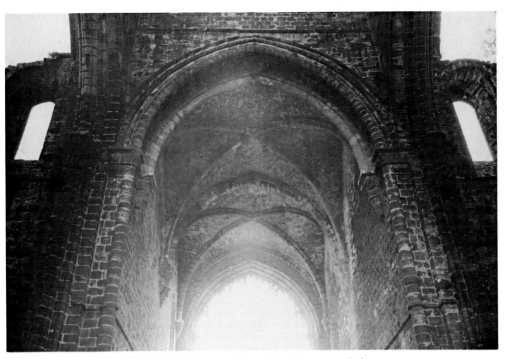

XIA. Kirkstall Abbey, crossing and presbytery vault from west

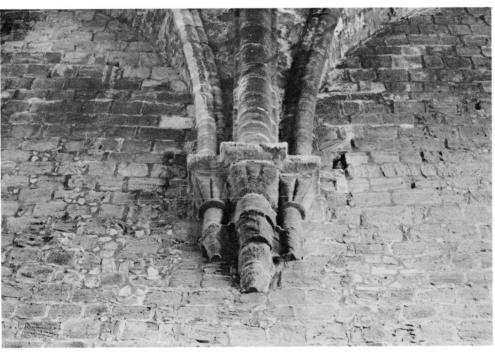

XIB. Kirkstall Abbey, presbytery, north vault corbel
Photos: Malcolm Thurlby

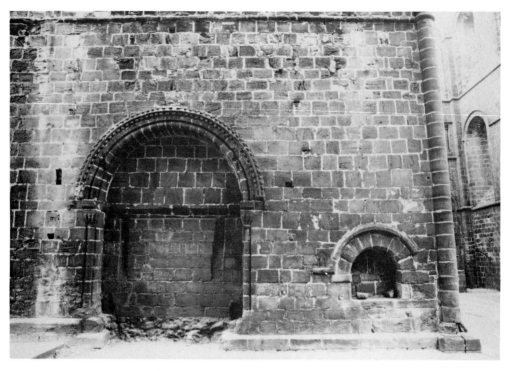

XIIA. Kirkstall Abbey, presbytery, interior south wall, west bay

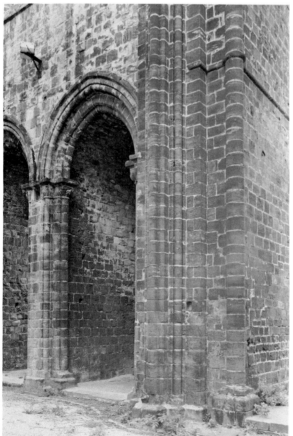

XIIB. Kirkstall Abbey, north-east crossing pier, detail west face

Photos: Malcolm Thurlby

XIIIA. Kirkstall Abbey, arch from north transept to north nave aisle, detail of north respond

XIIIB. Kirkstall Abbey, nave piers

XIIIc. Kirkstall Abbey, dormitory undercroft, east aisle to north

Photos: Malcolm Thurlby

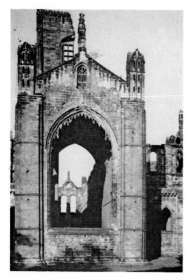

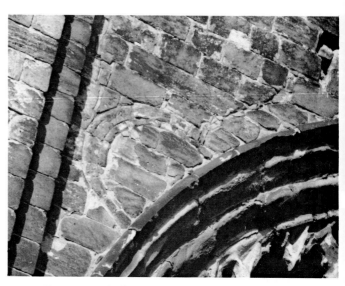

XIVA. The east gable showing the inserted 15th-century window and the surviving 12th-century elements

XIVB. Detail of south side of east front showing the partially destroyed and blocked upper oculus, similar remains are visible internally indicating that it was pierced as a window

XIVc. One of three surviving rose window rim sections, showing the external face with interlace ornament. A curved spoke is placed in position to show its relationship to the rim section

XIVd. One of three surviving rose window rim sections showing the prominent rebates for glazing and a curved spoke placed in position to show its relationship to the rim section. Just to the left is a hole in the rebate for a metal glazing retaining pin. Note the prominent chamfered hoodmould present on only two of the surviving pieces

Photos: Author

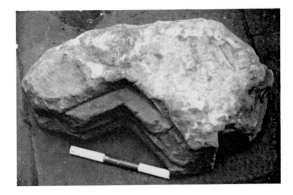

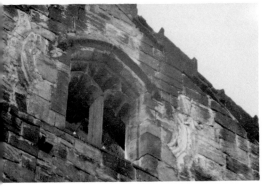

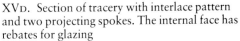

XVA. Intermediate tracery ring section showing the interlace decoration and stepped masonry joint at the top. Although the piece is incomplete sufficient survives to establish its former extent

XVB. Internal face of the intermediate tracery ring section, showing the prominent glazing rebates and the stepped masonry joint at the bottom

XVC. Section of tracery from a foiled opening. Its internal face shows rebates for glazing

XVD. Section of tracery with interlace pattern and two projecting spokes. The internal face has rebates for glazing

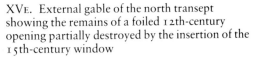

XVE. External gable of the north transept showing the remains of a foiled 12th-century opening partially destroyed by the insertion of the 15th-century window

All scales have 10cm divisions
Photos: Author

XVIA. Holy Trinity Priory, York: View from north-east in the 1840s.
F. Bedford and W. Monkhouse, *The Churches of York*, York nd.
(about 1845)

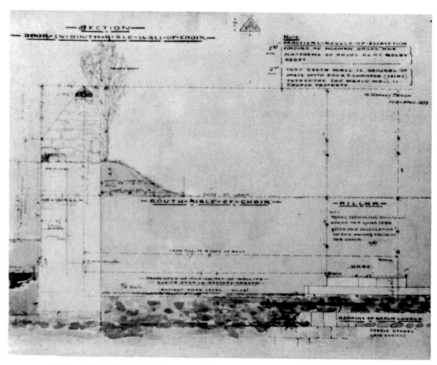

XVIB. Holy Trinity Priory, York: north–south section through 1899
excavations in choir
Brook Notes, II, f.30v

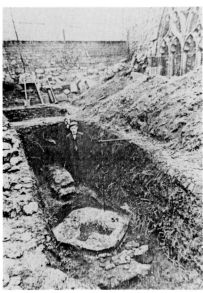

XVIIA. Holy Trinity Priory, York: photograph of excavations in Rectory garden, 1899. The view is looking east along the exposed remains of the north choir arcade, with the sub-base of the second pier from the west visible in front of Walter Harvey Brook and his nephew F. W. Newton. (Borthwick Institute, RXii HTM 25)
Copyright: The Borthwick Institute of Historical Research

XVIIB. Holy Trinity Priory, York: foliate capital found during 1899 excavations in the choir
Photo: Author

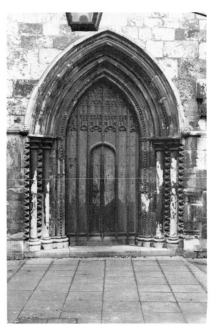

XVIID. Holy Trinity Priory, York: north nave doorway. The doorway was reassembled from *in situ* excavated remains and fragments found in 1904–06
Photo: Author

XVIIC. Holy Trinity Priory, York: eastern belfry window in north-west tower. The window was reassembled from late-twelfth century fragments when tower was built in 1453
Photo: Author

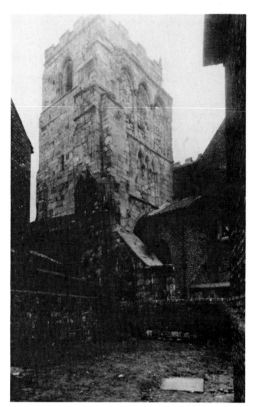

XVIIIA. Holy Trinity Priory, York: remains of the medieval west front. This photograph (taken by Stanley Brook in about 1904) shows the remains of the north nave internal elevation preserved in the south wall of the north-west tower. The remains of the jamb of the northern lancet in the west front, the blind arcade below and the northern jamb of the original central doorway are clearly visible
Brook Notes, I, 199

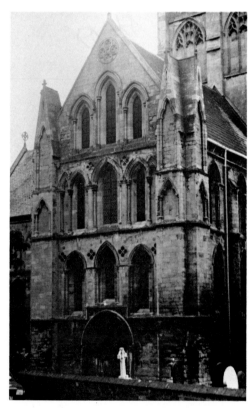

XVIIIB. St Augustine, Hedon, North Humberside: the north transept from the north-west
Photo: Author

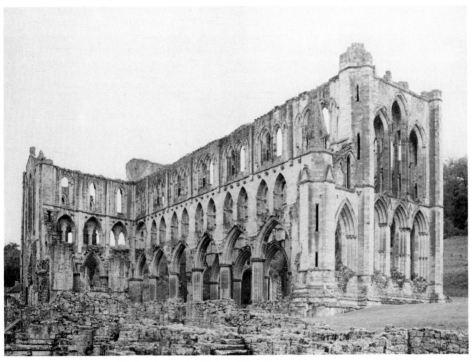

XIXA. Rievaulx Abbey. View from the south-east

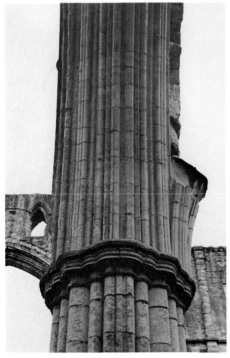

XIXB. Rievaulx Abbey. Choir arch
moulding *a*

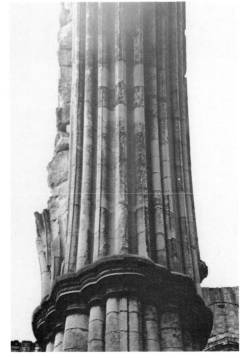

XIXC. Rievaulx Abbey. Choir arch
moulding *b*

Photos: Author

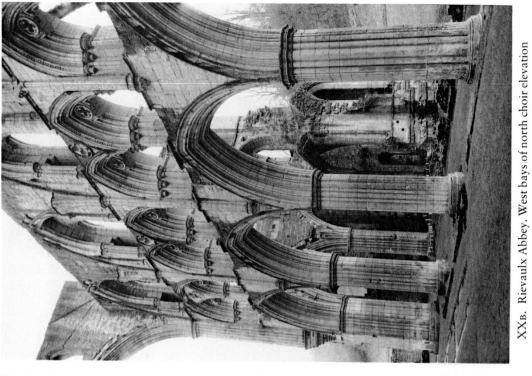

XXB. Rievaulx Abbey. West bays of north choir elevation

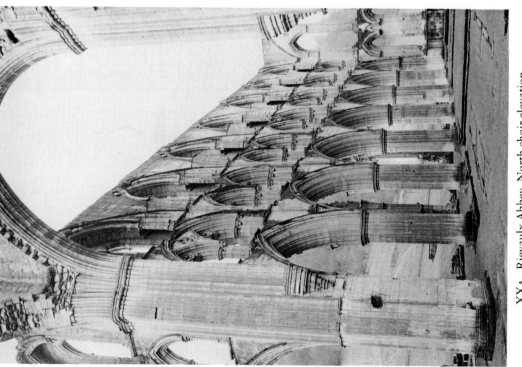

XXA. Rievaulx Abbey. North choir elevation

Photos: Author

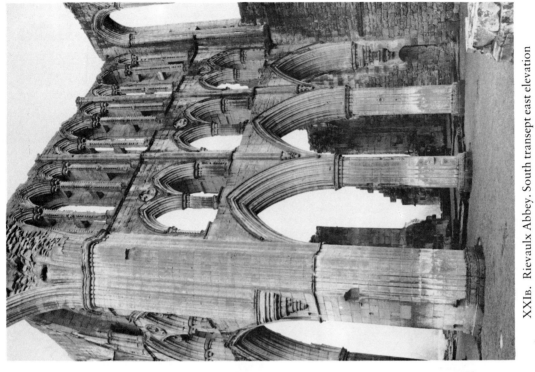

XXIB. Rievaulx Abbey. South transept east elevation

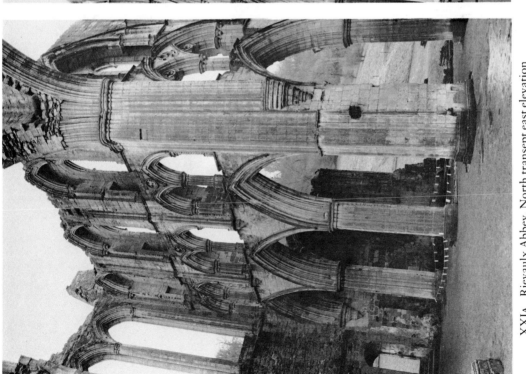

XXIA. Rievaulx Abbey. North transept east elevation

Photos: Author

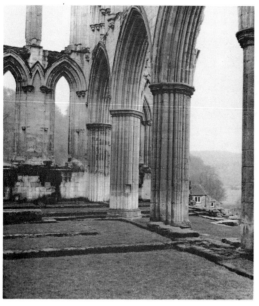

XXIIA. Rievaulx Abbey. East piers of the
south choir arcade

XXIIB. Rievaulx Abbey. North transept
arcade, south arch, from the east

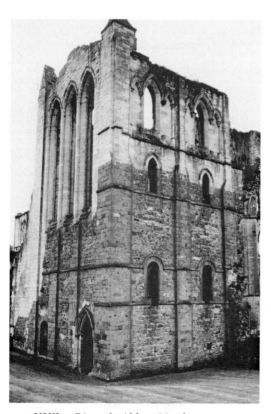

XXIIc. Rievaulx Abbey. North transept
exterior from the north-west

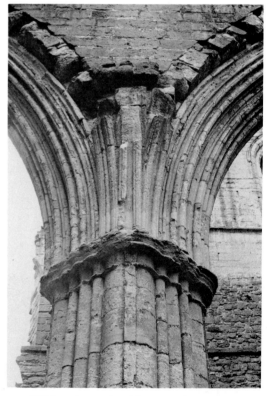

XXIID. Rievaulx Abbey. North transept,
first pier north of the crossing, from the east

Photos: Author

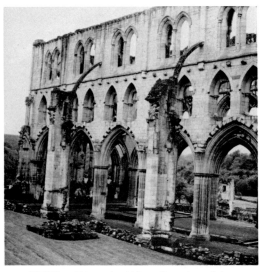

XXIIIA. Rievaulx Abbey. Exterior of the choir from the north-west

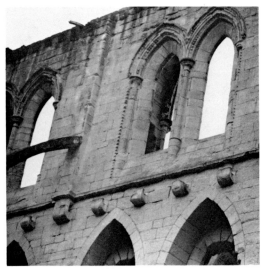

XXIIIc. Rievaulx Abbey. Remaining vertical buttresses of north choir aisle wall

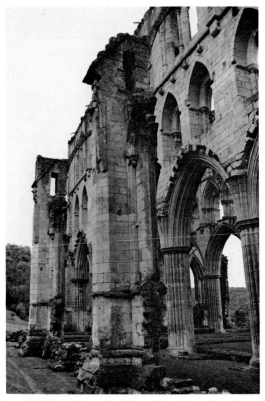

XXIIIB. Rievaulx Abbey. Exterior of north choir clerestory

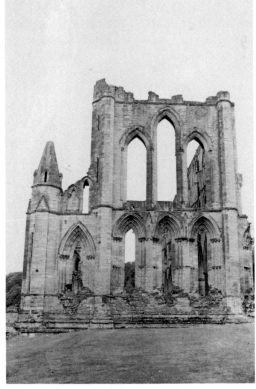

XXIIID. Rievaulx Abbey. Exterior of choir east facade

Photos: Author

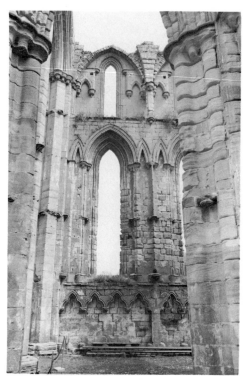

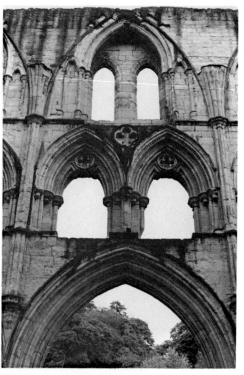

XXIVA. Fountains Abbey. Interior bay
of the east wall of the Nine Altars Chapel

XXIVB. Rievaulx Abbey. Upper storeys
of north choir elevation

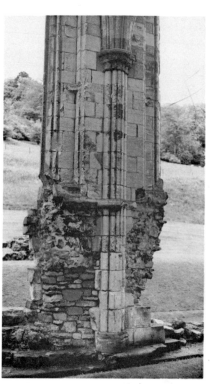

XXIVc. Rievaulx Abbey. North
choir aisle wall respond

XXIVd. Whitby Abbey. North choir
elevation

Photos: Author

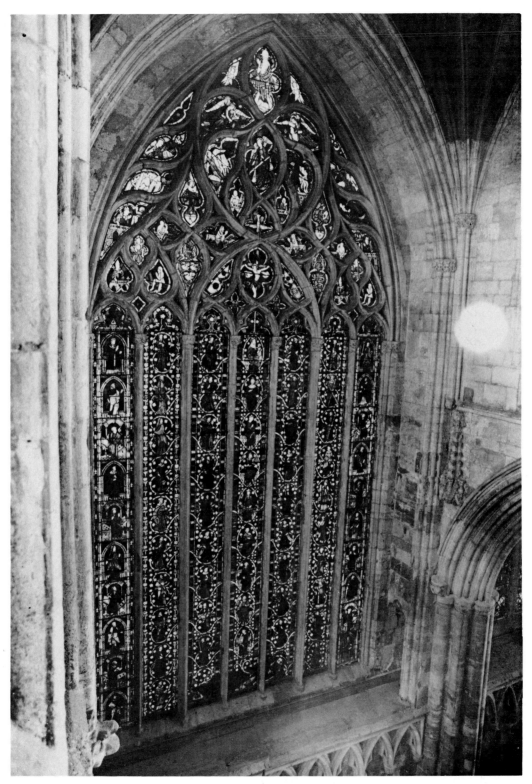

XXV. Selby Abbey, east window (I)
Copyright: D. O'Connor

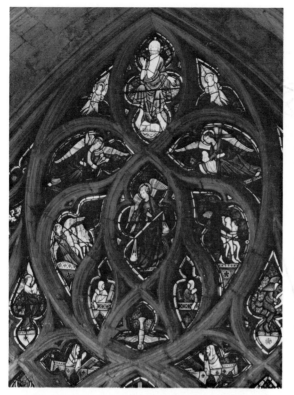

XXVIA. Selby Abbey I tracery top section: Doom
Copyright: D. O'Connor

XXVIB. Selby Abbey I 4–6cd: Jesse Tree
Copyright: D. O'Connor

XXVIC. Selby Abbey I tracery left section: Doom
Copyright: D. O'Connor

XXVIIA. Selby Abbey
I 1f: Sarasam.
Engraving by William
Fowler, 1820

XXVIIB. Selby Abbey
I 9c: Herod the Great.
Engraving by William
Fowler, 1820

XXVIIC. Selby Abbey
I 2g: St John the
Evangelist. Engraving
by William Fowler,
1820

XXVIID. Selby Abbey
I 10g: St Paul.
Engraving by William
Fowler, 1820

XXVIIE. Selby Abbey
I D2: Resurrection of
Man. Engraving by
William Fowler, 1820

XXVIIF. Selby Abbey
I H2: Resurrection of
Abbot or Bishop.
Engraving by William
Fowler, 1820

*Photos: Copyright:
D. O'Connor,
reproduced by kind
permission of the Dean
and Chapter of York*

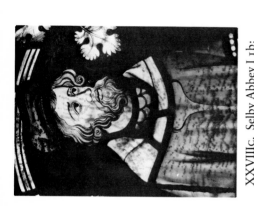

XXXVIIIc. Selby Abbey I 1b:
Samuel. Ward and Hughes,
1906–09
Copyright: D. O'Connor

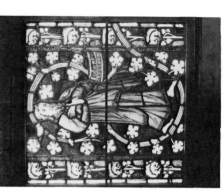

XXXVIIIf. Ely Cathedral
Stained Glass Museum:

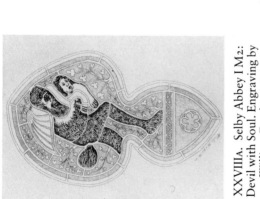

XXXVIIIb. Selby Abbey I O2:
Resurrection of Woman.
Engraving by William Fowler, 1820
*Copyright: D. O'Connor, full
acknowledgement on p. 141*

XXXVIIIe. Selby Abbey Sac

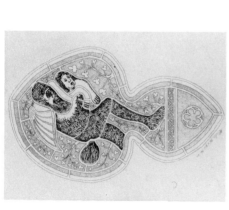

XXXVIIIa. Selby Abbey I M2:
Devil with Soul. Engraving by
William Fowler, 1820
*Copyright: D. O'Connor, full
acknowledgement on p. 141*

XXXVIIId. Selby Abbey Sac

XXIXc. King Achaz from
Selby, *c. 1340*
*Photo: D. O'Connor, full
acknowledgement see
p. 141*

XXIXf. Cartmel Priory sII:
Tree of Jesse
Copyright: D. O'Connor

XXIXb. Dorchester Abbey I 5e:
Resurrection of Abbot or Bishop
from Selby, *c. 1340*
Copyright: Dennis King

XXIXa. Dorchester Abbey I 5b:
Resurrection of King from Selby,
c. 1340
Copyright: Dennis King

XXIXe. King Jotham from Selby,
c. 1340
*Photo: D. O'Connor, for full
acknowledgement see p. 141*

XXIXd. King Amaziah from
Selby, *c. 1340*
*Photo: D. O'Connor, for full
acknowledgement see p. 141*

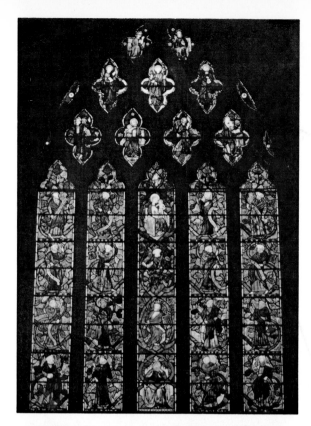

XXXA. Morpeth, St Mary, east window (I). Tree of Jesse
Copyright: D. O'Connor

XXXB. Carlisle Cathedral, east window (I) tracery: Doom
Copyright: D. O'Connor

XXXC. York Minster, nXXX 3b: head of Christ child, *c.* 1339
Copyright: D. O'Connor, reproduced by kind permission of the Dean and Chapter of York

XXXD. York Minster, west window, wI 8g: St Peter from Ascension, *c.* 1339
Copyright: D. O'Connor, reproduced by kind permission of the Dean and Chapter of York

XXXE. Selby Abbey Sac. sII 2b: head of St John the Evangelist, *c.* 1340
Copyright: D. O'Connor

XXXIA. Shrewsbury,
St Mary, east window (I):
Tree of Jesse
Copyright: RCHME

XXXIB. Selby Abbey,
interior to east after fire in
1906
Copyright: RCHME